The Hitchcock Murders

Peter Conrad was born in Australia, and since 1973 has taught English at Christ Church, Oxford. He has written numerous works of criticism, including *Imagining America*, *The Everyman History of English Literature*, *A Song of Love and Death: The Meaning of Opera*, and *Modern Times, Modern Places: Life & Art in the 20th Century*. He has also written two autobiographical works, *Down Home* and *Where I Fell to Earth*, and in 1992 he published his first novel, *Underworld*.

The Hitchcock Murders

Peter Conrad

faber and faber

First published in 2000
by Faber and Faber Limited
3 Queen Square London WC1N 3AU
Published in the United States by Faber and Faber Inc.
an affiliate of Farrar, Straus and Giroux LLC, New York

This paperback edition first published in 2001

Photoset by Parker Typesetting Service, Leicester
Printed in England by Mackays of Chatham plc, Kent

A CIP record for this book
is available from the British Library

ISBN 0-571-21060-0

2 4 6 8 10 9 7 5 3 1

Contents

Preface

The day after Hitchcock's centenary, in August 1999, I was driving through southern Portugal with some friends. We stopped for coffee in a small town that was near enough to the coast to have a supplementary population of tourists. The streets were a scorching desert, the single café a shady, conspiratorial cave. Local elders gossiped and grumbled at the bar, dogs scratched on the floor, and some sun-mottled Germans drank beer at a corner table. The café had a rack of newspapers for sale – not just those printed in Lisbon, but a selection flown in from all over Europe. I glanced at the front pages as I drank my coffee, and noticed that they all told the same story, in different languages and in type-faces of differing stridency. Yesterday's news, in Madrid, Milan, Paris, Frankfurt, Stockholm and of course London, was the commemoration of Hitchcock's anniversary.

His image accompanied most of the stories: a face that scowled like that of a fractious baby in some versions, and in others guile-lessly beamed. In one portrait he puffed on a bulbous cigar; in another a crow perched on his shoulder. Despite the glare in the street, the café was dark, and although it was only mid-morning, I could hear Hitchcock insidiously murmur 'Good evening', as he used to do every week on his television series. The imaginary sound made me shiver, in spite of the heat. With that greeting he invited us to enter his private domain – an infirmary of moral qualms and mental ailments, a catacomb of curios (including a coffee cup like the one I held in my hand, although the Hitchcockian prototype contained poison). A rational person would have politely refused to step into that booby-trapped lair, yet few of us did. That is why journalists in a dozen languages had written those columns. Their assignment was to thank Hitchcock for terrifying us. He filled us with fear – but of what exactly? Perhaps of God, or the gods. For a few minutes, as I scanned the cover stories and finished my drink, the dim café became an outpost of Hitchcock's numinous world. What was that black

smudge crossing the white street outside the door? Only a gipsy turning the corner with a bag of contraband.

This book is a voyage around the idiosyncratic universe inside Hitchcock's head – a place of solitary confinement, which all the same manages to accommodate more people than can be crammed into Radio City Music Hall. It is about his imagination, but it concentrates on the ways in which that imagination colludes with ours. The cinema enables reveries to be pooled, and the transgressive scenes Hitchcock photographed were present behind our eyes long before we saw them projected on to a screen. He chose his medium well, since films are an extension of our dreaming. The stories he preferred were also tailor-made: murder is the fantasy's revenge on niggardly reality.

Like millions of others, I have come to feel a covert intimacy with Hitchcock, who dramatizes conflicts and compulsions we all share. My book therefore begins and ends personally. Truffaut, Hitchcock's most loyal devotee and most perceptive apologist, said that he infected the entire world with his neurosis. The tribute failed to notice how keenly we all volunteer for contamination. Speaking for my precocious self, I could not wait to be corrupted, as the first chapter of this book relates: 'A Blooding' recalls my earliest encounter with one of Hitchcock's films. The last chapter, 'A Haunted Head', describes the gruesome mementoes of his art that, almost forty years later, have invaded my house.

In between these confessions, the book comprises three main sections. To begin with, 'The Art of Murder' explores Hitchcock's daring as he prompts us to challenge legal and moral propriety. Next, 'The Technique of Murder' shows him investigating the cinema's mechanical procedures and its remorseless execution of a world that, seen through a camera, is no longer safely, recognizably real. The technician, for me, is also a visionary: 'The Religion of Murder' goes on to guess at Hitchcock's ulterior aim, and suggests that, by enticing us to look at death and to speculate about what follows it, he takes us into regions of experience that we can only call spiritual.

I do not plod through Hitchcock's work chronologically, because I do not believe that his concerns or his tactics changed significantly in

the course of a career that lasted half a century. His films are grounded in obsessions – hang-ups (as the jargon has it) that keep us in suspense, like one of his characters dangling unsupported in draughty space. Whether in England or America, he explored the locked rooms and hidden recesses of the same many-chambered mind. I have tried to learn from his procedures. Ranging backwards and forwards, I rely on the surrealistic association of ideas, and on my own brand of cinematic cross-cutting. Hitchcock made more than fifty films. Most books about him are content to analyse half a dozen. I find it less easy to devise a list of favourites, and draw as much of his work as possible into my discussion. I have learned a great deal from his earliest and superficially least characteristic efforts, made before he discovered his special aptitude for the thriller; and I have not been deterred by his sniffy comments on *Jamaica Inn* or *Mr and Mrs Smith*. Nor do I accept the critical consensus that disparages *The Paradine Case* or *Torn Curtain*. After reading Leon Uris's novel, I even became aware of some alluring undercurrents in *Topaz*. Anyone who is genuinely fascinated by Hitchcock will find all his work indispensable.

This book avoids the theoretical controversies that vex and envenom the debate about Hitchcock in universities, where he is a pretext for trying out the conceptual tools deployed by queer polemics, feminism, post-structuralism, or whatever the latest methodological tic might be. After completing *The Hitchcock Murders*, I glanced at a typically embattled essay on *Vertigo* by one of these theorists, just to sample what I had missed out on. From it I gathered that the film had recently been used 'as a tale of male aggression and visual control; as a map of the female Oedipal trajectory; as a deconstruction of the male construction of femininity and of masculinity itself; as a stripping bare of the mechanisms of directorial, Hollywood studio and colonial oppression; and as a place where textual meanings play out in an infinite regress of self-reflexivity' – not to mention, if I might guess at the purpose of all this bogus cerebration, as a means of securing academic jobs. I wonder if any of these conscientious axe-grinders, who value *Vertigo* only as 'a proving ground for a complex array of theories', has paused to notice how deliriously beautiful and achingly sad it is? I suppose not. Even to call *Vertigo* a masterpiece probably

convicts me of sexism. Luckily for Hitchcock, the world contains more lovers of film than pseudo-scientific professors of Film Studies.

I take pleasure in defending Hitchcock against critics who see him as a front devised by the marketers, or those who reduce his films to muddled specimens of a false consciousness, compounded (depending on the critic's particular gripe) of misogyny, homophobia or Cold War propaganda. It appears the 'auteur' theory has fallen from favour, a casualty of those whimsical fads that academics call 'paradigm shifts'. Films admittedly are composite products, and their closing credits nowadays pedantically recognize the contributions of best boys, grips, gaffers, caterers, hairdressers, animal trainers, transport co-ordinators and insurance executives. All the same, Hitchcock demonstrates that a single, peremptory consciousness can imprint itself on the cinema's industrial artefacts. He had no doubts about the authorship of what he called 'a Hitchcock picture', and nor do I.

Of course he relied on expert collaborators, towards whom he was not always generous. The scriptwriters Sidney Gilliatt and Frank Launder resented the way Hitchcock monopolized credit for the success of *The Lady Vanishes*. He overlooked their contribution on principle, believing that films should tell stories visually and (if possible) silently. But despite this pretended indifference to words, he maintained strict control of what his characters said, and made sure that the writers he hired – as Joseph Stefano and Evan Hunter testify in describing their work on *Psycho* or *The Birds* – took dictation from him. I have therefore listened closely to the dialogue in Hitchcock's films, picking out tell-tale oddities of phrasing or diction. My book also pays close attention to his adaptations. Hitchcock did not make up any of his stories, but he certainly made them his own. He drastically changed the plots he borrowed from Joseph Conrad, John Buchan, Robert Hichens, Daphne du Maurier, Patricia Highsmith, Cornell Woolrich, David Dodge and others, bending them to fit his monomaniacal concerns; the alterations are a precious guide to his intentions.

The Hollywood system granted stars a degree of independence, though here again Hitchcock did his best to assert ownership. For convenience, I usually identify the principal characters in his films by

referring to the actors he cast in the roles. Cary Grant and James Stewart have name recognition, whereas Johnnie Aysgarth and Ben MacKenna do not. But no matter how familiar the performers were, Hitchcock revised the personae they brought with them. Though Cary Grant plays himself in *North by Northwest*, that self is different from the one he exhibits in the films he made with Howard Hawks; Hitchcock's James Stewart is not the same modestly virtuous figure used by Frank Capra or John Ford.

At the end of his career, Hitchcock declined to cast Liza Minnelli as the medium in *Family Plot*: she would have lessened his share of the profits and challenged his top billing. By now, he was the star, and the actors he engaged were taking part in his own psychomachia – an internal war between curiosity and prohibition, desire and disgust. His work, to borrow the phrase Buñuel used in *Un Chien andalou*, is 'a passionate call to commit murder'. This does not mean that his films are merely a record of obstinately personal anxieties and enmities. If they were, they would not have continued to grow in our minds, acquiring a force and authority that would surely have surprised their director. Like Freud, Hitchcock diagnosed the discontents that chafe and rankle beneath the decorum of civilization. Like Picasso or Dali, he registered the phenomenological threat of an abruptly modernized world.

He often wondered why people were so eager to let him scare them. My book suggests a possible answer. Terror, I think, is our response to an imminent revelation; it is the price exacted by dreams, which alarm us because they make visible what slumbers inside our heads. Like the devil tempting Eve as she lies asleep, Hitchcock sets us thrillingly free by arousing our imaginations, which turn out to be as vivid as his. What follows is my grateful fan letter to the bogeyman.

A Blooding

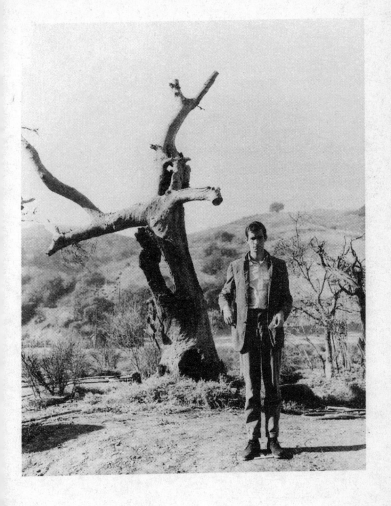

Hitchcock's Golgotha: Anthony Perkins at the swamp in *Psycho*.

I cannot recall how my obsession with Hitchcock started; it goes back almost far enough to qualify as an original sin. But there is a specific date that solemnized the affair. One afternoon in 1961, aged all of thirteen, I lost my virginity at a screening of *Psycho*.

Strictly speaking, it was only my innocence I lost. The technical loss came later, but you spend so long preparing for it – rehearsing the scenes in your head, starting with a jerky silent movie to which you gradually add dialogue – that by the time the occasion arrives it is probably anti-climactic. Your graduation from innocence to experience occurs when the feverish business of imagining begins, and for me, this raid on a forbidden knowledge will always be associated with *Psycho*. During my first under-age exposure to the film, the images that thrilled me were those of trespass and guilty surveillance. This, surely, was why the cinema existed: to depict what you were not supposed to be looking at.

An aerodynamic peeping Tom hovers above a city, which drowses in the early-afternoon sun. The people in those faceless boxes are presumably working, or eating their lunch. No, not all of them. The camera, nosing the air suspiciously, swoops towards a certain window on an upper floor of a hotel, nudges the sill, and sidles into the room, blinking at the contrast with the glare outside. The couple it spies on think they are safe from scrutiny because they are so high above street level, which is why they have left the blind half-lowered. Here, for a thirteen-year-old, was a first small and easily soluble mystery: why are they undressed at this time of day? *Psycho* starts post-coitally, and leaves the preliminaries to be scripted by us. In 1961, when the world was still blissfully ignorant, you had to work harder. Hitchcock supplied hints, or brief glimpses. Knowing us only too well, he left us to design our own private story-boards. Later comes a view even more privileged than the mid-air assault on the hotel room. Through a peep-hole drilled in a wall at the motel, there is a momentary sight – curtailed just in time – of a woman unpeeling her bra.

3

By the end of the film, worked up into a state of high excitement, we are ready to imagine what Hitchcock does not even bother to show us. In the house on the hill another explorer picks up a leather-bound book that has no title on its ornately tooled spine. She opens it, and her eyes imperceptibly widen. We are not allowed to see what she has seen. Robert Bloch, in the novel that Hitchcock adapted, offers no particular help, merely confiding that the illustrations clamped inside the covers are 'almost pathologically pornographic': it is a dare. When I became familiar with Hitchcock himself, after watching him eerily editorializing on his television series, I could hear his grave, glutinous voice muttering a clinical description of the book's contents. But that was later, once my capacity to fantasize had come up to speed. Meanwhile, there beside a rumpled, tormented bed in the same room on the screen was a collection of obsolete toys – a brutalized doll, a rabbit with a wilted ear: the relics of someone else's lost childhood.

On its long journey across the Pacific to Australia, and then on its second, even more tantalizing trip from the mainland to the island state of Tasmania where I was born, *Psycho* had acquired an unwhole-some reputation. We had just completed a decade of satisfied subur-ban niceness and compulsory normality. Since the prosperity of the 1950s seemed too good to be true, no questions were to be asked, for fear that the illusion of affluent content might be revoked. My par-ents, having lived through a depression and a world war, were grate-ful for this oblivion. My own generation was bound to challenge it, and Hitchcock offered an early inducement. How normal was Nor-man Bates, who according to the psychiatrist in Bloch's *Psycho* enjoys an extra identity as Norma, inhabiting the stuffy persona and musty clothes of his own mother? An officious aunt warned my parents to ban me from seeing the film. 'It's too hot for his blood,' she said. West-erns were thought appropriate, because the violence in them offered a training in virility. But *Psycho* dealt with seamier matters, about which the grown-ups went into whispered conclave. The moralistic aunt claimed to know of someone who had already seen it in Sydney. He hadn't been able to sleep for a week afterwards, suffered scream-ing fits, and finally needed a prescription from the doctor. 'And he,'

she said, 'was a naval man!' That, supposedly, should have immu-
nized him.

As it happened, there was no need for a parental embargo. The
censors saw to this, branding the film with an 'M'. That letter stood
for 'MATURE', which made *Psycho* all the more enticing. It was, as I
soon enough found out, a film about ripening – and also about rot-
ting. I was sure, consulting the physical evidence, that I could pass as
mature. But according to the aunt, you had to prove mental maturity
as well before they'd sell you a ticket; otherwise you risked perma-
nent harm. In advance, *Psycho* had come to resemble a rite of passage,
a visceral, constricted tunnel you had to pass through to get from one
age to the next. Ingmar Bergman once imagined the breathless fore-
boding of those who buy tickets for a film: the audience, collectively
tensed, says to itself, 'Here I am, seated in the darkness, and, like a
woman about to give birth, I want deliverance.' Allowing for the
transposition of sexes, that was what I required from *Psycho*. It was
to be my blooding; a death from which I might, if I was lucky,
recover, since the actual blood would be shed on my behalf by others
– a woman whose body is slashed in a shower, a man whose brain is
punctured as he climbs a staircase.

The week before *Psycho* arrived in town, I began to plan my strat-
egy. The censor's certificate precluded a children's matinee on Satur-
day, and I was not allowed out of the house at night. What choice did
I have? Playing truant from school, I intended to see it on a weekday
afternoon. I would break the law, and tell lies to cover my trail. It
was a life-changing decision. I was already behaving, if I had only
known it, like the heroine of the film, who – after her own sweaty
matinee in the hotel bedroom – asks her boss's permission to go
home early. She then drives briskly out of town with the forty thou-
sand dollars he has given her to deposit at the bank. She feigns a
headache: a feminine ailment, inappropriate for adolescent boys.
Toothache was the excuse I chose, and I dramatized its onset when I
bit into a lunch-time sandwich. Excused from school for the rest of
the day, I wondered whether I might not have strayed into perilous
territory. If acts had immediate consequences, as we were always
being told by those who dosed us with the Bible, wasn't I goading

one of my own teeth to ache? It might have made a neatly retributive plot for an episode of *Alfred Hitchcock Presents*; but in fact my teeth behaved themselves throughout the afternoon. The episode counted as one of my earliest and most valuable moral experiments, investigating how much it was possible to get away with.

I stuffed my school cap and blazer into the satchel that contained my books, and left it in the city library. The few blocks between there and the cinema had their dangers, like a snipers' alley. Ours was a small town, and I might have run into the invigilating aunt. Janet Leigh, after all, is spotted by her boss when she pauses at the traffic lights on her way out of Phoenix. To be thirteen and at large so soon after lunch was itself an admission of guilt, like being an able-bodied civilian in wartime. Head down, I made it. The cinema was called the Avalon; its name evoked chivalry and medieval enchantments, bravely defying the trams that clattered past and the odour of meat pies and pungent tomato sauce from the shop next door. A grim brick chapel stood opposite it, frowning. The lobby, to my surprise, was not barricaded against me. Shouldn't there have been barbed wire, or officials demanding the presentation of documents? In America they had apparently hired guards to marshal the queues of ticket-holders, and played tapes of Hitchcock explaining why no one was allowed to enter the theatre after a screening of *Psycho* had begun. I almost expected an improvised infirmary for those who allegedly staggered out at the end, their nerves shredded. But so far as I could see, no ambulance was standing by.

I cannot remember the rest of the experience without turning it into an anthology of Hitchcock clips, abbreviated excerpts from films I had not yet seen. The lobby elongated as I walked across it: an expressionistic camera trick like the swooning zoom that opens a crevasse beneath James Stewart in *Vertigo*. Then there was the box office, where a suspicious attendant behind the grille might call the police, which happens when Cary Grant – on the lam, like me – tries to buy a train ticket at Grand Central Station in *North by Northwest*. Instead a bored teenage girl glanced idly at me. Did I dry up, like Gregory Peck when he faces the ticket clerk at Pennsylvania Station in *Spellbound*? All he can blurt out is an absurd request for a ticket to Rome.

What I said, I suppose, is: 'One, please.' Determined to cast off childhood, I did not ask for a child's discount. I got my ticket without trouble – but as Joan Fontaine discovers in *Rebecca* when she bypasses the rusty, overgrown gate of Manderley, dreamers have an agility denied to those who remain awake, and can vault over obstacles. I was soon inside, in the darkness where the revelation, lit by a lunar beam from the projector, was due to occur.

Psycho did not disappoint me. I may not have understood all I saw, but I knew that taboos were being breached. What I didn't know was that Hitchcock omitted a few of the scabrous sights and thoughts with which Bloch's novel regales us. In the book, Norman tells himself not to make mental pictures of certain bodily parts, even though in erasing the images he admits the imagining he has already done. 'Mother's thighs were dirty. Mustn't look,' he says. Likewise he pointedly 'never thought about Mother's breasts'. When he transports his querulous parent to the fruit cellar, he reminds her that there's a pot for her to use. 'Norman,' she croaks, '*must* you talk that way?' Despite these repressions, the film gave me plenty to think about. After that first glimpse of avid tussling in a cheap hotel came the examination of a bathroom. For the first time in a film, someone flushed a toilet (though an incriminating scrap of paper, stained with a sum, remained behind in the bowl). There were confrontations, when I managed to unclench my eyes and look, with what ought to have remained invisible. Here was the featureless mask of an avenging deity: the traffic cop, inscrutable behind his dark glasses, or the shadowed figure with the slicing knife. At last I saw the face of death, leathery-skinned and laughing, with cavities where the eyes once were. I had been handed a psychological agenda for maturity, supplied with a life-time's worth of bad dreams. I was definitely no longer innocent.

I retrieved my disguise as a schoolboy from the library cloakroom, and went home by bus. I looked out of the back window in case a vizored cop on a motor cycle should happen to be closing in, ready to arrest me for truancy or for knowing too much. Guilt, I discovered, is like back-projection in a film: a nocturne in broad, indifferent daylight, cast on a blank screen. You can see it, because you are inside

the trauma. Who else can? The sun still blandly shone, and objects beside the road were healthily flushed with colour, despite *Psycho's* bleached ceramic tiles and its muddy, heaving swamp. At home, our bathroom had only ordinary tales to tell: a comb with snagged teeth, the razor I would one day (as the maturing proceeded) have to scrape across my face, a Plimsoll line of soap scum around the tub. But when I used the shower next morning, I found that it too had lost its innocence. The plastic curtain squealed in alarm when tugged on its metal rod. Hot icicles of water felt like needles, or dental drills. And the plughole, although the water swirled in a different direction in our hemisphere, announced that your life was leaking away even as you got yourself ready for another day at school.

Hitchcock took particular pleasure, I later learned, in estranging people from their bathrooms, which before *Psycho* were resorts of impregnable privacy, closets or cloisters where puritans purged themselves. He facetiously claimed to have received a letter from a mother and father who blamed him for their daughter's insanitary state. Ever since seeing Henri-Georges Clouzot's *Les Diaboliques*, where the murderesses drown their victim in a tub, she had refused to take a bath. Now, having been to *Psycho*, she flinched from the shower too. Hitchcock suggested that they should send her out to be dry-cleaned. It was an old joke, freshly adapted to America, where your clothes at least could be cleansed without immersion in water. In *Blackmail*, the first of Hitchcock's British talking pictures, a London gossip – a woman whose stale face powder and flustered perspiration you can almost smell – prattles on in a shop about a local stabbing, unaware that the heroine has committed the crime. The case reminds her, she says, of a recent murder where the man was drowned in his tub. For a month she was too frightened to have a bath; then for weeks after that she wouldn't go beyond a rinse-down. Listening, you tighten your nostrils in sympathy with the other customers in the shop.

Dirt is our admission of guilt, the trace of the anxieties Hitchcock smuggled into our heads. We rely on the bathroom for a daily purgation, which, we hope, will leave us with a cleansed record. We also need it to relieve other, intermittent tensions. In *Rear Window*, Thelma Ritter plays a nurse despatched by the insurance company to deliver

rub-downs to James Stewart while his broken leg heals. She reminisces about her long experience, which has given her powers of prognostication. She foretold the stock market crash in 1929, she says, because she was treating a GM executive who had kidney trouble, and 'when General Motors has to go to the bathroom ten times a day, the whole country's ready to let go'. Her patient, she deduced, was nervous because of over-production, which might lead to collapse. A dirty joke, for Hitchcock as for Freud, tells complicated truths. Excess on the assembly line in Detroit is mimicked by the body's over-production of fluids, which it must somehow expel. Micturition is not the only way to disburden yourself. Dreams, whether dry or wet, are vents for the morbid, wicked or salacious images we over-produce.

Psycho infected me – and how many others? – with a mistrust of motels, which institutionalize our transitoriness. Even in hotels I tread carefully in case I step on the nail clippings of former occupants, embedded in the carpet pile, and try not to notice stray hairs in the bath-tub. Surely the maids protest too much when they place those paper seals on the toilet seat, pretending that you have had no predecessors. The terrors are not confined to the bathroom. In Hitchcock's films, the most innocuous objects can rear up threateningly. What could possibly be sinister about the record of Beethoven's *Eroica*, which Vera Miles during her investigation of the Bates house finds on a gramophone turntable? At the age of thirteen I had no idea, though I felt an unmistakable chill when the camera peered into the gaping box to read the label of the silent disc. Now I think I know the answer. The symphony summarizes one abiding undercurrent of Hitchcock's work. It is about Napoleon, a man who – like many of Hitchcock's psychopaths – set himself up as a god, and it includes a funeral march for the toppled idol. It first rejoices in the hero's freedom from moral inhibitions, then recoils in dismay. Truffaut, detecting unease beneath the joviality of *The Trouble with Harry*, suggested that Hitchcock's films were afflicted by the mood Pascal analysed – 'the sadness of a world deprived of God'.

Gradually I came to understand Hitchcock's surreal genius: he knew how to rescind reality, and to make you afraid. 'I brought you

nightmares,' whispers Joseph Cotten as the wicked uncle in *Shadow of a Doubt*, pleased to have upset a soporific town not unlike the one I lived in. Other founding fathers had higher-minded hopes for the new art of film. D. W. Griffith set out to make heaven visible from the lowly earth, and Chaplin's tramp mutely appealed to the brotherhood of man. Hitchcock, however, was no evangelist. He wanted to frighten us. Those who consider themselves invulnerable call this trivial or childish; to me, fear is the most rational response to existence, and the most reverent tribute to its irrationality.

For Hitchcock, film was a weapon. It penetrated our unconscious minds, and it did so with the aid of a knife. In *Un Chien andalou*, Buñuel uses a razor to slice open an eyeball. Hitchcock had his own equivalent to this small fable about cinema and its lacerating insight. Mrs Bates removes the curtain that stops us from seeing clearly, like a cataract on the eye. For her second murder, she stabs a man in the forehead, ensuring direct access to the place where our fantasies live. Less bloodily, film goes to work like the deftest of robbers. T. S. Eliot once compared poets to burglars, who give the guard dog a scrap of meat to keep it quiet while they creep into the house. The meat is a poem's meaning, which distracts the conscious mind; the robber's goal is the unconsciousness, peacefully asleep upstairs. The cat burglar in *To Catch a Thief*, stealing baubles from dowagers on the Riviera, operates even more audaciously. We see a hand lightly tugging a jewel case from beneath the pillow on which the owner is snoring. It is as if that hand was reaching into the woman's head and withdrawing the private cache of her dreams. How much opposition does the rational guard dog, bribed with food by Eliot's thief, actually offer? In *Strangers on a Train*, Farley Granger steals into Robert Walker's house after dark. A mastiff sprawls on the stairs, barring his way. Granger freezes; the dog growls, lunges towards him – and then licks his hand in welcome, letting him pass. Films for Hitchcock were assaults that we, the victims, only pretend to resist.

Perhaps this is why, in his preambles to episodes of his television series, Hitchcock so wickedly baited his sponsors and mocked the commercials touting their paltry products. The advertisers riled him because they usurped his role as a hidden persuader, copying the

subterfuges he used when burgling our brains. Introducing an instalment of *The Alfred Hitchcock Hour* in 1962, he rambled nonsensically for a while and then, just before the transition to a commercial, added 'Naturally these remarks have nothing at all to do with tonight's story. They are only meant to divert your attention so that our sponsor can sneak up on you – and here he is, ready to pounce'.

Like Walker befriending Granger on the train, Hitchcock inveigles us into intimacy. Or is he our accomplice, the obedient servant of our lethal wishes? The truth is that we help each other. His eye needs only to alight on a kitchen utensil, or one of the aids to self-fashioning that we keep in our wardrobe, for us to notice its deadliness. Guns, vulgar and obvious, are seldom used in his films, and then only by sordid professionals like the assassins in *Foreign Correspondent* and *The Man Who Knew Too Much*. Hitchcock's killers, by contrast with these political hirelings, are amateurs. They work for love not money or principle, and they use whatever lies close to hand around the home. The knives grabbed by Anny Ondra in *Blackmail* or Sylvia Sidney in *Sabotage* have recently been slicing bread or carving meat. Grace Kelly's scissors in *Dial M for Murder* come from her sewing basket. If you possess a gift for improvising, anything you happen to have hanging about your person will do. In *Frenzy* Barry Foster throttles women with his fancy neckties, and in *Young and Innocent* the same service is performed by a belt from a raincoat. Ties and belts are supposedly emblems of propriety. A knotted tie signifies gentility and professionalism, yet why do we think it so important to strangle ourselves for the sake of appearances? A belt is even more versatile: like the hangman's rope, it is a suspension device. A shoe, decommissioned, has other uses. After William Bendix's leg is amputated in *Lifeboat*, he stops wearing one of his boots. Henry Hill grabs the spare during the concerted execution of the Nazi, and – once the victim has been shoved overboard – batters his head with it until he sinks.

André Breton, in a surrealist manifesto published in 1930, recommended 'total revolt, complete insubordination, sabotage according to rule', and added that surrealism 'expects nothing save from violence'. Hitchcock's *Sabotage* begins with a dictionary definition of that incendiary word, which was a modern coinage, first recorded in

1910. The definition has an inimitably Hitchcockian emphasis. The *Oxford English Dictionary* restricts itself to saying that sabotage is 'any malicious or wanton destruction'. Hitchcock's lexicon supplies something more: a glimpse of psychological purposes. The wilful destruction is carried out, the film's dictionary says, 'with the object of alarming a group of persons or inspiring public uneasiness'. That succinctly defines the aim of Hitchcock himself, who sought to alarm his audiences or make them uneasy. The saboteur Verloc boasts that his attack on a power station has 'made people sit up', which is the reaction Hitchcock wanted from his customers. Verloc is chided because the citizens of London turn the blackout into a party. The crowds fumbling out of subway stations giggle as they strike matches or produce candles to help them negotiate the dim streets. The paymaster withholds Verloc's fee, complaining that the supposed sabotage entertained its intended victims. 'When one sets out to put the fear of death into people,' says his superior, 'it's not helpful to make them laugh. We're not comedians.' The sulky Verloc has no answer to that; but Hitchcock, like Freud, would have known how to reply. Comedy defies taboos and flexes rules, performing sabotage in its own sneaky way; laughter is how we ventilate uneasiness, or cope with outright fear.

The Brazilian government paid Hitchcock a compliment by banning *Sabotage*. The politicians were convinced that the film was capable of goading the docile citizenry to acts of affray, or at least of disrespect. The surreal notion of a joking assault on reality recurs in *Saboteur*, where Robert Cummings is accused of setting fire to a wartime aeroplane factory. 'You look like a saboteur,' Priscilla Lane rails when he claims to be innocent. But what does a saboteur look like? Cummings has the rubbery face of a light comedian; sabotage, as Hitchcock's own persona demonstrated, could just as well be practised by a portly gentleman in a business suit. 'You have a saboteur's disposition,' Lane adds. She then amorously nestles her head on Cummings's shoulder, as if warming to his mischievous way with bombs and booby-trapped fire extinguishers.

Unlike the communist Breton, Hitchcock did not expect his systematic policy of violence to deliver a new social and political order.

It was enough that it should do some small psychological damage – condemning me, for instance, to unquiet nights after that trip to *Psycho*. Thanks to the film, I learned that the world was a scary place. Perhaps I should have been spared the knowledge for a few more years, or possibly I ought to feel grateful for having received an advance warning at the age of thirteen. *Psycho* did more than cater to my sexual curiosity; it replaced what the teachers at school called religious education, offering a glimpse of mysteries not available elsewhere. It took me on an initiatory journey.

After *Psycho*, I began to wait for Hitchcock's new films and to watch out for the old ones, which sometimes turned up on television, interspersed with commercials for used cars and kitchen appliances, at hours when I should have been in bed. Violations of curfew were necessary. Much later, to see some of them was a matter of conspiracy, almost as exciting as my truancy from school. During the 1970s, *Rear Window* and *Vertigo* were tantalizingly withdrawn from circulation. Run-down repertory houses in Notting Hill or Greenwich Village made coded announcements, never naming names, and showed scratched, blotchy prints. The sneaky circumstances seemed apt, because the two films are about the deviancy of the fantasist, who in *Rear Window* wills a death and in *Vertigo* even more morbidly wills a rebirth.

I assumed that I would eventually recover from the obsession, just as I outgrew my adolescent rashes. Now, accepting that I never will, I want to understand why. There are, I know, directors who are greater, with nobler and more humane motives – or at least there is one, Yasujiro Ozu. And there are films in which you can breathe, which Hitchcock, so claustrophobic and such a controller, does not permit. Michelangelo Antonioni shows time as it passes, moving through rooms and across faces like a wind, and John Ford's Westerns reveal the airy amplitude of space. But Hitchcock remains my film-maker – though not mine alone, since the vulnerability he exploited is shared by so many others. He is, as Truffaut said when reviewing *Rear Window* in 1954, 'the man we love to be hated by'. He frightens but also enlightens us, telling us things we might prefer not to know – about film, an art whose illuminations can only occur in

13

the dark; about a modern world that invented film in its own image, replacing reality with experimental scenarios of deviation and defiance; and about ourselves, since at night we are all surrealists, imaginary killers.

The films confess Hitchcock's illicit longings and fanciful lapses. They flagrantly disobey that law of silence that constrains the priest played by Montgomery Clift in *I Confess*, and they encourage us all to come clean. Hence the use made of *I Confess* in 1995 by Robert Lepage's *La Confessional*. Lepage's film begins in 1952 with Hitchcock on location in Quebec City, auditioning extras and sagely listening to the sexual confession of his limousine driver. Lepage's priests are hypocrites, and Hitchcock himself, savouring the secrets he is told, is not qualified to grant absolution. *I Confess*, esteemed and imitated by Lepage, serves as an unsealed confessional box, wired up with stereophonic sound. Clift had only two pieces of privileged information to guard: his own early liaison with a woman, and the identity of a murderer. Lepage's characters commit a more fashionably contemporary range of sins – drug abuse, adultery, suicide, possibly murder, with lap dancing and homosexual prostitution thrown in – for which they ask no forgiveness. Hitchcock in *La Confessional*, rather than prescribing Hail Marys, makes summary judgements, sending people who displease him directly to oblivion. Lepage shows him listening to a succession of little girls, who are reading for the roles of two passers-by. Above the table he mouths profusely complimentary words. Below it his foot impatiently signals rejection, and his assistant hurries the children away.

I caught sight of Hitchcock once, while he was filming *Frenzy* in the Covent Garden market during the summer of 1971. A crowd of technicians and anachronistic cockney porters surged around the buttoned-up blob in the sagging canvas chair. This unmoved mover hardly seemed to be directing; he just lumpily sat there and watched other people do things – mostly carting bags of vegetables, one of which might have contained a dead body. By then he did not need to bestir himself. He had succeeded in deliciously tormenting the world; and all of us, whether within the camera's range or not, were acting in the nightmare he had devised.

Perhaps the mayhem was now beyond his control. *Psycho*, which Hitchcock insisted on regarding as a comedy, did not stay within the harmlessly ribald precincts of the cinema. This was the film that inaugurated the 1960s. By the end of the decade, in 1969, the Manson gang could stage its homicidal rampages as a form of riotous self-expression and political protest. In John Carpenter's *Halloween*, released in 1978, a psychiatrist played by Donald Pleasence arrives after dark at an asylum where the maniacs are at play in the grounds. A nurse, aghast, asks 'Since when do they let them wander around?' The correct answer would probably be 'Since *Psycho*.' Pleasence's character is called Sam Loomis, in a small tribute to the proprietor of the hardware store played by John Gavin in Hitchcock's film. The original Sam Loomis is a sturdy saviour, who finally disarms and unwigs Mrs Bates. But Carpenter's namesake is permitted no such victory. Although he thinks that the killer he has tried to treat should 'never never never' be released from custody, the man escapes. At last Loomis shoots him. But when the camera next looks, the corpse has clambered to its feet and set off in quest of a sequel.

Hitchcock's characters enjoy a riotous after-life in our imaginations, where they can couple at will. Their escapades even send them slithering between films. Norman Bates, for instance, returns in the ballet *Deadly Serious*, choreographed by Matthew Bourne in 1992 for his company Adventures in Motion Pictures, though he has now been assigned a different mother. Bourne makes him the offspring of Mrs Danvers, the funereal housekeeper in *Rebecca*. The transference is logical enough. While casting *Psycho*, Hitchcock teased agents and publicists by hinting that he intended to offer the non-existent role of Mrs Bates to Judith Anderson, who was his adamantine Mrs Danvers; for him, the two women were sisters under the skin. Norman's problems are exacerbated in the ballet when his adoptive mother interrupts her domestic chores to seduce the second Mrs de Winter. Bourne arranges another intertextual liaison between Max de Winter – the indifferent husband played by Laurence Olivier in Hitchcock's film – and a limber lad in tennis shorts: this is Farley Granger, the athlete from *Strangers on a Train*. It's clear in the film that the fluttery, insidiously flirtatious Robert Walker is infatuated by Granger. Bourne

entices Granger to reciprocate, but awards him an object of affection more enticing and more discreet than Walker. Bourne called the second half of his Hitchcock compendium *Rear Entry*. You can elicit startling truths about the films if you creep up on them from behind.

Having once been let out to play, the demons refuse to retire indoors. They prefer to take part in murderous charades, quoting *Psycho* with triumphant bravado. In 1998 the BBC paid O. J. Simpson for a television interview. He indignantly insisted that he had not slaughtered his wife and her friend, then addressed a sideways smirk to the camera. Parting from the interviewer, Ruby Wax, he said he had a surprise for her, and promised to deliver it later. When the bell rang, she opened the door of her hotel room. There loomed O. J., his arm raised, emitting a series of staccato shrieks: he was tunelessly singing Bernard Herrmann's score for the shower scene in *Psycho*, with its fraught strings, while he lowered his arm to stab her. His weapon? Not Mrs Bates's knife, but a banana purloined from one of the hotel's hospitality baskets.

I had already performed in my own version of this scene on a return visit to my parents in Australia. The episode did not quite follow Hitchcock's story-board. I was in the shower one morning when I heard a fumbling at the bathroom door. Surely, I thought, the sound of running water safeguarded my privacy. But the door opened, and a shape positioned itself on the other side of the translucent curtain. A hand reached up; the curtain squeaked, and so (I am ashamed to say) did I. It was my father who stood there, neatly reversing roles for both of us. He held not a knife but a pair of over-sized carrots that he had dug up in his vegetable garden. Their tips were jagged, and he kept a strangling grip on their green top-knots. They might have been a brace of downed game birds.

He blinked, even more startled than I was. 'I thought it was your mother,' he said; it seems he wanted to show her his carrots. At the time I remember wondering why that couldn't wait. The disinterred vegetables hadn't even shaken off their shroud of dirt. Now the incident seems touchingly matrimonial, proof of the intimacy my parents enjoyed with one another but not with me. I tugged the curtain back into place, and I suppose he took his carrots to the bedroom. No

blood was spilled, but I'm not sure that there was a happy ending. My father, who never saw *Psycho*, died soon afterwards. Those few seconds in the shower were as frank a confrontation as we ever had. I still shudder when I think of it, and the chill is supernatural, like the fear that Hitchcock induces. For the ancient Greeks, the symptoms – prickling skin, an involuntary shock – warned that you were in the vicinity of a god. My parents explained such sensations according to their own more or less pagan theology. Someone, they used to say, is walking over your grave. And where, I always asked myself, might that resting place be? *Psycho* offered a choice: the white tub, so easy to scrub clean, or the black, gluttonous bog that gobbled cars and the bodies buried in them. Or, if you preferred, the cellar in which the fruit matured.

At the Universal Studios theme parks in Los Angeles and Orlando, a facsimile of the *Psycho* set is a place of pilgrimage. The queues for admission to the traumatic bathroom are always long. Visitors line up to borrow Mrs Bates's smock and her hair-net, which come in all sizes. Suitably attired, you are then issued with a rubber knife and directed to slash a Universal Studios intern, who modestly showers in a body stocking. The duplication on opposite coasts recognizes a ravenous public demand. Everyone, it seems, has spent some time at the Bates Motel – or would like to do so. On arrival, a film we know by heart assigns us our moves. After depositing our worldly goods in a cabin, we go for a stroll. There is only one route to take, since the set ends just out of the view-finder's range. Inevitably we climb the path towards the family home on the hill. Of course it has a different use nowadays. That ghoulish house, with the silhouetted body in the window like a figure at a magic-lantern show, is a cinema. Inside it, we are licensed to dream.

The Art of Murder

The Chief Executive

Hitchcock officiating in *Family Plot*.

Even in the California heat, Hitchcock squeezed his bulk into a woollen suit of sombre colour. Sometimes he clamped a bowler hat, like a lid, on his seething head. Applying strict pressure to a body betrayed by its appetites, he wore the weapons used by two of his killers, which he turned against himself: a necktie, and a belt that over the years crept higher above his tummy until it almost met the tight knot in his tie. This uniform, like the gravity of his manner, was a camouflage. In the films he made while wearing these stringent, muffling clothes, the unconscious mind exposed itself. Art dared to liberate the unruly imagination, lethally and sometimes obscenely.

Once, in an interview with Peter Bogdanovich, Hitchcock established his own credentials as a modern artist – a participant in that visual revolution which disrupted reality in the early twentieth century – by claiming: 'The area in which we get near to the free abstract in movie-making is the free use of fantasy, which is what I deal in.' Revealingly, he identified abstraction with licence, licentiousness. Its graphic riddles, which apparently represented nothing in particular, were a coded replica of something unknowable or at least untouchable. In *Vertigo*, as Kim Novak sits in a San Francisco museum, the camera closes in from behind on the twisted bun of her hair, and looks into the ashen vortex. It is one of those things, like the thighs of Mrs Bates in Bloch's *Psycho*, that you should be on guard against thinking about, let alone staring at: a substitute for the other apertures or orifices that permit entry to the body. The abstract form is enticing and also – because the blonde greyness of the dyed hair is unnatural, like the wig that hastily dresses the skull of Mrs Bates – alarming. The coiled shape extends a sexual invitation. But the camera can't see around corners, or penetrate the darkness deep in that nest of hair. Perhaps death is lurking there.

Doubly emphasizing freedom, Hitchcock's comment about fantasy was the rampant credo of a surrealist. Salvador Dali, engaged by Hitchcock to design the dream in *Spellbound*, called surrealism a

mutilation or massacre of the material world. For Breton, the most pure and true surrealist act involved going down into the street, drawing a gun, and firing at random into the crowd. Hitchcock worked more stealthily. He lured the crowd in from the street, collected its money, then discharged his gun. Leo G. Carroll, the mad and murderous psychiatrist in *Spellbound*, commits suicide by aiming a gun barrel at the camera in close-up and firing it into our faces.

In Joseph Conrad's novel *The Secret Agent*, Verloc keeps a pornographic bookshop as a camouflage for his activities as a saboteur. Hitchcock, who adapted the novel in *Sabotage*, was obliged to be stealthier, and made Verloc the proprietor of a shabby local cinema. Were the two establishments after all the same? Conrad's preface describes the city as 'a cruel devourer of the world's light', and cinemas gobble up a greedy portion of that light. Whereas Conrad sent his saboteurs to blow up the observatory at Greenwich, in Hitchcock's film they attack the Battersea power station. In the novel, their target is the meridian, responsible for the fictitious organization of time that governed traditional literary narrative. Hitchcock instead makes them assault the cinema's light-source. A bulb fizzes and dies; the projector in Verloc's cinema fails and the screening is aborted. The technologies of terrorism and of film are only too alike. One of Verloc's colleagues, the deranged Professor who designs the explosives, carries around with him a pocket detonator, just in case circumstances should require him to commit instantaneous suicide. It is based, he explains, on 'the principle of the pneumatic instantaneous shutter for a camera lens'.

Verloc recruits his wife's younger brother Stevie to plant a bomb, which blows up prematurely. The boy is killed, and his mother, demented by grief, murders Verloc. Conrad describes her distress before she relieves herself with the carving knife: she stares at 'a whitewashed wall with no writing on it', or dully contemplates 'a blank wall – perfectly blank'. In *Sabotage* the wall becomes a screen, written on by light from the projector, and the breakdown of Mrs Verloc (played by Sylvia Sidney) is hastened by the cinema itself. On the afternoon of Stevie's death a Disney cartoon about the murder of Cock Robin is shown at a children's matinee. It is hardly suitable for

its young audience, since its anthropomorphized birds are driven by erotic or vindictive instincts. The amorous cock is shot down by a rival while serenading a canary modelled on Mae West, which lecherously grinds its hips and emits husky murmurs of gratification. No wonder that Rod Taylor in *The Birds*, buying a pair of canaries for his young sister, requests a couple that are not 'too demonstrative'. Adults do their best to keep sexual mechanics a secret, but children are free to observe the more unguarded antics of birds, bees and domestic pets.

Sylvia Sidney, distraught at her brother's loss, wanders up and down the aisle of the cinema. Shock disengages the usual emotions, and she finds herself joining in the audience's laughter, though the automatic, twitching rictus around her mouth never reaches her eyes. She is not comforted or sustained by the film she sees. Hitchcock would have disagreed with Eisenstein, who called the cinema 'the great consoler'; Sidney's macabre amusement confirms his belief that life, like *Psycho*, should be viewed as a black comedy. Death is a practical joke played on us by the universe, or by our booby-trapped bodies. Sidney smiles and chortles because others are doing so: laughter is joylessly involuntary behaviour, triggered by reflexes, and it may involve a risk to your health. You can be tickled to death. Eisenstein, who struck up a friendship with Mickey Mouse during his visit to Hollywood in 1930, regarded Disney's cartoons as 'paradise regained'. The animated cartoon for him was 'a direct embodiment of animism'. Motion is a sign of life; the animator breathes a soul into immobile clay. Hitchcock's attitude towards Disney was less messianic. Cartoons, cueing automata to simulate emotion, prove our manipulability. In 1966 Hitchcock remarked that Disney had the best answer to the problem of refractory, undirectable actors: 'If he doesn't like them, he tears them up.' Having studied the lessons about life and death, comedy and tragedy, that are wordlessly written on the bright, blank, luminous wall, Sidney goes behind the screen to the flat she shares with her husband and skewers him while serving his dinner.

When Hitchcock replaced Conrad's pornography shop with a cinema, he put into practice a jest that other surrealists had idly

talked about. In 1930, six years before *Sabotage*, Buñuel and the poet René Char went to see a short pornographic film called *Sister Vaseline*, which spied on the carnal romps of a monk, a nun and a gardener. Afterwards they discussed what fun it would be to insert the item into a programme for children. *Who Killed Cock Robin?* may not be quite as scabrous as *Sister Vaseline*, but the lewd innuendi of the feathery Mae West, together with the tactless mockery of Robin's demise, make it indecent enough. Although the script tidied away Verloc's sleazy trade, Hitchcock could not resist alerting us to his own daring. A policeman keeps the cinema under surveillance, and he too has a camouflage. He pretends to be working at a greengrocer's stall next door. Having assembled the evidence he needs, he quits the job that gave him his alias. Verloc, played by Oscar Homolka, asks the greengrocer what has happened. The greengrocer reveals that the man was a detective, though he doesn't know the details of his mission. He speculates with a chuckle that he may have thought Verloc was showing 'funny sorts of films – perhaps a bit too hot'.

The blank wall is not the only metaphor of Conrad's to be given a startling actuality by Hitchcock's film. In the novel, the Assistant Commissioner charged with investigating the saboteurs leaves his lofty office and plunges into the London streets, as if descending 'into a slimy aquarium from which the water had been run off'. The image becomes fact in *Sabotage*, when Homolka has a rendezvous with a colleague in an aquarium at the London Zoo, where pot-bellied turtles and saw-toothed fish cruise in tanks. Like the wall, the aquarium is another ersatz cinema: a series of phantasmagoric recesses, eerily bright in the twilit room, which allow us to spy on dreamy monsters in their submarine habitat. Homolka gazes at a school of heedless, flickering fish in a grotto, and the concentration of his stare – like that of a film director making phantoms materialize – changes what he looks at. The tank dissolves into a view of Piccadilly Circus. A dissolve is one of the cinema's technical tricks, and also, like Dali's molten watch, a surreal warning that the reality of masonry, traffic and neon advertisements is dissolute, as untrustworthy as liquid. Then Piccadilly Circus, the target for the next

bombing, suffers a second dissolution. The urban scene, projected inside the tank as if on a cinema screen, buckles, warps and streams towards oblivion. The city has been liquefied.

The cinema, like a bomb, is a device for dematerializing the world. Hitchcock made the comparison himself in an article that he contributed in 1949 to the magazine *Good Housekeeping*. The subject on which he addressed the apron-clad home-makers of America was 'The Enjoyment of Fear', and he explained the workings of his own films by contrasting the two kinds of aerial explosives that had rained on London during the war. Buzz bombs chugged along noisily, announcing their arrival well in advance, though you never knew on whom they would fall. While you listened to their motors, they taught you the meaning of suspense. V-2s, a later specimen of Nazi ingenuity, were silent until they exploded. They allowed you only an instant in which to respond, and what you felt was terror. Hitchcock's own preference was for the buzz bomb, which prevaricated before deciding who to kill, rather than the shock of the V-2. Janet Leigh is surprised by Mrs Bates, and therefore terrified; but we have already seen her shadow slide into the bathroom, and what we experience, for the few seconds before she raises her knife, is suspense.

The catastrophe imagined by Homolka in the aquarium is silent, without an explosion on the soundtrack. That turns his cinematic vision into a magical exertion of will, a kind of voodoo. His eyes, or the cold lens of the camera that imitates them, work like one of those ray-guns with which villains are armed in science fiction. By remote control, they atomize objects. The incident is a manifesto about the powers of fantasy, which can override the rules of morality and the more inflexible laws of physics. Hitchcock encourages us to flout all the commandments, to work through the entire inventory of abominations.

In his films you are permitted to kill your father, or at least to imagine doing so. Robert Walker suborns Farley Granger to execute his father in *Strangers on a Train*, offering in exchange to eliminate Granger's sluttish wife. Though the film spares the old man, there is a different and more logical outcome in the novel by Patricia Highsmith that was Hitchcock's source. Highsmith's Guy, the character played

by Granger in the film, actually commits the crime, whereas Hitchcock sends Granger to warn the victim about his son's Oedipal fury. While the character in Highsmith's novel suffers a mental collapse as a result of his guilt, Granger is saved for a happy ending. This may look like the moralistic cowardice of Hollywood, but in fact it questions Highsmith's mandatory punishments. Even though Granger failed to keep his part of their bargain, he profits from Walker's murder of his first wife and can now marry Ruth Roman. It is easy to live happily ever after if you have a slippery, face-saving talent for forgetfulness.

You can kill your mother, like Anthony Perkins in *Psycho*, then excavate the body inside which you once lived and fill it with straw. Ed Gein, the Wisconsin maniac whose atrocities are alluded to in *Psycho*, chose his middle-aged victims because they reminded him of his adored mother. Death was the consummation of love, and Gein – who robbed graves in quest of supplementary mothers – sliced off the breasts and lips of his victims for safekeeping. Bloch and Hitchcock improved on Gein's record by making their hero commit matricide, the ultimate act of filial devotion. Having killed his mother, he is now free to become her.

In his last film, *Family Plot*, Hitchcock with uncharacteristic clemency spared the lives of characters condemned to death in Victor Canning's novel *The Rainbird Pattern*. The story told by both Canning and Hitchcock concerns a kidnapper called Eddie Shoebridge whose crimes are a private vendetta against society. Canning follows a trail that reveals that property, inheritance and the rule of law all depend on summary executions. Civil servants hush up a scandal by killing Eddie and his wife, who have already killed the clairvoyant Blanche. Eddie's son Martin kills Miss Rainbird, who once had Eddie, her sister's illegitimate child, adopted by strangers, and who also killed her drunken brother Shotto. As the novel ends, Martin plans to do away with the harmless, guiltless George, Blanche's lover. Hitchcock, changing this paranoid parable to a comedy, called off all the killings; but he made up for this leniency by adding to the story two murders of his own devising, doubly violating the taboo first challenged by Norman Bates. Canning's Eddie loves his adoptive parents, and prefers

them to the starchy Miss Rainbird. The Eddie in Hitchcock's film, played with silken malice by William Devane, arranges a new life for himself by killing the Mormon couple who have raised him.

Retaliation is possible. A parent can equally well kill a child, as Homolka's Verloc does in *Sabotage*. In his preface to *The Secret Agent*, Joseph Conrad insisted that in his story of urban terrorists he had 'not intended to commit a gratuitous outrage on the feelings of mankind'. Hitchcock, unabashed, did exactly that when he followed the doomed Stevie through the streets of London, allowing him to be detained or distracted, elasticizing his last instants of life in an agony of anticipation as the bus dawdles towards Piccadilly Circus; Conrad at least had the tact not to describe the explosion, which is reported after the event.

The apologetic preface was added to *The Secret Agent* in 1920. By 1936, gratuitous outrages had become a surrealist speciality. In the novel, the boy – wandering through Greenwich Park – is the sole casualty. Hitchcock placed him in the centre of the crowded city, where the blast does more damage, and compounded Conrad's offence by blowing up all the other passengers on the bus. The incident in the film puts into practice a murderous whimsy of Dali's, which horrified his more squeamish surrealist colleagues. When Macedonian anarchists bombed a first-class compartment on the Orient Express, Dali scoffed at their tactics. If he were bombing a train, he said, he would place the explosive in a third-class carriage, rather than among the richest passengers. To kill the poor counted as 'more of a scandal'. Because rich people do not ride on London buses, Hitchcock in effect acted out Dali's scheme, and provoked a satisfactory scandal when the film was released.

The victims include a Jack Russell puppy, which lovably nibbles the fingers of the boy with the bomb and exercises its teeth on the shoulder of his jacket. If you are prepared to kill a child, it is a small matter to kill a dog. Raymond Burr does so again in *Rear Window*, when a nosey pet scratches at the flower bed where he has stowed a section of his wife's body. Poison is the approved remedy for disposing of such nuisances. Burr prefers a more personal touch: he strangles the dog. Its distraught owner, haranguing the Greenwich Village

courtyard from her fire escape, accuses all her neighbours of complicity. The dog's only crime, she cries, is that it liked and trusted everyone. Perhaps such naivety is reason enough for denying life to the affable creature.

Even if you have been supplied with a compelling legal justification for homicide, you might find that you have killed the wrong man. What then? Does it really matter? This is the enquiry undertaken by Hitchcock's *Secret Agent*, based not on Conrad's novel but on two separate stories by Somerset Maugham about the British spy Ashenden. In the first of Maugham's tales, Ashenden's accomplice, known as the Hairless Mexican, follows orders by killing a Greek trader in state secrets. It is a case of mistaken identity, but the marked man remains invisible, unknown, with no claim on our emotions. The second story concerns the entrapment of Grantley Caypor, a traitor Ashenden lures back to England, where he is caught and executed. Caypor, a repellent figure, gets what he deserves. Hitchcock cast John Gielgud as Ashenden, with Peter Lorre as the Hairless Mexican; he gave the role of Caypor to the avuncular Percy Marchmont. Lorre pushes Marchmont off a cliff in the Swiss mountains. Then the film, advertising another gratuitous outrage, suddenly reverts to the first of Maugham's stories and discloses that the victim was after all not a traitor. The revelation matters because Marchmont (unlike Maugham's Caypor) is such a convivial fellow, heart-rendingly mourned by his dachshund. Lorre's response is to shrug and snigger.

Gielgud had first played Hamlet two years before the film was made in 1936, and Hitchcock persuaded him to accept the part by telling him that the character of Ashenden was 'Hamlet by other means'. The means were indeed very different. Hamlet, scrupulous to a fault, delays killing Claudius. He wants to be sure that the ghost's account of his guilt can be trusted, and he does some detective work of his own. Hitchcock did not warn Gielgud that he had attached a coda to *Hamlet*: it is as if, after the stabbing of Claudius, the ghost had reappeared to apologize for a slight misunderstanding. Hamlet's anxious, self-accusing postponements make him tragic. Hitchcock's Ashenden behaves less creditably. He assigns his dirty work to a venal, cynical accomplice, the Hairless Mexican. What

would we think if Hamlet had paid Rosencrantz or Guildenstern to do his murdering for him? During their alpine hike with the victim, Gielgud changes his mind; but his qualms of conscience come too late, since Lorre, a professional assassin, is determined to earn his fee. Gielgud retreats to an observatory, where he watches as Lorre shoves their friend into the gulf.

The crime happens far away, but Gielgud sees it in close-up through a telescope. Like James Stewart with his cameras and binoculars in *Rear Window*, he is a professional observer. 'Oh God, look out!' he cries, as ineffectually as someone in the audience warning Janet Leigh that the bathroom door has opened. The film of course plays on, unstoppable, regardless. Isn't that the devious attraction of the cinema? It allows us to watch, while saving us from physical participation, and therefore – if we wish to delude ourselves about the fantasy and our responsibility for what we imagine – from moral involvement.

Often Hitchcock's killings are disinterested, abstractly freed from any personal desire for gain or vengeance. You can kill in order to perform a mental experiment – to test the moral vigilance of the universe, which may not notice or bother to rebuke you; to discover what it feels like. In *Rope*, John Dall and Farley Granger murder their best friend because they believe, as his intellectual superiors, that they are entitled to do so. After stowing the body in a chest, they lay out a buffet on this improvised coffin and prepare to serve dinner to the dead man's father. Dall calls the party 'the inspired finishing-touch'. To cancel it, Granger agrees, would be 'like painting the picture and not hanging it'. Dall thinks the comparison in poor taste, as they have used a rope to hang their friend while holding him upright in what looks like a triple-headed act of homosexual intercourse. As they talk, they are standing in front of an insipidly modernist painting of a girl in a white dress, already on display in their apartment. The corpse is a more conceptual creation: an art-work meant to be admired in its own absence, since no one can see it.

Like Hitchcock – who meticulously thought out his films in advance, so that shooting them felt like an anticlimax – the character played by Dall in *Rope* identifies artistry with control. Producing

champagne to toast a death, he boasts: 'I'd never do anything unless I did it perfectly.' He regrets his lack of artistic talent, but consoles himself by declaring: 'The power to kill can be just as satisfying as the power to create.' Bruno, the madman in Highsmith's *Strangers on a Train*, goes further. Though he is 'not a writer or a painter or a musician', he refuses to apologize for his inadequacy. After killing Guy's wife, he imagines bragging about the achievement at a press conference. People wonder at 'the mystery of life, of beginning life', which to him is banal: the accidental encounter of an egg and a squirming tadpole. What about 'the mystery and the miracle of stopping life'? Robert Walker in the film is denied this mental rhapsody, but its unholy sentiments were shared by Hitchcock.

Films supposedly celebrate animation, the inspiriting anima. The films made by Hitchcock, however, long for the moment when motion stops, spirit freezes, and the body sinks into the composure of a tableau. In *Topaz*, a Cuban revolutionary shoots his mistress, who has conspired with a foreign spy. His motive, like that of the amateur taxidermist in *Psycho*, is love. He wants, he murmurs, to forestall 'the things that will be done to your body – this body' by Castro's torturers. Clasping her, he fires the shot. As she crumples, the loose folds of her purply-blue dress billow outwards (with the help of concealed wires, which tugged at the hem). Seen from high above, her gown is a coagulated blot of colour on the black-and-white tiles: an amorphous life spilled on the starker, tidier geometrical floor. Death composes a picture. There is no need here for the mop with which Anthony Perkins swabs the motel bathroom. The blood, as abstract as a crimson ribbon in a Japanese Noh play, is soft, velvety cloth, and leaves no stain.

The murderer applies ruthless aesthetic standards, eliminating anyone who mars the picture. For the Nazi sailor played by Walter Slezak in *Lifeboat*, killing is social sanitation, a way to dispose of the weak or the maimed. The same principles are applied at home in America by Uncle Charlie, the serial killer played by Joseph Cotten in *Shadow of a Doubt*. His particular mission is to rid the world of parasitical and self-indulgent widows, symbols – like the blob on the tiled floor in *Topaz* – of the messy organic existence that the artist seeks to regulate.

The dramatist Thornton Wilder worked on the script of *Shadow of a Doubt*, and earned an acknowledgement from Hitchcock in the film's credit titles. Startlingly, Uncle Charlie's homicidal creed quotes from a much more innocuous speech by a character in Wilder's farce *The Matchmaker* (later set to music as *Hello, Dolly!*). In *The Matchmaker*, a clerk called Malachi explains his petty pilfering as a way of redistributing income. He targets the kind of widow 'who sits in hotels and eats great meals and plays cards all afternoon and evening, with ten diamonds on her fingers'. Paraphrased by Cotten in the film, Malachi's whimsical free-thinking becomes a diatribe of savagery and contempt, all the more chilling because of the bland, measured tone in which it is uttered during a dinner-table conversation. Cotten derides the 'useless women' who squander the money left to them by their dead husbands 'in the hotels, the best hotels', where they drink money and eat it or fritter it away at bridge, 'smelling of money, proud of their jewellery but of nothing else – faded, fat, greedy, women'. His niece and namesake, played by Teresa Wright, interrupts to protest that the women on whom he trains this scorn are alive, that they're human beings. Until now Cotten has been seen in profile: he speaks quietly, looking aside into a remote, ideal distance, a future when he will presumably have murdered all those superfluous creatures. Challenged, he turns towards the camera and stares into it in close-up, daring us to disagree. 'Are they?' he asks. 'Are they human, or are they fat, wheezing animals? And what happens to animals when they get too fat and too old?'

The discussion breaks off in embarrassment, since eugenic slaughter is not a topic for meal-time banter; but Hitchcock himself answered the question voiced by Cotten whenever he described actors as cattle. What happens to actors when the camera deems them too fat or too old? They undergo a mercy-killing and retire into invisibility, just as cattle are rounded up and directed towards the abattoir. Cotten adopts Hitchcock's conceit about his bovine performers and applies it to an even lowlier species. The world, he says, is a foul sty, inhabited by swine. One of the many courses in Hitchcock's gargantuan domestic dinners often consisted of a small boiled ham.

Fantasizing, you could also slowly and luxuriously kill yourself, as Hitchcock did by his immoderate consumption of food and alcohol. He took pride in his art collection, but was equally proud of the walk-in freezer – a mortuary for expensive imported meat – that he installed in his house in Bel Air. He knew the risks. Eating, we fuel ourselves; overeating, we may think we are making ourselves immortal, or at least fortifying a rampart of flesh inside which we will be safe. The gruesome meals in Hitchcock's films are a reminder of our self-deception. In his television series, poison is served as nourishment, medicine, or a slimming aid: in one episode, the fatal dose is administered in saccharine tablets. Another victim is eaten, after being baked in a pie.

At the end of their long conversation, Hitchcock told Truffaut that he wanted to film the daily routine of New York. He intended to dramatize the food cycle, with its warning that the human body, no matter how eagerly it provisions itself, is destined to become a waste product. In fact he had already made a brief version of this parable in *Champagne*, a silent film that he directed in 1928. Here the narrative is reversed, like a film run backwards. Rather than culture relapsing into nature, as the city's garbage is dumped in the ocean, the mess of unreconstructed nature is disguised as culture. In *Champagne* Hitchcock glances at the preparation and presentation of food in a restaurant. The kitchen is mucky, and the cooks dip dirty hands in the ingredients or salvage food from the floor with their fists. The same unhygienic, manhandled dishes are next seen arriving at a restaurant table, fancily arranged on salvers and served with a flourish. Civilization is about the concealment of ordure; cooking supposedly tidies away the evidence of our rawness.

The amoral fantasy ignores all these evasions. Dreams permit us another life as gluttons, or as murderers. The stories that attracted Hitchcock often jeered at the law. *The Lodger*, made in 1926, which he identified as 'the first Hitchcock picture', was based on a novel by Marie Adelaide Belloc-Lowndes about a serial killer who stalks and slashes his female victims in foggy London. In the novel, the killer is protected by his landlady Mrs Bunting, whose motive is squalid self-interest. He pays his rent and, while on her premises, behaves with

the neatness of the confirmed psychopath. Why should she interfere with his savage hobby? Mrs Bunting engineers his escape from justice and contentedly presides over her daughter's marriage to the detective who was tracking her tenant. Hitchcock apparently softened this cynicism. His lodger, played by the epicene matinee idol Ivor Novello, is wrongly suspected of the crimes. Cleared, he is free to supplant the amorous detective and wed his landlady's daughter: the better man wins. But the film, as it turns out, compounds the novel's challenge to morality. Hitchcock teases us, creating doubt about Novello, making his guilt seem incontrovertible, encouraging our rush to judgement. Then, when a crowd pursues the lodger and prepares to beat him to death, his innocence is fortuitously revealed. Watching, we too have been enlisted in a hasty, brutal lynch mob. Novello's posture, limply crucified against an iron railing and lifted to safety as if in a deposition from the cross, accuses us of sacrilege. But who incited us to condemn him? Hitchcock, like jesting Pilate, can demur with a smile.

Hitchcock's problem was to reconcile his assault on propriety with the timidity of the industry he worked in. Often, compelled by the prospect of censorship to alter a source, he contrived an ingeniously, speciously happy ending that was more disconcerting than the unhappy alternative. Deaths at least offer termination, and the appearance of moral resolution. After killing her husband, Mrs Verloc in Conrad's *The Secret Agent* flees to the continent with one of the conspirators. Her companion jumps off the boat train before it departs, leaving her to hurl herself overboard as the ferry crosses the Channel. There could be no such desperate, comfortless end for the expensively imported star of *Sabotage*; but the compromise worked out by Hitchcock entailed a last, voluntary sabotage of the law. Sidney wants to confess her crime. It is the detective, betraying his duty because he fancies her, who suggests that they take a quick trip abroad. But they do not need to go to such trouble: an explosion in the cinema destroys the evidence of murder, and they have the temerity to live happily ever after.

Hitchcock's gleeful perversity might easily have kept him on the margins or confined him to a dissident underground. He resisted this

35

relegation. During the 1940s he complained that his early British films seemed predestined to play in 'little side-street cinemas' – establishments as dubious as Verloc's in *Sabotage*. By then he had gone to work in the glossy Hollywood factory, where commercial taboos posed as moral embargoes.

Stars, he soon learned, did not commit murder. This created a problem in *Suspicion*, adapted from a novel by Francis Iles called *Before the Fact*. Its subject is a besotted girl who falls in love with a glamorous scapegrace. He squanders her money, kills off her father, rapidly disposes of her inheritance, and then sets about poisoning her. She consents to her own death: it is her last abject offering of love to him. Hitchcock, having cast Joan Fontaine and Cary Grant in the film, needed to find a way of telling the story without making Grant a killer. He did so by allowing Grant to remain ambiguous, while assembling a montage of his disconnected facial expressions – tender at one moment, contorted by rage and loathing at the next. We share Fontaine's agonized frustration: in a film, there is no knowing what lies behind a face. Even a first-person narration can't be trusted, as Hitchcock later demonstrated in *Stage Fright*. That film begins with a flashback narrated by Richard Todd. Because his is the only voice we have so far heard, we rely on him to talk us into the action and to explain why he is driving a getaway car at speed through London. As it happens, he is lying, and he has somehow convinced the camera to film events that never took place. Truffaut called the boy's execution in *Sabotage* an 'abuse of cinematic power'; here was a second offence, for which the deceived critics reprimanded Hitchcock. But what's the use of possessing directorial power unless you can abuse it?

During the decades when Hitchcock worked in Hollywood, stars had a dual value. They were financial assets who also possessed a moral bankability. They were paid for being beautiful, but their beauty was meant to be an image of virtue. Hence the need to protect them from scandal, or supply them with heterosexual alibis if they remained unmarried. The stars viewed their reputations as a trust fund, which they refused to put at risk. An inappropriate role could permanently damage their stock. *D'entre les morts*, the novel by Pierre Boileau and Thomas Narcejac on which Hitchcock based *Vertigo*,

ends with a spontaneous execution. The detective kills his adored Madeleine, who has betrayed him by earlier faking her own death. James Stewart, however, would never have consented to murdering Kim Novak. Hitchcock circumvented the problem with his usual slippery ingenuity. The heroine's second death is accidental. She falls from the bell-tower; although Stewart hauls her up the steps while berating her treachery, he does not push her.

Stars could not kill. Nor, as immortals, could they be killed – though they might choose to expire ecstatically, like Garbo in *Camille*. This, for Hitchcock, was the ultimate challenge. 'The whole *point* is to kill off the star,' he told Bogdanovich. He was discussing *Psycho*, and explaining his determination to have Janet Leigh slaughtered less than halfway through the film. He had already killed a star in *Young and Innocent*, where the act is more shocking because it happens in the first few minutes, and more startlingly pertinent because the victim, Christine Clay, played by Pamela Carme, is a movie actress. In Josephine Tey's novel *A Shilling for Candles*, Christine and the young man who is suspected of murdering her meet on a street corner in London. Hitchcock's script makes the meeting a professional encounter, not a pick-up: it took place in Hollywood, where he sold her a story he had written. Did stars retain their value if they could be so abruptly and pointlessly eliminated? Did any value at all remain intact if our fates were decided by such a deadly whim? In *Psycho*, Hitchcock set out to do more than make us feel uneasy in the shower. The purpose was to make us nervous about being alive, since life is liable to end when you least expect it, and for no discernible reason – unless you believe in a director who, somewhere out of sight, controls our exits.

For the final cameo of his career in *Family Plot*, Hitchcock chose to appear in silhouette, seen through the frosted glass of an office door in a government building. His body by then was recognizable in outline. Transformed into an inky shadow, he is already almost a posthumous presence, who warns that he will continue to haunt our dreams. The silhouette therefore points a finger in admonition. A sign on the glass door identifies the particular precinct in this bureaucratic hell where Hitchcock intends to go on exercising power: it

announces the REGISTRAR OF BIRTHS AND DEATHS. He prefers, of course, to register demises. There are no births in his films (and the birthday parties of children, when they occur, are sabotaged – confounded by a madcap fugitive in *Young and Innocent*, who presents the birthday girl with a statuette stolen from the front porch of her own house; assaulted by kamikaze gulls in *The Birds*). Death is his speciality.

Staging a private last judgement and dealing with long lists of victims at his own deliberate, corpulent pace, Hitchcock seemed intent – like the beaked, avenging harpies in *The Birds* – on doing away with humanity. Once again, his source drops hints about his intentions. The characters blitzed in Daphne du Maurier's story wonder what might have caused this upheaval in nature. A front of cold Arctic air has propelled the birds from the north towards temperate England. Perhaps the Russians have somehow mobilized the marauding flocks for the Cold War? A national defence effort is mounted, with naval guns blasting the sky. Politicians discuss the possibility of using mustard gas. The campaign is described as a 'battle'. Hitchcock, transferring the action to northern California, gets rid of these political concerns. Instead of a military invasion, he assumes that the creatures are guided by malice. They target people because they share the director's playful pleasure in destruction.

At the Bodega Bay restaurant, refugees convene to discuss the motives of the birds. Tippi Hedren begins the debate by contending that the crows at the schoolhouse intended to kill the children. A tweedy, wizened female ornithologist rebuts this view, asking why birds, which are 'not aggressive creatures', should have waited 140 million years to instigate this 'war against humanity'. Then the rational exchange of opinions is shouted down by quarrelsome human noise. A waitress bawls an order for three fried chickens and two Bloody Marys. After this tellingly raucous interruption, the ornithologist continues: 'It is mankind rather who insists on making it difficult for life to exist upon this planet.' A drunk toasts the arrival of the apocalypse, a metaphysical showdown that du Maurier's more practical, down-to-earth farming family never consider. It is, he declares with a grin of anticipation, 'the end of the world'. A

frightened mother, unable to comfort her whimpering children, screeches that Hedren is to blame. Imperilled communities defend themselves by marking out a stranger who can be sacrificed with impunity: the fur-coated Hedren has driven up from San Francisco in a sports car, so she will do. Next a man in a pork-pie hat swaggers in, demands a Scotch ('light on the water'), denounces the gulls as scavengers, and recommends extermination.

None of these people come from du Maurier's village household. They are present in Hitchcock's film in order to suggest that there may be reasons for expunging the malign, brawling race to which they belong. The obnoxious man with the Scotch offers to guide the flustered mother back to the freeway. But before they leave he lewdly winks at her and raises his glass: 'Haven't finished my drink yet.' On the way back to his car, he is incinerated when he lights a cigar after the gulls puncture a petrol bowser and spread a rivulet of gasoline. Who cares? Disaster movies are usually conscientious about characterizing victims, so as to elicit our sympathy. Not Hitchcock, for whom the man in the pork-pie hat is expendable, regretted by no one. When Hedren returns with Rod Taylor, the camera strays into a corridor and seeks out a huddle of women, most of them never seen before. One elderly frump, with a green turban like that worn by genteel London charladies in Hitchcock's youth, seems to have arrived in Bodega Bay aboard a time machine. They all glare at Hedren with stupid, unreasonable resentment. Who are these people? Just average humans, mean-minded and sour-faced. Hedren justifiably slaps the hysterical woman who calls her evil. The scene in the diner has no equivalent in the story; it exists to prompt Hitchcock's misanthropic verdict on humanity.

The last stage of his career coincided with the perilous global politics of nuclear stand-off. As the dictator of dreams, Hitchcock jovially acknowledged only one rival: the man whose initiative could end the world. But the director refused to defer to the Commander-in-Chief. Publicizing his ban on late entry to *Psycho*, he boasted that an exception would not be made for the President of the United States (or for 'the Queen of England, God bless her!'), and when *North by Northwest* was re-released in 1965, the posters added Hitchcock's glowering

face to the frieze of chief executives on Mount Rushmore. President Johnson, lamed by the Vietnam war, announced in 1968 that he would not seek re-election. Hitchcock at once offered to fill the vacancy, and announced to the press, 'I'm going to run.' He then paused, and added that he would be running a picture, *Topaz*, 'in about a year'.

Leon Uris's novel *Topaz* begins in 1962 as one of President Kennedy's advisers speeds from the Pentagon to the White House with a warning about the Russian installation of missiles in Cuba. He pities the decision the young man must make about retaliation – 'too great a judgement for a single mortal', because it ought to be 'God's decision if the human race should survive or perish'. That moment of misgiving didn't get into Hitchcock's film. The script prudently excluded the figure of Kennedy, still sacrosanct during those first years after his assassination. And in any case, such summary powers were now wielded by the director.

Playing God

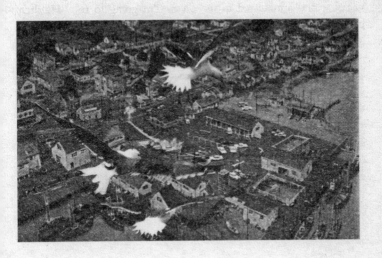

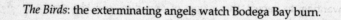

The Birds: the exterminating angels watch Bodega Bay burn.

'Did you think you were God?' This is the question that James Stewart furiously addresses to John Dall in *Rope*, after discovering the body in the trunk. God, of course, had been dead for some time. His demise is belatedly announced in *Juno and the Paycock*, the film version of Sean O'Casey's play about the Irish troubles that Hitchcock directed in 1930. Near the end, one of the aggrieved women, having lost her lover, cries out, 'There isn't a God!' Her mother seconds the complaint, and upbraids a statuette of the Virgin Mary. But the vacancy in the sky was promptly filled by Hitchcock – the author and organizer of life, the controller of fates, the referee of the blindly chancy games we play.

The script for *Strangers on a Train* found no room for the metaphysical speculations about divine indifference or malice that preoccupy the characters in Patricia Highsmith's novel. Highsmith's Guy enters into a deal to exchange murders with the psychopath Bruno. No moral prohibitions deter him, since God is no longer on duty in his watchtower. A newly relativized universe, in which the split atom reduces all men to fragments hurtling through space on destructive errands, actually decrees these crimes. Guy reflects that he and Bruno are like positive and negative ions, interchangeable and mutually necessary. This guilty physics disappeared from the film, but in its place Hitchcock inserted a barbed comment on a deity who enjoys the pointless, sportive fracas of nature.

Highsmith's novel concludes with Guy's arrest. The film, frivolously cheering itself up, ends with another trip on the train between Washington and New York on which Guy first met Bruno. A fellow passenger recognizes Farley Granger, as Robert Walker once did. As a tennis champion, he qualifies as a celebrity, someone with whom strangers feel entitled to be intimate. He is now addressed by a devotee of the game, who looks up from a copy of *Sport* magazine and asks if Guy didn't win the tournament at Forest Hills. Granger, not wanting to repeat the action of the film, quickly denies it and

exchanges a flustered giggle with his brand-new bride, Ruth Roman. The tiny scene would be insignificant if it weren't for the profession of the man reading the magazine – and even that might be insignificant if it were not for Hitchcock's second thoughts about it, which prompted him to make an editorial change. For the passenger with the subscription to *Sport* is a clergyman.

A partiality for tennis seems an innocuous hobby in a man of the cloth, no worse than cultivating rhododendrons or collecting first editions. So why did Hitchcock snip this last-minute gag from the film? Preparing a print for exhibition in Britain in 1951, he first cut the clergyman, then – missing the ironic fillip in his recognition of Guy – reshot the scene, removing the actor's clerical collar. Still dissatisfied, he never cleared this alternative ending for release. It remains as his memo to himself, a clue to his suppressed intentions. With his usual sinister glee, Hitchcock envisaged God's representative on earth as a sporty type, and the sport in question has its own terrifying appropriateness. Bosola in John Webster's *The Duchess of Malfi* says that men are 'the stars' tennis-balls, struck and bandied/Which way please them'. Are we simply projectiles, violently shuttled to and fro by the blows we receive? Perhaps the cleric likes tennis because it is the chosen game of his celestial employer. In *King Lear*, Gloucester observes that the bored, amoral gods have a malevolent notion of exercise or entertainment: 'they kill us for their sport'. Hitchcock repented, afraid he had gone too far – at least for the market in Britain, with its established church and its monarch sworn to defend the faith.

In 1959 Hitchcock delivered himself of a rare disquisition on metaphysics. Contributing an essay to Norman Vincent Peale's magazine *Guideposts*, he admitted that his own chosen vocation contained an element of supernatural conceit. The director's foreknowledge of our scripted lives was 'a godlike quality', which gave him 'a great sense of power'. He humbly acknowledged that this power ended when the director left the artificial environment of the studio – but Hitchcock himself seldom did so: he detested filming on location, where casual reality could intrude. Struggling in the essay to reconcile his Catholic boyhood with the refined cruelty of his artistic temperament, he described the deity as a maker of thrillers, a would-be

Hitchcock, and argued that 'when God keeps the future hidden, He is saying that things would be very dull without suspense'.

Hitchcock valiantly pretended to find this occlusion of the end 'one of God's most merciful and exciting gifts'. God tantalizes us, dashing our hopes so as to afford us, if we are lucky, a delayed gratification. He claimed that a special providence was at work in the fate of *The Lodger*, shelved by the studio, then reprieved and released a few months later, when it became a hit. What happened to change the minds of the producers? Exaggerating somewhat, Hitchcock called the first hostile verdict 'a day of judgment'. He and his wife responded to the sentence of doom by going for a walk. 'And,' he added, 'we prayed.'

Miracles do indeed happen in Hitchcock's films, but mostly by inadvertence, or as the result of human ingenuity. A hymn book stowed in the pocket of a purloined coat stops a bullet aimed at Robert Donat's heart in *The 39 Steps*. The stolid anthology of grim, grovelling low-church verses finds an unexpected use. 'Some of those hymns,' as a policeman comments, 'are awful hard to get through.' Donat next takes refuge from his pursuers by disappearing into the ranks of the Salvation Army as it marches through a Scottish town. More concerned to save his life than his soul, he does not pause to thank God for these small gifts.

When Hitchcock moved to America, he found that miracles were available to order, since the country's technology performed supernatural feats all day long. Young Charlie in *Shadow of a Doubt* says she is waiting for a miracle, some radiant surprise that will overturn the banality of her small-town routine. She prods providence into action by sending a telegram to her Uncle Charlie, begging him to visit; at the telegraph office she discovers that he has already telephoned to announce that he is on his way. The coincidence stuns her. 'Mrs Henderson,' she says to the telegraphist, 'do you believe in telepathy?' Mrs Henderson snaps, 'I ought to, it's my business.' Charlie explains what she means, and describes the marvel of mental attunement across distance. Mrs Henderson does not approve of beaming thoughts through the air without paying the appropriate fee: 'I only send telegrams the normal way,' she grunts. Hitchcock knew better.

A director is also a telepathic god, who can transmit his will through space and make things happen in his own absence.

In his televised *Histoire(s) du cinéma*, Jean-Luc Godard describes Hitchcock as 'the only one, apart from Dreyer, who knew how to film a miracle'. The scene Godard uses to illustrate this contention comes from *The Wrong Man*. Henry Fonda prays for divine assistance, and a distant figure appears in a nocturnal street, walking forward until his face is superimposed on Fonda's in close-up: it is the right man, the robber for whom Fonda has been mistaken. Yet despite Godard's pious awe, this is a very different event from the miracle filmed by Carl Theodor Dreyer in *Ordet*, where the power of prayer revives a dead mother. We long to believe what Dreyer shows us, and our faith makes it true. Hitchcock's scene is more like demonic possession than the miraculous intervention of grace. The robber's face comes to rest on top of Fonda's, fuses with it, then obliterates it. The superimposition is not maintained; the robber takes over the shot, and walks into a store, which he holds up. He and Fonda are virtual doubles. Could the robber be the law-abiding man's ulterior self, as Hitchcock suggests by making him first materialize inside that close-up of Fonda's head?

Whether or not Hitchcock believed that *The Lodger* owed its second chance to divine intervention, most of us could do without the excitements – disguised as mishaps or disasters – that God prescribes, and would prefer not to wait for merciful reprieve at the final fade-out. It is Hitchcock himself, not God, who keeps people in suspense, like Eva Marie Saint swinging from Mount Rushmore or Norman Lloyd in *Saboteur* hanging from the Statue of Liberty. According to the director, these characters should be grateful: he has jolted them out of lives that would otherwise be boring.

Gods who view the world in this way have adamantine, unfeeling faces, like the stony presidents, like Liberty with her frozen visage, or like Hitchcock himself. The chase through the British Museum at the end of *Blackmail* depicts the relationship between these unmoved movers and their desperate, harried subjects. The blackmailer is seen self-suspended, taking a short cut from one floor of the museum to another by shinning down a rope like an agitated spider. It is hardly

likely that any such rope would be available to him; besides, there's a staircase handy, which would have been quicker. The point is to show our tenuous state as we grapple in empty space, and to confirm the indifference of our supernatural surveyors. Behind the man on the rope is the sculpted face of an Egyptian god, which occupies the entire wall. A carved inscription deciphers the thoughts that might be coursing through its head, but its eyes are blank and its mouth curves in a serene smile. The blackmailer runs on through the museum's reading room, which Virginia Woolf in her novel *Jacob's Room* – published in 1922, seven years before Hitchcock made *Blackmail* – likened to 'an enormous mind'. Hitchcock's long shots once again see man under the aspect of eternity: the fugitive in those avenues of books is like a disreputable thought, a fantasy that has escaped from the safe confinement of covers and bindings. Somehow the blackmailer finds his way on to the roof, and plunges to his death through the glass dome that surmounts the library. That skylight might be the aperture, like a camera lens, through which God peers down, enjoying our absurd battle against gravity.

The spirit of modernity made atheism compulsory. The free-thinking young socialites in Hitchcock's 1931 film *The Skin Game* do not hesitate to take the name of the Lord in vain. The factory-owner Hornblower, played by Edmund Gwenn, knows about the pact between puritanism and capitalism. Threatening a haughty patrician family with eviction, he asserts a divine right that smiles on his plan to replace their forest with puffing chimneys: 'I'll answer to God for my actions.' The daughter of the family scornfully comments: 'Poor God!' Hornblower denounces her as a 'blasphemous young thing!' It's his mistake to imagine that his social superiors are cowed, as he is, by the authority of scripture. When he wants the squire's wife and her legal adviser to keep a secret, he makes them swear with their hands on the Bible. Of course they break the oath. Unbelief has invaded his own family, thanks to his disgraced daughter-in-law, who hires herself out as a co-respondent in divorce cases. She admits that she deceived her husband, but adds, 'I'd have deceived God himself, I was so miserable.'

Just in case the old fogey might still residually exist, clinging to

office even though his constituency has deserted him, why not make sure by assassinating him? When Nietzsche first reported that God had died, he spoke metaphorically. Hitchcock insisted on actualizing the event by filming it. In *Foreign Correspondent*, a gunman concealing his weapon behind a flash camera kills the wise, benign elder statesman who might have saved the world from a war, and in both versions of *The Man Who Knew Too Much* – a title that refers to the sublime conceit of men, who have arrogantly outgrown their belief in a maker – humanity assembles in the domed, cosmic arena of the Royal Albert Hall to witness a similar outrage, accompanied by a massed choir of female singers dressed like angels and a rumbling, sanctimonious organ. Three eruptive sounds, more or less synchronized, abruptly conclude the cantata: a woman's scream, a clash of cymbals, and the assassin's gunshot. Together they amount to a big bang, a moment when tempo is jarred, manners disrupted, and the spatial order of the hall reverts to anarchy and fragmentation.

Later, at the embassy reception, Doris Day rescues her kidnapped son by signalling to him with a reprise of 'Que sera, sera'. Her song, which insists that 'the future's not ours to see', anticipates the lesson preached by Hitchcock in his *Guideposts* homily. There he rejoiced in 'a blind future', foreknown only by God. 'I thank Heaven daily,' he concluded, 'that tomorrow does not belong to any man. It belongs to God.' He was, ironically enough, chanting Day's refrain, while also paraphrasing another exchange from the 1955 *Man Who Knew Too Much*. Near the end, the kidnappers are rehearsing the assassination that is due to happen later that day at the Royal Albert Hall. Brenda de Banzie, who has misgivings, says, 'I wish it was tomorrow.' Bernard Miles, playing her husband, replies, 'That's not a very orthodox sentiment.' Orthodoxy requires us to suffer time patiently, rather than wishing ourselves into the future. His enigmatic remark has an unusual doctrinal significance, because he makes it while strapping on a clerical collar and a black bib. Miles's current incognito is that of a clergyman, getting ready to conduct evening service.

The devil is adept at quoting scripture; when Hitchcock invoked the same moral in earnest four years later, the memory of Bernard Miles's vulpine grin and falsely holy get-up made the director's piety

seem questionable. By then, in any case, Hitchcock had rescinded this conventional view that effects follow causes, just as heaven, hell or purgatory follow earthly lives. His spokesman was a wise child, wilier than the boy who is lulled to sleep by Day's song. The film that preceded *The Man Who Knew Too Much* was *The Trouble with Harry*, released in 1955. In it, Shirley MacLaine's young son sagely explains that tomorrow never comes, which must mean that tomorrow is yesterday. Events confirm his looped, ludic view of time. Death is meant to be an irrevocable end, though it also supposedly introduces us to the post-mortem regime of rewards and penalties overseen by God. So how is it that Harry, whose corpse migrates around the New England countryside at will, enjoys so many spontaneous rebirths? And if we must pay tomorrow for what we do today, how come the members of Harry's burial party, any one of whom might have killed him, blithely escape blame? What will be might already have been, or it may be indefinitely postponed.

Orthodoxies are certainly at work in *The Man Who Knew Too Much* – two of them at least, Christian and Moslem – but Hitchcock's view of these opposed religious dispensations is distinctly unorthodox. The first *Man Who Knew Too Much* begins in St Moritz, before returning to London; the second starts in Marrakesh, where the American family is on holiday. The new setting makes possible a novel sacrilege. On a bus, the son of two vacationing Americans stumbles and by chance tears the veil from the face of an Arab woman. Her irate husband threatens young Hank. Despite the outcry, this is the kind of indelicate assault Hitchcock was always committing, and not by accident: here he rehearses the unveiling of Janet Leigh when the shower curtain is ripped aside in *Psycho*. Day pleads that her little boy meant no harm. 'The Moslem religion,' she is told, 'allows for few accidents.' Hank is sceptical when it's explained that Moslem women never unveil in public. 'You mean they feed intravenously?' he asks. He has picked up the polysyllable from his father, a doctor; he can also spell 'haemoglobin', though he has difficulties with words like 'dog' and 'cat'.

Is Hank the boy who knows too much, kidnapped to punish his curiosity and his precocious familiarity with bodily matters? Of

course there is no moral logic to this, but in Hitchcock's fatalistic universe – where if you're a Moslem you can be condemned for losing your step when a bus lurches, and if you're a Christian you can only dolefully repeat 'Whatever will be, will be' – legal proofs are not necessary. Religion creates a free-floating sense of guilt, and dooms the believer to a life of gnawing dread, like James Stewart later in *The Man Who Knew Too Much* pursued down a sunlit, empty street in Camden Town by the sound of phantasmal footsteps.

In both versions of *The Man Who Knew Too Much*, the gang of political assassins has its hideout in a chapel. In 1934 the establishment is a heterodox den in Wapping, where slum-dwellers take part in heliocentric rites. For these dwellers in the sooty East End, the divinity is solar, even though it remains absent, invisible somewhere above the besmirched, foggy city. A prune-faced priestess moves up the aisle appealing for donations, and encourages generosity by aiming a gun at her flock; a frumpy organist wheezes out a tune to drown the noise of breaking chairs during a brawl. The Tabernacle of the Sun is also a surrogate cinema, where an unholy radiance is placed on show; it induces a kind of faith, by dazzling the eyes and sedating the brain – as Hugh Wakefield discovers when the priestess waves a bauble in front of his eyes and hypnotically sends his reason to sleep.

In 1955 the chapel – relocated in Bayswater, in the west of London – no longer purveys sun worship. Bernard Miles, the kidnapper who doubles as a parish priest, administers doses of puritanical self-contempt. When Stewart interrupts a service, Miles curtails his sermons and abruptly sends his gaggle of down-at-heel worshippers home to reflect on their unworthiness. Stewart is knocked out and imprisoned in the chapel. As a stalwart Midwesterner, he trusts in his own energy and ingenuity, rather than imploring divine aid. He escapes through the bell-tower, climbing up the rope used by the bell-ringers and levering himself on to the steep slate roof.

Two of Hitchcock's most beguilingly satanic villains mock the demeanour of churchgoers, sheepishly collectivized and therefore manipulable, like an audience at the cinema. In *Shadow of a Doubt*, Cotten excuses himself from attendance at Sunday service and sneers at the smug, godly self-congratulation of those who crouch in the

pews. In *Family Plot* William Devane plans to kidnap a bishop by jabbing a hypodermic into his arm as he processes into a cathedral to conduct Mass and spiriting him away. Nothing could be simpler, he tells his accomplice Karen Black: people in church are paralysed by decorum, and will watch as the impossible happens before their eyes. Priests, like film directors, know how to take advantage of this suggestibility. Devane, disguised in a clerical collar, sees that there are opportunities for a criminal too.

Even more audacious than Devane, Hitchcock loved staging murders in cathedrals or, failing that, in humbler churches. In *Foreign Correspondent*, Edmund Gwenn, playing an officious bowler-hatted killer, takes Joel McCrea to Westminster Cathedral, intending to shove him from the bell-tower. A requiem mass is being sung in the Catholic cathedral and Gwenn, indignantly Protestant, won't enter because he disapproves of the candles and the chanting. As it turns out, Gwenn himself lunges from the tower and thuds on to the pavement in time – despite his doctrinal qualms – to take advantage of the requiem's appeal for grace and rest. Some nuns run out and, like their colleague at the end of *Vertigo*, cross themselves as they gaze at this latest evidence of God's mysterious will. In *Secret Agent* Gielgud and Lorre have a rendezvous with the organist of a church in a Swiss village. They are puzzled by the dreary, whining monotone of the organ as they approach; the organist is slumped across the keyboard, dead. They light candles, and Gielgud asks if Lorre knows any prayers. 'Don't insult me, please!' replies the decadent gnome.

Hitchcock maintained this habit of desecration, even when the settings in question were secular. The United States Ministry of the Interior accused him of impiety when he asked permission to use Mount Rushmore for the climax of *North by Northwest*. The bureaucrats regarded the mountain as a devotional shrine of democracy, and took offence at Hitchcock's plan to have Grant suffer a sneezing fit while hiding inside Abe Lincoln's nostril; they obliged him to confine the action to the gaps between the solemn presidential faces. This, for Hitchcock, was not enough. He always wanted to penetrate the bodily interior where we generate our fantasies. Buñuel announced that violent entry in *Un Chien andalou*, personally taking

up a razor and slashing open a woman's eyeball, and Hitchcock often alluded to this directorial attack. Gregory Peck wanders through the house with an open razor in *Spellbound*. Though Mrs Bates uses a kitchen knife and thrusts the shower curtain aside rather than piercing it, she too attacks our eyes so as to agitate our brains: thanks to rapid editing, we think we have seen things – a naked body, and a knife making love to it – that we have only imagined. Challenged to be more outrageous than Buñuel, Hitchcock achieved the scandalous feat in comedy. Since *Un Chien andalou* had proved the permeability of the eye, why not try out the body's other orifices by insinuating Grant into Lincoln's nose?

The civil servants who guarded the sanctity of America's national monuments should have been warned by Hitchcock's cheeky treatment of the Statue of Liberty in *Saboteur*. At the end of *Saboteur* the villain flees to Liberty Island after the explosion at the Brooklyn Navy Yard. Priscilla Lane follows him, climbs up through the statue's hollow body, and tries to detain him inside the giantess's head. She does so by flirting. The statue, she simpers, 'means so much to us now': the film was made in 1942, and the saboteurs are undermining America's war effort. She adds that she 'could just sit up here all day thinking about it', hoping he will linger too until he can be captured. The ferret-faced Norman Lloyd sneers at her as 'little Miss Liberty holdin' the torch'. The cold carved flames of the statue's torch, shown in close-up during the final struggle between Lloyd and Robert Cummings, are unflustered by the gales in the harbour. But the beacon Lane displays signifies desire not enlightenment. To a fascist, liberty means messy promiscuity.

So what does Hitchcock think about the statue – America's magna mater, the goddess who stands guard beside the golden door? He sees the grotesquerie of that embodied idea. People crawl inside the icon's brain; a spiral staircase is her corkscrewed spine, or perhaps her tangled alimentary canal. No wonder that the unpatriotic saboteur wants to escape from a notion that has absorbed everyone else. Hitchcock watches for gaps between the haughty allegorical remonstrance and our earthlier needs: the contrast between the statue's resistance to gravity, holding up her bicep-bulging arm for ever, and

the slippery hand-clasp by which Cummings tries to keep Lloyd from falling; between her stony face and their grimaces of human pity and desperation; between the inflexible steel of her torso and the fragile unravelling cloth of civilization, represented by the thread that comes undone in Lloyd's sleeve and leaves him to plummet to his death.

Foreshortening changes the matron to a monster. Into the struggle on the torch Hitchcock inserts an astonishing view from above – a divine perspective, like the matte shot from mid-air as the gulls convene in *The Birds* to watch the bombarded town burn; the vantage-point from which a deity can observe, unimpressed, the fall of a sparrow. The camera might be looking down from outer space, with the statue's spiked crown as planetary orbitals. Light years below, flailing men like fleas in a circus struggle to stay alive. When Cummings grabs Lloyd's sleeve, Lloyd swears he will cling. A rope is made ready to hoist a sinner up to salvation; but the saboteur, called Fry, is one of the small fry of fallen mankind, and the gulf of perdition claims him. Liberty does not blink. She could not care less about the 'huddled masses' of mortals to whom she offers asylum in Emma Lazarus's poem. Why else would she refer to them as 'wretched refuse'?

God, the moral overlord to whom Christians defer, has been harried into exile. The murderous experiment in *Rope* proves his impotence. Dall and Granger consider themselves to be supermen, and assume the godlike power to ordain death. They share this defiance with other Hitchcock characters. The book that Vera Miles opens in *Psycho* has no title, and its contents are withheld from us. Bloch's novel supplies more details about Norman Bates's reading matter. He has the Marquis de Sade's *Justine* in his bedroom, along with J.-K. Huysmans's *Là-Bas*. Bloch mentions only the titles; we are left to deduce their relevance to Norman. The Sade item is a scabrous mockery of religion, chronicling the carnal travails of a stupidly virtuous heroine. Possibly it is a reminder of the heroine's ironic fate in *Psycho*: Marion (called Mary by Bloch) is slashed to death after she repentantly decides to return the money she has stolen, which shows that virtue will not necessarily be rewarded. The presence of *Là-Bas* in

Norman's library is even more telling. The satanic hero of Huysmans' novel, published in 1891, considers Sade 'a timid bourgeois, a mediocre fantasist', and sets himself to be even more brazenly depraved. He celebrates 'deicidal Masses', at which God is symbolically slaughtered; another fallen churchman venerates the devil, feeds the consecrated hosts to white mice, and has 'the image of Christ tattooed on his heels so that he could always step on the Saviour'. Bloch's Norman, like Hitchcock, is a black magician, whose crimes were prudently obscured by the adaptation.

The characters of Sade and Huysmans are not the only deicides who lurk in the hinterland of Hitchcock's films. A demoniac with similar habits appears in *The House of Dr Edwardes*, the novel by Francis Beeding on which Hitchcock based *Spellbound*. The source was whitewashed by its adaptors. The sanatorium in *Spellbound* is a sedate establishment with the comforting pastoral name of Green Manors, situated in rural New England. The asylum in *The House of Dr Edwardes* lies much further from reality and normality: it is housed in an alpine chateau, among gaping precipices and bristling forests on the border between France and Switzerland. The location is regressive, since in the surrounding villages people still live in the Middle Ages, believing in witchcraft and 'curious superstitions'. Rather than devoting itself to the restoration of mental health, this institution – like the sealed, inaccessible castle where Sade's libertines explore the body's filthiest and most recondite possibilities in *Les 120 journées de Sodome* – functions as an orgy room. The demented proprietor of the place conjures up the devil, and slays victims on a sacrificial stone in the woods as offerings to him. The doctor who conducts these revels wears the same satanic tattoo as the priest in *Là-Bas*. The revelation happens in a bathroom, where he is discovered stretched out in a tub. His feet have been marked with 'two crosses, one upon each of the soles'; he too enjoys treading Christ in the mire.

Scarcely a whiff of diabolism survives in *Spellbound*. Yet the film did not timidly renege on its source. The new plot it devised is actually more disturbing than Beeding's Gothic farrago. In *The House of Dr Edwardes*, the madman only kidnaps and drugs the real Dr Murchison, who returns to rout the pretender. In *Spellbound*, the guilt

is more threateningly immediate, and not so easy to dispel. Gregory Peck passes himself off as Dr Edwardes, the new head of Green Manors. He admits that he is an imposter, and suspects he has murdered the real Edwardes. In fact the crime has been committed by Dr Murchison, played by Leo G. Carroll, who resents having been replaced by Edwardes. Supposed to be healers, the two men are actually killers – for although Peck is innocent of Edwardes's murder, he did cause the death of his brother when they were both boys, impaling the child on a pronged fence during a game. *Spellbound* may avoid blasphemy, but it weakens our faith in those whose authority we revere. Priests profane the sacraments, and doctors too betray the oath they have sworn.

God's secular deputies are also demoted, though Hitchcock took care to muffle the affront, keeping his offence a secret by adroitly suppressing the evidence. *Murder!*, released in 1930, was based on the novel *Enter Sir John* by Clemence Dane and Helen Simpson. It concerns the amateur sleuthing of an impresario who swoops down from his lofty perch in the West End to investigate a murder in a provincial repertory theatre, and manages to save an unjustly accused actress from the gallows.

The flashy, supercilious Sir John – based on the actor-manager Sir Gerald du Maurier, Daphne's father, and played in the film by Herbert Marshall – is of course a knight, with a personal investment in the hierarchical society upheld by the monarch. In deference to the theatrical setting, the novel prefaces each chapter with an epigraph from Shakespeare, and these quotations often allude to the killing of kings, whose divine right to rule is ignored by usurpers. The first epigraph comes from *Macbeth*, a play about a king's murder. As it happens, on the night of the crime Martella Baring and her colleague Magda Druce have been learning their lines for a new play. Martella, on trial for Magda's murder, tells the judge she needed help because the role was 'the longest I've ever tackled'. The judge, evidently a keen playgoer, asks if it was as long as Lady Macbeth's part. 'Oh, much longer,' the prisoner replies. Had she perhaps commited murder in imitation of the lethal heroine? Her defence is a mental lapse, known as a 'fugue': consciousness took flight, and she simply has no

idea how her friend came to be clubbed to death. Like Lady Macbeth, she might have been sleepwalking. Martella turns out, indeed, to have a history of somnambulism. Her lawyer explains this temporary insanity by using metaphors that paraphrase the scenarios of royal execution or abdication in Shakespeare's histories. The 'directing intelligence' has been 'deposed', and though it might 'return to its throne', it would find a 'desolation for which it could not account'. Martella has dethroned reason, which ought to maintain sovereignty inside her head. She has suffered a moral blackout – cover for a crime, but also a necessary condition for the cinema's uncaging of its luminous phantoms.

Hitchcock continued to brood about regicide, a crime that, since the Shakespearean king is a deputy anointed by the Lord, rehearses deicide. Long after his attempt to persuade Gielgud that Ashenden was a modern Hamlet, he hoped to make a film of Shakespeare's play with Cary Grant. It might have been extraordinary: *Hamlet*, after all, is something of a screwball comedy, in which vindictive schemes are scattily disrupted by accident and misunderstanding, and its killings look like practical jokes. Grant never signed on for the role, but Hitchcock did at least manage to film part of the play. The cast of *The Trouble with Harry* – toiling around the clock to inter the troublesome corpse and keep it buried, chuckling and jesting to keep their spirits up as they spade the soil – are a contingent of gravediggers who might have strayed in from Ophelia's scanty funeral, where the rites of the church are grudgingly curtailed. Hitchcock himself plays a gravedigger in a Californian lawn cemetery for the trailer that advertised *Family Plot*. Dressed in his usual dark suit, he indolently pauses on his shovel and watches an extract from the film: Mrs Maloney, attending her husband's funeral, angrily pummels the tombstone of Eddie Shoebridge with her foot. 'What a grave insult,' purrs Hitchcock.

'Hamlet,' Hitchcock said in 1950, 'is a detective.' But Hamlet's business goes beyond the uncovery of evidence. He is also the appointed killer of the usurping king, who killed the previous king. Himself a rebellious son and an amateur philosopher, he questions traditional prohibitions; he knows that to murder a king is to

challenge sanctity, and – even though he is the heir to the disputed throne – he is irresistibly attracted to this act of symbolic defilement.

Hitchcock, sympathizing with Hamlet, must have been intrigued by the element of 'lèse majesté' (which literally means 'the wounding of majesty') in Victor Canning's novel *The Rainbird Pattern*. Here it's not a king but a queen who is slighted. The first scene of the novel is superintended by a portrait of Elizabeth II, who looks on as some senior civil servants gather in London to ransom a cabinet minister. They pay off a kidnapper (played in the film by the silky Devane) who has mocked the solemnity of government and taunted the blandly smiling monarch. *Family Plot* moved Canning's story from England to California, which meant that the portrait of Elizabeth II disappeared from view, along with the suggestion of royal fallibility. But Hitchcock had ways of revealing what he had discreetly concealed, and he perhaps recalled the wry insult to the sovereign in Canning's novel when Elizabeth II, four years after *Family Plot*, remembered his existence. In 1980 she made him a knight. He had only four months left to live, so the honour came too late to make any difference. At the ceremony, held in Los Angeles because he was by then too ill to travel, a journalist asked Hitchcock why it had taken the queen so long to accord him this recognition. A dying man has no time for diplomacy. 'Perhaps,' he replied, 'she forgot.' It was an eloquently abrupt remark. Isn't a sovereign, like a god, supposed to be omniscient, which ought to rule out such oversights?

Having made his point about the infirmity of the state by capturing a cabinet minister, the kidnapper in *The Rainbird Pattern* ridicules the church by choosing an archbishop as his next victim. *Family Plot* adapts his crimes to America: Devane first seizes a tycoon, and then has to settle for a mere bishop. The film has no time for the moral quandary of Canning's cleric, who wonders if he deserves the ransom and debates whether he should sacrifice his life to combat evil. But Hitchcock did not exactly omit such scruples; his film slyly redistributed them. The bishop in *Family Plot* has other, worldlier reasons for not wanting to be released. He so relishes Karen Black's cooking and Devane's wine that he asks if he can finish his meal before he is returned to freedom.

In its own underhand way, *Family Plot* manages to be more cheek-ily blasphemous than Canning's story. The archbishop in the novel is seized during a country walk; in the film Devane, with insolent bra-vura, abducts him as he conducts a service in his cathedral. In addi-tion, the character of the clairvoyant Blanche (played by Barbara Harris) permits Hitchcock to joke about the relation between official religion and the fuzzy spirituality of California. Blanche, an amiable huckster who surprises herself when she has a genuine vision, deploys the trinkets of Catholic credulity, designed to inculcate faith. She clutches a rosary during a séance, and has an image of a levitat-ing Virgin Mary on the wall of her sitting room. In her role as a med-ium, she airily traverses 'heaven and hell – the great beyond'. Yet when she strays into the townhouse where Devane and Black lock up their prey, the great beyond bumps down to earth at 1001 Franklin Street in San Francisco. Heaven, paraphrased by Blanche as 'the upper brightness', is a crystal chandelier, whose sparklers include a diamond that Devane demanded as ransom, and the underworld is located in a windowless room off the garage that serves as the deten-tion cell for the kidnap victims.

Blanche's lover George, a disgruntled and sexually overtaxed taxi driver played by Bruce Dern, knows her too well to be credulous. He tells her that she is as psychic as a dry salami, and complains that she's got him by the crystal balls. Arguing with each other, they turn a sacred name into an expletive. 'Christ, no!' says Dern. 'Christ, yes!' shouts Harris, and scolds him for blaspheming. Miss Rainbird, who has employed Blanche to trace her lost nephew, says that Bishop Wood might have some information. 'Holy Christ!' says Dern. 'No, not him,' Harris pedantically replies; 'Bishop Wood at St Anselm's Cathedral.' Later they are lured to a meeting at a country diner. While they wait, a priest comes in, bringing a troop of chil-dren fresh from Sunday school. Next to arrive is a lush young woman, who pretends to be surprised when she recognizes the priest. He moves aside to sit with her at a separate table; the chil-dren were merely his excuse for the rendezvous. Leering, Dern com-ments: 'Nice arrangement.' He uses his pipe to express a casual contempt for hypocritical Christianity. He puffs on it when he strolls

into the cathedral, and in the cemetery he taps it on a gravestone to empty its cold contents. Tobacco, like the human body, is reducible to drifting smoke and sifting ash. But though he lacks reverence, he can be scared into respect for the dead. When he stumbles on an over-grown burial plot, he apologizes to the mouldy sleepers beneath the soil, as if fearful that they might have tripped him up. At the end of the film, he finds spots of Barbara Harris's blood on the handbag she dropped when Devane seized her. He is right to suspect the worst: in the novel, the kidnapper does summarily kill Blanche. Dern earlier names Christ in his ribald oaths. Now he gasps 'Oh my God!' – devoutly, or reproachfully?

In *The Rainbird Pattern*, the plot is superintended by an invisible metaphysical director. Although the archbishop believes himself to be 'in God's good hands', it is not the providential Christian God who arranges these fatal coincidences. The civil servants know better. They assume that victims are selected by 'the gods', who look down on mortal mishaps 'with proper irony'. These are the madcap, vindictive deities of paganism – older than the Christian deity who tried to unseat them, and less concerned to justify their actions and interven-tions. *Family Plot* rises towards their vantage-point during the burial of the man who dies after trying to kill Dern and Harris on the moun-tain road. The man's widow scuttles away from the grave on a weedy path. Dern walks off in the opposite direction. But their tracks even-tually converge, as the two intersecting plots of the film are fated to do; the camera lifts into the air to reveal the rude geometry of the angular design around the edge of the graveyard, and as it does so, the priest who conducts the service intones a tribute to the god – a camera operator, or the grounded director from whom his orders have come – mounted on this craning machine: 'For he knoweth all things, and there is not anything save he knoweth it.' This god can foresee the future. He wrote the script, and has treated himself to a bird's-eye view of human mischances.

Swooping into view as homicidal gulls, or as a crop-dusting plane that sprays bullets not pesticide, the gods who are eyed askance in Canning's novel had been foregathering on the fringes of Hitchcock's films for decades. They are present in Daphne du Maurier's novel

Jamaica Inn, published in 1936, although Hitchcock kept them out of the film he directed in 1939. The film's villain, played by Charles Laughton, is a corrupt magistrate, secretly the chief of a pirate gang. In the novel, the same character has a different profession, which serves equally well as a cover for his iniquity. He is an unbelieving priest, and the shipwrecks from which he profits rehearse a more ambitious outrage. His grand aim is deicide. The most murderous wreck accordingly happens on the morning of Christmas Day, and serves to spoil the commemoration of a saviour's birth. The heroine Mary simultaneously decides that the Christian God, who grievously let her down by allowing her mother to die, no longer deserves credence: 'she would offer no prayers to God this Christmas'. Such atheistic anger was deemed inappropriate for Maureen O'Hara, the sweet Irish teenager cast as Mary in Hitchcock's film; but the novel's metaphysics sneak into Laughton's death scene. He plunges from the rigging of a ship, shouting at his pursuers, 'I shall be down to you before you are up to me' – a wild parody of the saviour's descent from eternity into time at Christmas.

In the novel, the priest Davey tempts Mary with an alternative religion, better suited to the wild Cornish landscape in which they find themselves. He keeps faith with the 'old gods', denounces Christ as 'a puppet thing created by man himself', and – anticipating Cotten in *Shadow of a Doubt* and Devane in *Family Plot* – sneers at the congregation to which he preaches: 'they sat there in the stalls like sheep . . . with their mouths agape and their souls asleep'. Davey schemes, as the deranged asylum-keeper had done in *The House of Dr Edwardes*, to revive the rites of those chthonic spirits, who require human sacrifices. The old gods are not mentioned in Hitchcock's *Jamaica Inn* or in *Family Plot* but they do not need to be: the cinema itself is consecrated to their worship, since film stars are the contemporary embodiments of pagan divinity. Like the Olympians, they are larger than us and lovelier, immortal and amoral, and Hitchcock's films constitute their pantheon. Cotten in *Shadow of a Doubt* arrives in answer to a prayer, sunnily distributing largesse until he tires of life among the downtrodden inhabitants of earth. Kim Novak dies in *Vertigo* and is reborn with a different hair-style. Harris in *Family Plot* is a greedy Venus,

stuffing herself with hamburgers while she plans the next coital bout with her taxi-driving lover.

Du Maurier made Davey an albino, a freakishly pallid creature whose white hair forms a sinister aureole around his head. He resembles Lucifer, the fallen angel who was born of light, and sees himself as an emissary of elucidation. On a walk across the waste he revises the itinerary of Genesis: 'the moors were the first things to be created; afterwards came the forests, and the valleys, and the sea'. In the Bible, God's first feat was to illuminate the world. Hitchcock had a different priority. He preferred to suddenly turn the lights off, or to put out the light that serves as a rational monitor in our heads.

The first such concussion occurs in *The Lodger*. A gloved hand switches off the lights at a dance. In the darkness, a woman is strangled. It is the lodger's sister. He is finally cleared of this and the subsequent copy-cat crimes, but who can be sure of what happens in the obscurity of the cinema? In 1927, the year after making *The Lodger*, Hitchcock staged another, more subjective blackout in *The Ring*. The film is about the professional and amorous rivalry of two boxers, and the incident should technically be classified as a knockout. Filmed from the point of view of the downed fighter, it shows what happens inside his head after the lights go out. The episode has an extra significance because the boxing match takes place, like the concert in both versions of *The Man Who Knew Too Much*, at the Royal Albert Hall. Hitchcock's treatment of the events is uncannily similar. Seen with hindsight, the fight in *The Ring* might be an account of how *The Man Who Knew Too Much* would have concluded if the assassin, who is distracted by the screams of Edna Best or Doris Day, had not missed his aim – and now the camera is in the position of the marked man, not the helpless, anguished spectator.

The same audience is in attendance. Socialites gossip in their boxes, and the dress code for the boxing match, as for the concert in the later films, is white tie. The referee, like the conductor of the cantata, bows to the crowd. Of course the spectacle is a little grubbier, and Hitchcock notices the water buckets in the corner of the boxing ring, the sponges and the sand, all intended to mop up the blood and sweat of the performers. But there is an equivalent to those brilliantly

polished, deafeningly symbolic cymbals that give the gunman his cue and provide him with cover in *The Man Who Knew Too Much*. This is the gong, banged with a mallet in close-up to announce the beginning and the end of the match's rounds. Ian Hunter, playing Bob, aims a ferocious punch at the camera, which represents his opponent Jack, played by Carl Brisson. A prize example of what Hitchcock called 'the free abstract in movie-making' follows: an uninhibited play of deforming fantasy, made possible by violence. Jack blacks out, and so does the Royal Albert Hall. White flashes like lightning with black intervals between them scythe across the screen. The arena swoons and swirls out of focus. The ropes of the boxing ring criss-cross like railway lines that head in all directions at once. Discs of fuzzy light swim through the air, then sharpen: they belong to the lamps above the ring. The arm of the referee beats diagonally, like the conductor of the cantata. Then the gong is struck, with resonant finality.

It is not quite a universal extinction, because the crying, gasping woman in the audience comes to Jack's aid, more effectively than either Best or Day are able to do. Lillian Hall-Davies plays Nelly, who has been involved with both fighters. Now she decides that she belongs in Jack's corner, and climbs into the ring to hug him. He sees her reflection shimmering in the slop-pail – a wry Hitchcockian aside about the inspirational role of the female. The sight revives him, despite the dirty water, and he bounces back to knock Bob out in the next round. Cosmic catastrophe, for which the Royal Albert Hall would be such an ideal setting, is once more averted.

Two later films start with blackouts, reversals of that primal enlightenment described by Genesis. In *Sabotage*, a power station is disabled, and the plug is pulled on bright London. The city's nocturnal amusements – including the cinema – are curtailed. A dark age briefly recurs: night is the native realm of fear. It might seem as if Verloc's crime is self-spiting, since it disables his own business; but perhaps the resulting murk really is the show. André Breton, hailing the advent of the cinema in the first of his surrealist manifestos in 1924, proposed 'Three cheers for darkened rooms!' To him, what mattered was the irrational, regressive blackness of the auditorium, not the

light projected on to one of its walls. Because an infinitesimal closure of the shutter follows every single frame, Ingmar Bergman calculated in 1956 that 'If I see a film that lasts an hour, I am in fact plunged for twenty minutes into total darkness.' The snooping policeman Ted archly asks Mrs Verloc 'What goes on after hours in that cinema of yours?' Joining in the joke, she giggles 'Deeds of darkness.' She may have unwittingly blurted out a truth: what other kind of deeds could be performed in a cinema?

In *Suspicion* we are initially the victims of an attack like Verloc's: a sudden and unexplained sensory deprivation. The film begins with a completely black screen, though it has a whistling, clattering sound-track. Has there been a projection fault? Have we suddenly gone blind? Then some indistinct, grappling shadows appear and Cary Grant's voice is heard, unmistakable even without a face. He has evidently been up to no good in the gloom, since what he says is, 'Oh, I'm so sorry – was that your leg?' The cinema, in the first decades of its existence, was a convenient lair for conducting sexual exploration. When he went to see films, André Gide strayed restlessly between seats. He claimed to be avoiding draughts; actually he was on the lookout for young men he might nestle up to, cocooned in a safely anonymous darkness. Eventually in *Suspicion* the lights come on: we are in a railway carriage – where Grant has jostled the prim Joan Fontaine – as the train emerges from a tunnel. A similar train burrows back into the instinctual dark at the end of *North by Northwest*, plunging into a tunnel as Grant and Eva Marie Saint couple on an upper bunk in their roomette. The fade-out spares their modesty, but the cinema has taught us to see without help from the sun.

The worst consequence of the blackout in *Sabotage* is that the customers at the cinema demand refunds. The cashier fends them off, while Sylvia Sidney argues that the responsibility lies with 'Providence'. The undercover policeman selling fruit and vegetables at the next-door stall saves the cinema's money by improvising a garbled legal defence. 'It's an act of God,' he says. Or, perhaps, of God's shadowy other half, who made the movies possible by declaring: 'Let there be darkness.'

Portraits of the Artist as a Killer

Anny Ondra at the easel in *Blackmail*, with paint – or blood – on her hands.

'Murder can be an art too,' says John Dall in *Rope*, producing champagne to toast the consummation of a killing. It was a romantic maniac, Thomas Griffiths Wainewright, who first ventured to include murder in the ranks of the fine arts. In 1829 Wainewright poisoned his uncle with a dose of strychnine, and a year later disposed of his wife's mother. His third victim was his sister-in-law; he cited her thick ankles as just cause for a sentence of death, and impudently sued the company that declined to pay him the benefits from her insurance policy. Next, moving from London to Boulogne, he poisoned a male friend. By then his effrontery had attracted the attention of the police. Wainewright was captured, put on trial, and transported to a penal colony in Australia. During his sea voyage, he sniffed at the vulgar common criminals whose company he was obliged to keep.

In 1891 Oscar Wilde vindicated Wainewright in an essay called 'Pen, Pencil and Poison'. The title alliteratively blurred the disparity between artistic creativity and murder. Wainewright was a painter of some talent, and Wilde honoured his preoccupation with 'beauty of form'. To rid the world of thick-ankled female relatives counted as an aesthetic initiative. Don't ugly people mar creation? The artist must manufacture perfection, using whatever means he can. 'There is no essential incongruity,' Wilde concluded, 'between crime and culture.' A few decades later, Hitchcock could abandon Wilde's defensively negative phrasing. Crime and culture, for him, were entirely congruent; artists – himself most of all – take an exquisite pleasure in killing the thing they love. The male lovers in *Rope*, a pair of Wainewrightean dandies, murder their best friend because he is insufficiently cultivated. Then they resolve to show that their crime is the very foundation of civilization, which demands that we cover our nakedness, deny our own natures, and live out an elaborate, decorous lie. They do so by staging a sacrilegious funeral, and invite the young man's parents to a feast served from atop his casket.

Wilde inaugurated an aesthetic campaign against morality that reached a conclusion in 1949, the year after the release of *Rope*, when Jean Genet published *The Thief's Journal*. Genet, a self-confessed and impenitent homosexual, thief and murderer, took advantage of God's demise by sanctifying his own crimes. Murder incited a 'religious fear' in him. The attraction was that of deicide, presumably savoured as well by Norman Bates in his reading of Huysmans. In killing one of our fellow creatures, we slay the God who created all of us. Genet, however, made amends to the victim – typically a desirable young man – whose death served to prosecute this quarrel with God; and in doing so he might have been remembering the party in *Rope*. 'A madman,' he said, 'can pay homage to his dead with astonishing funerals. He can and must invent rites.' In *Vertigo*, James Stewart plays a madman who pays homage to his loved one by inventing rites. His second wooing of Kim Novak is his interment of her. Only after he has changed her into the waxen replica of a dead woman can he make love to her. Stewart's obsession makes an artist of him, and the end-product of his artistry is death. Hitchcock often fabricated such ceremonies, though he also reserved the right to mock their solemnity. *Secret Agent* begins with the lying-in-state of the spy Ashenden. Mourners file past the coffin; when they shuffle out, a one-armed servant uses a funereal candle to light his cigarette and, manhandling the coffin, knocks it to the floor. At the stonemason's yard in *Family Plot*, a long-haired hippie called Marcella carves 'DIED' on a headstone while listening to uproarious jazz on her transistor.

For Genet, to kill was a sacred act. A corpse, like Christ's body symbolically served up in the Mass, was a cult offering. He thought that 'murder might very well transform me into a priest, and the victim into God'. Hitchcock quietly demonstrated the logic behind Genet's audacity. Montgomery Clift is already a priest in *I Confess* when the murder occurs, but the death of the blackmailing lawyer confirms his faith. Does God answer prayers by arranging for our enemies to be slain? In this case – as Hitchcock picks Genet's formulation apart – it is society that deifies the victim, mistaking a sleazy predator for an embodiment of the law.

The rite invented by Hitchcock places a dead body on display. His

fascination with the spectacle of mortality forces him to resist the vital imperative of his own art. Movies demand mobility; a corpse is a stilled life, more like a painting than a film. Novak floats in the bay beneath the Golden Gate Bridge like the drowned Ophelia, surrounded by flowers from the bouquet that she has scattered across her own grave. That posy, like her hair-do, comes from the canvas she studies in the art museum: motion pays yearning tribute to a dead, painted woman. Though she destroys the arrangement of flowers, she does not disarrange herself, and is still wearing her high-heeled shoes when Stewart fishes her out. Later her broken arms and legs arrange themselves at cubistic angles on the tiled roof of the San Juan Bautista chapel. 'Is it a still life?' Stewart asks when Barbara Bel Geddes tells him she has taken up painting again and points to an easel with its back mysteriously turned. 'Not exactly,' she replies. Touchingly jealous, she has copied the same portrait, but given it her own bright, beaming face, hoping to transfer Stewart's affections from the dead to the living. He takes offence: she has ridiculed the object of his necrophiliac desire by reincarnating her. If only the canvas had been a still life – a wan, bleached corpse! Hence Novak's rigid poses beside the tomb at the Mission Dolores, or in front of the painting at the Palace of the Legion of Honour. She is rehearsing for death, or auditioning for art: the two are much the same. On her second visit to the Palace, she stands up from the bench and walks towards the portrait as if wanting to vanish into its frame, just as Stewart in his nightmare tumbles into the oblong frame of the open grave.

Among the sequoias at Big Basin, she studies a tree, envying its insentience and indifference. Stroking the cross-sectioned rings of its trunk, she tells the tree that her life-span was 'only a moment for you, you took no notice'. After their walk through the redwoods, she and Stewart emerge on the coast at Cypress Point, beside a broken-backed tree that had been transplanted there by Hitchcock's art director. Novak crosses the road with an apathetic, almost paralysed gait. Stewart tags along, speeds up for a couple of steps, then slows down his spindly, ungainly limbs for fear of seeming too eager. 'Why did you run?' she asks accusingly. This long, halting chase concludes at San Juan Bautista, where unstable, fluent time has settled down into

the stasis of history. The place, Stewart says, is 'preserved exactly as it was a hundred years ago, as a museum'. And what is a museum if not a funeral parlour where the past is taxidermically preserved? Novak arrives at a solemn quietus – before, remembering an appointment at the top of the tower, she runs across the grass with awkward haste. In the livery stable, she sits in a carriage that is yoked to no horse. She has dreamed of horses, and Stewart finds one for her. It is wooden, mercifully incapable of motion.

A love with more natural promptings would have reached its climax soon after their first meeting, when Stewart undresses a supposedly unconscious Novak and installs her in his bed, leaving her wet clothes strung up in his kitchen. The situation could come from any Hollywood sex comedy between *It Happened One Night* in 1934 and *Pillow Talk* in 1959; but Stewart is an artist, not a seducer. *Vertigo* is the story of Pygmalion in reverse: a man who wants a live woman to be a statue (or at least a shop-window mannequin). Novak's extraordinary walk, when she emerges from the bedroom in Stewart's apartment and later from her own bathroom in the hotel, makes this point. She keeps her upper body taut, stiff, with her head thrown back. Her legs apparently move sideways not forwards, to belie or muffle the effort of motion. She seems to be on a plinth or a pedestal, on rollers or runners, moved against her own volition.

For Stewart, she is an aesthetic idol. For his cynical employer, she is simply a dummy, the lay figure artists use in the absence of a model: he breaks his wife's neck, then hurls the unresisting replica of a living woman from the tower. To keep Novak company, Hitchcock's films show off a gallery of more or less elegantly mortified specimens. Leigh slumps on the bathroom floor while the water heedlessly drivels down the plug-hole, her sightless eye staring. Grant and a diplomat converse in a lounge at the United Nations. Suddenly the man stops talking, though his mouth gapes wordlessly open. He stands to rigid attention, fixed in place by a knife in his back. Such bodies are the director's marionettes. He permits them to move around for a while, allowing them to feel autonomous. Then he stops tweaking their reflexes and artificially agitating their limbs. Rigor mortis sets in. In *Frenzy*, Barbara Leigh-Hunt stiffly occupies the office chair in

which she has been strangled, her tongue protruding, while Anna Massey's body turns inflexibly statuesque inside a sack of potatoes.

Art converts living subjects into mute, manageable objects, and murder, as Roland Barthes once said, is 'the ultimate objectifying act'. During the 1920s Salvador Dali venerated Saint Sebastian, whom he nicknamed Saint Objectivity. It was a compliment to the stern self-control of the martyr who, punctured by arrows, allowed himself to be turned into an object. The saint's taut restraint is shared in *North by Northwest* by Eva Marie Saint – an actress whose name, which yokes together the woman who caused Adam to fall and the sanctified woman who gave birth to the second Adam, must have attracted Hitchcock as much as her gelid blonde persona: in any case, he let her keep her own name in the film, where the character she plays (a harlot and, as we later discover, a saviour) is called Eve. At the auction in Chicago, Grant upbraids her, convinced she has deceived him. He refers to her as 'this little piece of . . . sculpture'. His slight pause before the last word and the scornful flick of his tongue that emphasizes the sibilant are thrilling. He seems to be on the point of uttering the word 'shit', which in 1959 no one ever said on movie soundtracks. The momentary hesitation is enough to register a connection between art and ordure. Then he glances at the squat, burnished pre-Columbian statuette that James Mason, Eve's protector, has bid for. With thick legs and a pointy nose, it is the totem of a different religion. Eva Marie Saint sits there rigidly, pallid and apparently incapable of feeling.

Near the beginning of his career, perhaps without knowing it, Hitchcock filmed a candid admission of his own motives, which coupled artistry and killing – and promptly censured himself for his perversity. The cast of *Blackmail* includes the character of a painter, whose name is Crewe, although he is identified in the credit titles as The Artist. This allegorical figure (played by Cyril Ritchard) does not commit a murder; instead he is murdered, stabbed by the heroine Alice (Anny Ondra), who panics when he seduces her. The outcome might seem to castigate artists – louche painters who persuade women to undress by saying that they need models, or directors who suborn the same women to act out their fantasies. Doing sound tests

with Ondra on the set of *Blackmail*, Hitchcock asked if she was a virgin and chucklingly interrogated her about recent sexual escapades. Did he, in this one case, permit the artist's persecuted subject to retaliate? Not quite. The murder is not his reprimand to himself. Alice can only kill The Artist after she too, during a seductive encounter that is also a tutorial, has learned how to be an artist. Like Wainewright exchanging pen and pencil for poison, she graduates rapidly from a paintbrush to a bread knife.

Having lured her back to his studio, The Artist gives her a painting lesson. She is – as Stewart puts it in *Vertigo* when, just before Novak's second death, he rages at her deceptive skill as an actress and her obedience to the directing intelligence that trained her – 'an apt pupil, a very apt pupil'. Alice first learns how to position herself at the easel, holding the brush poised upright, out of harm's way. Then she naughtily stains the blank canvas with her first incriminating dab of colour. 'Ooh,' she shrills, 'look what I've done!' Next she designs a rudimentary face. 'Rotten,' says The Artist, and guides the brush as she adds a body. The subject, traced by her hand (and by that suggestive tuft of bristles) though deriving from his head, is apparently a female nude. He makes the brush hover tantalizingly around the contraband anatomical bits, as if uncertain whether they should be depicted. 'Ooh,' she sighs, deliciously alarmed, 'you *are* awful.'

She then offers to impersonate one of the sexual fantasies he paints, asking: 'How would I do for one of your models?' She toys with a ballerina's frilly tutu, and he encourages her interest. 'Do you mean put it on?' she asks, though the idea had been her own. A coughing fit reminds her of the strong drink he has given her, and she begins to make excuses. He entices her to stay by saying he'd have liked to paint her in the costume. 'Shall I really try it on?' she wheedles, still pleading for him to take responsibility for her actions. Finally, behind a screen, she undresses; he confiscates the clothes she discards, and congratulates her by playing 'Miss Up-to-Date' on the piano. He tells her that the song is about her. She is a child of 'this fast age', given over (like the cinema, with its frenetic quota of twenty-four images a second coursing through the projector) to revved-up pleasures.

Once more she changes her mind, and reaches for the clothes he

has hidden. Out of sight, he attempts to rape her. Their shadows struggle on the wall; then he forces her on to his canopied bed, whose curtains billow to record their flailing. Her hand extricates itself and grabs the knife. Gradually the curtains pulse more faintly, then come to rest. Alice emerges to retrieve her dress, which The Artist has slung over one of his easels. A painted jester jeers at her; she gashes the canvas, ripping it with her fingernails. Then she takes the sly Hitchcockian precaution of unsigning the picture she painted with The Artist's assistance. She had scribbled 'Alice White' in a corner, and she blacks out the autograph with a brush.

This denial of authorship ensures that she gets away with the murder. The blackmailer, who falls to his death through the glass dome of the British Museum, is assumed to be the culprit. Alice's boyfriend, a policeman, knows better, but he protects her. The partners in *Rope*, too proud of their exquisitely artful murder, fail to heed Alice's circumspect example. When Granger wants to cancel the evening's entertainment, Dall insists, with a flourish of self-congratulation, 'The party is the signature of the artist.' Alice, however, advises against auteurism. It's important to suppress clues that might connect you with the crime. Anne Baxter in *I Confess* regrets the confessional account of her romance with Montgomery Clift that she gives to the detective. Without intending to, she has supplied Clift with a motive for murder. 'I should have lied, Pierre,' she says to her husband, who, as a Quebec politician, presumably agrees with her. 'I've lied before, I should have lied last night.' It would indeed have saved much unnecessary distress.

Hitchcock made sure his own work was signed, and flaunted his name above the title. He even affixed handwritten replicas of his signature to books he had supposedly edited, and to advertisements for his films. The elegantly looped name appears at the end of the preface in a collection of short stories, *My Favourites in Suspense*, published in 1959, and on posters for *The Birds* beneath his proud declaration that this 'could be the most terrifying movie I have ever made!' The signatures, however, could not be less personal. They are trademarks, and the statements they signed were drafted for Hitchcock by the surrogates who wrote the monologues for his television show or by

advertising copywriters. The impression of inauthenticity is enforced by the presence of a middle initial, J., in this standardized signature. Unlike the B. in Cecil B. de Mille, it was no part of Hitchcock's official identity, and it alerts us to a commercial forgery. (The J., for what it's worth, denoted 'Joseph'.)

Despite his exhibitionism, Hitchcock made sure that he gave nothing away. Though he sacrificed the director's privileged invisibility by making brief appearances in his films, he atoned for his omnipotence by representing himself as a loser, snubbed by the very characters he was so tightly controlling. Huffing and puffing in *North by Northwest*, he misses a bus during the New York rush hour. In *Rebecca* he waits impatiently to use a phone booth while George Sanders makes a call that is essential to the dénouement of the plot. In *Marnie* he walks down a hotel corridor, unnoticed by Tippi Hedren, the reluctant object of his affection.

The collaborative nature of the work supplied Hitchcock with other means of camouflage. He retold stories made up by someone else (though he always personally customized them). Buying books for adaptation, he took care to remain anonymous: if authors knew who they were dealing with, their asking price would rise. He filmed scripts that other people had written (while he looked over their shoulders). On set, he avoided looking through the lens of the camera. He did not need to, having already visualized the film in advance on his story-boards. But this superstitious scruple also protected him from having to see those pinioned bodies as the victims of his private vision. Who, after all, really killed the woman in the motel bathroom? Norman Bates? His mother? Anthony Perkins? Not, to be sure, Alfred Hitchcock, who was sitting at a distance in his deckchair all the while, as every member of his crew could vouch.

The scene between Alice and The Artist in *Blackmail* resembles other primal scenes in later films: the lingerie-clad Grace Kelly's killing of the man sent to strangle her in *Dial M for Murder*, or – because murder and sex are so easily transposed by Hitchcock – the wedding night in *Marnie* when Sean Connery abruptly removes Hedren's nightdress and takes possession. What makes the earlier episode uniquely complex and candid is that Hitchcock, usually the aggressor,

in this case plays both parts. He is the shrewd, seductive Artist, enticing a woman to do as he directs her; but he is also the talented amateur who commits a murder without taking the blame. Her crime turns Alice into an artist, an actress whose vocation is lying. When she leaves the studio she wanders through London at night, mingling with the happy crowds disgorged by theatres. She returns home in the bleary dawn, and sneaks into bed, still fully dressed, just before her mother enters the room to wake her. Roused, she does not wash. Instead she applies make-up, painting on a false face.

Another Hitchcockian painter, whose methods mimic the director's sleight of hand, follows Alice's evasive lead. This is Sam Marlowe, the character played by John Forsythe in *The Trouble with Harry*. Sam's abstract style bewilders his rustic neighbours. Mrs Wiggs (Mildred Dunnock) claims to admire one of his paintings, though she holds the canvas the wrong way up. Miss Gravely (Mildred Natwick) has at least learned the critical art of decipherment, so necessary for reading Hitchcock's films. Introduced to Sam, she tells him she knows his name from the signature on his paintings, which Mrs Wiggs exhibits at a roadside stall. He pretends to be affronted, as if he had been found out. The signature is supposed to be illegible: obscurity is the sign of his arcane professionalism.

Sam's abstraction comes in handy when the characters have to outwit the law and explain away the presence of Harry's migrant corpse in their community. Out sketching, he turns the dead Harry's shoeless feet into non-representational blobs, and at first can't tell that they belong to a corpse. Art's saving grace is to make reality look unreal. There is a dangerous moment when the deputy sheriff scrutinizes a sketch Sam has made of Harry's face. Captain Wiles (Edmund Gwenn), who thinks he has accidentally shot Harry, trembles nervously. But he needn't have worried. What Sam produces is a cubified, elongated mask, as impersonal as a tribal carving, not a resemblance at all. The deputy sheriff asks where the model came from. Sam replies 'From my vast subconscious,' and further modernizes the sketch, effectively destroying the evidence of Harry's identity. Nevertheless, the tramp who stole Harry's shoes spots a likeness, so perhaps Sam's manner is still too realistic for comfort.

Hitchcock had his own ingenious reasons for confirming a popular prejudice against abstraction. Modern art was often decried by its critics as a crime against nature. Picasso brutally rearranged faces; the expressionist Otto Dix painted himself as a sex-killer, rampantly dismembering bodies; Dali was a connoisseur of putrefaction. Robert Walker, as Bruno in *Strangers on a Train*, relishes this avant-garde defacement, which curses staid reality. His mother dabbles at painting, daubing a gargoyle; Bruno identifies it as a portrait of his hated father. Himself an artist of the modern kind – seditious, a virtuoso of visual assault – Hitchcock flaunted the violence that the opponents of modernism condemned.

The detectives in *Saboteur* know the kind of place that the enemies of society frequent in New York, and mention a recent arrest at 'that Museum – the Modern Art place'. These FBI operatives agree with Hitler, who in 1936 at the exhibition of Degenerate Art in Munich impugned the patriotism of those who saw the world in a new and disorienting way. A policeman in *Suspicion*, like his colleagues in *Saboteur*, looks askance at the caprices of modernism. Lina and Johnnie (Fontaine and Grant) have a vaguely cubist still life of some fruit hanging just inside their front door. It becomes an object of suspicion. The policeman, calling to question Johnnie about the murder of his friend Beaky (Nigel Bruce), eyes it uneasily on his way in, and repeats the inspection as he leaves. If cubism suggests that the master of the house may have criminal tendencies, another painting in a very different style serves as a stern, invigilating superego. Cedric Hardwicke plays Lina's dull, disciplinarian father. When he dies, he bequeaths to her a pompously academic portrait of himself in military uniform painted by 'the distinguished Sir Joshua Nettlewood'. The phrase is his own, quoted from his will, and it refers as much to his own social distinction as to the spurious painter's professional status. Johnnie mocks the picture when it is delivered, flinching from the glare of posthumous disapproval it trains on modernity in morals and in art.

To the conventional eye, the morphological changes wrought by modern painters looked like torture, even when the objects in question could not feel pain. In *Rebecca* the bluffly philistine Giles (Nigel

Bruce again) has heard that the hobby of the new Mrs de Winter (Joan Fontaine) is sketching. He hopes she doesn't do anything too modern: 'You know, portrait of a lamp-shade upside down, to represent a soul in torment.'

Of course the timid bride disavows such advanced notions. The sculptor in the Greenwich Village courtyard below James Stewart's apartment in *Rear Window* has fewer scruples. She toils away in the open air, bludgeoning a lump of stone. A man delivering a block of ice asks, 'What's that supposed to be, ma'am?' She replies, 'It's called Hunger.' Fair enough: the torso has a hole where its belly should be, and evisceration makes an allegory of it. The camera silently comments on her morbid methods by tilting upwards to compare the statue with the neighbour who lives on the floor above. She too – a cavorting blonde, skimpily dressed in the heat, who bumps and grinds in her kitchen – is statuesque, and Stewart, ignoring the fact that she possesses a head, has nicknamed her Miss Torso. The movement of the camera juxtaposes fixity and dynamism, cold stone and feverish flesh; but how different are Hunger and the well-fed Miss Torso, who is hungry for love? A woman, in Hitchcock's brisk appraisal, is a cavity awaiting repletion. Some of the body's vents are points of sexual entry. Violence, excavating additional holes, can augment their number.

This being Greenwich Village, everyone is or wants to be an artist – even the murderer. Miss Torso is a ballerina, while across the way a Tin Pan Alley composer pounds out tunes on his piano. Stewart works as a photojournalist, and Grace Kelly, more adept at modelling than the clumsy heroine of *Blackmail*, poses for the covers of glossy magazines. The man who carves up his fractious, invalid wife has a humble day job: Thorwald, played by Raymond Burr, is a travelling salesman whose stock-in-trade is costume jewellery. His claim to artistry depends on the method of disposal he uses. After butchering his wife, he carts her to the river in sections, carrying the bits in his sample case. He is a trunk murderer.

In 1938 Hitchcock inserted a joke about such clinically fussy characters into *The Lady Vanishes*. Michael Redgrave and Margaret Lockwood, hunting for the vanished lady, ransack the train's baggage

room. 'Looks like supply service for trunk murderers,' Redgrave flippantly remarks as they survey a pile of crates and wicker baskets. (One receptacle shuffles across the floor – though it contains not the vanished Miss Froy but a live calf, presumably bound, like all Hitchcockian cattle, for the slaughterhouse.) During the 1950s, a painter whose reputation resounded throughout New York identified his own art with the same criminal strategy. The abstract expressionist Mark Rothko mordantly admitted that his paintings resembled trunk murders. Rothko's canvases were awash with bloody lakes of congealed pigment, as lurid as the painted New York sunset that flares across the sky-cloth in *Rear Window*; in 1970 he testified to the intimate relation between art and agony by killing himself, opening his veins into a kitchen sink.

The painter saw himself as a killer, and the killer in *Rear Window* paints the bathroom – in which he does the dismembering – with gore. Across the courtyard, the rival artist whose professional intuition alerts him to the crime flirts with death in his own way. Stewart plays a photographer. The narrator of the story by Cornell Woolrich that Hitchcock adapted has no profession. By giving the voyeur this job, Hitchcock made *Rear Window* an oblique meditation on his own art and a commentary on its bloody-mindedness. Thorwald's resemblance to Rothko is unwitting, but the character called L. B. Jefferies was based on an actual photoreporter, Robert Capa, who specialized in combat zones.

For *Life* magazine Capa photographed the civil war in Spain, the Japanese bombardment of China, the blitz in London, Allied battles with German snipers during the reconquest of Paris, and a murderous Mexican election campaign. He took a valiant existential delight in risking himself, and argued that if a war photographer's pictures weren't good enough, then he hadn't got close enough to the action. He proved his point during the D-Day landings in Normandy in 1944, when he waded through the water onto Omaha Beach beside the troops, dodging bullets and finding time to admire what he called 'the surrealistic designs of Hitler's anti-invasion brains trust'. This suicidal bravado endeared Capa to Ernest Hemingway, who persuaded *Life* to use his Spanish photographs as illustrations when the

magazine reviewed *For Whom the Bell Tolls*, though it must have alarmed the timorous, stay-at-home Hitchcock, who preferred to keep as far away from his subjects as he possibly could. The globe-trotting of Jeffries and his steely-nerved technical mastery under fire pay tribute to Capa. So does the broken leg that confines him to his apartment, with nothing to do but snoop on his neighbours. Obeying Capa's admonition, he has succeeded in getting only too close to one of his subjects: he ventured onto the track to photograph a racing car, and was run over. Broken legs, however, eventually mend. Capa was less fortunate. He stepped on a land-mine while covering the French colonial war in Indo-China, and died when it exploded. The accident happened in 1954, the year of *Rear Window*'s release.

Capa had come to Hitchcock's attention in 1946, when he photographed on the set of *Notorious*. One of his shots shows Hitchcock whispering behind his hand to the cameraman, directing him to focus on the purloined key to the wine cellar, gripped in Ingrid Bergman's hand. Capa and Bergman were lovers at the time, and between scenes she told Hitchcock about a dispute they could not resolve. He was determined to continue his itinerant career, seeking out Cold War trouble-spots; she wanted him to remain with her, and recommended soft, lucrative assignments like his report on *Notorious*. In *Rear Window*, Hitchcock breached Bergman's confidence. The lovers' quarrel between Capa and his film star was replayed in the relationship between Jeffries and his pampered mannequin. He is anxious to get back into battle, while she pleads with him to stay in New York and concentrate on fashion shows.

They reach an uneasy compromise. She swaps her cocktail dress for sporty slacks, and prepares for an arduous life on the road by reading a book about the Himalayas; but she keeps a copy of *Harper's Bazaar* hidden, and brings it out when he falls asleep. In any case, it's hardly likely that they'll be going anywhere soon, since he now has two broken legs. The eternal woman does not lead man upwards, as Goethe insisted at the end of *Faust*; she tethers him to the ground, keeps him housebound. The uxurious, domesticated Hitchcock, the faithful partner of a wife called Alma (which means soul), was content to roam vicariously, through the indulgence of fantasy. Restless,

rankling imagination made him an artist, and it also made him an imaginary murderer.

In *Frenzy*, a doctor and a lawyer gossip in a London pub about the 'criminal sexual psychopath' who has strangled a succession of women and personalized his art-works by using a necktie to do the job. The killer in Arthur LaBern's novel *Goodbye Piccadilly, Farewell Leicester Square*, which was Hitchcock's source, adds other, fouler identifying fillips to his signature. His first victim (the character played by Leigh-Hunt in *Frenzy*) has a paper-knife 'inserted into her' after death. The novel refrains from specifying that the blade is inserted into her vagina. With the second victim (played by Massey), LaBern does vouchsafe more details. The poor woman is posthumously raped among the sacks in the back of a lorry, then has 'a potato . . . pushed into the private parts with such fiendish force that the interior of the vagina was torn'. Film's invasion of our squeamish insides is here prosecuted with a vengeance – though Hitchcock of course could not permit such things to be spoken of in his script. Instead, the doctor in *Frenzy* sagely warns his colleague that the maniac might look like a conventional adult, though he reverts to primitive behaviour when aroused. His motive is sexual self-gratification. He is 'governed', the doctor concludes, 'by the pleasure principle'. Is that not also the compulsion of the artist, who in dreams awards himself the delights that reality denies him?

That mental liberty must be jealously guarded. A woman, as *Blackmail* demonstrates, is liable to destroy an artist by demanding that he renounce desire. *Rear Window* ends with Kelly's smile of triumph as – lolling like an odalisque on a seat beside the window and resolutely not looking outside – she watches over her captive, immobile, emasculated consort. A pity that her ankles are so shapely.

The Fat Man and His Disguises

CHARLES LAUGHTON

JAMAICA INN

MAUREEN O'HARA · LESLIE BANKS · EMLYN WILLIAMS · ROBERT NEWTON
FROM THE NOVEL BY DAPHNE DU MAURIER · A POMMER-LAUGHTON "MAYFLOWER" PRODUCTION
Directed by ALFRED HITCHCOCK · A Paramount Release · Produced by ERICH POMMER

Charles Laughton as Hitchcock in *Jamaica Inn*.

A fat man wears soft armour, whose insulating layers preserve him from harm. Hitchcock conscientiously cultivated his bulk, and elaborated a persona to match it. He spoke slowly, decelerating and elasticizing his vowels as if his voice were hard put to make its way out through the folds and billows that encased it. He became globular, relying on his suits to give him a rudimentary structure. Clothes for him were a mould into which we pour ourselves. The travelling salesmen on the train in *The 39 Steps* prove the point when they unpack their sample cases and display the latest foundation garments: two different kinds of corset, and a brassière. Left to their own devices, bodies are as fluidly unruly as dreams.

He knew the perils of his weight. In 1966 he was asked how he would choose to be murdered. 'Well,' he answered, with one of his deliciously unctuous pauses, 'there are many nice ways. Eating is a good one.' It was a cunningly contradictory reply. The overeater is not a murderer but a victim of slow, pleasant suicide; and even that fatal outcome was disputed by Hitchcock, who relied on his bulbous outline to advertise his prosperity, his self-possession, ultimately his immunity – inside all that cushioning, quilted flesh – to death.

Murder to him meant a diet. In *Lifeboat*, he makes his personal appearance while the castaways are discussing their starvation rations and calculating how long they can survive on a few biscuits salvaged from the shipwreck. Given the watery setting, Hitchcock cannot manage a walk-on. He floats past instead, in the form of a soggy newspaper advertisement. The page advertises a product called Reduco, and Hitchcock is photographed before and after it goes to work on him. Reduco supposedly helps you to slim; in fact it's a killer, which boasts of being an Obesity Slayer. Before, Hitchcock is proud, on parade. His belly confronts the world, and the profile of his whole body looks like his later caricature of his puffy-cheeked face. After, he is dispirited, slain. His head is bowed, and he stares down sadly at the portion of him that has vanished.

No wonder he mourns for the loss of his embonpoint. Hitchcock's weight was not a curse; it served as his excuse. A fat man is slumbrous, inert, more trustworthy than those with a lean and hungry look. In Conrad's *The Secret Agent*, Verloc is described as 'undemonstrative and burly in a fat-pig style'. The man's physique – duplicated by Homolka in the film – almost disqualifies him from being taken seriously as a revolutionary. His employers scoff at his politically incorrect body, and remind him that members of the proletariat should look as if they are starving. Hitchcock, a saboteur himself, recognized the usefulness of Verloc's affliction. A fat man is above suspicion. He has grown backwards into the innocent androgyny of our beginnings, since a pregnant belly obstructs his view of his private parts. Perhaps the reduced Hitchcock in *Lifeboat* is so downcast because he has been reacquainted with them.

Reflated, he looks like a harmless, overgrown baby – a perpetual infant, still held hostage by childish greeds. Yet self-exculpation is always shadowed by witty self-accusation. Hitchcock twice appears in company with children, and on both occasions they get the better of him. Travelling on an underground train in *Blackmail*, he is harassed by a little boy who tugs his hat down over his eyes. The child's mother won't restrain him; the intimidated Hitchcock is bigger but weaker – less agile and less ready to upset social decorum. In *Torn Curtain*, Hitchcock sits in the lobby of a Copenhagen hotel crossly nursing an infant that has wet his knee.

A baby has absolute power, directing adults to fulfil its wishes, because it has not yet learned to control its appetites and bodily functions. Its life, like a Hitchcock film, is about instantly gratified wishes, fantasies that grown-ups hastily put into action. Scream if you are hungry: you will be fed. Murder may well have to occur so that you can be sated, but that is the responsibility of others, your providers. Why not, a little later in life, demand sex with the same intemperate wailing you once used when ordering your meals? The two desires overlap: in *Notorious*, Grant and Bergman – glued together in a long close-up as they roam through a Rio de Janeiro apartment – smooch, nuzzle, nibble, graze and, while discussing what they might have for dinner, seem to be feeding on each other.

Food served Hitchcock as a metaphor for killing, for copulation, and for their secret similarity. Metaphors are in the business of transposition; it is their morose duty to appease our impossible longings. Hitchcock's silent comedy *The Farmer's Wife*, made in 1928, is about a widower who goes wooing metaphorically. He appraises marital candidates as if they were livestock or agricultural produce. A village elder establishes the likeness when he reports on a crop of turnips 'as round and white as a woman's bosom'. Turnips, like breasts, exist to be eaten. Sam the farmer has more carnivorous tastes. Shortlisting likely brides, he says: 'There's a female or two floating around my mind like the smell of a Sunday dinner.' The source of the tempting erotic aroma has already been graphically exposed. A side of lamb is suspended in front of the fire for roasting, succulently basted with juice from the ladle. The cut of meat, with its bared ribs, represents the imagined bride. Off to court the first woman on his list, Sam expects her to 'come like a lamb to the slaughter'. She happens to be a fox-hunting widow, and he tells her that his purpose, like that of a fox, is 'to pick up a fat hen'. She wonders if he wants to eat the hen; she doesn't realize that he has designs on her. Sam later proposes to a flustered spinster called Thirza Tapper at a chaotic tea party. Again the targeted woman is a titbit, a tasty delicacy. As he asks her to marry him, she grips a plate of shuddering jelly to her gelatinous chest. Then the maid slops a tray of ice cream on to the floor. Thirza weeps, the maid caterwauls; the jelly quivers and the ice melts. Male desire is a furnace, like the fire that cooks the roast, while female emotion turns solid bodies back into water. Hitchcock's symbols effect neat, teasing substitutions. Coitus, like every meal we eat, entails carnage.

The most rapacious and unashamed display of appetite comes in *Frenzy*. The serial killer, played by Barry Foster, stuffs Anna Massey's body into a sack of potatoes, which he dumps in the back of a lorry. The potatoes are unsold rejects from Covent Garden market, being driven back to Lincolnshire – for reburial, or for consumption by pigs? But Massey has tugged an incriminating pin from Foster's tie while defending herself. He grapples with her corpse to retrieve it, and he too is carried off in the lumbering, earthy hearse, entangled with his stiff, naked victim.

In *The Farmer's Wife*, turnips impersonate breasts. In *Frenzy*, the dead woman's toes look like grubbed-up new potatoes. The killer reaches into the sack, and her dead leg retaliates, kicking him in the face. 'I've heard of a leg of lamb,' commented Hitchcock in a trailer, 'but not of a leg of potatoes.' Foster next has a sneezing fit: an involuntary reaction, like an orgasm. He buries his head in the bag and fumbles between her legs. 'Bitch!' he shouts. 'Where's that bloody pin?' It is the eternal complaint of the deflated male. A woman confiscates his sharp projectile, which emerges blunt or, in this case, not at all. He rolls the sacking further up, almost to her waist. Potatoes tumble out as if she were giving birth to them, and are jolted overboard. The driver of a car that passes the lorry yells at the driver: 'You're spilling your load!' – another rudely colloquial way of describing the sexual mishaps the frustrated killer suffers. He finally retrieves the pin, held fast by her rigor mortis. He presses the fingers apart with his penknife, which they break; he has to snap the bones, and they yield with a ghastly crack. Once more the woman has won: her stiffness mocks the man, who can only briefly manage such rigidity.

When the lorry stops at a roadside café, Foster scampers into the outside lavatory and stands silhouetted at the urinal, peering through a cracked pane. He has perhaps retired to the GENTS for some rapid, solitary relief. The lorry trundles off with the body, whose blue-white legs poke out the back, invitingly spread. Then the corpse bumps on to the road. The sack still covers its head: a proverbial way of denying identity to the woman you are having sex with. Police uncover the face, which is a twisted mask – the still photograph of her final anguish.

The sequence is more shockingly funny than anything imagined by Buñuel or Dali. Hilarious in its disrespect for death, and yet daringly unscrupulous in the way that, like Foster, it roots around in the dusty murk of that darkened room on wheels, this is the last and most ribald orgy staged by Hitchcock the surrealist. All the forbidden vices are indulged at luxurious length: violation, necrophilia, even cannibalism. During the 1930s the surrealists teamed up to create collective art-works, made from the communion of their unconscious minds, which they called 'cadavres exquis'. The body in the bag of

potatoes is not quite an exquisite cadaver, but it has been placed there by the same process of collaborative dreaming, in which we are all enticed to share. Hitchcock was an expert at the surrealists' parlour game, having already played it in *The Trouble with Harry*. Jack Trevor Story, in the novel that Hitchcock adapted, even describes the irrepressible dead body in a phrase that might be a direct translation of 'cadavre exquis'. After numerous burials and disinterments, Harry is brushed off, dusted down, and even has his clothes cleaned and pressed, with fresh sticking-plaster applied to the gash on his head. 'He was' – when the little boy discovers him anew at the end of the novel – 'a most immaculate corpse.' As it happens, Harry is a fat man, whose face remains concealed. This supplies Hitchcock with his slyest incognito: playing dead, he awards himself the title role. Bernard Herrmann described the overture he composed for *The Trouble with Harry* as his 'portrait of Hitch'. The score lurches between skittishness and malevolence, with a farcical chase being interrupted by growls from the brass; it exactly catches the ambiguous mood of the film and the gruesomely jovial temperament of its director.

Fantasy frees itself from all prohibitions, all customary decencies. The fantasist, however, lurks out of sight, or at least, in the case of Harry, does not show his face. But Hitchcock could not help characterizing himself indirectly, and his completest and most candid self-portraits occur in two roles played by Charles Laughton. His choice of a surrogate was not accidental. Laughton too was a fat man, a figure of plaintive grotesquerie whose own body derided him and baffled the sexual longings he harboured within. He specialized in portraying monsters – a holy fool in *I Claudius* and a gargoyle in *The Hunchback of Notre Dame*; a voluptuous Herod in *Salome* and a fiendishly intellectual Dr Moreau in *The Island of Lost Souls*; a wife-slaying despot in *The Private Life of Henry VIII* and a tycoon who kills off his mistress in *The Big Clock*. His two performances for Hitchcock added to his array of enraptured ogres. He is a crazed squire in *Jamaica Inn* and a cruel judge in *The Paradine Case*. Both characters, on closer inspection, look like projections of the director.

Hitchcock's *Jamaica Inn* replaced the lapsed priest of du Maurier's novel. Instead of an albino demon, Laughton plays an ugly aesthete

who relies on piracy and murder to subsidize his lust for things of beauty (including, of course, Maureen O'Hara, who later fended off Laughton's Quasimodo in *The Hunchback of Notre Dame*). He has the face of a malevolent baby. Ruffles and frills maraud on his chest; his walk is a strut. Laughton bestows on Sir Humphrey Pengallan the imperial megalomania that he brought to all his frothing tyrants. Like Caligula, he leads his favourite horse through the dining room. Before his plunge from the ship's mast, he shouts down his own vainglorious epitaph to the spectators: 'Tell your children how the great age ended.' The great age in question is that of romanticism, with its ideal expectations of mankind: the film is set in 1819, and Pengallan, who has just returned from a Wordsworthian tour of the Lake District, quotes Byron's love poem, 'She walks in beauty like the night'.

But while Pengallan owes his lyrical fervour to the actor (and to the dialogue written for him by J. B. Priestley), his role as the covert ringleader of the pirate gang places him on the director's abstracted perch. 'He remains aloof,' says Robert Newton, who plays a lawman working undercover as a pirate; hirelings do his killing for him, then hand over the profits and the glory. Pengallan reminds the wreckers of their dependence by grandiloquently quoting *Macbeth*. 'When the brains are out, the body dies,' he tells them, paraphrasing Macbeth's remark about the ghost of Banquo and correcting his superstition: 'You and your fellows are only the carcase, and the brains are here' – at which he complacently indicates himself. A director possesses the same lofty intelligence. Actors are dummies, activated in response to the demands of that detached brain. In 1937 Hitchcock declared: 'The best screen actor is the man who can do nothing extremely well.' The definition suits a mannequin like Tippi Hedren; it also applies to a carcase. The two were symbolically joined by the jauntily macabre theme tune that Hitchcock selected for his television programmes – *Funeral March of a Marionette* by Charles Gounod, in which the decorous mourners following the coffin can hardly resist breaking into a dance.

Pengallan's finicky fixation on the heroine also derives from Hitchcock. The squire is a connoisseur. Attempting to define beauty, he produces a Greek bust, though a friend objects that 'it's not alive'.

Then Mary (O'Hara) arrives seeking shelter, and replaces the figurine as the object of his devout infatuation. In an anticipation of *Vertigo*, he worries about her wardrobe, as if supervising a screen test. He wants to spirit her off to Paris, and promises – every bit as obsessive as Stewart when remodelling Novak – 'I'll see to your new clothes myself. Pale green silk, I think, what?' But Mary is only too peskily, querulously alive. Pengallan gags her to prevent her from protesting. When he unstops her mouth he tells her to stop crying and issues an order that summarizes the director's sad, angry plea to all the actresses he engaged. 'Be beautiful!' he shouts; but she goes on squirming and quibbling. Perhaps he was better off with the blood-less statuette. Or might he persuade her to be permanently, placidly beautiful by killing her? Like so many subsequent Hitchcock heroes, he toys with the option of necrophilia as he places his gun to her head and says, 'It must be now, please be still.'

Jamaica Inn was the last film Hitchcock made before migrating to America in 1939. He took to disparaging it, probably for defensive reasons: it is a reckless commentary on his own romanticism and its peculiar variety of mad love. A harsher self-analysis followed, again with Laughton's assistance. Hitchcock and Bernard Herrmann once mused, while doing the washing-up after a meal, about what careers they might choose if they were granted another life. Herrmann's fantasy was mild enough: he would have liked to be the landlord of an English country pub. Hitchcock performed a charade to act out his wishful vocation. He draped an apron over his head to serve as a wig, and explained that he wanted to be 'a hanging judge' – not just any old magistrate, but one who prescribed capital penalties. He did not need to wait for a reincarnation, since in 1947 he had phantas-mally played the part in *The Paradine Case*.

'I am the law here, I am justice,' Laughton the corrupt magistrate repeatedly avows in *Jamaica Inn*. Pengallan's magistracy is rural; in *The Paradine Case*, Laughton has risen to the top of his profession, acquiring titles of nobility on the way. Here, playing Lord Horfield, he sits in portly judgement over Mrs Paradine (Alida Valli), who has murdered her old, blind, heroic husband. Horfield gloats from the bench as she bewitches Keane, the lawyer who defends her (Gregory

Peck), and enjoys Peck's distress when he learns that she has already seduced her husband's valet (Louis Jourdan). For good measure he lecherously paws Peck's prim wife Gay (Ann Todd), whom he thinks of as food. Staggering in from dinner, Laughton catches sight of her bare shoulder, and squeezes on to the sofa beside her. 'You look very, very appetising tonight, my dear,' he murmurs as he pours a drink. 'A charming compliment from such a gourmet as yourself,' Gay nervously responds. After these refined amusements, he dons a black cap, rather than a dish-cloth, and condemns Mrs Paradine to hang. Lady Horfield (Ethel Barrymore) hints that he takes sexual pleasure in handing down the death penalty. 'He comes home,' she says with a shudder, 'looking so . . .'. The rest remains unspoken, unspeakable. Ann Todd tactfully covers the gap: 'Yes, I can well imagine.'

Robert Hichens' novel *The Paradine Case*, published in 1933, is less discreet about the judge's motives, and it names his mythic sponsors. The lawyer calls him 'a Sadist', and Hichens notes that he is 'physically . . . of the Satyr breed'. His tastes are savage. Hichens includes a conversation in which Keane tells Horfield that the self-control of the English reminds him of 'frozen meat from the Antipodes'. He prefers the taste of fresh blood, and Horfield concurs: 'Le boeuf saignant!' he says with lip-licking relish. Keane and Horfield also discuss their different attitudes to the legal process. Keane's job is advocacy, and he flinches from promotion to the bench. That, he says, would mean 'the rather god-like lifting up of the man to the Judge – or superman in Court'. Nevertheless, his wife seems prepared for such an elevation. Her tea-time reading is Nietzsche's *Zarathustra*, and elsewhere in the novel she can be found consulting the works of Maxim Gorky and Ramacharaka's *Yogi Philosophy and Oriental Occultism*. (Ann Todd does not bother her pretty head with such texts, but she is capable of some genteel connubial sadism. She sympathizes when her husband battles against his fixation on his client. 'I've seen your torture,' she tells him, 'and I've loved you all the more for letting me torture you.') Horfield, discussing the law with Keane in the novel, says he has been a judge for so long that he cannot summon up the emotional engagement that comes naturally to an advocate. He defines his view in a chillingly suggestive phrase: 'I feel simply executive.'

That exchange is absent from the film, though the same deathly word occurs seven years earlier in Hitchcock's second American film, *Foreign Correspondent*. The newspaperman played by Joel McCrea chases an assassin to a windmill outside Amsterdam, and sends George Sanders back to fetch the police. 'I hate to seem executive,' he says, 'but this is serious.' The idiom resonates. Being executive means briskly taking command, but it also involves a willingness to act as executioner.

The Horfield of the novel is lean, and practises rites of self-castigation. He laughs at his wife's religious devotions, and says, 'I content myself with Swedish exercises. I attack the soul through the body.' Laughton altered Horfield's physique, making him bloated and smug – a poisonous toad not a flickering adder. The film found room for a second overweight, elderly roué. Charles Coburn, who went on to play Marilyn Monroe's dotard admirer in *Gentlemen Prefer Blondes*, is Mrs Paradine's solicitor. He calls himself 'an old ruin', but says that she raises his temperature. Hitchcock planned his personal appearance in the film so as to invite and at the same time reject a connection between himself and the characters played by Laughton and Coburn. He struggles off a train, clutching a cello that is as stout as he is, like a swaddled, supplementary body. But though he admits to sharing the physique of Laughton and Coburn, he denies possessing their erotic excitability. While cuddling the cello, he also grips a cigarette between his thumb and forefinger. The attitude is affected, even effeminate, and its prissiness clears him of sexual guilt. This fat man does not belong to the breed of satyrs.

By assigning Horfield to that breed, Hichens accused him of satyriasis, otherwise known as priapism: a violent and unassuageable sexuality, which in Horfield's case splices together pleasure and pain. The novel boasts a more conventional, cloven-hoofed wood demon. This is Marsh, Colonel Paradine's valet, who despite his boggy name has 'a suggestion of the jungle' about him. He is apparently a sexual omnivore. Mrs Paradine stigmatizes him by saying, 'He is a man who does not like women. There are such men and he is one of them.' Yet despite this disinclination, he has been her lover; and his devotion to his master also seems to have gone beyond the call of

duty. Even the upright Keane – whose wife, repetitiously protesting too much, vouches that he is 'a big man, a manly man, a man of dominant personality' – reacts to Marsh with a frisson. 'The fellow's terrifically male!' he thinks, 'superbly handsome in his uncommon way!' Later he likens Marsh to a panther. The two men confront each other in a duel of bristling, erectile wills. Marsh with his 'intensely masculine fearlessness' explains that he has come to see Keane because 'I thought: "He wants me. Very well, then, he shall have me."' Keane accepts the offer, and luridly wishes that he could say to Marsh: 'Uncover your nakedness to me.'

These were not the kind of throttled desires Gregory Peck could express, so the dialogue between the pair in the film lacks this inflamed subtext. In any case, the valet is now more of a lounge lizard than a big, virile cat: the meddlesome producer David O. Selznick gave the role to Louis Jourdan and rechristened the valet André Latour. Hitchcock would have preferred Robert Newton, whose persona was grimier, redolent of the farmyard if not the jungle, whereas Jourdan's proper province was the salon. Mrs Paradine should have been icily Nordic. During her multifarious career, summarized in the novel, she has worked as a Swedish masseuse in America. Horfield, valuing Swedish exercises, might have been one of her customers. Hichens calls her a Strindberg woman, and notes that she played the *Blue Danube Waltz* on her piano while waiting for the poison to kill her husband. Her first name, according to the novel, is Ingrid, which ought to have made Bergman an automatic candidate for the role; Hitchcock wanted Garbo, who also blended ice and fire. Selznick, however, insisted on using Valli, an irrelevantly sultry southerner. His casting veto neutralized Hichens's story; but at least Hitchcock, aided by Laughton, got away with his most sinister and intimate self-portrait.

Quite apart from their reputation for goatish lechery, satyrs had another function for Hitchcock. They were the inventors of satire, with its libel on human arrogance. Their grimaces and their untamed antics held nothing sacred: at the end of Greek tragedies, they overran the stage in a lewd, drunken pandemonium, chasing nymphs whom they hoped to ravish. Hitchcock often yearningly remembers

the licence they enjoyed. Foster in *Frenzy* belongs to their breed, with his ginger hair and his lecherous humour. A painted jester sardonically enjoys the last laugh in *Blackmail*, and in *Shadow of a Doubt* Cotten disconcerts the placid citizens of Santa Rosa with his satirical banter when he goes to open a bank account. He accuses his brother-in-law, a bank employee, of embezzlement, and explains his caustic wit by saying, 'The whole world's a joke to me.'

The fat man's last disguise was as a plump woman – though, because by then he was beyond caring about concealment, he did not so much impersonate her as stage a grumpy usurpation. The clairvoyant played by Barbara Harris in *Family Plot* has an appetite for greasy food, though a health-crazed Hollywood could hardly permit her to resemble the Madame Blanche described by Victor Canning's novel, who weighs one hundred and eighty pounds. Canning's Blanche is 'a Mother Ceres', a totem of 'warm, milky womanhood', whose proportions – in an abrupt jump from classical Greece to primitive Germany – are 'Wagnerian'. This is the character whose role Hitchcock assumed in one of the film's trailers.

After a scene in which Harris makes babbling contact with the beyond, Hitchcock himself appears, ensconced at the table where she conducts her séances. 'That's Madame Blanche, a medium,' he says, and at once discredits this romping pagan goddess: 'Being a master spiritualist myself, I can assure you that Madame Blanche is a fake.' He spits out the words, then gazes into her crystal ball and sees his own name. The pregnant Blanche – who hopes that she might one day open a temple, her private 'church of spiritualism' – is abruptly killed off in Canning's novel. Hitchcock's attack on her is no less startling. It is as if he had murdered her so as to take her place, like Peck supposedly stealing the life and the job of the psychiatrist in *Spellbound*.

Hitchcock's denunciation is all the more suspect for being undeserved. Blanche is not a fraud, as the fade-out of *Family Plot* demonstrates. Could he, in introducing his final film, have been admitting the fakery of his own art, which turns reality into a bad dream? Orson Welles took a similar risk in his autobiographical documentary *F for Fake*, made in 1973, two years before *Family Plot*. Here Welles

investigates the forgeries of Clifford Irving (who pretended to have written the memoirs of Howard Hughes) and the painter Elmyr de Hory, and accuses himself of the same charlatanism. But Welles's piteous appeal to be loved, valued and forgiven for having traduced his genius by doing tawdry magic tricks on television lay outside Hitchcock's emotional range. The trailer for *Family Plot* is hardly penitent, though the boast it makes is unexpected. Hitchcock – looking immovably carnal, with a body like an opaque, uncrystalline ball – chose on this last appearance before the camera to call himself a spiritualist. The irony is that we cannot deny his claim. His films show that, however assiduously we feed it, the body is no impregnable fortress. What could be sadder or more deluded than a corpulent corpse? Murder, which snaps the imperceptible link between flesh and spirit, conducts the most metaphysical of experiments.

Modernity and Murder

James Stewart suspended in *Vertigo*.

What prompts instinct's revolt against law, which incites our flagrant dreaming?

We were first freed from traditional restraints when Nietzsche killed off God. The consequence of the deity's removal was spelled out by Dostoevsky in *The Brothers Karamazov*: if nothing is true, then everything is permitted. The permission extended to gratuitous acts – those reckless initiatives that define modern morality – includes a licence to kill. Society itself, in the twentieth-century's wars, encouraged men to become mass murderers. Norman Bates in Bloch's *Psycho* educates himself in the mental revolutions that relativized codes of conduct and allowed him to do things previously called abominable. He cites Einstein's theory of time's subjectivity, and paraphrases the Freudian Oedipus complex during a quarrel with his mother. Presumably he has also read the anthropologist Margaret Mead, another modern relativist who demonstrated how variable ideas of civilization are: his mother condemns a book he has 'about the South Seas' and its 'dirty savages'. Mrs Bates is all for burning the disreputable volumes in his library. She calls psychology 'filthy', and rages that Norman's pet philosophers write 'against religion'.

The genre Hitchcock virtually invented had its own unique modernity. The thriller derives its thrills from our innate fearfulness; what makes us afraid is the volatile reality we inhabit, whose permanence is no longer ensured by God, and the irrational people we have to deal with. Yet we derive a sophisticated delight from scaring ourselves. Perhaps because medicine and technology have prolonged and eased our lives, we remain perversely nostalgic for a mortal uncertainty we have outgrown. Dall in *Rope* refuses to lock the chest in which he stows the dead body. 'All the better,' he says, 'it's more dangerous.' Danger, which Antonin Artaud in analysing what he called the 'theatre of cruelty' saw as the voltage of performance, counts as a modern addiction. In *Shadow of a Doubt*, the timid Joe pores over magazines about unsolved crimes, and – in company with

his equally nerdy neighbour Herb – amuses himself after dinner by plotting murders. Joe's wife Emmy defends this foible as his 'way of relaxing'. There may be another modern mental bonus to this macabre foible. As he and Herb quibble about the deductive logic of Sherlock Holmes or Hercule Poirot, Emmy explains, with a mixture of exasperation and pride, that they see themselves as literary critics. They have learned the intellectual lesson of the modern world, whose obscure workings make detectives of us all. The talents of the literary critic are necessary for survival. We must be sceptical about words, especially those that claim to be uttered by God, and we also need to know how to decipher images.

Hitchcock's irony precluded outright political commitment. He deprived John Buchan's novel *The Thirty-Nine Steps* of its imperialistic credo. Buchan's Richard Hannay is an empire-builder schooled in guile and in what he calls 'savage thinking' by his apprenticeship in the South African veld. Hitchcock's *The 39 Steps* blurs the man's origins and makes a joke of his military chores. Robert Donat's Hannay comes from Canada. He naughtily terrorizes Madeleine Carroll by telling her that his family had to flee there after the identity of the Cornish Bluebeard was revealed; he jeers at Carroll herself, to whom he is shackled, as 'the white man's burden'. Escaping his pursuers, Buchan's Hannay dodges into a political meeting and is forced to improvise a speech about Free Trade and the German threat to British command of the oceans. He busks his way through it, making up some facts about Australia, the furthest-flung of the empire's domains. But he is doctrinaire enough to be offended when a liberal politician argues for the reduction of British naval defences and fraternal conciliation with the Kaiser. Hannay denounces this as 'poisonous rubbish'. *The Thirty-Nine Steps* was published in 1915, by which time the foresight of Buchan's hero had been justified. *The 39 Steps* appeared in 1935, long after the war. Donat skips Hannay's attack on the unpatriotic liberal, and delivers a speech that derides the attitudinizing of party politics. It is an aria of eloquent gibberish, and it earns him a standing ovation.

Later Hitchcock characters do attempt to fly the flag, without much conviction. The pretence of partisan engagement when McCrea

broadcasts to America from London during the blitz at the end of *Foreign Correspondent* seems false. In *Saboteur*, Cummings delivers a tirade about how dearly he loves his country, to which the silver-haired fifth columnist responds with a patrician yawn: 'You have the makings of an outstanding bore.' Priscilla Lane later lectures her blind uncle on his duty as an American, which is to hand Cummings over to the law. The old man tells her not to be so stuffy.

On their way through the conflict-ridden twentieth century, Hitch-cock's characters occasionally stray into combat. *Secret Agent* ends with the Allied advance through Turkey in 1916, and *The Lady Vanishes* stumbles into the factional politics of an imaginary Balkan country; but it is seldom clear who is fighting, or about what. In films set during the Second World War, muddle prevails. The American clipper in *Foreign Correspondent* is shot down by friendly fire over the Atlantic, and the Nazis in *Lifeboat* sink a merchant vessel. In the Cold War films, *Torn Curtain* and *Topaz*, ideological concerns are dismissed: here, as in *Notorious*, sexual treachery matters more than treason. Nevertheless Hitchcock's people are all, in different ways in different decades, the moral casualties of war, prolonging hostilities into peacetime. Despite his witty disengagement, he inevitably reacted to convulsions in society, and brooded about humanity's vicissitudes in a world that had become inhuman.

Somerset Maugham based his stories about Ashenden, two of which Hitchcock conflated in *Secret Agent*, on his experiences at the Intelligence Department during the 1914–18 war. Hitchcock ignored the logistics of espionage, and concentrated instead on the moral revelation of the first modern war that, casually and rapidly exterminating more than eight million men, demonstrated that individual lives – and perhaps life itself – had no intrinsic value. In Maugham's stories, Ashenden occasionally demurs when asked to do things that will cause deaths. His superiors remind him to heed the law of battle: generals giving orders expect casualties, and have no time to be compassionate.

The Hairless Mexican, Ashenden's accomplice, rejoices in this new freedom from emotional and legal consequences. Hence the glee with which Lorre in *Secret Agent* pushes a blameless, tweedy, dog-loving

Englishman into a crevasse. Between assignments, Maugham's characters pause to reflect on modern morality and the artistic adjustments it prompted. Ashenden's peacetime avocation, like Maugham's, is writing stories. The Hairless Mexican wonders if he writes detective stories. Ashenden demurs: he has too much respect for the narrative convention that requires a murderer to be brought to justice, and he once alarmed himself by inventing a murder so ingenious that he could not devise a way of entrapping the murderer. His colleague, whose literary and moral tastes are more up to date, laughs at his compunction, and suggests – like Bruno in *Strangers on a Train* – that there is no need for heavy-handed reprisals, because if you kill a total stranger, you will never be suspected. 'It was inevitable,' the Mexican adds, 'that Jack the Ripper should escape unless he was caught in the act.' Hitchcock of course treated the Ripper's case in *The Lodger*, though he salvaged morality by a perfunctory contrivance that ensured that the killer did get caught in the act.

There may be an explanation here for one of Hitchcock's frustrating abstentions. For more than forty years he toyed with the possibility of adapting Buchan's *The Three Hostages*. It is easy to see why the novel, published in 1924, intrigued him. Buchan begins with an inquest on the psychological fall-out of the war. Hannay bluffly complains that those embattled years have taken the place of original sin, and are now being used to explain human criminality. His friend Greenslade, a doctor with a modish interest in psychoanalysis, corrects him. The sin was always there, and still is; war weakened our civilized defences against it. More calamitously, the war left behind it a kind of generalized shell-shock, 'a dislocation of the mechanism of human reasoning'. It produced a new, mutant creature, 'the moral imbecile' – a man inured to death and immune to pain because he has overdosed on them, who despises 'the old sanctities' and takes pride in his own 'utter recklessness and depraved ingenuity'.

Greenslade has described in advance the Hitchcockian hero, a self-seeking genius liberated by that small, imbecile deficiency. The definition fits Uncle Charlie in *Shadow of a Doubt* and the Nazi superman Willie in *Lifeboat*, the lovers in *Rope* and Bruno in *Strangers on a Train*, even the languid tennis champion in *Dial M for Murder*, who engages

a stranger to kill his wife. Norman Bates also qualifies, if he is given back the library of highbrow books he consults in the novel. Wilde in his essay on Wainewright accepted that those with artistic temperaments will lack 'wholeness and completeness of nature'. A psychiatrist confirms the point at the end of Bloch's novel with a play on words. Norman's crimes, he says, were committed while he pretended to be Norma, his mother; their aim was to destroy the invidious notion of a moral norm.

Buchan's stuffy Macgillivray attributes the revolutions that agitate the modern world to men of this kind, and names some specimens: 'young Bolshevik Jews . . . the young entry of the wilder Communist sects, and . . . the sullen murderous hobbledehoys in Ireland'. The Hairless Mexican might be enrolled in this company, since he 'was mixed up in some revolution' at home, which cost him all his possessions and feudal privileges. In 1941 Maugham added an autobiographical preface to his Ashenden stories, first published in 1927 and 1928. With deft irony he recalled his own impersonations of Ashenden, and conceded that his attempts to change the course of modern history 'during the last war' had been ineffectual: 'In 1917 I went to Russia. I was sent to prevent the Bolshevik revolution and to keep Russia in the war. The reader will know that my efforts did not meet with success.'

The vituperation of Buchan's character and Maugham's defeatist joke are two different voices of conservatism. Buchan believed that the world could be rectified by stern policing; Maugham knew that nothing could be done. Hitchcock never expressed such opinions. Yet his films express them for him, and eventually he worked his way through the revolutions surveyed by Macgillivray. *Juno and the Paycock* deals with the Irish troubles, and *Torn Curtain* and *Topaz* glance at the communist regimes in East Germany and Cuba. But did Hitchcock share Macgillivray's contempt for the scoundrels who shake the world? How could he have done? His own art was as intimately seditious as the work of the wreckers in *Saboteur*.

This may be why he did not go ahead with *The Three Hostages*. He usually explained that he gave up because Buchan's plot depended on hypnotism, which could not be 'put over on the screen'. Yet he suc-

cessfully put the illusion over in the first *Man Who Knew Too Much*. The real reason was probably the character of the hypnotist Medina, supreme among the 'hierophants of crime' whose 'sinister brains' take command in a post-war world where there is no God to chasten their conceit. Medina resembles Mabuse, the necromancer who in two films directed by Fritz Lang – *Dr Mabuse der Spieler* (1921) and *Das Testament des Dr Mabuse* (1933) – foments panic in Germany during the years of inflation and then sponsors the Nazi takeover by bewitching a credulous, demoralized mass. But he also resembles Hitchcock, an astute manipulator of the collective unconsciousness.

Medina is a contemporary Lucifer, and 'like a god . . . it is souls that he covets'. Hitchcock, in the light-born medium of the cinema, had similar aims. Medina or Mabuse use their wizardry for political advantage, just as Hitler bewitched an entire population with the help of radio waves. Hitchcock too, in a phrase used by Buchan's characters, deploys 'the power of mass-persuasion' and 'works by spirit on spirit'. One of Hannay's friends actually anticipates the title of a Hitchcock film when he calls the professional mass-persuader a 'spell-binder'. But Hitchcock was no Hitler. Inside the darkened room, we are shown what we are capable of, and watch as others perform the crimes we have imagined. The spectacle, in most cases, scares us into behaving as society ordains, or at least into denying that we ever nurtured such reckless fantasies. A revolution is forestalled; the psychological revolt is contained, and never spills on to the streets outside the cinema, as it did in Russia.

Even so, Hitchcock knew that, like Medina, he was trafficking with irrationality. The American poet Vachel Lindsay argued in 1915 that film used machinery to satisfy the ancient 'spirit-hungers' of its modern urban public. Hitchcock satisfied those same hungers by frightening us, inciting a contagious delirium. This factitious hysteria, so characteristic of the twentieth-century city and the collective mood-swings of its people, is discussed by a character in Josephine Tey's *A Shilling for Candles*, who holds the cinema responsible for rousing the rabble.

Tey published her detective story in 1936; the following year Hitchcock used it as his source for *Young and Innocent*. Little of the plot

remains, except for the initial premise: what attracted Hitchcock was the murder of a movie actress. Tey, unlike Hitchcock, found room in her narrative for an account of Christine Clay's funeral in London, which is witnessed with disgust by her husband. Fans screech, wail and faint, behaving as if the dead stranger had been a loved one. Christine's husband blames the indecorous spectacle on the trauma of 1914–18: 'We came through the war well, but perhaps the effort was too great. It left us – epileptic. Great shocks do, sometimes.' He is a veteran of the more recent war between China and Japan, where he saw 'machine guns turned on troops in the open'. The slaughter appalled him, but he would have been overjoyed, he says, to see 'that sub-human mass of hysteria' at his wife's funeral riddled with bullets. He concludes with a depressing reiteration of the modern pessimism voiced by Buchan and Maugham. He thinks that 'the end of our greatness as a race must be very near', and he is not only referring to Britain's racial eminence. The obscenely distraught fans made him 'ashamed of being human, of belonging to the same species'. The speech had no place in *Young and Innocent* – though perhaps it became a monologue silently delivered by Hitchcock himself.

After the next war, George Orwell assessed its moral damage to civil society. In 1946 he lamented the 'Decline of the English Murder' – the decline, that is, of stealthy bourgeois crimes, generally committed in the privacy of the home by murderers concerned to maintain the appearance of respectability. The preferred method, Orwell noted, was usually poison. That, as the gossipy neighbour says in *Blackmail* as she tut-tuts over the use of knives, is the time-honoured English way. *Suspicion* would have been a textbook example of an English murder, if Cary Grant had actually been allowed to place the fatal dose in the glass of milk. But now, Orwell claimed, English murders had become American – frivolously callous, gruesome yet pointless. He blamed the change on 'the brutalising effect of the war', and summarized a recent case by noting that the culprits, an American army deserter and a striptease artist, 'committed their murder to the tune of V-1, and were convicted to the tune of V-2'. They did the killing in the summer of 1944, while doodlebugs rained down; they were caught and tried in the autumn, by which time the Germans

had launched rockets against England. Orwell's chronological joke is worthy of Hitchcock, for whom the V-1 and the V-2 symbolized the difference between suspense and surprise.

In *The Three Hostages*, Macgillivray defines two sets of conspirators, both of which he wishes to crush: 'The first are devilish deep fellows, but the second are great artists.' Hitchcock happened to be both, which made him invincible. Throughout his career he continued to test both Medina's claim that 'the only power is knowledge' and the Hairless Mexican's theorem that individuals can be written off with impunity; and he never forgot that this inhumane free-thinking was legitimized by the circumstances of war. Dall in *Rope* asserts the expendability of the friend he killed when he sneers: 'Good Americans usually die young on the battlefield, don't they?' The film was released in 1948; the play by Patrick Hamilton that Hitchcock adapted had had its first performance in 1929. Surviving for two decades, in the course of which its setting changed from London to New York, Hamilton's story about a gratuitous action served as a retrospective commentary on the damage done to humanity by two different wars.

In Hamilton's play, Rupert the philosopher – whose Nietzschean doctrines have inclined his young protégés to kill – calls society's moral bluff by pointing out that we deplore murder but applaud massacres. How, he asks, can he pretend to condemn murder when, 'in the last Great War', he did his best to kill as many Germans as he could? The script prepared for Hitchcock by Arthur Laurents and Hume Cronyn necessarily took account of a more recent war, which did not have the impudence to call itself great. When that war broke out in 1939, Hamilton gloomily predicted that it would bring 'the end of life as we know it'. The human race survived; humanism did not. The theory that the superman should dispose of those he considered sub-human was put into practice by the Nazis. After one of Dall's rants, Cedric Hardwicke (who plays the father of the murdered man) asks if he agrees with Nietzsche's gay science of genocide, and says, 'So did Hitler.' Dall saves his face by dismissing Hitler as a 'paranoiac savage' whose supermen were brainless.

Rupert also detaches himself from his own teachings; but before he could do so, Hamilton's character had to undergo an urgent reforma-

tion. In the play, Rupert is foppish, 'enormously affected in speech and carriage', and supports himself on an 'exquisite walking-stick' that turns out, at the showdown, to contain a sword. Americanizing the action, Hitchcock cast James Stewart in the role, which meant an end to mincing and the replacement of that concealed blade by a gun, the most masculine of accoutrements. Hamilton's Rupert summons help from the Mayfair police by shrilly blowing a whistle out of the window. Hitchcock's Rupert uses a tougher and more home-grown method to alert the cops: he fires the gun at the Manhattan skyline. Reincarnated as the upright Stewart, Rupert can now contend that his ideas have been defiled, and insist that he has 'something deep inside' that would prevent him from committing such a crime.

It's a convenient self-exculpation, propped up by the persona of Stewart himself. Like Gary Cooper, he was the very image of provincial American virtue (which makes him an odd choice for the cerebral New York publisher in *Rope*). Yet the credibility he brings to Rupert's final sermon is weakened by his homicidal musing earlier in the film. In a scene that has no equivalent in Hamilton's *Rope*, he elaborates on some of the laughing murders any of us might commit, if we were Hairless Mexicans. Supposing we could get tickets for a Broadway hit or a table at a velvet-rope restaurant by killing strangers? What categorical imperative would deter us? Stewart, by now positively skittish, recommends concussing landlords with sash weights, and subjecting hotel employees to slow torture. He has his own categories of sub-human creatures, who might be discreetly got rid of: top of the list are small children and tap-dancers.

Though Hitchcock's *Rope* invokes the recent war, it supplies no information about the military records of its characters. The dandies presumably avoided the call-up, but how did Stewart cope with the experience of combat? The actor is given military credentials in the second *Man Who Knew Too Much* where, when the family revisits Marrakesh, his son credits him with the liberation of North Africa during the war. Stewart takes a more indirect and disillusioning journey through the same instalment of modern moral history in a later Hitchcock film, *Vertigo*.

The setting of *Vertigo* is San Francisco during the 1950s; but the novel *D'entre les morts* by Boileau and Narcejac that Hitchcock adapted takes place in France, and its action traverses the Second World War, implicating its characters in the shame of their country's military collapse and its collaborative role as a conquered province of the Third Reich. *D'entre les morts* begins in the first weeks of the war. Skirmishes on the Rhine are reported as the hero Flavières (rebaptized Ferguson in *Vertigo*) has his meeting with Gévigne, who engages him to keep an eye on his suicidal wife Madeleine. Gévigne surmises that her mental distress may be a response to political circumstances. Perhaps, he suggests, the current state of the world has rendered her neurotic. Meanwhile he prepares himself, as an industrialist, to make a profit from the war. After Madeleine's first death in 1940 Flavières is called up. He takes the disgrace of fallen France as a personal reproach, accusing himself of cowardice since he was unable to prevent Madeleine's death. He finds her again when France itself, roused by de Gaulle, is resurrected: he sees her in a newsreel of the general's visit to Marseilles. She is still living off the spoils of war, with another profiteer as her protector. In a scene cut from *Vertigo*, Hitchcock tidies up the plot by having Ferguson hear on a radio news broadcast that Gavin Elster, the character who corresponds to Gévigne, has been arrested in Europe. The novel leaves Gévigne to the summary justice of the partisans, who machine-gun him in 1944; but Madeleine, whose deception of Flavières recalls the infidelity of France, must also be held to account for war crimes. Flavières therefore, following a lament for 'le pays perdu', strangles her. After death, her face – as if it had become an image of the country – seems to have relapsed into 'une grande paix'. The cantankerous Bernard Herrmann was unconvinced by the story's relocation, and argued that *Vertigo* should have been made, if not in France, then at least in Louisiana, with Charles Boyer as the transplanted hero. When in 1976 Brian de Palma paid imitative tribute to Hitchcock's film in *Obsession*, he did set his pastiche in New Orleans, and engaged Herrmann to compose the score.

Shipped across the ocean and given new lives in the next decade, Hitchcock's characters seem to have no recollection of their soiling

origins in the novel. *Vertigo* ends with Ferguson as the distraught, heartbroken witness of Madeleine's second death, not its cause; but the abrupt murder at the conclusion of the novel helps to explain the deathliness of Stewart's erotic obsession in the film. As always in Hitchcock, there is a subtext. Did Novak stumble on the ledge of the bell-tower? Could Stewart, at the very least, have driven her to suicide? A nun, who suddenly climbs into the tower and startles her, conveniently forestalls such questions by taking the blame, and immediately consigns the dead woman to the church's care: she makes the sign of the cross, and funereally tugs the bell-rope.

The illogical materialization of the nun through the trapdoor is justified by a logic that the film covers up. Why did Hitchcock make the Mission Church of San Juan Bautista, down the coast from San Francisco, the setting for both deaths (awarding it a matte-painted bell-tower, which it does not actually possess)? The California of *Vertigo*, like the France of *D'entre les morts*, has a history that it would prefer to keep buried. The suave industrialist Elster (Tom Helmore) presides over a shipyard in the Mission District of the city, and subscribes to the opera; but, as he tells Stewart when they first meet, he yearns for an older San Francisco – the frontier town with its lawless, promiscuous Barbary Coast, when the Embarcadero was the scene of brawls and shoot-outs in piratical saloons. An antiquarian expert on local history later describes the same period, before San Francisco settled down into propriety. In those days, rich men exploited women and idly discarded them, which is what happened to Carlotta Valdez, Madeleine's imaginary ancestor.

Pretending to be Madeleine, Novak loiters near Carlotta's grave at Mission Dolores, and claims to dream about her previous existence at San Juan Bautista. Those missions remain as monuments to Spain's messianic aim of civilizing the wilderness. Reborn as Judy, Novak lives in a seedy hotel on Sutter Street, called the Empire: could this be a reminiscence of another missionary's prophecy about the future of California? In the eighteenth century, Bishop Berkeley predicted that 'the course of empire' – by which he meant enlightenment – would press inexorably westward. He did his best to help it along by travelling from England to Bermuda and Rhode Island; just before the

Western world runs out, his imperial dream is commemorated at the university campus of Berkeley, across the bay from San Francisco. But the conversion of California, whether entrusted to Catholic priests or Anglican educationalists, never quite succeeded. The vertiginous city of steep streets contains gulfs, abysses of ancient terror. When the Golden Gate Bridge was opened in 1937, it became a favoured launching place for suicides. Novak, who is daintier and in any case has no intention of drowning, hops into the bay just below the span, at Fort Point. The church – as the nun's swift, face-saving response makes clear – serves to excuse the gravitational accidents that befall us by ascribing them to God's will.

Vertigo may spare its hero a recapitulation of French history from 1939 to 1944; instead it sends him on a longer trip through the early years of settlement in California, which leads to the same alarming conclusion. The proud skyscrapers and pious steeples, the art galleries and beauty salons, even the name of the saint adopted as San Francisco's patron – all these modern benefits amount to decorous, deceptive set-dressing, like the preservation of San Juan Bautista, its stables and its blacksmith's shop as an open-air museum. Landmarks mutely tell truths that the municipal myth does not sanction. *Vertigo* goes a little out of its way to include Coit Tower, a squat column on Telegraph Hill erected in 1933 to replace the semaphore that warned longshoremen that a ship was about to dock on the Embarcadero. Stewart can see the tower from his apartment, though the building had to be turned on its axis when it was reconstructed in the studio to provide him with this view. After he saves Novak from the bay, she mazily finds her way back to Lombard Street, using the tower as a navigational aid. 'I never thought I'd be grateful to Coit Tower,' Stewart says. The grudging turn of phrase sounds odd. Why should he be ungrateful to it? Perhaps because it starkly recalls the temporariness of San Francisco, levelled by an earthquake and then gutted by fire in 1906. The tower was built to commemorate Lillie Hitchcock Coit, a philanthropist who amused herself by chasing fire-engines. Though she was not related to the director, her hobby, like his thrillers, points to the morbidity of modern entertainments, which are invigorated by danger.

However well they seem to have acclimatized themselves to San Francisco, the characters of *Vertigo* never really live down their trans-atlantic past. It is curious that Novak, convinced she is the reincarnation of a Spanish woman, should have been sent to visit the portrait of this imaginary forebear at a place with French connections, the California Palace of the Legion of Honour. Its cliff in Lincoln Park is guarded by a bronze Joan of Arc on horseback, and Rodin's Thinker broods in the grounds. The Legion's founder was Alma de Bretteville Spreckels, a Frenchwoman who married a San Francisco sugar importer; she aimed to commemorate American soldiers killed in France during the First World War, and invited Marshals Foch and Joffre to the Palace's inauguration in 1924. The myth of French military honour faltered during the years covered by *D'entre les morts*.

The same past that compromises the characters of *Vertigo* encroaches in *To Catch a Thief*. Ferguson and Madeleine, like Rupert and his young disciples in *Rope*, were brought by Hitchcock from ruined Europe to America, and they carried their gospel of despair with them. The hero's course in *To Catch a Thief* proceeds in the opposite direction. John Robie, played by Cary Grant, goes to Europe from America before the war. An acrobat in a touring circus troupe, he is detained in France as an enemy alien. Escaping, he and his fellow prisoners join the Resistance. (At least, unlike Gévigne and Madeleine, he is on the right side.) Robie's head for heights provides him with an alternative career as a cat burglar. Pardoned as a reward for his contribution to the Resistance, he is threatened with re-imprisonment when the burglaries resume on the Côte d'Azur; and theft is not the worst of his misdemeanours. The novel that Hitchcock adapted has its own supplementary tale to tell. In David Dodge's *To Catch a Thief*, published in 1953, Robie is nicknamed John the Neck-breaker to honour his skill in snapping the spines of Gestapo officers. The film had to clear Grant of any such crimes, and it transfers this expertise to his pudgy housekeeper Germaine – a scapegoat, like the nun in *Vertigo*. Grant restricts himself to remarking, over lunch with the insurance investigator played by John Williams, that the same capable hands Germaine used to whip up the aerated pastry of a quiche Lorraine enabled her to 'strangle a German general once, without a sound'.

To Catch a Thief looks elegant and expensive, and it pays glossy homage to the prosperity of the 1950s. When Brigitte Auber, as the flirtatious Danielle, flaunts her English vocabulary while she ferries Grant to Cannes, she chooses one crucial, modish word to pronounce and define: affluence. Taking surplus and surfeit for granted, affluence was the official creed of the times. Americans, victors in the war, now returned to take possession of Europe as swanky, self-advertising tourists. The credit titles of *To Catch a Thief* unroll over a shot of a travel agency's window display that entices passers-by on Fifth Avenue to go on holiday to France; Williams tells Grant that his villa in the hills above Cannes is 'a kind of travel-folder heaven'. Yet, after the credits have mused about luxury and leisure, the film's action begins with a close-up of a woman screaming, followed by a series of similarly hysterical alarm calls. What are those moneyed matrons screeching about? More than the loss of their jewels, purloined by the cat burglar. Dodge's novel gives them another reason for grief. They are reacting to that most modern of prospects, rehearsed by all of the twentieth century's wars. Their cries announce the imminent end of the world.

Dodge's *To Catch a Thief* is about the Cold War, and takes up the modern world's history at the point when *D'entre les morts* breaks off. The Americans are already fighting in Korea, getting ready for the third world war that will be averted in *Topaz*. The gaiety of the Riviera, with its casinos and fancy-dress balls and flaunted trinkets, is a terminal symptom. Robie's old friend Bellini predicts that 'another war will kill France for ever'. Such pessimism is banished from the film – though perhaps a foresight of Europe's doom prompts Auber to dream of escaping with Grant to South America, the fanciful destination of many Europeans in quest of refuge from nuclear fall-out. In 1948 Herbert von Karajan announced plans to decamp to South America. 'There is going to be another war in Europe,' he shrugged, 'and I intend to be elsewhere.' Dodge drops a silent typographical hint about the emergency in his description of Danielle's swimming costume. She wears, he notes, 'a Bikini'. The capital letter, soon lowered, is a timely reminder that the garment got its name from Bikini atoll, where the United States had detonated an atomic bomb for the

benefit of press photographers in 1946. During the jittery 1950s the highest compliment you could pay to a woman was to call her a bombshell and liken her body to a nuclear warhead.

Hitchcock concentrates on the contemporary amenities of a tourist playground – motor boats, fast cars, roulette wheels. Dodge's narrative has a longer memory, noticing mementoes, like the California missions, of earlier empires that have come and gone on this over-built littoral, precursors of the declining West. The film concludes with the party at the Sanford villa, whose history Dodge fills in. Its site was that of a Roman lookout, fortified in the fifteenth century, reclaimed from collapse by a new, rich American owner. Soon the moated château, its feeble defences struck down, may be a ruin again.

The novel shares in the post-war mood of existential instability. Where could men find a footing in a world that seemed to be on the point of expiry? Grant, who began his career as a music-hall tumbler, negotiates tiled rooftops and exiguous ledges with inimitable grace. He does not suffer from James Stewart's dizziness: he can fend off the 'moral vertigo' that, as the surrealist Louis Aragon put it, was the fate of disoriented modern man. These acrobatics are more than a mere balancing act. There is no safety net beneath us. Robie's father, according to the novel, was a trapeze artist who inadvertently killed his mother during one of their displays. When Dodge's hero hangs 'suspended' from a sagging gutter on Sanford's roof, he turns into the dangling man addressed by the existentialists. Perhaps, in that heavenly villa, Robie possesses a copy of Albert Camus's *L'homme révolté*, published in 1951 and translated into English as *The Rebel* in 1953, the year in which Dodge's novel first appeared.

Dodge's Robie uses the jargon of the existentialists, who praised men for escaping from doubt and inertia by launching themselves into empty air, making leaps of faith. He waits all night for the thief to appear, anxiously anticipating 'the moment of action'. Other characters employ similar terms, aware that the existential code of valour requires them to justify their entitlement to life. Dodge's Bellini wonders if the pampered Francie (played by Grace Kelly in the film) has 'a reason for existence', and says that we all need one. Anything, he adds, will suffice: a desire to do good works, or a compulsion to

commit murders. During his precarious vigil on the roof, Robie arrives at a confidence in his own assessment of the case that supplies him with a 'reason for his existence'. The local industry on this blue coast is gambling, and the casinos assist society's breakdown by making an entertainment out of waste – the spendthrift disbursement of gains that a good bourgeois citizen ought to be hoarding. Francie, whose mother is forever losing to the wheel, enjoys the revolutionary rotation of fates and funds. She is equally exhilarated by the moral daring of the criminal career, and regards Robie, who shins up drainpipes just as Nietzsche's Zarathustra vaulted over canyons, as 'a kind of superman'. Using the same philosophical catchphrase, she encourages his revolt against conventional values when she argues that 'a thief's only function was to steal, as the Monte Carlo roulette wheel's only reason for existence was to win money for the Prince of Monaco'. Therefore, she concludes, no harm will be done if Robie squanders money in the casino and robs the prince to make good his losses.

Luckily this radical analysis of property as theft did not make its way from the novel to John Michael Hayes's script, because in 1956, two years after the release of To Catch a Thief, its star became the Princess of Monaco and acquired a personal stake in the casino's proceeds. Dodge had wryly imagined just such a possibility. His novel contains a Grace Kelly character, 'a one-time American cinema star, now the Princess Lila'. She is the trophy bride of an oriental potentate, and weds him wearing a dress encrusted with six thousand precious stones, among them a string of pearls once supposedly given by Solomon to the Queen of Sheba. Grace's marriage to Rainier was a commercial merger as much as a romance. She bankrolled the principality by repairing its sordid reputation, and attracted extra mobs of the tourists on whom its economy depended. The free-thinking Francie would not have approved. Hitchcock did his best to make Princess Grace regret her choice of a new career, and tried to tempt her back with Marnie. She wanted to accept the role, though the Monaco courtiers changed her mind by pointing out that Marnie was a killer and a kleptomaniac, sexually frigid except for a fixation about her horse – hardly fitting for the wife of His Serene Highness. Hitchcock accepted

her regrets, conveyed in a handwritten letter, but subtly retaliated in his reply. With his own letter to her, he enclosed a tape 'made especially for Rainier'. The prince shared Hitchcock's partiality for smut; they often exchanged salacious jokes. The tape must have contained a choice anthology of these, because Hitchcock warned Grace that her husband should treat it like a top-secret state document: 'Please ask him to play it privately. It is not for all ears.' His gift sabotaged the moral posturing of the Monaco court, which found *Marnie* so offensive.

Robie in Dodge's novel has much in common with the angry protagonists of 'film noir', who during the late 1940s attributed their existential quandaries to the war. While fighting, they were idealists; but the civilian society to which they returned – where business venally went on as usual, and newly independent wives did little to conceal the evidence of their infidelity – left them disillusioned, eager to begin reprisals. Alan Ladd feels this way in George Marshall's *The Blue Dahlia*, made in 1946 with a script by Raymond Chandler, as does Bogart in John Cromwell's 1947 film *Dead Reckoning*. In 1971 the war is still held responsible for the apparently homicidal rage of the demobbed London barman in *Frenzy*. The military career of Blaney, played by Jon Finch, is vaguely sketched in. He attained the rank of Squadron Leader in the Royal Air Force, and won a medal for 'inspiring leadership'. Yet when he bumps back to ground, he proves less capable. Good in battle, he is ineffective in commerce, which is the preoccupation of peacetime. His roadhouse 'didn't go'; then he opens a riding stable, which is promptly torn down by his local council because he lacks the proper permits. He tells his former wife Brenda (Leigh-Hunt) that he is unskilled at dealing with bureaucrats. Reduced to pulling pints in a Covent Garden pub, he is sacked for helping himself to a drink. His acquaintances fall back on the 'film noir' hypothesis, and conclude that resentment and frustration have goaded him to murder.

The war Blaney led his squadron into casts an improbably long shadow. Despite its anachronisms – antique slang, cockney porters in the Covent Garden market who might have been left over from *My Fair Lady*, primly genteel dress codes, everything but the fogs that

obfuscated the city in *The Lodger* – *Frenzy* is set more or less in the present. Blaney and Brenda do some sums, making clear how far back they go. They were married for ten years, and have been divorced for two, which means that his war must have taken place during the mid-1950s. An air-force comrade tries to make it add up by offering the information that Blaney was 'in the Suez business'. Britain invaded Egypt to regain control of the Suez Canal in 1956, so *Frenzy* is a post-imperial film rather than a post-war one.

The hastily adjusted dating almost works, but the chronology and the moral causality it implies are clearer in Arthur LaBern's *Goodbye Piccadilly, Farewell Leicester Square*, Hitchcock's source. Here the story is backdated a further decade. LaBern's hero Blamey (Hitchcock changed the spelling, which lightens the man's paranoid burden) has a proper war record as a bomber in Germany. Like Patrick Hamilton's Rupert, he can congratulate himself on his success as a serial killer, honoured by society for his crimes. He flew on the missions that incinerated Dresden, and admits – when interrogated by the police investigating the spate of necktie strangulations – that he murdered 'hundreds of thousands' there. Brenda was the airman's good angel, the voice in the control tower who talked him back to base after those German raids. (Kim Hunter does the same for David Niven's RAF pilot in *A Matter of Life and Death*, made by Michael Powell and Emeric Pressburger in 1946.) Blamey and Brenda marry in 1943, and are together for twenty years rather than ten, which accounts for the decade elided by *Frenzy*. The foreshortening was necessary for cosmetic reasons. A Hollywood film – even one made in London with physically nondescript English actors – could hardly have a hero who is middle-aged and balding. Blamey, metamorphosed into Blaney, also loses his limp, another souvenir of the war.

Dragging his bad leg around London, Blamey reviles the city's crass lapse from glory after 1945. Berkeley Square has lost its nightingales, put to flight by automobile showrooms, and Piccadilly Circus is choked by diesel fumes. The lofty view during the credit titles of *Frenzy*, following the imperial waterway from the East End to Westminster, can only be a bitter joke. London may look splendid from high above; when the camera, like Blaney the grounded flying ace,

comes in to land, the first thing it notices is a corpse afloat in the river. LaBern's novel says a terse goodbye to Piccadilly, where tourists sweat in synthetically modern Bri-nylon shirts or carry handbags of white plastic, and bids an unregretful farewell to Leicester Square, where Brenda is murdered in the office of her matrimonial agency (moved further north by Hitchcock, who located it down an alley behind Oxford Street).

The film, forgetting LaBern's title, chose to be frenetic rather than elegiac, but it absorbed the novel's agenda. In his penultimate work, Hitchcock returned to his native city to take his own parting look at it. Like LaBern, what he saw was a shoddy modernity that glossed over ancient ordure. The bureaucrat sermonizing outside County Hall at the end of the credits announces that the Thames has been cleansed of industrial effluent and promises that it will be kept 'clear of the waste products of our society'. So how come there's a dead body just off the embankment? Hitchcock wanted to make a film about the daily routine of alimentation and evacuation in New York, which would end as the sewers discharged waste into the harbour. The faecal corpse in *Frenzy* transferred that pet project to London.

Describing his documentary parable to Truffaut, Hitchcock said that he intended to begin with 'gleaming fresh vegetables' and then show their progress towards the cloaca. He did exactly that by setting *Frenzy* in the fruit and vegetable market at Covent Garden. Jon Finch abbreviates the cycle in one of his rages: given a box of grapes, he hurls it to the ground and squashes the contents with his foot. The streets of the old market were slippery with bruised bananas and overripe tomatoes; no wonder that, soon after Hitchcock made *Frenzy*, the messy trade was moved to a remote suburb. The closure of the market served as a cover-up, like the bureaucratic lie about the pristine river. *Frenzy* exposes the hygienic pretence.

The laundering of London began with the Clean Air Bill in the mid-1960s, which made the burning of smokeless coal compulsory and brightened the city's sky. This achievement is wittily revoked at the beginning of *Frenzy*. Just after Hitchcock's personal credit, the camera swoops down towards the improbably blue Thames and ducks beneath Tower Bridge. The bridge has its roadway raised, as if

to award the camera the freedom of the city; by placing his own credit exactly here, Hitchcock turned his homecoming into a public triumph and accorded himself the kind of welcome usually reserved for kings or conquering heroes. But even before the slogan fades, a sooty fulmination starts up to the right of his surname. Then, defiantly smudging the clear vista that lies ahead, a tug steams across the river from north to south, and fills the entire width of the screen with black smoke puffed from its funnel. The sight is as impertinent as a fart. London, Hitchcock mordantly notes, is not quite so spotless – atmospherically or morally – as it likes to think.

That stain on the sky is Hitchcock's protest against the tendency that Camus in *The Rebel* identified as the apostasy of the modern world. We live, as Camus pointed out halfway through the century, in a time of mass murder. Governments discovered their capacity to organize slaughter during the 1914–18 war. After that, they made it an instrument of their peacetime policies, and killed in order to achieve what they thought of as scientific ends: agricultural reform in Stalin's Russia, genetic purification in the Third Reich. Thanks to their clinical procedures and the technological jargon they use, 'blood is no longer visible'. Those who plan the massacres wear spotless white laboratory coats, and keep their distance from the squelching waste of the Covent Garden market, the tea-coloured filth in the Thames or the drifting smoke above it. Camus was disgusted by this surgical refinement. Ancient murder, he argued, shed blood in full view, as when beasts were sacrificed at the altar (or when the Incas, studied by Norman Bates in Bloch's novel, tore the hearts from their human victims). These acts of carnage produced a 'religious horror' – like the 'religious fear' provoked in Genet by the act of murder – and thus sanctified the lives they curtailed. In our world, machines kill men negligently, and negate the value of existence itself in doing so.

Modern crimes are not passionate; they are logically planned, which is what makes them humanly unforgivable. This industrialized inhumanity provides a moral context for Hitchcock's films. Once at least he confronted it directly: he advised the Ministry of Information on *Memories of the Camps*, an unreleased documentary tour of the killing factories set up by Hitler and Stalin. Even so, his

imagination could never completely dissociate itself from this clinical butchery. When describing his prospective journey through the excremental food cycle in New York, he railed about 'the rottenness of humanity', just as Aragon, vilifying the corpse of Anatole France in 1924, had dreamed of 'an eraser to rub out human filth'. Walter Slezak, the Nazi in *Lifeboat*, encourages William Bendix to drown himself after his leg is amputated: what is a cripple's life worth? Ray Milland kills by remote control, dialling a murder. By exhibiting the evidence – a staring eye in *Psycho*, a protruding tongue in *Frenzy* – Hitchcock compelled us to care. Yet his motives were mixed. Blood is only occasionally visible in his films, and then it is not blood at all. In *Psycho* he used chocolate sauce; in *Topaz* the substitute was soft, dry cloth. Like the nihilistic killers denounced by Camus, he relied on technology to do his dirty work. Janet Leigh's body is lacerated by the knife. Hitchcock dissected the last forty-five seconds of her life into seventy different shots. With his editor, he pieced together the scraps of celluloid that narrate the shredding of her body, but he could not bring her back to life.

In 1950 – a pivotal year, when men took mortified stock of the seventy million human beings who had (according to Camus) been 'uprooted, enslaved, or killed' since the century began – Raymond Chandler published an essay on 'The Simple Art of Murder'. He disparaged the amateurism of English detective stories, which located their crimes in sedate country vicarages and deployed little old ladies to solve them like crossword puzzles, and instead praised the hardbitten urban novels of Dashiel Hammett, who 'gave murder back to the kind of people that commit it for reasons'. Those reasons, as Chandler and Hammett both knew, were usually squalid and self-interested. Chandler was also working on the script for *Strangers on a Train* in 1950. The experience was unhappy, and he disowned the film because Hitchcock, in his view, possessed no sense of 'dramatic plausibility'. Chandler had missed the point. Hitchcock was less interested in the reasons for murder than in the rationality of murderers – men who find in murder a reason for existing. The Cuban revolutionary in *Topaz*, who tortures suspects to elicit the truth, is just such a chilly fanatic. He shoots his mistress – producing that puddle

of velvet gore – while he grips her in an embrace; he both kills and makes love in cold blood.

Camus, in the year after Chandler's essay, dispensed with the enquiry about reasons, which reduced murder to a social or economic problem. Whether directly or indirectly, Camus said, 'all contemporary action leads to murder'. Hitchcock confronted the same dead end. He told the same story dozens (or, if you include his television series, hundreds) of times. Sometimes he reacted to the unavoidable outcome with a religious horror of which Camus would have approved, as when Stewart in *Rope* throws open the trunk. But it was also Hitchcock who likened his films to buzz bombs – clever engines of mass destruction, invented by a century in which men made war against humanity.

The Pursuit of Unhappiness

Hitchcock, his cast and the jury of Manhattan skyscrapers on the set of *Rope*.

To obtain an American visa you used to have to assure the consular staff that it was not your intention to subvert the constitution of the United States. Hitchcock – who moved from London to Los Angeles in 1939, halfway through his life and a third of the way through his career – gave no advance warning of his aims, but his films rewrote that enlightened, confidently hedonistic document. His daughter Patricia, cast as Babs in *Strangers on a Train*, shrugs off the murder of Granger's wife by remarking, as if this were just cause, 'She was a tramp.' Her father, a United States senator, intones the national litany: 'She was a human being, and she had the right to life and the pursuit of happiness.' The sassy Babs replies: 'From what I hear, she pursued it in all directions.' In *Saboteur*, Priscilla Lane makes the constitution responsible for her impulsive decision to believe in Cummings' innocence. 'It's a free country,' she says. 'A girl can change her mind, can't she?'

Hitchcock's films test America's sainted truisms. In *Shadow of a Doubt*, Cotten coolly denies those parasitical widows their right to life. At the end of *Rope*, Stewart tells the young killers that 'we're each of us a separate human being . . . with the right to think and work and live as individuals, but with an obligation to the society we live in'. He includes more provisos than the eighteenth-century founding fathers needed to bother about, but even this cautiously revised theory is contradicted by the spectacle of America behind him. As he speaks, he crosses the room and the camera swerves across the nocturnal skyline of Manhattan, elaborately duplicated to scale with each of the skyscrapers separately wired for electricity. Here are the individuals – but they are dehumanized, and their height is a monument to the overreaching arrogance that Stewart condemns. This city has no people in it, only lights and sounds: alarmist sirens, or the voices that shout up from the street when Stewart fires a gun at the skyline. The pursuit of individuality, embodied in Manhattan's tall towers, refutes the very notion of society, which cowers somewhere out of sight below.

Critics have complained that Hitchcock noticed nothing in America except the tourist sites. His films do make pilgrimages to the expected places, but their aim is not patriotic. The terrorists in *Saboteur* drive across the top of Boulder Dam, and appraise the membrane of reinforced concrete that restrains the tonnage of water: this, presumably, is on their list of prime targets. The Cuban revolutionaries in *Topaz* have similar plans to bomb the Statue of Liberty. The characters in Highsmith's *Strangers on a Train* shuttle by train between New York and Texas. Hitchcock shifted the action to Washington, D.C., and the credit titles begin with a shot of the Capitol framed in the arch of Union Station. Trailed by a detective, Farley Granger later goes walking beside the Potomac, observed by Robert Walker, who lurks beneath the neoclassical cupola on the steps of the Jefferson Memorial. Imperial America sought to consolidate its power by the Roman pomp of its architecture, and to erase the stains of history with successive coats of white paint. Walker's shadow warns that these messianic hopes are deluded. One of his lunatic schemes, now that Hitchcock has relocated him, is a plan to blow up the White House.

Topaz manages a passing slight to that supposedly pristine dwelling when the Russian defector is being driven through Washington on the way to a safe house on the outskirts of the city. His daughter notices the Capitol, and asks if that's the White House. The family's CIA minders correct the error, but her disappointment is understandable. She has come from a totalitarian state where power immures itself on a hilltop, walled off from the lowly civilian city beneath and additionally protected by a cluster of cathedrals with golden domes inside the red ramparts. What kind of paltry chief executive lives in a modest suburban mansion? *North by Northwest* also briefly touches down in Washington after the killing at the United Nations, identifying the location with another view of the Capitol. Government agents shake their heads over a scheme that has gone wrong. They admit that the position in which they have placed Grant is tragic. 'Then how is it,' asks one of them, 'that I feel like laughing?' So much for a government that is meant to ensure that Grant can pursue money, Martinis, and other men's wives in peace.

One of these desk-murderers (Leo G. Carroll, the insane psychiatrist from *Spellbound*) later turns up at the airport in Chicago, and explains the plot to the befuddled Grant. He is delightfully vague about his affiliations. FBI, CIA, ONI – 'we're all,' he says, 'in the same alphabet soup.' Those institutions devoted to national security and global surveillance are reduced to the letters that stand for them, and those letters are set afloat in a bowl as playthings for children, who are free to make newly nonsensical compounds out of them.

The films Hitchcock directed during his first two years in Hollywood admittedly paid little attention to America. *Rebecca* and *Suspicion* recreate rural England. *Foreign Correspondent* begins in New York, but promptly takes ship for London. *Mr and Mrs Smith* is set in the usual Manhattan venues of screwball comedy, with an excursion upstate to a ski resort at Lake Placid – though even there the action stays mostly indoors. Then in *Saboteur*, released in 1942, Hitchcock undertook a tour of the United States, crossing from the west coast to the east.

The journey begins and ends with acts of subversion: arson in a Los Angeles hangar where planes are being manufactured for the air force, a bombing at the navy yard in Brooklyn. Usually the adventuring heroes of picaresque romance take to the road voluntarily, but Cummings lacks the leisure to pursue happiness: he is on the run. The faith that traditionally buoys up such wayfaring narratives is recalled by one of the strangers who shelters him. Hitch-hiking, he claims, 'is the best way to learn about this country, and the surest test of the American heart'. But the man who says this is a blind hermit, so disconnected from America that he passes the time in his woodland cabin playing English pastoral music by Delius on his piano. And if the American heart is so benevolent, why does the hermit keep a snarling Alsatian? Further on, Cummings and Lane are picked up by a consortium of itinerant Americans. 'We acquire two more vagabonds,' says the leader of this commune, 'Bedouins like ourselves.' America, for this band of travellers, is an uncharted waste. They gratefully accept its wildness, because they too – like the fugitives to whom they give a ride – are outcasts from society. They belong to a freak show, and parody the proud American cult of indi-

viduality. The skeletal Bones clatters like a xylophone when he moves; his wife Esmerelda crimps her luxuriant beard with hair-curlers. A bellicose dwarf wants to make war on the world. A fat lady, who pursues happiness orally, resembles a quiescent mound of blancmange. Mignonette and Marigold, Siamese twins, quarrel over the bodily living-room they share, and cannot agree about a beau who wants to court both of them at once: is he just 'a common novelty seeker'?

That, however, merely makes him an archetypal citizen of a country tantalized by novelty and self-renovation. When the latest new thing grows old, you simply move on. In America, there is always somewhere else to go. *Saboteur* notices the detritus that America's dreams leave in their wake. Cummings and Lane make a detour to a place in the mountains called Soda City. The name promises much: could this be a town as effervescent as Las Vegas? They arrive to find a few empty sheds of rusting tin. The place was a salt mine, but the earth has been bled of its riches, and the exploiters have gone looking for fresher land to despoil. Otherwise, the American landscape remains invisible, blocked off by roadside billboards, all of which contain grinning portraits of Lane, a photographic model. Her uncle, the blind hermit, spared from having to see these eyesores, remarks: 'The billboards she adorns would reach across the continent if placed end to end – though I can't imagine who's going to place them end to end.' The film, however, does so, in a succession of travelling shots. America, in this long horizontal mural that you travel past at speed, becomes a wrap-around panorama of commercial desires. Lane's image is available to sell anything at all. On the first billboards she recommends a brand of motor oil, then a soft drink called Cocarilla. The two products are interchangeable: fuel for your car, or fizzy refreshment for your body. To be American, in either case, requires you to top up your energy supply. At some distance down the road, she lends her smile to the common destination of all these energetic pursuits: now she advertises Beautiful Funerals.

After this brisk synopsis of the continent, Hitchcock settled down in *Shadow of a Doubt* to concentrate on a single small town, the cosy crucible of American democracy. In Santa Rosa, people are militantly

nice. A traffic cop beams at the orderly pedestrians, and a poster in the library exhorts readers to BUY A STAKE IN AMERICA by subscribing to war bonds. Yet Teresa Wright dreams of deliverance from this soporific idyll, and invites her widow-killing uncle to 'come and shake us up'. He is, she thinks, 'just the one to save us'. But Cotten brings perdition, not salvation: a digest of the century's bad news – God's demise, the devaluation of human lives, even (since he leaves a flotsam of dollar bills lying round in his room) the irrelevance of money and all other bourgeois verities. After his death, Wright remembers that this fiendish evangelist 'said that people like us had no idea what the world was really like'. Her boyfriend, a policeman, assures her that the world is not such a bad place. Treating the devil to a lachrymose funeral, Santa Rosa instantly recovers its homely composure.

Perhaps that is why Hitchcock sent a second destructive embassy to the town in *The Birds*. Santa Rosa is near Bodega Bay, the fishing village that the birds attack, and is often referred to in the later film. Making plans for escape, someone says that you can pick up the freeway to San Francisco at Santa Rosa. The cops are sent from there to investigate the death of the farmer whose eyes have been pecked out: they dopily conclude that it's a case of robbery. After Taylor boards up the windows of the house, he and Hedren watch a flock wheeling in the twilit sky. She wonders where they are heading. He says, 'Somewhere inland.' She asks if they could be bound for Santa Rosa. 'Maybe,' he replies.

The policeman in *Shadow of a Doubt* admits that 'the world . . . goes crazy from time to time'. His comment, made in 1943, implicitly blamed Uncle Charlie's maniacal behaviour on the war; but when the war ended, a peaceful and affluent America, according to Hitchcock, perpetuated the madness. This is the suggestion of *Strangers on a Train*, released in 1951. Everyone is in pursuit of something – but is it happiness, or just the idea of hepped-up pursuit, conducted at maximum velocity? Breton's manifesto for the surrealists established the country's contagious insanity. 'Columbus,' according to Breton, 'set out with madmen to discover America;' since then, 'this madness has taken shape and permanence'. Walker in *Strangers on a Train* is a

deranged vitalist, who boasts to his mother about gobbling an entire bottle of vitamin tablets in a single day. Like Jack Kerouac and the restless Beat poets, he is an enthusiast for motion. The pills keep him peppy, whereas Granger's wife relies on fast food. At the funfair she consumes an ice cream, demands a hot dog, and appeals for popcorn: the little kernels, popped by heat, explode into life inside you. Walker munches a packet of the stuff, storing up the energy he will need to kill her.

In this hectic culture, it's entirely logical that the profession of Highsmith's Guy should be changed. In the novel he is an architect; the film turns him into an athlete, who somehow combines his political chores as a senator's aide in Washington with tennis championships at Forest Hills in New York. Sport, like the movies, worries about the ratio of time to motion, and Granger's challenge – if he is to get back to the fair before Walker can deposit evidence to incriminate him – is to beat the clock on the court by winning the match in three sets. Walker is also persecuted by a time that, in the somnolent Pennsylvania countryside, will not speed up in obedience to his wishes. He must wait until nightfall to drop Granger's cigarette lighter at the site of the murder. Fidgeting, he asks what time it gets dark around here. A man at a hamburger stand languidly replies, 'What's the hurry?' Walker, irritated, asks again. The man's answer is: 'Soon enough.' Some people tolerate time, and adjust to its snail-like pace. Others, more impatiently modern, seek to outstrip it.

The so-called Bedouins in *Saboteur* traipse across the wilderness in a trundling caterpillar of caravans. The America of *Strangers on a Train* has accelerated, and fires itself into the future. The leisurely unspooling of the terrain outside the train window bores Walker, who claims to have flown in a jet and driven a car blindfold at 150 miles an hour. Gatecrashing a Washington party, he chatters about a plan to harness the life force, which will 'make atomic power look like the horse and buggy'. *Strangers on a Train* ironically remembers a sedater age, when horses were the swiftest means of locomotion. Walker seductively chases Granger's wife on the bobbing horses of a carousel, which gently move up and down while going nowhere. The cavalcade takes a humorously nostalgic pleasure in slow motion.

That's why it serves the purposes of dalliance: the woman being pursued does not really want to escape. Elsewhere, the park's amusements cater to the more frenzied, extra-terrestrial tastes of the 1950s. On his second visit, Walker lingers in front of a machine that whirls its riders through the air inside buckets, as if treating them to a preview of space travel. Finally the sedentary merry-go-round lurches off its rocker, bouncing away from its anchorage and refusing to stop even when the electrical supply is unplugged. A hysterical woman in the crowd screams for her son, but he grins with delight as it bucks and gyres beneath him. He knows he is at the movies, and as the Korean inventor Nam June Paik has said, the word video really means 'I fly', not 'I see'. The chairs in which the audience sits are no longer anchored to the ground; they are like ejector seats in a jet, liable to catapult us across the sky. Hitchcock's films deliver thrills, but point out how spurious how they are. The artificial cascade at the entrance to the Tunnel of Love in *Strangers on a Train* is churned into froth by a useless mill-wheel. Hitchcock both caters to the craving for revved-up excitements, and staidly criticizes it.

The two motives clash inside the New York apartment to which he confined the action of *Rope*. There is no space here for the whirlwinds whipped up by the funfair. Bones in *Saboteur* calls the American West a 'desert sea'. The skyscrapers ranged outside the window of the Sutton Place penthouse make up a desert of stone; but inside the room, as the camera prowls around during those ten-minute takes, nothing is rooted. Even the furniture – to use the term employed by the technicians – was 'wild': tables, bookshelves and walls had to slither aside or fly upwards. Despite its apparent fixity, *Rope* extends the same invitation as the carnival barker in *Strangers on a Train*, who calls out: 'Take a ride, take a slide.' The skyscrapers go along on the journey. *Rope* observes the unities of time and place that were mandatory in classical tragedy, and the miniature city in the background assumes the function of a Greek chorus, cued to register every change in psychological atmosphere. But this chorus, like an audience in the cinema watching one of Hitchcock's films, can exhibit only the emotions it has been programmed to feel; it has no power to intervene. The painted sky first flushes, as the sun sets during the cocktail party,

then frowningly darkens. At last, after nightfall, it makes a sign: an announcement spelled out in glaring neon, which ignites a word it cannot speak. The word, however, offers neither comfort nor commiseration.

Stewart, who always has one eye on the monoliths of midtown, describes detection architecturally. Surmising that the young men might have kidnapped their friend, he says, 'It's odd the way one can pyramid simple facts into wild fantasies, isn't it?' The pyramidal buildings are a deductive ladder, up which he climbs towards the truth; the sky above them is a collective mind, and the louring clouds tethered there throughout the film are its dubious thoughts. You can interpret the action by following this meteorological monologue. At first the sky is neutral, metallic, the clouds like immobile clods. Soon, as the party begins, a single chimney – positioned just above an open champagne bottle inside the room – starts to smoke. The city simmers, evacuating nervous unease like the bottle when it expels its bubbles. Then the clouds flush yellow or faintly pink, and the grey sky, sensitized, turns blue like a bruise. Granger is embarrassed by the story about his chicken-strangling, and the sky flares up on his behalf, suffused as if with blood. The next tint is green, acidic: the sour, curdling tone of decay, as things in the room begin to go wrong. The buildings flash with light, chimneys fume, a siren wails. This is dusk, when the city's purpose changes from labour to the satisfaction of desire.

Soon afterwards the sky is striped with dark, the buildings punctured by light. A nearby neon sign appears as Stewart assumes command and strides across the room past a side window that until now has been ignored by the camera. The sign is not yet alight, and is interrupted by a pillar. But the letters 'S' and 'R' are visible; when the angle changes, an 'A' is added. Has the mute city learned a language in which it can protest? Neon is a denunciatory writing on the sky, as if on the wall at Belshazzar's feast. At last, as Stewart discloses what he knows, the neon spills into the room and irradiates the air in a systolic pattern of red, white and green: a palette of prohibition and permission, like traffic signals with their commands to stop and go. One more letter is obliquely glimpsed: a 'T' after the 'S' – still not enough

to make up a word. Is the sign trying to say 'ASTORIA'? But surely the Waldorf, which is anyway situated several blocks to the west, would not advertise in brash neon. No, the word, as we are left to guess, is 'STORAGE': a facetious comment on the body bundled into a makeshift coffin, and on the skyscrapers that are filing cabinets for people. At least the windows in the Greenwich Village courtyard that Stewart studies in a later film contain live specimens. The skyline in *Rope*, by contrast, is a meticulously orderly vertical cemetery.

North by Northwest introduces an even more austere and abstract New York – the capital of modernity, as diagrammatic and rectilinear as Mondrian's patterns of coloured tape in *Broadway Boogie-Woogie*. The sliding, interlocking lines of Saul Bass's credit titles, driven by Herrmann's fandango, depict the city as a technically immaculate machine. Those diagonals are the incarcerating parallelogram of the Manhattan grid, and at the end of the credits, the urgent lines dissolve into a glass-walled skyscraper. They mark out the trajectory of the rush-hour crowds, hustled through the streets in the opening sequence. Cary Grant plays Roger O. Thornhill, a Manhattanite who knows how to exist inside the parameters of Bass's design. His commandment to himself is: 'Think thin,' as if he wanted to emulate one of those high-powered, hurried lines. He has already refined away part of his name. The 'O.', he explains, stands for nothing.

Having dispensed with such excess baggage, he is slick, sleek, quick on his feet – adept at dictating memos in the street, and at hijacking a cab when his secretary refuses to trot beside him for two blocks from Madison Avenue to the Plaza Hotel. He knows that the secret of survival is to keep your energy stoked up, and tells the lazy secretary to use her reserves of blood sugar. In his own case, he looks forward to two Martinis after work, though he tries to refuse the bottle of bourbon that the kidnappers pour into him at Glen Cove: 'I've had enough stimulation for one day.' An advertising man, he is himself an advertisement for the pampered American way of life. His schedule for the next day includes a 'Skin Glow rehearsal', and the very title of the film might be one of his insidiously memorable, meaningless coinages. No compass is capable of pointing north by northwest, but the slogan – glimpsed in the Chicago airport – serves

as a catchy sales pitch for an actual airline. Making love to Grant on the train to Chicago, Eva Marie Saint comments that advertisers sell people things they don't need, and the selling is done by sex. She is a satisfied customer, happy with her purchase. He disentangles himself for a breather and reflects on his success with a grimace and a grin: 'I'm beginning to think I'm underpaid.' Grant makes the cheeky remark in his own person, not as Thornhill, the actor's flimsy alias. A star is a commodity; Grant, to the director's abiding chagrin, was paid more for the film than Hitchcock.

Stalking through New York, Grant imagines that he can operate this grand apparatus of steel, stone, concrete and glass. Of course his professional haste leaves a mess of unfinished business and broken promises behind him. Chased on to the train by a posse of cops who want him for the murder at the United Nations, he explains his predicament to Eva Marie Saint with a cocky smirk: 'Seven unpaid parking tickets.' In New York, you are penalized for being stationary. But Grant has not understood Hitchcock's America, where there are ruling powers that can veto the 'hidden persuaders' of Madison Avenue. Those converging arrows in the credits are the vectors of fate, and the points of their intersection produce terrifying coincidences. Grant, signalling to a page boy at the Plaza, steps into the spectral outline of a government agent who, like Thornhill's middle initial, is a literal nonentity. A geometrically minded god looks down from a dizzy height as Grant runs out of the United Nations, and takes note of his cosmic insignificance. The scuttling figure is a speck beneath a wall that resembles a vitreous ski-slope, a device for free fall.

North by Northwest keeps irresistibly moving, even though it proceeds in a direction that does not exist, and its final landfall is a town in South Dakota named, with exquisite aptness, Rapid City. This detour alters the epic course of American exploration, which proceeded unstoppably from east to west. Even Fritz Lang followed that triumphal route, and in Western Union, made in 1941, he celebrated the completion of the railway that linked the two coasts. Once it leaves Chicago, North by Northwest also turns into an oblique account of America's open spaces – a Hitchcockian Western. It was not his first exercise in this unaccustomed genre. At the end of Strangers on a

Train, Granger and Walker grapple on horseback, with Granger grabbing a bridle to support himself. Then, falling off their mounts, they punch one another beneath the rhythmically pounding hooves. But this is a static stampede. Those wooden animals, running on the spot, resemble nothing so much as the patterns of galloping horses, artificially animated by light, that coursed in pointless circles on the zoetrope, that humble ancestor of the cinema. Hitchcock, in a sequence that deployed all the illusory technology of model shots and back projection, jokingly suggests that the windy, exhilarating terrain of the frontier existed only inside a movie studio; it was the Western that retroactively created the myth of the American West.

In *North by Northwest*, a bus drops a man in a blue business suit at the Prairie Stop on Highway 41, half an hour outside Chicago. Grant rides to his rendezvous in a vehicle that no cowboy would have approved of; he has still not shed his New York clothes. The West in which he alights is a vacancy, minimally written on by men. God always geometrizes and so, studying the terrain from a steep vertical angle, does Hitchcock. The road slants diagonally across the screen, with the upright poles of fence-posts like aborted trees planted at unnaturally regular intervals. The traces of ploughing in the fields are equally strict. The bus pulls away in a cloud of dust. Grant is the only moving thing in this lunar waste, though the aerial perspective turns him into an uprooted fence-post. The West is land that men conquer and cultivate; but here their progressive efforts have been abandoned. As Grant waits at the bus stop, the camera notices one field of corn in this brown desert. It is a jungle of desiccated stalks – grown but never harvested. Meanwhile a crop-dusting plane, madly persisting in the routine that fertilizes the desolate earth, dusts crops that do not exist.

The expected encounter soon occurs, though it does not follow the salutary rules of the Western shoot-out. A car emerges from behind the tattered corn and deposits a man whose face is shaded by a hat on the other side of the highway. (Grant's bare head is another sign that he has strayed into the wrong genre; even the wardrobe department has deserted him.) The two figures face each other under the ruthless sun, separated by the road that tapers to its vanishing point on the flat

horizon. They are ready for the immemorial showdown in the Western street, though they lack the demeanour of gunfighters. The newcomer has his hands in his back pockets. Grant shifts nervously on his feet, then awkwardly places his hands on his hips. After that he lets them drop to his sides, though he has not accessorized his suit with a gunbelt. But he goes through the motions prescribed by the Western, and walks across the highway towards his opponent. Just abreast of the other man, he says 'Hi' – surely the etiquette of the gun battle debars such greetings – and, to signal his unreadiness for this kind of Western encounter, pleadingly clasps his hands in front of him. Held like this, they are of no use in reaching for a weapon, even if he had one. The stranger notices the distant plane and – with a laconic fatalism that is, at last, genuinely Western – remarks, 'Some of these crop-dusting pilots get rich – if they live long enough.'

Left alone, Grant faces an aerial sniper, and saves himself by reacting as no Western hero ever would. He runs for cover, goes to ground among the unharvested corn, then desperately halts a passing oil tanker. A malign geometer continues to plot coincidences. The plane swoops low towards the tanker and crashes into it. Grant, quitting the inhospitable frontier, scurries back to Chicago in a truck he steals from a farmer. It has a refrigerator propped in the back, so the theft is a setback for the owner's campaign to civilize the scorching plains. He runs along behind, shaking his fist as this trophy of progress returns east.

After this tactical retreat, Grant is forced to resume his cross-country journey. He resists: 'I've seen Mount Rushmore,' he says at the airport. His weary inflection dismisses a West that has been colonized by political propaganda and overrun by mass tourism. The Westerns made by John Ford in Monument Valley treat the tapering buttes as symbols of heroic man, weathered by nature but indomitably enduring. Rock is slowly eroded into a likeness of the human form: the geological world has its own abrasive campaigns. At Mount Rushmore, nature is humanized by industrial force, which reduces a mountain to a three-dimensional billboard. Frank Lloyd Wright allegedly said that Mount Rushmore seemed to have redesigned itself in response to mankind's prayer. In fact it surrendered to dynamite and electric

drills. Hitchcock finds an angle from which he can expose the myth. Escaping through the woods, Grant and Eva Marie Saint arrive at the top of the monument. Seen from above and behind, it is all unkempt, non-representational rubble, and the presidential egg-heads are more obtuse and insentient than human skulls.

The dapper Grant and his co-star, whose high heels place her at a disadvantage in scrambling down the mountain, make a vow to return to New York by train when the job is done. The rest of the westward trek can be left to others. The characters of *Vertigo*, made immediately before *North by Northwest*, had already completed the journey, though San Francisco is for them a tragic terminus, a place where you go to drop out, like the depressive cop played by Stewart, or to die. *Psycho*, Hitchcock's next film, does not quite get to the coast.

Absconding with the envelope of dollars, Janet Leigh drives towards California in pursuit of happiness. The pursuit ends prematurely in her cabin at the motel. Hitchcock changed the itinerary of Bloch's heroine so as to include the last stage of that cross-country pilgrimage in quest of orange groves or holly woods or surfy beaches or Barbary coasts or (as Leigh puts it in the film) private islands. In the novel, she sets out from Dallas and travels north through Texas. Leigh, however, begins in Phoenix and travels west across the state line. After being woken by the cop, she turns at an intersection that, according to its signpost, is only seventy miles from Los Angeles. Her eye is attracted by the California licence-plates in the used-car lot, owned by a dealer called California Charlie; she also buys the *LA Times* while changing cars. She has already unwittingly arrived there: this scene was filmed in the San Fernando Valley, just a few miles from Universal Studios, and on her way to the lot she drives past palm trees – not a natural growth in the vicinity of the Bates Motel, where the vegetation is Gothic, emaciated, twisted. Following her trail, John Gavin and Vera Miles adopt a variant of her course. Gavin tells Perkins that they were hoping to travel straight through to San Francisco; they have decided to stop overnight because they don't like the look of the weather. But you only arrive at the motel if you have quit the high-speed, hopeful route that leads west. As Perkins says, 'they moved away the highway'. He is stranded somewhere off the

map, in a warped, looped backwater. Beyond the motel there is only the cloacal swamp, which gobbles up cars, bodies, bundles of irrelevant money: an alternative American destination.

Between Phoenix and Los Angeles is the desert, with its mercenary mirages. The flirtatious oil man whose wad Leigh steals recommends a weekend in Las Vegas, 'playground of the world'. She is probably – in Hitchcock's stern reckoning – better off at the motel, where, after her conversation with Perkins, she remorsefully renounces her belief that she has a right to happiness. Even the venal oil man corrects the constitutional dogma. He admits that money won't make you happy; it can only protect you from unhappiness. Miles persists in equating cash with felicity, and imagines that Perkins, stuck with an unprofitable business, stole the money from her sister. She cannot conceive of the dutiful, almost vocational acceptance of unhappiness that Leigh and Perkins share in their long talk. Having decided to return to Phoenix, Leigh takes her shower. Its purpose might be ritually to lave what Scott Fitzgerald called the 'foul dust' of American dreams. Mrs Bates, unfortunately, has other ideas about purification.

The shower is necessary because all those entropic American dreams generate such a seamy, unseasonal heat. Phoenix swelters, even though an opening title – inserted to explain the presence of Christmas decorations in the torrid streets – gives the date as December 11. The oil man complains because the realtor's outer office is not air-conditioned, and the car dealer shakes his head over the sweaty expenditure of energy and money, both of which should be cautiously conserved, when Leigh impatiently accepts his price: 'First time the customer ever high-pressured the salesman.' America is overexcited, in need of a cold shower and perhaps of sedation. Patricia Hitchcock, playing Leigh's secretarial colleague, offers her some tranquillizers for her headache, and confides that her mother gave them to her on her wedding day. We are a long way from the vitamin pills guzzled by Walker in *Strangers on a Train*: now, in an anxious, therapeutic culture, the life-saving imperative is to lower your vitality and neutralize excitements, even if that means dozing through the consummation of your marriage. Leigh refuses the remedy that supplies instant nirvana or oblivion, and separates herself from this

chemical version of the American dream. 'You can't,' she says, 'buy off unhappiness with pills.'

Hitchcock made it his business to remind optimistic America of mortality. He wanted to conclude *The Birds* with a preview of man's expulsion from California: driving back from Bodega Bay, the characters would have reached the Golden Gate and found that its rigging, meant to clamp the headlands together and solemnize American dominion over the ocean, now served as a jostling roost for birds. The avenues that lead to a remote, illusory future are closed off. The Baltimore street in *Marnie* abruptly ends with a matte-painted ship, docked there just a few yards away. It does not offer escape; ships like this brought abusive sailors to buy sex at the house of Marnie's mother, so the foreclosed vista measures the limitation of lives. Meanwhile the glossy America of mod cons recedes into a past that is funereally dim, like the filtered gloom of the sequoias at Big Basin in *Vertigo*. Or else it reverts to the jungle. In Winston Graham's novel *Marnie*, the heroine's boss has a collection of Greek pottery from Crete and Delos. He asks Marnie if she is interested in such things; she could not care less. When Hitchcock transferred the story from England to America, he changed the provenance of the relics. Now Mark (Sean Connery) shares his office in Philadelphia with an array of grimacing pre-Columbian totems – images of America's ravenous native gods, never altogether usurped by the kindlier imported deity of the Spanish missionaries. The Marnie of Graham's novel is becalmed in the English Midlands; the closest she gets to equatorial culture is when someone trying to lure her on to the dance floor at an office party asks: 'Can you do Latin American?' But Hedren, as Hitchcock's Marnie, undergoes instruction in such matters when Connery sets her to type out his manuscript on *Arboreal Predators of the Brazilian Rain Forest*. He is a frustrated zoologist, and specializes in the study of instinctual behaviour, which we derive from our fanged, clawed ancestors in the forest. Bagging Hedren for his menagerie, he boasts that he has 'caught something really wild this time'. This zoo-keeper, obsessed with disciplining and sexually dominating the beasts he traps, is as crazed as the psychiatrist who regulates his fellow lunatics in *Spellbound*.

Philadelphia, despite its official ethic of temperate brotherly love, is not so very distant from the savagery of tropical America. Hedren goes berserk when a storm interrupts her typing. Lightning scythes through a tree, which crashes into the room and splinters the glass case containing the barbarous gods. 'The building is grounded,' Connery says. But that is no guarantee of our safety. Watching Hitchcock's films, we are assailed by the same turbulent energies, which seem to rip the protective screen; all of us are buffeted by the private tempest of desire and fear he stirs up. Are we purchasing happiness at the movies, or experimenting with self-destruction?

The Technique of Murder

Black, White, and Red

Entering the kingdom of shadows in Portland Place: a storyboard for Hannay's flat in *The 39 Steps*.

Having grown up with the movies, we take them for granted, and can hardly imagine the shock – physical, psychological and spiritual – of their arrival in the world. In *Bedlam*, produced in 1946 by Val Lewton and directed by Mark Robson, the idea of the moving picture is dreamed up by a madman in an eighteenth-century asylum. He draws sequences of pictures on the page-corners of a book, and flips through them so that they seem to start into life. If only he could get a light behind them, he says, he could throw them on to a wall. A fellow inmate suggests that they might charge admission. Then the anachronistic inventor remembers 'It's because of these pictures that I'm in here.' Who but a lunatic would dare to imagine such a thing? Hitchcock, whose career began in the 1920s as the new art experimented with novel ways of representing reality, never lost sight of the cinema's strangeness. He regarded it with awe, warily amazed at the power it possessed. Stevie in *Sabotage* has to walk to Piccadilly with the tins containing *Bartholomew the Strangler*, which he cannot carry on to public transport. Film is rightly debarred because it is flammable; in this case, it is explosive as well as combustible. Defying prohibitions, Stevie sweet-talks his way on to a bus, which is blown away by the energy stored in those cans of looped imagery.

Hitchcock personified the art he practised. In exploring its possibilities, he discovered himself, and the medium's technical edicts became the constituents of his bizarre and violent world-view. To begin with, the cinema was monochrome and silent. Hitchcock relished these limitations, which made films look and sound like dreams or like death. The agitated mobility of motion pictures worried him. Were those giddy wraiths alive, or merely undead? In 1945 the critic André Bazin traced 'the ontology of the photographic image' back to the funerary practices of ancient Egypt. Photography had finally made it possible for men to halt time and preserve the body from decay by fixing an image of it, so film caters to what Bazin called our 'mummy complex'. Hitchcock proved the point with astonishing literalness. Like Bazin's

Egyptian embalmers, he shows how we can 'keep up appearances in the face of death by preserving flesh and bone'. Miss Froy in *The Lady Vanishes* is bandaged from top to toe in mummy cloths, and Mrs Bates is tanned and pickled. These images – glimpses from outside human experience – flicker into life on a screen. This too was an amenity that had a complex meaning for Hitchcock. Traditionally, screens conceal whatever is behind them. The movie screen could be used to expose truth, and also to occlude it.

Films assembled the stories they told in a new and non-consecutive way. The world is chopped into fragments, then pieced back together. Having learned the technique of editing, Hitchcock discovered that it was a rehearsal for murder. Montage testified, as the Hungarian theorist Béla Balázs declared in 1945, to 'the power of the scissors'. In 1955 Josef von Sternberg flourished the shears at recalcitrant stars, warning them that a 'posthumous operator, known as a cutter, literally cuts the actor's words and face'. Hitchcock shared this relish for the editorial blades. When suturing together clips of murders from his films, he chose for the last of these bleeding chunks Grace Kelly's deadly recourse to her sewing kit in *Dial M for Murder*, which proved the fatal efficacy of the scissors.

Though dismemberment was practised in the editing suite, this analytical surgery produced an account of the human body more intimately intrusive than anything ever seen before. Film studied the body sectionally, often in dazingly amplified close-ups. Hitchcock, as Godard said, is 'the director of the couple'; more than that, the way he fits body parts together shows how coupling occurs. The director (and, thanks to him, the spectator) is a third party in these corporeal duets, tolerated because invisible. The camera in Hitchcock's films wanders all over the physiques of its subjects, fascinated by their hair and the backs of their heads, their feet and their fists, and of course their lips. But it pays fascinated tribute to one organ in particular, whose power the cinema so startlingly augmented. That organ is the eye; film turns us into both visionaries and voyeurs.

The shock from which Hitchcock never recovered was first registered by Maxim Gorky, after his visit to a fair in Nizhnii-Novgorod in 1896. In a room at a restaurant that had been darkened for the pur-

pose, he saw his first film, a brief documentation of a train's arrival at a station by the Lumière brothers. Gorky described the event as his induction into 'the Kingdom of Shadows'. Like Hitchcock, he understood at once that the cinema was somehow spectral – otherworldly, or perhaps an underworld. 'If you only knew,' Gorky wrote for the benefit of those who had not yet had the mystical experience, 'how strange it is to be there.' Colour had drained out of things; even trains made no sounds. He speculated that some ingenious goblin had been at work, stopping people's mouths and blanching their bodies to a dismally uniform grey, condemning them to a purgatorial parody of existence, and he shuddered at the ease with which the spell went to work: 'Suddenly something clicks, everything vanishes and a train appears on the screen. It speeds straight at you – watch out!' Naive audiences recoiled from that advancing train. Hitchcock was still able to startle us into the same retreat more than fifty years later, when the oil tanker that Cary Grant tries to flag down in *North by Northwest* charges at the screen and seems to run over him and us.

The Lumière brothers photographed scenes from daylight actuality, at railway stations or outside factories, which could only frighten someone who knew nothing about cinematography. Hitchcock, as if attempting to understand the genuinely spooky nature of the cinema, told specialized stories about people travelling into the realm of shadows. With luck, they reappear: a lady vanishes on board one of his trains, then steps back from shadow into substance. On other occasions, they do not reascend to the light. Could we bear it if they did? The attraction of *Rebecca*, for Hitchcock, was to film a story about a woman who is dead before it begins and who never reappears even in flashback, though her shadow is omnipresent, like the ghosts or evil spirits who must – as Gorky thought – somehow have dwarfed and diminished the living people at the railway station and deprived them of energy. After describing those 'soundless spectres', Gorky rapidly explained how they came to be that way, anxious that his readers should not suspect him of 'madness or indulgence in symbolism'. Hitchcock had less compunction about indulging in symbolism, and the kind of art he created, which cajoled reality into the semblance of fantasy, was madness by other means.

Perhaps Gorky's assumption that the travellers photographed by the Lumières had fallen victim to 'Merlin's vicious trick' was not entirely fanciful. The anthropologist Claude Lévi-Strauss accepts, with proper deference, the capacity of sorcerers to place a curse on individuals, as Australian aborigines do when pointing the bone at someone who has offended tribal customs. The targeted person forfeits the right to exist. Cast out by the community, his social personality dissolves; death, induced by a cataclysmic terror, soon follows. Lévi-Strauss, fortuitously varying the phrase used by Gorky, explains that 'sacred rites are held to despatch [the victim] to the realm of shadows'. Lining up to see Hitchcock's films, we pay for the privilege of consignment to that subliminal land. Or perhaps we watch them on video, preferably with the television set positioned at the foot of our beds: we are asking the film to help us make the transition between waking and sleep, or between life and whatever comes next.

The irresistible appeal of the cinema is nullification, nihilism. A film, as John Boorman has said, is a way of turning money into light. Marnie, in the novel by Winston Graham on which Hitchcock based his film, works as a cinema usherette in Manchester. Early in the novel, after robbing the cinema's safe and stealing the money that people have paid to watch light perform its delusive tricks, she transcribes some fatuous romantic dialogue delivered by characters on the screen. 'That stuff,' she comments, 'was as real as nothing.' Much later, the phrase recurs. She has invented a false identity for herself and then, having committed another robbery, causes her alias to vanish into air, as a film would do if daylight leaked in. 'It was funny,' she says. 'There was nothing. Mary Taylor was as real as nothing.' Her phrase has a cynical, scornful inflection; for Hitchcock, as for the shaman described by Lévi-Strauss, the transformation of reality into nothingness was an occasion for numinous wonder.

Gorky thought that those first monochromatic films merged all tones into grey. Hitchcock preferred to maintain the polarities of white and black, which match the moral chiaroscuro of his world. 'Think of white, white!' Bergman beseeches Peck during a psychoanalytic session in Spellbound. The cinema, shining a beam from its projector through the darkness, might be an illustration of Freud's

therapeutic aim, which was to press the lucid ego into the obscure hiding places of the id. But Peck recoils from white tablecloths and fresh snow. The idea of whiteness is sullied by his memories of a crime. Although Bergman optimistically insists, 'We have the word white on our side,' you can only think of white by conjuring up its opposite, black. The first version of *The Man Who Knew Too Much* neatly indicates their interdependence when the scene changes from St Moritz to London. A last alpine panorama looks out across the mountains, with black rocks jutting through the white counterpane of snow. The landscape then dissolves to Piccadilly Circus after dark, with a neon sign flashing on and off. It advertises a brand of Scotch whisky called BLACK & WHITE; it also measures the oscillation of Hitchcock's characters between despair and hope.

Black and white inevitably blur. There is, as Gorky perceived, a grey area between them, and it is here that Hitchcock set *The Lodger*, which he subtitled *A Tale of the London Fog*. Mist stifles the daylight; the killer emerges from and retires into this atmospheric camouflage. Mrs Belloc-Lowndes, in the novel Hitchcock adapted, conceived of the murderer as a personification of the cinema, mysteriously juggling light and darkness. The landlady 'always visioned The Avenger as a black shadow in the centre of a bright, blinding light – but the shadow had no form or definite substance'. Every element in that sentence, especially the suggestive verb 'visioned', could be applied to the shady phenomenology of film. With Mrs Bunting's connivance, her guilty lodger escapes detection at the end of the novel by using an emergency exit at Madame Tussaud's. It is as if he has hurtled out of the cinema, and cannot adjust to the sunny normality of the streets: the curtains are pulled aside, the door is opened, and 'the light, for a moment, blinded Mr Sleuth'.

Hitchcock's early films often include beautifully abstract essays on light and the darkness that, like the villain in *The Lodger*, tries to extinguish it. In *The Manxman*, released in 1928, he designed a battle of light sources, which dramatizes the quandary of the heroine. Pete sets sail for Africa, leaving Kate behind on the Isle of Man; she betrays him with his best friend Philip. On the night before he departs, Pete climbs up to her bedroom window to say goodbye. She

promises to wait for him, then sharply tugs down the blind – a permeable, unprotective screen, like that on which the cinema projects its images – to shield her distress, or perhaps to cut off the association between them. But she remains visible in silhouette, her outlines etched by the lamp in her room. After he leaves, she peeps round the corner of the blind, then settles down to sit in the window. The intermittent beam from the island's lighthouse rakes her face, and causes the air to flare up and subside. She is caught between two alternative lights, which represent the choice between domesticity and adventure: the candle, sedately tended by the Virgin in Georges de la Tour's painting, and the fickle beam that sends out messages to seafarers, travelling in a circle before it returns to the spot from which it began. The war of lights goes on for a while, before she is slowly engulfed by darkness.

Number Seventeen, released in 1932, is equally abstract in its treatment of the medium. Its plot, which has something to do with the theft of jewels, is the excuse for an anthology of scenic effects without narrative causes. The fumbling intrigue in an old dark house enables Hitchcock to explore the scary insubstantiality of cinematic images. The characters experiment with different ways of casting shadows – striking matches, or holding up candles – and react with absurd dread to the phantoms they have projected. Hands belonging to no discernible body clutch and grip in close-up. Sounds too are disembodied. The house, as the dosser Ben says with a shudder, is full of 'footsteps with no feet'.

Gorky gently derided those in the audience at Nizhnii-Novgorod who were duped by that 'train of shadows'. Hitchcock took shadows more seriously. Like photography itself, they write with light, though the signals they inscribe are dark. Doubt is a shadow, intruding on the sunny blandness of Santa Rosa. The arsonist in *Saboteur* appears during the credit titles as a looming silhouette, soiling the corrugated-iron wall of the factory he has destroyed. In the personal prologue that he attached to *The Wrong Man*, Hitchcock himself – reversing the route taken by the killer in Mrs Belloc-Lowndes's novel – walks out of the light into the dark hangar of an empty studio, ominously preceded by a shadow that elongates his body; he has come

into this underworld to introduce a story about a man who took an involuntary trip into the terrain of shades.

We have no control over our shadows. They escape from the body that casts them; being projections, they may have tales to tell about us. At the beginning of *Dial M for Murder*, the shadows of Grace Kelly and Robert Cummings fuse on the door of her London flat, embracing. The coupled wraiths move briskly apart as the door opens to admit her husband, Ray Milland. For the survivors of the shipwreck in *Lifeboat*, shade represents relief from the blistering sun. The cinema moved its headquarters from New York to Los Angeles because of the year-round fine weather, but in *Lifeboat* Hume Cronyn prays for an overcast sky and rain to supply fresh water. 'Does it look to you as if those clouds are darkening up?' he asks. Hitchcock turns on a downpour, which lasts for a few seconds, depositing a meagre puddle in the outstretched sail. Then the droplets evaporate, arcs of bright sun scorch the canvas, and shadows – which here offer shelter – are expunged.

The people in *Lifeboat* are taunted and tormented by light, which the heliocentric cinema supposedly worshipped. D. W. Griffith made it a point of moral principle always to use natural light when filming, as thanksgiving for the sun; F. W. Murnau paid the same homage to the source of life in *Sunrise*. In *Suspicion*, Cary Grant – who first makes himself felt in the charcoal blackness of a railway tunnel – pretends to be a child of the sun, one of those alfresco hedonists who romped through the 1930s. Though he and Joan Fontaine live in Sussex, the nearby coast is patently Californian; his business partner Nigel Bruce shows off the plans for a clifftop holiday resort, enthusing 'What sun! What air!' The house Grant and Fontaine rent, designed by Van Nest Polglase, is like his glaringly laminated white sets for the musicals of Fred Astaire and Ginger Rogers – although the high windows that admit an un-English sun also cast shadows like an enmeshing spider's web. Hitchcock, no sun-worshipper, thought only of light's malevolence, its searing harshness, its almost toxic electric intensity. Already suffering the first symptoms of poisoning, Ingrid Bergman goes to visit her CIA controller in *Notorious*. She winces, holds her aching head, and asks him to draw the blinds.

He blames the fierce radiance of Rio de Janeiro: 'Some people get too much sun down here.' The wise old doctor in *Spellbound*, Bergman's mentor, has a clinical name for this reaction. He assumes that Peck is frightened by light, and diagnoses photophobia.

It is a strange ailment for a film-maker to be treating. Hitchcock passes it on to the cinema proprietor in *Sabotage*. The film begins with the tingling filaments of a light bulb – that icon of modernity, which the Italian futurists saw as a tragic symbol: cracklingly alive, furiously energized, yet doomed to expire. The bulb falters as the voltage from the sabotaged power station fails, then goes out. When the power is restored, Oskar Homolka glares in close-up at an incandescent bulb. Like a small sun suspended from the ceiling, it mocks him by flaunting its recovery. Hitchcock continued to contrive surreal punishments for impudent light bulbs. In *Suspicion* he drowned one in a glass of milk, though it continued shining when submerged: its radioactive glow warns that the soporific drink Grant brings to Fontaine may possibly be poisoned.

Leslie Banks, ensconced in the dentist's chair in the 1934 *Man Who Knew Too Much*, squirms beneath a spotlight as painful as a dental drill. The kidnapped statesman in *Foreign Correspondent* is literally grilled, interrogated by a battery of lights. The piled bulbs, branded EMPIRE ELECTRIC PHOTO FLOOD LAMPS, resemble cudgels in close-up. Behind the glare, the old man's tormentors line up under cover of darkness, like the technical crew on a film set. Upstairs during the blackout at the cinema in *Sabotage*, Sylvia Sidney finds Homolka shamming sleep, and shines a torch – an usherette's tool of trade – at him. He shields himself, terrified, unable to see her behind the fuzzy beam. Persecuted by light, Homolka suddenly has our sympathy, as does Raymond Burr when Stewart in *Rear Window* discharges flashbulbs in his face, producing a sickly yellow nimbus like the halation of some unknown planet. Which of us likes to have the private darkness inside our heads invaded? Janet Leigh is punished by the headlights of oncoming cars in *Psycho*, and in the fruit cellar Vera Miles is also traumatized by a lighting effect. As she recoils from the figure in the chair, she knocks a bulb that hangs from the ceiling. It ricochets to and fro, and a jagged blitz of shadows twists the wizened face of the

corpse into a fit of laughter. Lightning, as Frankenstein discovered, can revivify the dead.

Photography complicated the ancient opposition between white and black by showing them to be reversible. On the negative, each is negated: black and white change places. *Rear Window*, during its initial tour of Stewart's apartment, observes an example of this devious alchemy. Stewart has framed the negative of a portrait, which depicts a woman whose breasts jut out of a low-cut dress. She has black skin; the dress is white. Then the camera slides sideways to a pile of *Life* magazines, with the portrait on the cover. Tonal and racial values are suddenly altered: she is a white woman in a black dress. Hitchcock issued his heroines with Manichean underwear, enabling them to demonstrate their moral progress by changing their lingerie. Leigh wears a white bra and panties for her tryst with Gavin in the hotel, then changes to black before packing her bag to run off with the oil man's money.

Perhaps Hitchcock's infamous fixation on blondes derived from the fact that this unnatural hair colour, like photography, relied on a magic chemical, capable of altering black to white. The mysteries of the hair-tinting salon – exhibited in *Vertigo* when Kim Novak changes from brunette to blonde, recapitulated in *Marnie* when Tippi Hedren undergoes the same alchemical change in her hotel bathroom – resemble those of the photographic dark room. After immersion in a tank, the negative turns into a positive. Hitchcock preferred to reverse the process: the blonde, whether silvery like Novak or golden like Hedren, has negated whatever more positive colour she was born with.

This skill at tonal deceit incited Hitchcock's curiosity, and maybe also his anger. His killer in *The Lodger* has more specialized tastes than Mrs Belloc-Lowndes's Avenger. Hitchcock's character targets blondes, and some showgirls protectively revert to their natural colour: 'No more peroxide for yours truly!' giggles one of them. Jack Trevor Story's novel *The Trouble with Harry* might have sold itself to Hitchcock on the basis of one paragraph about the phenomenon of blondeness. Captain Wiles has just stumbled over Harry's corpse in the woods; a hobo is busy stealing his shoes. They are interrupted by

the town trollop and the town libertine, off to find a bed in the bracken. Story identifies the woman as 'a blonde', then adds that she 'was, moreover, A Blonde. One of the stereotyped blondes.' (Stereotyping, it should be noted, is an optical device: a technique, like photography, for artificially reproducing images.) He goes on to say that she was 'mass-produced by the age, thrown out by the million, conceived by progress, born of cinema out of magazine'. Though the novel was published in 1949, Story could be describing the blonde on the *Life* cover in *Rear Window*, made five years later. Magazines merchandized blondeness, but the cinema invented it. Platinum pallor suited the illusory world of film, where all objects were drenched in a lunar light. Story's blonde is 'one of the nameless, ageless women of the twentieth century' – a modern, peroxided Mona Lisa.

Bergman is wrong to place such faith in unspotted whiteness in *Spellbound*. So is Peck, who proposes to her after they ski through the bleached cleft of Gabriel Valley: 'You'll look wonderful in white,' he says, adding a little orange blossom to colour the mental picture. White, as they both should know, can also mean erasure, obliteration. Peck dreams about a gambling house where the cards are blank, and a man whose face is muffled by a white mask. Leo G. Carroll, who also happens to be the man with no face, interprets the dream by seizing on white as the colour of denial, or what Freudian psychiatry calls abreaction: those spurious, unmarked cards signal that the place was not a gambling house at all. Bergman's mentor dopes Peck, who is on the prowl at night with an open razor, by giving him a glass of milk laced with bromide. The camera adopts Peck's point of view as he drinks it, so that he seems to be pouring it down our throats. The glass tilts, and its thick base frames and focuses the nervous old man as if studying him through a rifle sight; then the angle tips higher, and the watching figure drowns in the white liquid's rising level, like the demon who disappears beneath an avalanche of flour ground by the mill in Dreyer's *Vampyr*. Some whited-out frames follow: the ellipsis represents the swooning loss of consciousness.

Whether it fades to white or black, the end of a sequence always marks that dangerous instant when the eyes close, and reason succumbs to dreaming. Blackouts are the cover for crimes in *The Lodger*

and *Sabotage*. Though Hitchcock filmed *Rope* in what looks like a continuous take, the need to change reels required him to insert half a dozen barely noticeable lapses, which briefly black out the screen. Generally he managed it by having characters cross in front of the camera, impolitely blocking the viewfinder. These transitory blackouts coincide with crucial moments in the action. They may last no longer than a blink, but they give us a chance to visualize something we have not been shown. The third blackout is covered by Dall's back; as it happens, Stewart suddenly mentions the boy whose body is in the chest. The last blackout occurs when Stewart opens the casket, whose lid now blacks out the screen. 'I hope you like what you see,' cries Dall. We see nothing at all – except, during that spliced interval between the reels, what we ghoulishly spy on with the mind's eye.

Hitchcock's technical tricks always correspond to neurotic quirks, and force us to share his surrealized vision of the world. To mark the difference between sober reality and the derangement of dream, he wanted to make *Spellbound* partly in black and white and partly in colour, like a schizoid *Wizard of Oz*. Once again, Selznick prevailed, and colour only intrudes for a few subliminal seconds when Carroll commits suicide. He swivels his gun towards the camera and aims it directly at our heads. The explosion is followed by a few red frames, as a geyser of blood – his, and also ours – pours from the ruptured brain.

Colour here makes its first appearance in Hitchcock's starkly monochrome world, and it arrives as a stain. With his compulsive cleanliness, he did his best to keep it out, and said that he returned to black and white for *Psycho* so as not to show the mess made by Mrs Bates's killings. Colour continued to signify filth, like the blood that Macbeth calls 'incarnadine', or perhaps the unhealthy brightness of fever. 'Stop the colours!' shrieks Hedren in *Marnie* when lightning gashes the air. 'What is it about colours that bothers you?' asks Connery. What was it about them that bothered Hitchcock – a staid, monochrome man, buttoned into his white shirts and black suits? Colours alarmed him because they exposed the body's lurid, vivid interior, its humid tropical garden of irrigated organs. Hedren reacts with horror to a vase of red gladioli. Even the orange and crimson foliage of the

New England autumn in *The Trouble with Harry* is evidence of decay.

In *Vertigo*, Stewart's delirium is illustrated by the intermittent blue and purple flushes that drench his face as he lies in bed. He spends the second half of the film bleeding the colour from Novak, like a taxidermist emptying her veins. Reborn as Judy, with russet hair and a green dress, she has the colours of the loamy, fertile earth. Stewart forces her to reassume the ashen character of Madeleine, with a grey suit and white hair. During their love scene in the hotel, colour – dank, sickly, not the emanation of live bodies – is supplied by the neon sign outside the window. Neon has little in common with the vital radiance of D. W. Griffith's sun. It is a gas, and therefore colourless; its molecules need to be excited by electric energy, and then they blaze in an artificial spectrum. The Empire Hotel's sign gives off a green fire. It burns phosphorescently on the bathroom door while Novak makes the last adjustments to her hair and perfects her resemblance to a dead woman; when she comes out, it thickens into a miasma. The green pea-soupers of Hitchcock's youth, which clog the London streets in *The Lodger*, are here decanted into this meagre room, where they coldly steam as Novak and Stewart meet in a necrophiliac embrace.

Hitchcock only once permitted himself to sit back and admire colour, during the evening of pyrotechnics in *To Catch a Thief*. The fireworks sizzle in the velvety air and blush on the skins of Cary Grant and Grace Kelly as they wrestle on a sofa. It is as if all the champagne bottles on the Riviera had been uncorked, discharging their gilded foam into the sky, narrating a deliciously lengthy sexual bout in that hotel bedroom. Yet even here, there is a worrisome memory to contend with. In *Sabotage*, Homolka is ordered to deposit a parcel in the cloakroom at Piccadilly Circus; it contains the bomb that kills his stepson. He asks what kind of parcel it is, and his controller replies: 'Oh, let's say – a parcel of fireworks.' What are fireworks but pretty bombs, and what are orgasms, if it comes to that, but enjoyable deaths? Technicolor enabled Hitchcock to display all the terrors of the rainbow.

The Blind Ear

Sound made visible in a silent film: the transparent ceiling in
The Lodger, with Ivor Novello pacing upstairs.

Films, when Hitchcock began to make them, were eerily mute as well as colourless, and proud to be so. 'We do not want now,' declared D. W. Griffith in 1924, 'and we never shall want the human voice with our films.' Five years after that pronouncement, Hitchcock directed the first British film with synchronized sound, *Blackmail*; but he never reconciled himself to the innovation, and – like Chaplin, whose tramp remained stubbornly speechless after the advent of sound – was happy to dispense with dialogue. He often had characters converse in isolation chambers, so he would not be put to the bother of recording what they said. Granger's wife in *Strangers on a Train* works in a music shop; for their quarrel, he takes her into one of the sound-proofed booths where – in the days before headphones – people listened to records. Much of the plotting in *Topaz* is summarized in mime. Frederick Stafford briefs Roscoe Lee Browne, who plays a florist, inside the glazed refrigerator where he keeps his stock cool. Browne bribes a corrupt Cuban official in the lobby of a Harlem hotel, while we and Stafford, well out of earshot, watch from across the street, loud with traffic and the chanting of demonstrators.

Perverse as ever, Hitchcock preferred silence simply because it was abnormal. Never mind if it was merely an affectation. In *Number Seventeen*, the befurred female robber confines herself to smouldering glances. When the detective thanks her for bandaging his wound, one of her criminal colleagues snarls, 'She can neither hear nor speak.' The ideally compliant Hitchcock heroine, she is a doubly dumb blonde. Soon after this she leaves, and startles the detective by assuring him that she will return. 'That deaf and dumb business,' she says, 'was a fake.' The artificiality of the embargo suggests how important it was to Hitchcock. This wilful sensory deprivation gave the sequences to which he applied it the look of dreams. People float or glide across the screen. If they make no noise, do they actually exist? The dream's volume is turned down, or off. That makes it easier to break the law and escape undetected, as Hedren discovers

155

in *Marnie* after robbing the safe. She creeps out of the office, terrified that the old woman who is swabbing the floor will hear her. She even removes her high heels and stuffs them into her coat pockets. But one of her shoes gradually, tantalizingly jolts loose, and clatters to the ground. The cleaner does not look up: as luck would have it, she is deaf.

The schizophrenic hero of Patrick Hamilton's novel *Hangover Square* suffers a periodic loss of hearing, and he thinks of it cinematically. (Hamilton's novel was published in 1941, and filmed in 1945 by John Brahm. Laird Creager played the protagonist; in 1944, Brahm had directed him in a remake of *The Lodger*.) Hamilton's character suffers "'dead" moods', cued by a click in his head, which has the sound of a camera's shutter. The world around him is suddenly mortified. A film descends over his brain, a baffling barrier that separates him from other people. It is also a film of the other kind, but a retrograde one: 'It was as if he had been watching a talking film, and all at once the soundtrack had failed. . . . Life . . . which had been for him a moment ago a "talkie", had all at once become a silent film. And there was no music.' It is when he is in this anaesthetized state that he kills. Numbed, he no longer feels alive, and his prospective victims are silent, purposeless automata.

For Hamilton, silence signified neurosis. Hitchcock too valued it as a defect, an emotional deficiency. He took pleasure in fiddling with his soundtracks so as to deprive people of their rightful reactions, and transposed sounds from one mouth to another or from a human body to an engine. In *Young and Innocent* the girls who discover the film star's corpse on the beach open their mouths, but the sound they produce comes – after a quick editorial cut – from the beaks of some swooping gulls. Even more shrilly, in *The 39 Steps* the shriek of the charlady who finds the body is supplanted by the whistle of the train that is carrying Donat off to Scotland. What difference is there between a scream and a squawk? Isn't the charlady also, like the express train, letting off steam?

Laughton, deputizing for the director as the sadistic aesthete in *Jamaica Inn*, fires bullets from off-screen to ensure that his dependants maintain their vow of silence. Maureen O'Hara's aunt opens her

mouth to name him as the leader of the gang, then falls dead. The innkeeper asks for a drink but doesn't need it, since he too slumps to the floor. Laughton, strolling into view, directorially prides himself on a 'good clean shot'. O'Hara incommodes him by screaming. To kill her is not an option, because he plans to carry her off to France. He silences her instead with some fussy bondage. 'I shall have to put this handkerchief in your mouth,' he warns. 'You must tell me if that hurts. Of course you can't, how silly of me': he has already gagged her. He manacles her hands with the same delicacy, and loops a cloth around them so that the cord won't bite into her wrists. Silence, along with the adroit application of some twine, guarantees sexual passivity.

Religions too have their silent orders. Hitchcock's respect for silence and his desire to preserve it long after films became tiresomely talky suggests that it had another value for him: it was a sacred state. In 1939 the amateur sociologists of Mass Observation, who compiled data about British folkways, reported on Armistice Day, when people remembered the end of the war in 1918 by falling reflectively silent for two minutes. This spell was an interval of mystery, perhaps of beatitude, known as 'the Silence'. Mass Observation considered the custom 'from the religious point of view', and saw it as a 'link between living and dead – like other ceremonies the world over at which the spirits of the dead members of the tribe are thought to return to their former home on earth'.

The shades are unloquacious. They drift among us, visible as ectoplasm or as wraiths that leave a trace of themselves on celluloid, but decline to tell us about their lives beyond the grave. The first reel of *Blackmail*, which follows the police on their rounds, remains silent. The lack of sound mystifies the transactions we watch, and turns routine arrests into something dreamier and more depressing. Lookers-on try to bar the police from entering a slum stairway, but their shouts are muted. The man who is hauled away mutters inaudible curses. In the charge room, he voicelessly replies when a sergeant demands his name. What difference would it make if he spoke up? Denied the capacity to express himself or to protest, he is already moribund.

More than a technical limitation, silence for Hitchcock implied the

presence of some mystifying prohibition, and hinted at the arcane secrecy of taboo. In *Murder!*, the actress Edna wants to tell her friend Diana the compromising truth about their colleague Handel. There is, she whispers, 'something he daren't have known'. She wants to warn Diana that he is a half-caste; she might have added (since Handel, fondly known in the theatrical troupe as a 'he-woman', specializes in transvestite roles, and later turns up in spangles and ostrich feathers at a circus) that he is probably homosexual. Diana takes refuge in silence. She plugs her fingers in her ears to block out Edna's calumnies – and therefore doesn't hear Handel wriggle in through the window and club Edna to death with a poker.

Even four decades after synchronized sound became customary, Hitchcock's people prefer a tight-lipped silence. They communicate by semaphore, by speaking looks. *Torn Curtain* is set in the totalitarian society of East Germany, where listening devices lurk in private recesses. Quite apart from the need to be cautious, Paul Newman speaks no German. Arriving at the farmhouse outside Berlin, he traces the symbol 'π' in the dirt with his foot. The farmer's wife answers wordlessly, pointing to a man driving a tractor in the field. She and Newman seal their pact of silence when they collaborate to kill the leather-coated secret policeman in her kitchen. They must do so without making a sound, because Newman's driver is waiting outside. A gun is no use; they stab the policeman, break his legs, and finally manoeuvre his head into a gas oven. Their exertions, which last several minutes, are doubly silent. They say nothing, and no music track turns the hard work of slaughter into melodrama. Herrmann prepared an accompaniment for the scene, helping along the executioners with brassy ostinati that come directly from Nibelheim, Wagner's underworld of malign gnomes in *Das Rheingold*. But Hitchcock rejected his score outright, and insisted that this scene in particular should play silently, except for the victim's grunts and groans or the hiss of gas. To kill is to extinguish breath, and the lack of music makes us listen intently for the moment at which the victim, with kicking feet and grappling hands, becomes a shade.

A conspicuously modern young man in Virginia Woolf's *The Voyage Out* announces his intention to write a novel about silence, 'the

things people don't say'. Hitchcock, no less avant-garde, made films about things people couldn't say out loud, and he relied on us to overhear them. The director Abel Gance, in a rhapsody about the cinema written in 1927, predicted that the fledgling art would endow man with a new sensory capacity: 'He will listen with his eyes.' For Gance, this was a sacred talent, foreseen by the Talmud, which declares that the elect 'have seen the voices'. He added that, when looking at a film, we should watch 'the versifications of light' – as we do, perhaps, during the scene with the metrically pulsing lighthouse beam in *The Manxman*. Hitchcock expected us to have auditory eyes. In *The Manxman*, he provided no title for the scene in which Kate tells Phil that she is carrying his illegitimate child: he knew that, solicitously or pruriently, we would read her lips. Silent films taught those who watched them how to translate sight into sound. Hence the inadvertent wit of Lorre's error in *Secret Agent*. After finding the dead organist in the Swiss church, he and Gielgud scuttle upstairs to the tower, and are deafened when the bell is rung to raise the alarm. Lorre later complains: 'Me still blind in this ear.'

He may not be idiomatic, but he has a point all the same. The ear is as voyeuristic as the eye. In *Easy Virtue*, a silent adaptation of Noël Coward's play, Hitchcock teases us during Larita's first divorce by rendering the raciest titbits of evidence inaudible. A title-card translates the judge's gruff warning to the gossips in the public gallery: 'Silence – or I'll clear the court!' But he is calling for silence in a silent film, just to remind us that we have been frustratingly denied the information we crave. He intervenes once more as the barrister who represents Larita's cuckolded husband discusses her misbehaviour in an artist's studio where, like Alice in *Blackmail*, she has 'disrobed' to have her portrait painted. 'Are all these details necessary?' demands the prudish judge on a title-card. To us they certainly are: divorce cases are a precious source of titillation. Justice is supposedly blind. Hitchcock, anarchic as ever, makes it deaf as well – or at least refuses to pay attention to its legalistic dronings. In *Easy Virtue*, the judge has to call for silence. In *Frenzy*, it is Hitchcock who negligently, dismissively silences the judge. At the end of Jon Finch's murder trial, the reading of the verdict is filmed from outside the court, through doors

that have swung shut. A policeman standing guard in the corridor edges one of the partitions ajar so that he can hear the sentence being pronounced. But the judge's blather about the crimes is verbiage, and the verdict is both a foregone conclusion and a miscarriage of justice.

Sometimes we are spared from having to listen. On other occasions, we are not allowed the chance. Later in *Easy Virtue*, the ingenuous John proposes to the seasoned Larita on the telephone. But their exchange is both unseen and unheard. Hitchcock relays it through the physiognomic reactions of the girl at the switchboard who connects them. She personifies the medium whose servant she is and, as if employing sign language for the deaf, narrates the stages of their tortuous conversation in facial mime – anticipation, doubt, distress, finally relief. Though the parties have voices and no bodies, she enjoys the uninvited participation that, as Hitchcock said, is the thrill of a cinematic love scene: you can snuggle in between Cary Grant and Ingrid Bergman or Grace Kelly as they kiss.

Language, according to humanists, is our highest talent, the sign of our God-given rationality, proof of our deserved pre-eminence among the species. Silent film revoked that divine bonus; Hitchcock nodded approvingly at the toppled hierarchy when he gave the women in *Young and Innocent* the voices of seagulls. What good are words? *The Skin Game*, the fourth of his films with recorded sound, is introduced in the credits as 'A Talking Picture by John Galsworthy'. The talk is certainly by Galsworthy, who wrote the original play about a bumptious industrialist called Hornblower (played here by Edmund Gwenn) and his battle with the genteel proprietors of a rural estate; but Hitchcock did his best to drown the dialogue in noise, more eloquent and compelling than reasoned speech. A car, the symbol of Hornblower's economic 'go', exchanges unverbal abuse with a herd of sheep in a narrow village street: an angry klaxon loses its temper, and the sheepdog hurls back insults of its own. At the auction to settle ownership of the land Hornblower wants to develop, legal propriety is overruled by the eruptive, incontinent body. The auctioneer coughs and sneezes, and the squire places bids by blowing his nose. An official mumbles the conditions of sale, prompting someone to shout, 'Speak up!' Could Hitchcock have

been deriding the unreliability of microphones? On one occasion, he both dampens the sound and averts the camera's gaze. The black rectangle of a door is open on to a room we can't see. Within, Edmund Gwenn's voice drones semi-audibly as he evicts the tenants from their feudal cottage. His driver paces outside, discreetly or disgustedly not listening.

In *Sabotage*, language itself is sabotaged in a scene that compounds fake etymologies, puns, misunderstood meanings and the obscure rhyming slang of the East End. Stevie, on his way to Piccadilly with the bomb, is delayed by a market trader in a bowler hat and a clinical white jacket – held up as if by a gunman, arrested as if by the police, as the trader makes clear in his spiel. The huckster is selling tubes of Salvo-Dont, a preparation whose name, he tells the bemused crowd, derives from two Greek words: 'Salvo', meaning no more, and 'dont', meaning toothache. 'What,' he asks, 'causes teeth to fall out?' Someone in the crowd suggests, 'A punch on the jaw.' The trader disagrees, and states a Hitchcockian axiom: the correct answer is: 'The process of decay, inevitable in all human organisms.' He then goes on to use the ambiguous word that haunted the quaking Hitchcock, who could never forget his childhood sojourn in a cell at the police station, where his parents allegedly sent him as punishment for naughtiness. 'Decay,' he says, 'can be arrested, instantaneously arrested.' So is there a form of arrest that is not an official summons to the underworld? This, for Norman Bates, constitutes the false promise of taxidermy. A joker in the crowd makes the punning connection when the salesman asks what the arresting agency might be. 'A copper,' he shouts. Coppers are policemen, who cop or catch thieves; but coppers are also coins, and the trader returns to his sales pitch with the help of one more pun. Yes, he says, but it takes 'rather more than one copper'. He brandishes the tubes of paste, which cost 'a few coppers', or sixpence to be precise.

Then he arrests Stevie in the second, more alarming sense, and forces him to sit down for an experimental brushing. 'The young man's teeth are very dirty,' he insists. Stevie asserts his innocence – 'No, they're not!' – but the trader has him pinioned. The muddling puns continue. 'Remove the cap,' says the trader, showing customers

how to uncap the tube before squeezing paste on to the brush; Stevie obediently pulls off the school cap he is wearing, as if the operation required this token of respect. Finally he smears an oil on Stevie's tousled hair to make it look like patent leather, and mutters, 'Bugger off, you little basket.' He doesn't mind calling the boy a bugger, which means a sodomite, but won't say he is a bastard: hence the convenient cockney substitute, basket. Stevie, having saved his teeth but forfeited a few minutes that might have saved his life, wanders off to die with varnished hair and a fresh smile.

The campaign against the jabbering impotence of words continues in *The Lady Vanishes*. The opening is a racket of random noise. Skis clatter to the floor of the inn, the unheeded telephone rings, and a trumpeter pops out of a cuckoo clock to blow the hour. The vanishing lady, Miss Froy (played by Dame May Whitty), is first expunged by the uproarious, indiscriminate soundtrack. When she introduces herself to Iris (Margaret Lockwood), a train whistle shouts her down, and she has to scribble her name – as if writing a title-card for herself in a silent film – with a finger on the steamy window. The word is speedily erased, blotted out when the train goes into a tunnel. After Miss Froy vanishes, Iris has trouble proving that she ever existed: images are impalpable – vague souvenirs or, as Gorky would have said, wistful shadows, just as fugitive as the words we breathe into the air.

The action takes place in a spurious country called Bandrika, a drop-out from the Austro-Hungarian Empire. The Balkans, like the rest of Europe, constitute a quarrelsome Babel of incompatible languages, and societies that cannot understand each other soon blunder into war. The innkeeper Boris gives out weather reports in four different European languages, whose vocabulary he improvises as he goes along. He communicates with the maid Anna in their own invented Slavic tongue, augmented by a non-verbal idiom of sniggers and winks. At best, the means of communication between these disparate holidaymakers and espionage agents consists of formulae from a touristic phrase-book. The sinister Dr Hartz (Paul Lukas), who suggests an operation on Iris's brain, offers to investigate Miss Froy's vanishing act, and leads the way to another compartment on the

train. 'Après vous, madame,' he says. Gilbert (Michael Redgrave) sneers, 'What a gift for languages the fellow's got!'

Boris's mispronunciations generate a comedy of linguistic errors. Announcing an avalanche, he seems to be inviting his customers to have lunch. Two Englishmen, unable to find room at the inn, propose spending the night on board the stalled train. He warns them that there's no eating on the train. They can't see why that should matter, because they only want to sleep there, not dine. They have been tripped up by a dropped 'h': when he mimes a fit of the shivers, they realize he means heating. Yet they have no more success when interpreting their own language. One of them worries about a newspaper headline that warns 'England on the Brink': will they manage to get home before war breaks out? But it's a game of cricket the paper is agonizing about, not the international situation. Another English couple conduct hostilities linguistically. The pompous, cowardly lawyer Todhunter (Cecil Parker) has sneaked abroad with his mistress (Linden Travers). Keen to keep up appearances, he won't share a room with her. She remembers that he wasn't so particular in Paris the previous autumn. He explains that he had no choice, because 'the Exhibition was at its height'. He is referring to the Exposition Internationale des Arts et des Techniques de la Vie Moderne, held at the Trocadéro in 1937, the year before *The Lady Vanishes* was made. Ignoring the capital letter he invisibly gives to Exhibition, she turns his remark into a scornful comment on his drooping ardour. 'Yes,' she sighs, 'I realize that now.'

Luckily, the characters do not entrust their most precious meanings to language. They rely on a different medium, apparently more nonsensical but closer to the encrypted truths of mathematics: they have recourse to music. Miss Froy's informant sings the secrets of an international treaty to her in a pretended serenade (and is unfortunately throttled in mid-performance). Gilbert, an ethnomusicologist, has been in Hungary notating the heavy-footed dances of the peasantry, which he accompanies on his clarinet – a startlingly timely activity, since Béla Bartók had done exactly the same in Hungary and Romania during the previous decade, as a means of combating the cultural menace of Germany. He is the ideal ally for Miss Froy, who asks him

to safeguard the tune that contains in code a vital clause of that territorial pact. 'I was brought up on music,' he chirps, 'I can memorize anything.' Even Iris, who speaks in a world-weary sing-song, has a lyrical talent. She alliterates as she tells the story of her life: 'I've eaten caviar at Cannes and sausage rolls at the dogs, I've played baccarat at Biarritz and danced with the rural dean. What is there left for me but marriage?' Just when she has begun to doubt that Miss Froy ever existed, a mnemonic tag with a musical rhythm attached to it changes her mind. Among the rubbish flung from the train Iris sees one of Miss Froy's tea-bags, and surprises herself by reciting the slogan printed on it – 'Harriman's Herbal Tea, A Million Mexicans Drink It'. She has remembered because of the alliteration; jingles go to ground in parts of the brain that the reason cannot reach.

Still grumbling about the talkies, Hitchcock complained in 1936: 'What appeals to the eye is universal; what appeals to the ear is local.' He proved himself wrong, just for once, in *The Lady Vanishes*. What appeals to the ear is local except in the case of music, which happens to be international. The kingdom of the shades is not entirely silent. But that nether realm excludes Gilbert's hearty jigs, and also the flirtatious dances anthologized in Hitchcock's biopic about the Strauss family, *Waltzes from Vienna*. The soundtrack for his version of the afterlife was composed by Bernard Herrmann, with stabbing strings to transliterate pain, and wrenching, irregular modulations that leave the ground quaking beneath our feet.

The Philosophy of Motion

Madeleine Carroll, John Gielgud and Peter Lorre after the train crash in *Secret Agent*.

Gearing up for more metaphysical excursions – the descent into an open grave in *Vertigo*, or a flight with the exterminating angels in *The Birds* – Hitchcock began by concentrating on the basic physics of film. Cinema is kinesis: it takes still pictures and makes them move. This technical marvel initially provoked a sense of unease. Surely life itself did not speed by at such a pace? In *Enter Sir John*, the novel on which Hitchcock based *Murder!*, the accused actress in the condemned cell has a 'sudden swift vision' of the last 'reeling weeks of horror'. Time unreels like the images that 'a child sees in a kinetoscope'.

Velocity, one of the cinema's pleasures, can also be a threat. In *The Skin Game*, Hornblower plans to build a pottery in sleepy Deepwater, with fuming chimneys in the meadows. 'I want to be the moving spirit here,' he says; the village shudders. Hitchcock could not help wondering what might happen if the supply of energy ran out, causing the machine to break down. Then his abiding trauma would come to pass again. When the movement stops, we are trapped in a frozen frame, as if a cell door has clanged shut. At the end of *Sabotage*, Ted the policeman comes to the cinema for Verloc, and announces: 'I'm hoping to arrest him.' But Verloc has already been arrested by death, and lies prone on the parlour floor, detained by the carving knife in his chest.

A film consists of a vertical strip of frames, spooled through a projector that circulates and animates them. Verloc, entrusting Stevie with the fatal parcel, tells him he is carrying a projector gadget, along with the cans of film that contain a two-reeler. Hitchcock often paused to watch the rotation of the projector's magic wheel, and to reflect on the dangers of its acceleration. The first image in *Blackmail* is the whirling wheel of the police van on its way to apprehend a criminal. At a party in *The Ring*, a gramophone record rotates on its turntable and gyres inside the head of Jack, who is deranged by sexual jealousy, goading him to lash out. As Stevie dawdles through London, the five

interconnected wheels of a clock inch around towards the appointed moment when his parcel will explode. In *Foreign Correspondent*, the creaking wheel inside the Dutch mill, grinding slowly, whisks away Joel McCrea's raincoat and almost consumes his arm.

The novel by Ethel Lina White that Hitchcock adapted in *The Lady Vanishes* acknowledged the giddy modern cult of motion in its title: it is called *The Wheel Spins*. In the novel, Iris asks Miss Froy why she enjoys being on the train. 'Because it's travel,' the old maid replies. 'We're moving. Everything's moving.' Aren't spinsters supposed to stay at home and content themselves with a different kind of spinning? The wheel that spins belongs to the train, but also to a movie projector. Iris, suffering sunstroke, has 'the impression that the whole scene was flickering like an early motion-picture'. The garrulous Miss Froy is a personification of the talkies: she chatters on 'like the unreeling of an endless talking-picture'. She also smokes while she talks, which prompts the most futuristic of Ethel Lina White's metaphors. Iris watches her face waver among the fumes, 'like an unsuccessful attempt at television'. In the film, Dame May Whitty is plumper, less racy, and not a smoker, but she does give a nimble display of how to cope with the kinetic, cinematic problems of life on an express train. She bounces and ricochets down the corridor on her way to the dining car, balletically bumping into walls as she goes. It is a small lesson in movie acting, all the more impressive because the carriage in the studio was probably stationary. She also gives Margaret Lockwood some sage advice about keeping your equilibrium: if you feel shaky, sit in the middle of the coach, facing the engine.

Miss Froy, who loves to move, suffers an appalling immobilization. Wrapped in bandages from head to toe, she is trapped in the lair of the shades like a living mummy. But the film's infectious delight in speed suggests another, more up-to-date explanation of her time in limbo. Objects in motion dematerialize, like the spokes of a train wheel or the blades of an aeroplane propeller. Is Miss Froy a simple case of mass vaporized by energy, just as the substance of the world becomes an agitated dance of shadows when it is filmed? Perhaps she falls victim to her own fascination with the spectacle of kinesis. Hitchcock here set out to capture the spectacle of disappearance on

film. The comic Englishmen Charters and Caldicott debate the slippery logistics of this attempt. The former, scoffing at the fuss over Miss Froy, says that people vanish all the time, and mentions the Indian rope trick as evidence for his claim. The latter smartly replies, 'Oh that. It never comes out in a photograph.'

Miss Froy might have retired into Einstein's third dimension, where space and time merge. In *A Book of Escapes and Hurried Journeys*, published in 1922, John Buchan connected the relativistic domain of space–time with the topography and chronology of his own adventure stories. Here, introducing a collection of cliff-hangers, he reflected on the perilous physics of those stories: they deal with 'the efforts of men to cover a certain space within a certain limited time under an urgent compulsion, which strains to the uttermost body and spirit'. This is the experience of Hannay in Buchan's *Thirty-Nine Steps*, and of Robert Donat who plays him in Hitchcock's *39 Steps*. (It is an even more urgent necessity for the Hannay of Robert Powell in a 1978 remake of the story: he has to dismantle a bomb wired to the mechanism of Big Ben, and ends the film swinging in mid-air from one of the clock hands as he tries to dissuade it from striking.) Instead of Einstein's merger, Buchan saw a clash between the two dimensions: 'We live our lives under the twin categories of time and space, and . . . when the two come into conflict we get the great moment. Whether failure or success is the result, life is sharpened, intensified, idealised.' Here, reduced to a theorem, is a prescription for the movies in general, and in particular for the films Hitchcock made about people who dare to live cinematically, reeling from one 'great moment' to the next – *The 39 Steps* and *The Lady Vanishes*, *Saboteur* and *North by Northwest*.

In explaining his theory, Einstein adopted railway travel as a model of relativity, because – as you speed through a still landscape, which seems to be moving with you – the train demonstrates that the very concept of movement is relative. The point was taken up enthusiastically by writers who wanted to describe the temporal and spatial novelty of modern life. In one of his spy stories, Somerset Maugham puts Ashenden on a night train to Paris, which metaphorically veers off its rails. Hurtling through darkness, he feels 'like a star

speeding through space. And at the end of the journey was the unknown.' Ashenden's favourite drink (also fancied by Grant in *North by Northwest*, and later by Ian Fleming's James Bond) pays tribute to modern mobility, since liquor is fuel. 'I move with the times,' he says in another story. 'To drink a glass of sherry when you can get a dry Martini is like taking a stagecoach when you can travel by the Orient Express.' Hitchcock's *Secret Agent* ends aboard the train to Constantinople; Graham Greene's thriller *Stamboul Train*, published in 1932, takes the same journey, notices the relativist disparity between the train's speed and the compulsory idleness of its passengers, and watches the world surrealize itself outside the window 'like lead upon a hot fire, [bubbling] into varying shapes'. Cornell Woolrich, who wrote the story on which Hitchcock based *Rear Window*, dissected the view from a train window in *I Married a Dead Man*, published in 1948. Clouds travel at a more stately pace than trees, as if they were 'on separate, yet almost-synchronized, belts of continuous motion'. Woolrich's heroine is speeding towards her own great moment: a train crash, after which – presumed dead – she reincarnates herself as someone else.

In Highsmith's *Strangers on a Train*, the relativity of the railway is more than a conundrum in physics. It instils a sense of moral instability. Guy, trapped with Bruno and forced to listen to his tempting plan, wishes he could escape by going for a walk. Hitchcock's Hannay does exactly that in *The 39 Steps*, disembarking from the 'Flying Scotsman' when it pauses in the middle of the Forth Bridge. Highsmith's train, less obliging, 'kept on and on in a straight line'. The rails represent the strict, economical geometry of tragedy. Unlike Dame May Whitty, who enjoys being jolted down the corridor, Highsmith's Guy feels morally lamed by the motion of the train – robbed of his will to resist, rendered inert: 'the swaying . . . made it difficult even to stand upright'. Guy commutes between New York and Florida by train in the course of his work as an architect; he wonders if this express life has corrupted him – 'he felt he moved too fast, had always moved too fast. There was . . . a lack of dignity in moving fast.'

Hitchcock's characters have no time to philosophize like this about

trains. They are too busy acting out the theory: the films they appear in are themselves express trains – unstoppable, though the belts of continuous motion are never quite synchronized. Once, however, his people pause to ponder the means of transport they are employing. In *North by Northwest*, Eva Marie Saint tells the police that she and Grant spent their time at dinner on the train discussing the relative advantages of travel by air and rail. They do so with the connivance of Bernard Herrmann's score for this scene, which accompanies sunset on the Hudson River with a quotation from the aphrodisiac languor of Wagner's *Tristan und Isolde*. Again the effect is relativistic: the train is shuttling towards Chicago as fast as it can, but the music – like the murmured, elliptical conversation – deliciously takes its time, prolonging each instant of pleasure. Grant is clear about the means of transport he prefers. He interrupts a clinch in Eva Marie Saint's roomette to say, 'Beats flying, doesn't it?' On the telephone from Grand Central Station, he tells his mother – played by Jessie Royce Landis, a Lady Bracknell of the Upper East Side – that he's going by train because you can't hide on a plane. Nor, unless it's an executive jet, is it so easy to have sex. (Incidentally, Hitchcock's casting of Jessie Royce Landis is another case of relativity at its sly, subjective work. She was Grant's prospective mother-in-law in *To Catch a Thief*. Here she plays his mother, despite the inconvenient fact that they were both fifty-five at the time. In Hollywood, men and women age at different rates.)

Orson Welles, seizing control of the medium in *Citizen Kane*, likened a movie studio to a train set. Hitchcock shared this infantile enjoyment of an art that was still in its infancy. *The Lady Vanishes* actually begins in toytown, with a flimsy, charmingly implausible model train and a beetling car that resembles a matchbox on wheels. The film is a game played by adults with a very expensive toy train. Michael Redgrave recognizes this with a wink of complicity. He is unconcerned when the train's drivers are shot, and volunteers to take charge. His qualifications? 'I once drove a miniature engine on the Devonchurch line,' he chirrups.

Welles possessed an effortless command of the switches. Hitchcock, however, could not contemplate a train set without foreseeing

disaster. A train set appears in the first *Man Who Knew Too Much* – made in 1934, seven years before *Citizen Kane* – and is instantly annexed to an emergency. The police, interviewing Bob, hint that his daughter Betty has been kidnapped. The shock of the word is registered by an abrupt cut next door to the girl's train set, which whirrs and rattles as an engine races down the track. Hitchcock's editing enforces a grim association of ideas: abduction (since the girl was snatched in Switzerland) must mean a train. Clive, Betty's uncle (played by Hugh Wakefield), gave her this present, and in her absence plays with it himself. Her mother Jill (Edna Best) wanly asks if it is electric, and he replies, 'Twenty volts': like film, it is an illusion powered from the mains. Then she notices a faux pas, and recovers from her depressed apathy to correct it. Clive has coupled a Pullman car and a coal truck to the same engine! The cult of mobility, as she ought to know, ignores such fixed, hierarchical distinctions.

Laraine Day is surprised to see Joel McCrea on the transatlantic clipper at the end of *Foreign Correspondent*, and asks: 'What are you doing here?' 'Having myself a ride,' he replies, like any cinema-goer who has paid for a diversion. Within minutes, the plane crashes into the ocean. Rodgers and Hammerstein named their 1945 musical after a carousel, which rotates in a sweetly nostalgic, drowsily repetitive waltz. The carousel in *Strangers on a Train*, less decorous, speeds out of control and lunges off its anchorage. In *Number Seventeen*, a double-decker Green Line bus is hijacked, and chases a runaway train to the coast. The bus customarily dawdles across the countryside. Now it rockets through a dormant village, where a sign ineffectually appeals 'Stop Here for Dainty Teas'. The jolted passengers on the upper deck are giddy with hilarity. 'These coaches can travel, can't they?' marvels one of them as the vehicle vaults over an obstacle. Real anguish is reserved for those who are moving too slowly, not too fast. In *Torn Curtain*, Paul Newman and Julie Andrews make their escape in a bus from Leipzig to East Berlin. It is a fictitious bus, but it has to maintain the cautious speed of a real one. Once again, the belts of continuous motion are unsynchronized: although a restless musical motif by John Addison tries to increase the pace, the driver halts every few minutes.

In 1927 the physicist A. S. Eddington delivered a series of lectures in Edinburgh on *The Nature of the Physical World*, which attempted to explain the behaviour of time in a relativistic universe. Eddington pointed out that we all live at very different tempi. For some of us, time ambles; for others, it trots or gallops. We can even persuade it almost to stand still. The faster we move, he argued, the less we age, because 'bodily processes in the traveller occur more slowly than the corresponding processes in the man at rest'. (He added, with a disbelieving wink, that these computations were made 'according to the Astronomer Royal's time', since the job of the Astronomer Royal is 'finding out time for our everyday use'. This is the antiquated artifice Verloc tries to sabotage by bombing the Astronomer Royal's headquarters at Greenwich in Conrad's *The Secret Agent*.)

Hitchcock – corpulent, sedentary – might have been Eddington's 'man at rest', otherwise known as 'the stay-at-home individual'. But his characters resemble Eddington's 'fast-moving traveller', and regard immobility as a fate worse than death. James Stewart in *Rear Window* is tethered to his apartment by a pair of broken legs. 'I want to get this thing off,' he says of the first plaster cast, 'and get moving', back to the practice of a profession in which 'your home is the available transportation'. William Bendix in *Lifeboat*, threatened with the amputation of a leg, frets about his career as a jitterbugging champion, but boasts 'I can outjive those hep cats even with a bum gam.'

Happily inert, Hitchcock seldom drove. He disliked sitting behind the wheel because he dreaded being pulled over by the police. Though he consented to be driven, he had his doubts about the whole process. The car mobilizes people, which is why the movies adore it. A long succession of car chases extends from Griffith's *Intolerance* to William Friedkin's *The French Connection*, with drivers like horse riders goading their mounts, taxing and heroically extending their own bodily powers. Hitchcock made no contribution to this tradition. In his films, cars drive people. In *North by Northwest* a Mercedes that Grant can't control skims along some coastal cliffs; in *Family Plot*, Dern and Harris panic as their car, from which the brake fluid has been drained, lunges down a mountain road. However fast you drive, there is no escape from your demons. Tracked by the

motorcyclist in *Psycho*, Leigh might be musing on the irrelevance of motion as she stares into her rear-view mirror. The cop is behind her, though the mirror makes it look as if he is ahead; her future is her past.

It's not just the cars that are untrustworthy. Those who spend time with them absorb their louche, rule-breaking allure. In *Rebecca*, Jack Favell – Rebecca's cousin and lover – is defined by his occupation: he's a car salesman (presumably more up-market than California Charlie in *Psycho*, who is that most proverbially dubious of creatures, a used-car salesman). George Sanders plays the role, as slippery as lacquered hair or the polished chromium on an automobile. Black-mailing Maxim (Laurence Olivier), he explains that it rankles to drive 'an expensive motor car that isn't your own'. He begins his attempt at extortion by having his own cheap car filled with petrol at Maxim's expense. During a recess at the coroner's inquest, Maxim and his new wife retreat to their car; Favell jumps in, uninvited, and helps himself to a chicken leg from their hamper. A car means temporariness, forgetfulness, carelessness. Even when it is parked in a village street, the space outside it, for Favell, is a limbo, useful for discarding whatever he no longer needs – his cigarette, or the chicken bone that he tosses negligently through the window. When the local magistrate threatens him with legal reprisals for the blackmail attempt, Favell cheekily replies, 'If you ever need a new car, Colonel, just let me know.' He does suffer some small come-uppance from the law, for a traffic offence. At the end of the film, he telephones Manderley from a public box, to tell Mrs Danvers (Judith Anderson) the truth about Rebecca; a policeman rebukes him for parking his car improperly while he makes the call.

Driving exhibits dominance, and soon became part of the mobilized male's courting display. But what if a woman seizes the wheel and applies her pretty foot to the accelerator? Hitchcock's cars are the arena in which the sexes choose to do battle. Cary Grant's experience in his three earliest Hitchcock films is instructive. He first drives, then is driven by women – and is unmanned in the process. In *Suspicion*, he spirits Fontaine away from the hunt ball and asks her if she has ever been kissed in a car. 'Never,' she replies. 'Would you like to be?'

he asks. She would and is. The titillation is all the more intense because the car is her father's, which Grant has commandeered. At the end, Grant seems ready to use the car, like George Sanders in *Rebecca*, for swift and easy disposal. By the time the unwanted article hits the ground, the motorist will already be far away. A door swings open as Grant drives along a clifftop road, and Fontaine lurches towards the drop. His face is contorted by fury and loathing – which he finesses, when he pulls her back into the car and drives off towards a putative happy ending, as concern for her safety.

After this, Grant gradually relinquishes the wheel. In *Notorious*, Bergman drags him away from her drunken party for a midnight picnic. 'I'm gonna drive,' she slurrily insists. 'That's understood.' His hand hovers nervously near the wheel as she skids and swerves along a coastal road in Miami. Finally he assumes command, resorting to Neanderthal techniques to salvage male self-esteem. He bangs Bergman's clenched hands to make her release the wheel, wrestles with her, orders her to move over (though the car is hers), and then concludes the argument by briskly punching her unconscious. Whistling in triumph, he drives home. He enjoys a second revenge at the riding club in Rio, when using her as bait to entrap Claude Rains. They draw abreast of Rains, who does not respond. Grant then surreptitiously spurs Bergman's mount. It bolts, and Rains gallops to her rescue, which effects the introduction. The equestrian Bergman is still the fast, runaway woman – but she is driven by the man who kick-starts her placid horse.

That was in 1946; by 1954, when he made *To Catch a Thief*, Grant had been relegated to the passenger seat. His reformed cat burglar – a feline and perhaps feminine man – allows the women in the film to do the driving. His chubby housekeeper races a decoy car along the corniche, while Grant escapes by bus, wriggling into the back seat beside the equally timorous Hitchcock. Brigitte Auber assumes the helm of the motor boat that takes him to Cannes, and Grace Kelly drives him off to look at villas in the hills, frightening him with her reckless speed just as she startles him by taking the sexual initiative when she suddenly, probingly, lengthily kisses him. The rival women conduct their competition as if they were vehicles at an automobile

rally. Auber, afloat on a platform in the Mediterranean, stares back scathingly at Kelly on the beach and asks Grant why he wants 'to buy an old car when you can get a new one cheaper? It will run better and last longer.' Grant glances over his shoulder, sees that Kelly has vacated the parking space in which she was sunbathing, and says, 'My old car just drove off.' Kelly, having swum out to join them, contradicts him: 'No, it turned amphibious.' Such a vehicle was expensively invented for James Bond by the producers of *The Spy Who Loved Me*; Hitchcock shows off the prototype – a navigable female body, born like Venus from the waves, yet equipped with jet propulsion below the waterline.

Grant tries to regain mastery by offering to teach Kelly how to water-ski. She was women's champion at Sarasota last year, she says. Unbeatable in the water, Kelly is handicapped on land by the frilly accoutrements of femininity. After the costume ball, the police chase Grant back to his villa, taking Kelly along with them. They'd have caught up with him, she says, if her Louis XV crinoline hadn't billowed over the steering wheel and gear shift. Her comment, like almost everything she says and does in the film, is wickedly erotic. She admits that the body is a reproductive vehicle, motorized by desire. What is a skirt for, if not to cover up a woman's steering wheel and her gear shift?

The driving lessons she administers are not forgotten by Hitchcock's subsequent heroines. One of the most haunting sequences in *Vertigo* is a car chase – achingly slow, not screechingly accelerated like the motorized pursuits through San Francisco filmed by Peter Yates in *Bullitt*, Peter Bogdanovich in *What's Up, Doc?*, William Friedkin in *Jade* or Paul Verhoeven in *Basic Instinct*. Novak's car meanders through the city inconsequentially, tracking backwards and forwards as she tries to find her way back to Stewart's apartment on Lombard Street. He follows, frustrated and impatient. Her mazy slowness is as much of an offence as the speed of Bergman in *Notorious* or Kelly in *To Catch a Thief*, because it disparages the male need for a purpose and a destination. Men prefer to travel in straight lines, which is why San Francisco's rectilinear grid ignores its hilly terrain. A woman has a different sense of topography. Novak travels in circles, adhering to

the contours of the land. Hedren in *The Birds* is given the choice of two routes from San Francisco to Bodega Bay. The freeway – safe but dull – takes ninety minutes, the coastal road two hours. She opts for the longer way, because of the risks, not the scenery, and drives her sports car fast on the bends. Ultimately these free spirits have to be curbed by the men they threaten to supplant. As Madeleine, Novak drives; as Judy, she is driven. Bruised, bandaged, semi-conscious, Hedren surrenders her car to Rod Taylor for the return journey to San Francisco.

Robert Mitchum – remembering his own vagrant youth, which he spent doing odd jobs all over America – once remarked that 'in those days, motion itself seemed an adequate philosophy'. So it was for Hitchcock. Or rather, the behest of perpetual motion dispensed with philosophical qualms and quibbles. While you kept moving, you were absolved from asking questions or having to answer them. This was the imperative of Hitchcock's story-telling technique. *North by Northwest* is his most breathless exercise in motiveless motion. Leo G. Carroll as the Professor hustles characters along, refusing to disclose where they're going or why. At the airport in Chicago, Cary Grant demands a plot synopsis. 'We haven't much time,' grumbles Carroll, and urges him to walk faster or they'll miss the plane. His reluctant and belated exposition, when he gives it, is blown away by the revving-up of a plane's propellers on the tarmac. He is equally per-emptory with Eva Marie Saint at Mount Rushmore: 'Miss Kendall, you've got to get moving.'

Hitchcock too knew that the built-in haste of movies licensed a cer-tain sleight of hand. When the scriptwriter Evan Hunter questioned him about plot contradictions in *The Birds*, he replied that so long as the pace never slackened, no one would notice. Hunter's objections were those of a novelist, accustomed to the steady, incremental rhythm of literary narrative, which takes its tempo from the disci-plined and deliberate way our eyes work through a page of print. The literary narrator must also be on his guard against the reader who wants to quiz the text by going back to re-read, or test the logic of a plot. *North by Northwest* jokes about these dull, sluggish proce-dures, which film has made obsolete. At the house on Long Island,

Grant is locked in the library to wait for the arrival of Vandamm (James Mason). 'Don't worry,' he tells the thugs, 'I'll catch up on my reading.' It's impossible to imagine him quietly absorbed in a book; if he writes – as when he dictates a memo in the street – it's while on the go. By the time he returns to the house with the police, the liquor cabinet in the library has been innocently filled with books. Jessie Royce Landis remarks: 'I remember when it used to come in bottles.' Seducing him on the train, Eva Marie Saint slights the consolations of literature. 'It's going to be a long night,' she says, 'and I don't particularly like the book I've started.' Secure in his conviction of what he could get away with, Hitchcock would have been appalled by video, which enables us truly to read his films – to conduct a cross-examination by stopping, starting, and re-running them, as if looking back through a book or pausing over one of its pages.

Defying such scrutiny, *North by Northwest* is improvised on the run. Its methodical zaniness recalls the plotting of Hamlet, to whom the film's title perhaps alludes: he tells his confidants that he is only mad north-northwest, and promises to behave rationally when the wind changes. After Grant crashes his car, the police doctor asks, quite unnecessarily, if he has been drinking. 'Doctor, I am gassed!' he replies. They draw a straight line on the floor with chalk for him to negotiate – hardly a diagram of the film's wayward course, so he fails the test. Had Hitchcock after all fulfilled his ambition to film *Hamlet* with Cary Grant as the prince?

The bravura of *North by Northwest* makes it an impudent apologia for its own art. Like a strip of celluloid, it is transparent, filled with agitated shadows who might be performing in a film within a film. What they do counts as acting, not action. Who are they, in any case? Cary Grant plays himself, impeccably groomed and ambiguously attractive. The epicene Leonard (Martin Landau) looks him up and down appraisingly when they first meet, and remarks 'He's a well-tailored one, isn't he?' It's a self-referential jest, since Grant wore a suit from his own tailor for the film. When he thinks he is out of sight, he preens, making himself ready for the camera. At Rapid City, half-naked, he combs his already immaculate hair. The woman in the hospital, through whose room he makes his escape, can't believe her

luck when she wakes up and finds Cary Grant by her bedside. 'STOP!' she shrieks, and then – after putting on her glasses – she repeats the command, turning it into a plea. Grant cautions her with a reproving 'Ah-hah'. He is a movie star: she may look but not touch. Hitchcock allows Grant to anthologize clips from his earlier performances in screwball comedies like *Arsenic and Old Lace* and *Bringing Up Baby* when he disguises himself as a railway porter or sabotages the auction. Vandamm's housekeeper traps him because she sees him reflected in the screen of the television set as he creeps downstairs: she might be watching a Cary Grant re-run on the late, late show. In the woods at Mount Rushmore, as if on a stroll between takes, Eva Marie Saint congratulates him on his expertly feigned fall when she shot him: 'You did it rather well.' Grant, who served his apprenticeship as a circus acrobat, is underwhelmed by the compliment. 'Yes,' he says, 'I thought I was quite graceful.'

Eva Marie Saint herself plays the archetypal Hitchcock blonde. She had the wrong credentials for the role: Elia Kazan, who helped to found the Actors' Studio, chose her for *On the Waterfront*, which associated her with the mumbling naturalism of Brando. Hitchcock disliked the Method inculcated by Kazan and his partner Lee Strasberg, and was impatient with actors like Montgomery Clift or Anthony Perkins who worried about their motivations. He therefore remade Eva Marie Saint, and included a joke about the schooling she received from Kazan. At the auction, Mason ridicules Grant for overplaying his various roles – the glossy Madison Avenue executive, the fugitive from justice, the peevish lover – which have been scrambled together from different films. 'You fellows,' he sneers, 'could stand a little less training from the FBI and a little more from the Actors' Studio.' Eva Marie Saint sits beside him, imperturbably beautiful, having unlearned everything the Actors' Studio taught her.

Mason – whose beguiling menace is discussed by his fans at the cocktail party in *Rope* – is hired to play James Mason, which no one else can do so well. He maintains a strictly professional interest in the proceedings. Arriving in the Mount Rushmore cafeteria, he behaves as if he were reporting to the set in the morning, dressed, made up, and ready to be handed whichever page of script he must go through

the motions of performing. He loftily winces at the unglamorous location, which he calls 'these gay surroundings', then prepares to receive direction: 'Now what little drama are we here for today?' He considers it bad form to take the business of making films too seriously, and would never confuse it with reality. He points out a breach of etiquette when the police marksman actually shoots Landau: 'That wasn't very sporting,' he comments.

Even so, this amused detachment from the fray tells only half the truth. The housekeeper draws a gun on Grant, just as another granite-faced housekeeper at the ranch in *Saboteur* detains Cummings by taking a pistol from her purse. Grant calls the bluff when he realizes the gun is loaded with blanks. Cummings too responds with scornful irony, and asks: 'What does that shoot – water?' He ought to know better, because at the beginning of the film he takes part in a game that ends in death. When smoke seethes from the hangar, he picks up a fire extinguisher. His friend grabs it from him, says, 'What about me? Don't I get to play too?', rushes into the flames, and is engulfed by them. Hitchcock's films are swift and sportive, but the games in them are always dangerous because, like all practical jokes, they jest both with and about annihilation. The imaginary guns contain real bullets, or – somewhat more surreally – the fire extinguisher contains gasoline, not foam to dampen the blaze.

Alone among film-makers, Hitchcock found the mobility of the medium scary. Once you have picked up speed, like Peck and Bergman skiing towards the crevasse in *Spellbound*, it is difficult to stop. The force of inertia hurls bodies through the air even after the brakes have been applied. A train leaps off its rails in *Secret Agent*, while another in *Number Seventeen* dives into the water and broadsides a ferry. The surrogate directors who ought to be in control have collapsed at their posts. An engine driver faints in *Number Seventeen*, and another is shot in *The Lady Vanishes*. In *Strangers on a Train*, the police accidentally gun down the operator of the carousel, who falls from his perch and sends the wheel into high gear.

Yet despite his staidness, Hitchcock never permitted the camera to stop moving. It whirls in giddy circles and knocks itself out when Jill learns of Betty's disappearance in the first *Man Who Knew Too Much*.

It weightlessly glides around the courtyard at the beginning of *Rear Window* and sidles back into the apartment. It cranes upwards in *Psycho* and hangs in mid-air as it watches Mrs Bates being taken to the fruit cellar. In *Vertigo*, the lens zooms forwards, while the camera itself dollies backwards; we share James Stewart's nausea as we are relativistically tugged in two opposite directions at once. Hitchcock's movies made a proud contribution to the store of our ailments by afflicting us with new varieties of motion sickness.

A Torn Shower Curtain

The home movie watched by Joan Fontaine and Laurence Olivier in
Rebecca.

In his *Republic*, Plato devised an allegory to analyse our human weakness for images, which replace the severe truths of our condition. He set his fable in a primitive cinema – a cave, occupied by huddled refugees from the daylight. Behind them, the bright sun illuminates reality, but they prefer to gaze at a fire in the furthest depth of their dwelling. Between them and the fire, Plato placed a low wall, 'like the screen that puppeteers have in front of them, over which they show the marionettes'. The troglodytes are entranced by the shadows that the fire casts on that wall; it is for this that they have quit the rational, sunlit 'upper world'.

A film too is a shadow play projected on to a screen. Does that make it false, as Plato would have thought? In *Under Capricorn* – set in 1831, well before the invention of the cinema – Michael Wilding rigs up a looking-glass that shows Ingrid Bergman what she would like to see, rather than the dismaying truth. Drunken and disgraced, Bergman has removed the mirrors from her house, to spare herself the shame of self-recognition. Wilding takes off his hat and holds it up behind a window, presenting her with the image of an ideal, forfeited self: Bergman the film star, not the dipsomaniac slattern she is currently playing. 'I'll buy you a new mirror,' he says; 'it'll be your conscience.' He presents it to her, and after she has begun to redeem herself and to reclaim her gentility, he calls it 'a respectful tribute to your reincarnation'. For his own reasons, he equates soul with face, self-knowledge with self-admiration. After he persuades Bergman to study her own reflection, the camera moves away from the glass, and they kiss. 'First work of art I've ever done,' he says, like Stewart cosmetically remaking Novak in *Vertigo*, 'and it's wonderfully beautiful.' Beautiful, yes – but true, or good?

A film can be the most flattering and meretricious of mirrors. Sitting in the darkness, we like to dream that it is ourselves we are gazing at. In *Spellbound*, Peck offers a narcissistic film star's definition of amnesia: he says it is like looking into a mirror and seeing no face. At

the cinema, we look into a mirror and see someone else's face, more alluring than our own. Hitchcock, preoccupied by the moral significance of the screen, discouraged its appeal to our vanity. Daydreams are not permitted; nightmares, being closer to the truth, are allowed. In *Psycho*, the sheriff has his doubts when Sam (John Gavin) reports seeing an old woman in the window of the Bates house. He is right to be sceptical: the silhouetted Mrs Bates sits there or stalks to and fro like one of Plato's shadows cast on the screen. 'You must have seen an illusion,' says the sheriff – though he pays Gavin the compliment of adding 'I know you're not the seeing-illusions type.'

In 1936, describing his own films as a species of curative shock-treatment, Hitchcock made it clear that a screen could have two quite different meanings. 'I am out to give the public good, healthy, mental shake-ups,' he said. He then explained why we needed such therapy. 'Civilization has become so screening and sheltering that we cannot experience sufficient thrills at first hand. Therefore, to prevent our becoming sluggish and jellified, we have to experience them artificially, and the screen is the best medium for this.' As he saw it, civilization itself is a screen, a piece of furniture whose dishonest function is concealment – like the screen in Sheridan's play *The School for Scandal*, behind which characters conduct sexual liaisons, or the screens hastily trundled into place in hospital wards so that death can happen out of sight. By using the word first in this pejorative sense, he was able to defend the cinema screen against the charge that it too shut out the obscene or ugly truth. The screen, when he mentioned it a second time as his chosen medium, could become a site of revelation.

It was a paradoxical proposition. A screen, which is supposed to shield us, instead becomes a means of attack, and administers those supposedly healthy shocks. Its primary function therefore has to be violently denied. Hitchcock warns us against relying on screens for protection. The shower curtain in *Psycho* is ripped aside, then the flesh – itself a screen for our 'jellified' organs – is gashed. Leigh grabs the curtain as she collapses, and tears it from the rail; it serves as her shroud. Even the sturdier Iron Curtain which the Communist bloc erected around itself can be penetrated, as *Torn Curtain* demonstrates. In *Stage Fright* a curtain acquires weight and a cutting edge, which

makes it a means of execution. The film begins with a shot of a thea-
tre's safety curtain, which rises not on a stage set but on a photo-
graphed exterior of the streets around St Paul's Cathedral. The
expected play opens out into a film; at the end it closes down again,
and the same safety curtain – inappropriately named, if you happen
to be in its way – descends abruptly like a guillotine to cut off Richard
Todd's escape, and kills him. Todd receives an advance warning
about screens and the protective claims they make. Making his get-
away, he jumps into his car and locks the doors. The police batter on
the windows and, even though he is desperately fiddling with the
ignition, he removes his hand to point sarcastically at a trademark
that boasts SAFETY GLASS. But it's not: one of the officers manages
to crack it with his elbow.

The hero of Jean Cocteau's *Orphée* is debarred from the kingdom of
shades by a mirror. He glides through by magic: the images on its
surface swim and ripple as he passes, like writing on water. Hitch-
cock's characters have to shatter a barrier before they can be admitted
to the nether world. The hysterical Vera Miles splinters a mirror in
The Wrong Man; in *Psycho* she is startled by her own reflection in a
mirror, as if she were already spectrally looking back at herself from
the other side of the glass. The 3–D process which Hitchcock used for
Dial M for Murder allowed him to penetrate the thin, taut fabric of the
screen, as filmy as the nightdress Kelly wears when she gets up to
answer the phone. Milland, rehearsing the murder with the killer he
has blackmailed, tells him to hide behind the curtains. Kelly always
answers the phone in the same spot, standing just in front of those
curtains: like an inhabitant of Plato's cave, she looks away from the
window and gazes back towards the glow – corresponding to the fire
in the allegory – that leaks out through the door of the bedroom.
Three-dimensional hands clutching a rope reach out from a gap in
the curtains. Then Kelly's hand, fixing on a pair of scissors, rakes the
blade through the air in front of our eyes and three-dimensionally
drives it into her assailant's back.

The screens in cinemas used to be curtained. When the curtain slid
back, we were shown a magic window, which enabled us to see
through a solid wall. Long before *Dial M for Murder*, Hitchcock had

begun to speculate about what the curtain might be hiding. In *The Skin Game*, the maligned Chloe cowers behind the curtains in the bay of an open window and listens to the members of her family denounce her. As her husband joins in, we see one hand clutch the rim of the curtain. Then, realizing there is no hope, she lets go. The squire's daughter draws open the curtains, as if signalling the start of a film, but the space is empty, the open window black. Chloe has gone off to drown herself. The closure of curtains signals an end – to films, and to lives. In *The Farmer's Wife*, Hitchcock shows the shadow of curtains being closed in the bedroom, to exclude the sun. They are being drawn shut long before dusk; the farmer's wife has died. Miss Lonelyhearts in *Rear Window* gives warning of her suicide attempt when, having laid out the pills and a copy of the Bible, she lowers the blinds of her apartment and wanders off into invisibility.

Our houses are screens for the cowering private life, boxed inside a barricade of walls and ceilings. What if those screening layers suddenly became transparent? In *The Lodger*, Hitchcock constructed a floor of glass so that the Buntings could see as well as hear their tenant pace up and down in the room above them. After this early experiment, Hitchcock tried other ways of breaching the screen or making it permeable. The plane crash at the end of *Foreign Correspondent* begins with a back-projection of filmed waves; then the cabin actually tumbles into a studio tank, and the screen with its simulated ocean is washed away by an actual flood. In *Saboteur*, the cinema screen is no longer a compliant blank on to which images are projected. It does some projecting of its own, and apparently discharges bullets. At Radio City Music Hall, a shoot-out on the screen is accompanied by a real gun battle in the auditorium. One of the spectators is killed, and it's up to us to decide who did it – the squabbling phantoms on the screen, or those equally obscure figures running up and down the aisles.

In the more modest surroundings of the suburban Bijou, *Sabotage* explores the dangers of the screen, and its tendency to jut out into a third dimension. When Ted visits the Verlocs in their parlour at the back of the cinema, a fanlight in the wall suddenly thuds open and a scream is heard from the other side of the wall. Mrs Verloc sends

Stevie to shut it, and Ted cautions him about getting too close to the murderous action: 'Look out George Arliss doesn't bite you.' (Arliss was a stagey rhetorician, famous for roles like Richelieu or Rothschild or Disraeli; on film, he acted as if intent on projecting himself across imaginary footlights.) Later, Stevie finds Ted snooping behind the scenes, and takes him on an alienating tour of the cinema's illusions. Ted, surprised as he sneaks into the corridor that houses the projection booth, claims he is searching for Verloc. 'Ooh,' says Stevie, 'he doesn't talk through loudspeakers.' As in his comment on Arliss, Ted pretends to believe that shadows have bodies, with real voices resonating inside them. Stevie has a case-hardened professional atheism about the place and the mysteries it dabbles in: 'It's only the screen – not much to look at.'

Meanwhile, behind the screen not in front of it, Ted himself now functions as a walking screen, with the film projected on to his grocer's smock. The reversed wraiths pass through the cinema screen – like Jean Marais penetrating the mirror in *Orphée* – and dance in air until they find a surface on which they can materialize. All they need is a patch of whiteness, a tabula rasa like the average human head, anxious to be filled with dreams. Gilbert in *The Lady Vanishes*, urging Iris to forget all about Miss Froy, says, 'Just make your mind a complete blank. Watch me, you can't go wrong.' His inanely cheerful grin vouches for his vacant brain: a sharply jocular comment by Hitchcock on the misuse of the cinema.

Rebecca includes a beautiful, ingenious essay on screens and projectors, which are both mental and mechanical. Olivier has made a home movie of his honeymoon with Fontaine. The showing is interrupted – first by a white-out, rather than the blackout that curtails a session at the Bijou. A picnic scene suddenly erases itself, as if the screen had become incandescent. Olivier has threaded the reel through the projector wrongly, and he turns on the lights in the room to correct his mistake. The error is not so easily rectified, because a reel of film is a stored memory – like the bottles in which his new bride wishes, during a drive in France, that happiness could be preserved. Olivier warns her that such bottles often contain demons; the film of the honeymoon jumps off its sprockets because he has other

189

memories, which overshadow such trivial enjoyments. These secret memories are as yet unscreened, and in fact are never shown. Olivier only tells her about them in his recitation at the boathouse, when he admits responsibility for Rebecca's death. The film's most obsessive images remain teasingly or mercifully unvisualized: the face of Rebecca herself; the two decomposed bodies Olivier identifies as hers; her cancerous womb, photographed by the doctor's X-ray.

The film within a film resumes, though now it is interrupted again by a quarrel. Furious, Olivier steps between the projector and the screen. He blots out the foolish, frivolous, jerky scenes, and steps into the scrutinizing beam of the projector, as if facing arraignment. On Fontaine's face, as she babbles a miserable apology, the play of reflected images still flickers, their agitation matching her confused thoughts. The motor whirrs, and the fictitious, mechanized memories go on unspooling. Olivier, unable to bear the simultaneity of past and present, turns on the lights once more and switches off the projector, killing the screen. Eventually he starts the film up again, hoping that he and Fontaine can agree to accredit its unclouded version of their lives. It shows them cuddling. 'Oh look,' he says, 'there's the one where I left the camera on the tripod – remember?'

This moving picture, however, tells another pretty lie, and in doing so alerts us to a truth. The Hitchcock couple is always a triad. His pairs of lovers are never left alone with their happiness; the camera, whether mounted on a tripod and allowed to operate on its own or not, is a compulsory presence, and it takes orders from the director, who looks over the shoulders of the lovers, breathes down their necks, impartially embraces both of them. Hitchcock, not Rebecca, is the ghostly, intrusive third party. What we see on the screen is the projection of his fantasy.

In his interview with Bogdanovich, he called film an area in which he was free to fantasize. The Greenwich Village courtyard in *Rear Window* is just such an area: a multiplex, on whose screens people undress, perform exotic dances, have sex, attempt suicide and commit murder, all to gratify a professional watcher who directorially projects his will across the empty space between his darkened lookout and the lighted rooms of his neighbours. *Rear Window* is Hitchcock's frankest

self-indulgence, and also – because he felt so congenitally guilty about his own ribald and ruthless imagination – his sternest self-reproof. For once, the figures on the screen are permitted to answer back. They look out from their bright rectangles into the darkness, and accuse the director who has imprisoned them there of misanthropy.

Grace Kelly at first treats *Rear Window* as a play, not a film. Arriving for dinner, she salutes the 'opening night of the last depressing week of *L. B. Jefferies in a Cast*', and starts a joyous countdown to the closure of the show. James Stewart, playing L. B. Jefferies with his leg in a cast, balks at being awarded the title role: he prefers the director's lurking invisibility. He says he hasn't noticed a demand for tickets, and Kelly replies that she has bought out the house. Once the play ends, the film can begin. 'Show's over for tonight,' she declares, pulling down the blinds. She then displays the silky contents of her overnight case, announces 'Preview of coming attractions', and goes to the bathroom to change for bed. That particular home movie, however, is not for exhibition to the general public.

Plays elide a fourth wall so that we can watch what happens on stage, just as Stewart's neighbours obligingly leave their lights on and their curtains parted. Nevertheless, in the theatre the people we spy on cannot acknowledge that they are under surveillance. The dynamics of the cinema are more complex and, oddly, more reciprocal, even though the figures we look at are not alive in front of us. Somehow we are more intimate with those luminous shadows on the screen than we can ever be with theatrical performers. We remain at a fixed distance from the stage; cinematography inserts us into the action, and presents us with faces in close-up, available to be kissed. Our reasoning powers are engaged, because the discontinuities of montage require us to interpret what we are shown, and so is our emotional empathy. The films Stewart watches across the way are silent, but he has learned how to interpret the signals. He knows what it means when Burr picks up the phone and dials three digits: he is asking the operator to place a long-distance call. The cinema, which is a collusive fantasy, expects audience participation. The spinster welcomes a non-existent suitor for dinner, bending sideways to receive his notional kiss and pouring wine for him. Stewart consents

to play the second role, and casts himself in her scenario: he raises his own glass to toast her.

Watching a film, we all wistfully project ourselves onto the screen. Kelly, climbing up the fire escape into Raymond Burr's apartment, actually invades that imaginary space, and is arrested there. The crisis comes when she signals to Stewart. Burr sees her gesture, realizes that he is being watched, and climbs down from the screen to demand an explanation. Initially he does not threaten Stewart. His tone, as he withstands the assault of the flash-bulbs, is dignified but plaintive: he asks, 'What do you want from me?' It is a question that any of us, given the chance, would address to our creator, if we had one. Or it might be one man's complaint against another who has exempted himself from common humanity and broken the social contract by claiming to be an artist. Why should Stewart have the right to see, without being seen in return? Burr receives no answer – neither from the photographer, nor from the director with a weakness for playing God. It is a moment of almost tragic remorse, transferring blame from the killer to the man who imagined the crime and chose a deputy to carry it out.

In its opening survey of the apartment, *Rear Window* intently studies Stewart's smashed camera: an icon of which the iconophobic Plato might have approved. Then, having imposed this embargo on the making of images, Hitchcock proceeds to defy it. The fire in Stewart's cave is generated by those flash-bulbs, which sear the room and blind the man who looks at them. There is a sun outside his window, but it is not the rational beacon of Plato's 'upper world'. During the day it raises his temperature, and is responsible for his sweaty, feverish imaginings; when it sets in the evening, its scarlet glare is painted across a sky-cloth inside the studio.

The Crimes of the Camera

Hitchcock loitering with photographic intent in *Young and Innocent*.

The vision that called itself modern used the eye analytically, and therefore aggressively. To analyse something means to reduce it to its constitutent parts. Picasso dismantled faces, and Dali caused forms to melt like wax. The camera enforced this cruelly incisive way of seeing. James Agee, who with the photographer Walker Evans exposed the rural poverty of the American South during the 1930s in his book *Let Us Now Praise Famous Men*, called the camera, 'next to unassisted and weaponless consciousness, the central instrument of our time'. That instrument armed the eye, and enabled it to scrutinise a world which only pretends to be real. Acknowledging this imperative, Hitchcock's films make the camera a character and also a culprit. In *Young and Innocent*, the director has a walk-on as an amateur photographer, loitering outside a court and sulking when he fails to get the snap he wants. Here the camera is a pest; in later films, it becomes a killer.

Supposedly incapable of lying, the camera is never as trustworthy as it seems to be. It does its looking in response to the decisions of an operator who seldom strays into view. Its vision is subjective and therefore unreliable, as the misleading flashback in *Stage Fright* demonstrates. The apparatus exemplifies the uncertainty principle of modern physics. We cannot observe the world steadily and strive to see it whole, as the Victorian moralist Matthew Arnold thought the artist should do; we have only partial versions of the truth, glimpsed from oblique and self-interested angles. In his memoir *Ways of Escape*, Graham Greene – describing his experiences of a coup d'état in Estonia and the Communist takeover in Prague – admitted: 'The view of an outsider at a revolution is an odd and slanting one, rather like a pretentious camera-angle.' The comparison between this sideways point of view and a mannered cinematic set-up is a predictable slur: Greene, during his period as a film critic in the 1930s, often attacked Hitchcock for being 'tricky, not imaginative'. A counter-revolutionary prejudice made Greene miss the point of such dislocated angles. The

modern eye looked at things in this way because it mistrusted appearances and disbelieved in reality.

The angles were mental attitudes, not mere gimmicky novelties, and they sceptically put received ideas or venerable concepts to the test. In *Easy Virtue*, for instance, Hitchcock's puzzling placement of the camera questions the all-seeing pretensions of justice. The film begins during Larita's divorce hearing with a shot looking down at the skull of the bewigged judge. He appears to have a hole in his head: it turns out to be the empty circle in the centre of his wig. Only after this abstract introduction does he raise his head to show a lean, sour face, which confirms that the dehumanizing angle told the truth about him. He employs his lorgnette as a camera, and its sampling of visual evidence reveals how bored he is by the proceedings over which he presides. A barrister's face, singled out by the lorgnette, zooms into close-up, while Larita slips out of focus in the distance. The odd and slanting angles, in his case, represent his effort to keep himself awake.

Hitchcock varied the trick with the lorgnette in another silent film, *Champagne* (made the year after *Easy Virtue* in 1928), though his intention here was very different. *Champagne* is about the spendthrift tipplers of the 1920s, so the ersatz cameras that warp the world or see it from seasick angles are drinking glasses, generally filled with fizzy, delirious liquid. One character in particular, a professional observer, keeps watch through these unreliable lenses. We first see a shipboard dance floor globed in the bottom of an upturned glass; then the same glass refracts and coarsens the drinker's face, making it bleary and sinister. Next, in a Paris cabaret, the glass pressed to his face is a mask. Though transparent, it still cramps his features, reducing him to a razory beak and a suspicious nose. Finally, at the end of the film, he raises another glass to toast the lovers and uses it as a studious microscope. It frames their embrace in two concentric circles, first inside the wide brim and next in the thin peep-hole of the stem. His surveillance, after all, is benign. Because the glasses have twisted his face lecherously askew, we have been encouraged to misjudge his motives. The drinking was an alibi; he has been sent by his rich employer in New York to look after his errant daughter. It's his duty

not to let her out of his viewfinder, and the glasses he drains are bell-jars inside which he seeks to protect her.

The camera makes visible the invidious motives of the eye behind it. Someone or something has been targeted for investigation, and when the shutter clicks an arrest occurs. You have no means of defending yourself, because the eye you look back at is a glassy lens. The free-spirited Larita in *Easy Virtue* is persecuted by the cameras that lie in wait for her. After her first divorce, a title-card proclaiming 'The Verdict' is superimposed on the silhouette of a movie camera, previously used for the film's credits, where Hitchcock's own name appears over it. She then flees to the south of France to escape gossip-mongering photographers. Respectably remarried, she throws a pillow at a Kodak Box Brownie on the sideboard of her husband's house, as if she wants to blind it. When this marriage fails, she surrenders in despair to the cameramen outside the divorce court, mouthing words translated by a title-card that Hitchcock himself wrote: 'Shoot! There's nothing left to kill.'

He later derided this line as the worst of his literary efforts; perhaps he disowned it because it was too blatantly confidential. Certainly he continued to use the camera as if its looks could kill – or, since he preferred to delegate the responsibility, to direct his director of photography to do so. Very occasionally, he allowed the photographic victim to retaliate. After the attack in the upstairs bedroom in *The Birds*, Tippi Hedren – her clothes ripped, her flesh lacerated – is coaxed back to consciousness with some brandy. The camera closes in to inspect the damage. She glares at it and wildly beats it away with flapping hands. Her fingers block the lens, like a celebrity fighting off the paparazzi not a squadron of imaginary birds. Rod Taylor soothes her, but the delusion has its own logic. The camera had impassively registered Hedren's distress in the attic, while the crew hurled live birds at her for days on end and watched as she battled against their flustered wings and dart-like beaks.

Larita's final pronouncement in *Easy Virtue* is grandly metaphorical. Hitchcock later allowed the notion of a camera that could kill to come out of metaphoric hiding. The political assassin in *Foreign Correspondent* conceals his gun behind a flash camera, and the bombers

at the Brooklyn Navy Yard in *Saboteur* operate from inside the sound truck of the American Newsreel Company, hooking up their explosives to a camera on the slipway that is poised to photograph the newly launched warship. The organizer regrets the loss of a good camera, then retires to wait for the outcome of the detonation at the company's office in the Rockefeller Center, among piles of canned film.

The spy counted as a distinctly modern character because his profession of espionage required a preternaturally acute vision. That same talent suited him to the cinema: what is a camera but a spyglass? Buchan's *Thirty-Nine Steps* judges characters by assessing their eyesight. Hannay himself needs no telescope when scanning the open country, because he possesses the predatory 'eyes of a kite'; he compares himself with the greyhound that helped him to hunt rhebok in South Africa – 'a greyhound works by sight, and my eyes are good enough'. Gielgud in *Secret Agent* makes use of the telescope disdained by Buchan's Hannay. Looking through it, he participates vicariously in a killing that his conscience has advised him against. The telescope enables him to be visually close but morally distant, but Hitchcock's camera – swooping across the floor of the observatory, vanishing down the telescope's black tube, then vaulting across space to watch Lorre push an innocent man into a crevasse – foreshortens the intervening space and calls his timid bluff. In Hitchcock's *39 Steps*, the foreign spy is identified by a missing finger. Buchan, more cinematic than Hitchcock in this case, gives Hannay a different clue: he is to look out for an enemy whose eyes are 'horribly intelligent' and glint with 'the inhuman luminosity of a bird's'. One of the film's additions to the novel was the figure of Mr Memory, the music-hall entertainer with the prodigious talent for recalling trivia, whose brain is used by the spies to store their secret formulae. But Mr Memory is the unwitting personification of a principle enunciated by Buchan, who says: 'A good spy must have a photographic memory.' In the absence of proper equipment, the trained spy will make use of whatever lies to hand. At the racetrack in *Marnie*, the man from Detroit rolls his newspaper into a telescope and uses it to scrutinize Hedren from afar.

Hitchcock, whose own art depended on the camera, criticized its

use by others. This was more than hypocrisy; his double standard allowed him to express doubts about his own procedures. In *Lifeboat*, Tallulah Bankhead plays a glamorous photojournalist – probably based on the intrepid Margaret Bourke-White, who accompanied the American army into battle for *Life* magazine. When the ship sinks, she scrambles into the lifeboat with all the implements necessary to her livelihood. These include silk stockings, jewellery and furs, since as well as producing sensationally topical art, she is herself a decorative and expensive art-work. In the course of the film she gradually forfeits her aesthetic and cosmetic chattels. She donates her fur coat to the shell-shocked mother, and it drowns with her; she gives up her diamond bracelet for fish bait. Her typewriter, on which she taps out a prospective best-seller about her ordeal, is bumped into the water, her memo pad is requisitioned for use as a home-made deck of cards, and she hands her typing paper to the Nazi, who needs a sterile surface on which to lay out the first-aid kit before he amputates William Bendix's leg. But the first trophy to be punitively taken from her is her movie camera. At the beginning of the film, she is busy making her own newsreel about the submarine attack, delighted by the welter of corpses. 'Look,' she says to the gruff oiler Kovak (John Hodiak) as a baby's bottle floats pathetically past, 'that's a perfect touch.' He strikes the bottle to sink it, condemns her for treating tragedy as a show staged for her benefit, and later – accidentally but unregretfully – knocks her camera overboard.

Art disengages her from life, and that cool immunity from feeling is formalized by a mechanical intermediary, the camera. It has no humane squeamishness, no nerves, no manners. Cameras in Hitchcock's films behave bumptiously, intrusively. The investigators in *Shadow of a Doubt* invade the house, disguising their curiosity as research for a national census. They have a misplaced faith in the camera's accuracy. The moment we catch sight of one, we rearrange our faces, doing our best to cover up the truth. Emma (Patricia Collinge) endlessly delays the photographer while she fusses over her hair and the frayed slip covers on her chairs. The family in Santa Rosa who allowed their home to be used as Hitchcock's location behaved with the same defensiveness. Before shooting began, they proudly

repainted the house; Hitchcock, who wanted it to look slightly the worse for wear, had to have it expensively distressed all over again.

We succumb to the camera because it blackmails us, persuading us that we have a duty to stand up and be counted, to join the group, and of course to look happy. A photographic session is customary when you are taken into custody by the police (though you are not obliged to smile). It is almost to Cotten's credit that he resents the coerciveness of the camera in *Shadow of a Doubt*, and refuses to be enlisted. 'I've never been photographed in my life,' he growls, 'and I don't want to be.' A startling claim: can anyone have grown to adulthood without being photographically indexed? The feat reveals a slippery talent for evading the law, and for fending off the possessive importunity of love. His sister challenges his claim by producing a baby picture. That hardly counts, as the child in the photograph is no longer recognizable in the adult. When one of the government agents slyly photographs Cotten as he comes in from the back stairs, he confiscates the film. But there is no outwitting the camera. The photographer juggles rolls, and holds on to his image. After all, the character's defiance of photography is uttered in a film by an actor who made a living by having his picture taken.

The camera in Hitchcock's films is an expert at subterfuge. It slithers across a window ledge, wriggles beneath the blinds and insinuates itself into the hotel bedroom in *Psycho*. In *Number Seventeen*, blown down the street in a gust of wind along with a flurry of leaves and someone's hat, it forces open a door: the gale is its convenient excuse for housebreaking. The barred, rusty gate at the beginning of *Rebecca* cannot deter it. Fontaine's narration, taken directly from du Maurier's novel, describes her return to Manderley in a dream. The gate at first blocks her way, but suddenly she is 'possessed of supernatural powers and passed like a spirit through the barrier before me'. The camera makes light work of that ethereal passage. When it draws close to the gate, the barrier simply dissolves. Possessing no body, the camera can easily squeeze through the crevices in the wrought iron.

Patrick Hamilton was taken aback by the sense of entitlement the camera displayed in *Rope*. Hitchcock explained his plan to film the

play in a series of continuous takes. The camera, Hamilton commented, was to be 'an invisible man', who 'walks about the flat . . . and sees and hears everything'. The invisible man, as Hamilton well knew, was invented by H. G. Wells in a novel written in 1897. Wells's hero is a physicist, rendered insubstantial by an overdose of photography: he X-rays himself, and becomes a ghost. But he does not regret his loss of visibility, because 'an invisible man is a man of power'. That is a boast which the camera implicitly makes as it glides across the floor in *Rope*, causing furniture to dodge out of its way and walls to slide sideways on tracks soundproofed with Vaseline – a more scientific demonstration of du Maurier's 'supernatural powers'.

It enjoys those powers without acknowledging any sense of responsibility. One of Hitchcock's most bewilderingly clever shots allows the camera to blamelessly quit the scene of a crime. In *Frenzy* it follows Barry Foster as he ushers Anna Massey upstairs to his Covent Garden flat; then, surprisingly, it respects the door he closes behind them. He claims to be merely giving her shelter. Is he seducing her inside? No, he is strangling her. The camera prefers not to get involved, and it backs off, eases itself around the crook of the narrow staircase, ducks under the lintel of the front door, saunters into the noisy street, and crosses to the pavement on the other side, where it executes a turn to look back at the blinded windows on the first floor. Its motto here is 'See no evil' – though, of course, during that twisting, tortuous retreat, we have done nothing else but imagine an evil that the camera for once declines to show us.

The inhuman camera confronts human faces. Are our organic eyes any match for the mechanical eye that tries to penetrate them? A bloodshot eye marks a frontier during the credit titles of *Vertigo*. The camera wants to know what is inside the head of that inscrutable woman, and chooses to make its entry through the eye. Its probe might have suggested a scene in Winston Graham's novel *Marnie*, published three years after *Vertigo* in 1961. Mark Rutland asks Marnie to remove an eyelash from his eye. (The incident disappeared from Hitchcock's film: how could Connery have made such a prissy request?) Marnie, who narrates her own story, reflects that 'taking an eyelash out is very much of a close-up project', and must be

conducted 'at nearer than love-making range'. She has the right train-
ing for this photographic transaction. She begins her career as a
cinema usherette, and – like Stevie in *Sabotage* when he nonchalantly
demystifies the screen – her job teaches her to mistrust the medium.
On her way to rob the safe, she looks askance at 'a big American face
. . . telling the audience why the film he was appearing in at this
cinema for seven days beginning next Sunday week was a unique
event in motion picture history'.

Graham's Marnie prises open Mark's lid, and is surprised by its
tender pink underside and the angry, broken blood vessels in his eye.
Then she studies the pupil, which is 'about the closest you can ever
expect to get to the personality'. In *Vertigo*, that is when Saul Bass's
biomorphic coils and spirals take over, abstractly deciphering a brain
whose workings cannot be photographed. The doctor who trips up
Paul Newman in *Torn Curtain* undertakes the same investigation, for
which she has proper medical grounds. Checking for concussion, she
shines a thin torch into Newman's famously blue eye. Miniature cam-
eras have since learned to go much further, and can now slide into
bodily apertures and photograph our insides. *Topaz* comically antici-
pates the intrusion when the spies in Havana conceal their camera in
a gutted chicken. Is the photographer, like the bird, an eviscerated
creature, lacking a warm, sympathetic interior?

This is the question everyone in *Rear Window* asks about the profes-
sional peeping of Stewart. Kelly rebukes him for his indifference to
her. Wendell Corey, representing the police, thinks that his scare stor-
ies make him a public nuisance. Thelma Ritter criticizes his ethics
while administering a massage. With her hardbitten wisdom and her
salty repartee, she is the most complex of the consciences gathered
around him; he has a more carnal and confessional relationship with
her than with Kelly, perhaps because it's her job to discipline him.
She behaves like a dominatrix making a house call, rather than a
nurse. First she changes the sheets; then she undresses him and oils
his prone body. After that she pummels it, which he finds exquisitely
painful. Before leaving, she removes the unctuous sheets. While bela-
bouring him with her fists, she tells him what a naughty boy he has
been, and threatens him – like the infant Hitchcock locked in the

police cell – with being sent to the workhouse, where there are no windows.

She adds that in the old days, the eyes of peeping Toms were put out with a red-hot poker, and asks if the bikini girls he has spent a month ogling are 'worth a red-hot poker'. He does not answer, but his sweaty, squirming frustration responds for him. The girls have already induced a red-hot poker. Ritter shifts the phallic evidence upwards, and makes it the instrument of his scourging. The punishment has a deadly accuracy. Eyes can have erections too, as Stewart shows when he fixes that elongated lens to his camera. A medium, as Marshall McLuhan pointed out, is the extension of a man. Unable to control the ignited poker, Ritter stops another orifice. Stewart begs her not to take his temperature, but she stuffs the thermometer in his mouth and snaps: 'Quiet, see if you can break a hundred.'

These qualms about Stewart's addiction to the camera arose only when Cornell Woolrich's story became a film. Woolrich's narrator is not a photographer, and his vigil in the window provokes no criticism from bystanders. The only other character in the story is a black retainer, who runs the narrator's errands without demur. The immobilized observer passes the time in intellectual deduction, figuring out that the killer has lowered his wife's corpse into an 'odourless coffin' of fresh cement in an apartment that is undergoing redecoration. That detail – by contrast with Burr's carving up of his invalid wife, and his piecemeal burial of her sectioned body all over Manhattan – indicates how cerebral Woolrich is. The strain of seamy complicity between observer and criminal is Hitchcock's invention, and it follows logically from his decision to turn Woolrich's vocationless narrator into a cameraman.

When Stewart picks up his binoculars or screws the lens that Ritter calls a 'portable keyhole' on to his camera or uses his flash like a stun-gun, he is acting out a ritual that reappears, in different forms and with different equipment, in many of Hitchcock's films. It might be called the empowering of the eye, and Hitchcock's kind of cinema cannot exist unless its solemn formalities are observed – just as Montgomery Clift in I Confess cannot celebrate Mass without putting on his vestments, genuflecting to the altar, voicing private prayers.

Sometimes the eye attains this power by commandeering the entire screen in close-up. In *Torn Curtain* the ballerina Tamara Toumanova, who plays an avenging harpy, inserts her eye into a hole in the wall that allows performers backstage to spy on the audience out front. Her eye is starkly outlined by theatrical make-up; raking the rows of seats, it might belong to a guard in a watchtower. Is she searching for Newman and Andrews in the theatre, or can she somehow see us too, as we skulk anonymously in the cinema?

The power of the eyes and the politics of looking are a recurrent subject of conversation in Hitchcock's films. During a mad monologue about the life-force in *Strangers on a Train*, Walker presents himself to a perplexed Washington politician as a television set in human form: he claims that he has developed an ability to see for millions of miles. In *Rebecca*, the obnoxious Mrs Van Hopper scowls when her companion (Fontaine) murmurs that she finds Monte Carlo artificial. 'Most girls,' she snarls, 'would give their eyes for a chance to see Monte.' Olivier asks whether that might not defeat the purpose. The issue is inevitably discussed in *The Paradine Case*, since the murdered Colonel was blind and relied on others to do his seeing for him. This fact prompts some odd locutions in the film's dialogue. The housekeeper in the Lake District, showing the view to Gregory Peck, remembers that the Colonel loved to have his wife describe the landscape to him, and in court when Louis Jourdan recalls the quarrel before his departure, he says that the Colonel 'looked at me – in his blind way'. Perhaps we are all equally blind, since we rely on film to brighten our darkness. The Colonel's predicament turns his wife into a martyr. 'You were his eyes,' says Peck to Valli. But if the eyes are not your own, can you be sure that the views they describe are truly there?

The bewitched Peck pays tribute to Valli in a curiously inflected speech. Her husband, he tells her, could not have appreciated her 'sublime sacrifice', because 'he'd never seen you – he'd never, as I say, seen you'. He means that the old man did not know how beautiful she was, and how much better she might have done for herself. The repetition draws attention to Peck's own adoring gaze, which Valli both deflects and encourages by averting her eyes. It also warns

that Peck himself has not truly seen her. The camera's subjects are professional dissemblers, creatures who – like the unreciprocating lover in Shakespeare's sonnet – are 'lords and owners of their faces'.

You can retain possession of yourself by hiding your eyes. The assassin at the Albert Hall in the second *Man Who Knew Too Much* rehearses his shot by studying the elder statesman through a pair of opera glasses. Fastened to his bony, dented face, they resemble prosthetic eyes. He pivots these metal gunsights so that they poke directly at us; when his gunbarrel protrudes from behind the curtain, it swivels through the same arc. Grant's escape from New York in *North by Northwest* is complicated by the universally recognizable face he wears. Like other celebrities before and since, he reclaims that face for his own private use by wearing dark glasses. 'Something wrong with your eyes?' asks a suspicious clerk in the ticket office at Grand Central. 'Yes,' replies Grant with the testiness of a star refusing an interview, 'they're sensitive to questions.' Poets have traditionally regarded eyes as the apertures where love enters, and the cinema has always happily catered to our ocular lust. Hitchcock, however, preferred to think of the unguarded eyes as the place where our guilt leaks out. The killer in *Young and Innocent* gives himself away by his twitching eyes; it is the camera, visually invincible, that detects that tic across a crowded ballroom and cranes through the air – like an eye ejected from its socket – to identify him.

During the 1920s, the painter and film-maker Fernand Léger issued a summons to people who wanted to be modern: 'Have your eyes, your spectacles remade. Cinema is about to begin.' Cinema administered a quick course in optical renovation. Hitchcock's characters follow Léger's advice, though for their own devious reasons. Often they have their spectacles remade because – like Grant in his shades – they want to remain unseen, not in order to see more clearly. Derrick de Marney, accused of murder in *Young and Innocent*, escapes from the court with his short-sighted solicitor's thick goggles as disguise. He is blind with them, the solicitor without them; he stumbles down the street blinking owlishly, unrecognized by anyone. Jane Wyman makes less successful use of the same method in *Stage Fright*. Impersonating a maid, she deglamorizes herself by purloining her mother's

reading glasses. The world swoons out of focus when she puts them on, and she preens before her shadow on the door, which she thinks is a mirror. But when she tests the camouflage, her mother (the dottily imperious Sibyl Thorndike) recognizes her at once, even though she has been placed at a disadvantage: 'Help me find my glasses,' she demands, 'I can't see a thing.'

Fontaine makes ambiguous play with her spectacles in *Suspicion*, revealing what contradictory functions they serve. She primly cowers behind them when Grant blunders into her railway carriage. At the same time, when she sets them down on top of a magazine portrait of Grant, they magnify his face and allow her to admire it: stealing the film-maker's prerogative, she obtains a close-up. To take off her glasses is a sexual concession, like the removal of a garment. She hides them when Grant reappears and invites her to skip church. Throughout the film she puts them on to read letters, telegrams or newspapers, which always bring her bad tidings. The very fact that she needs them hints that her view of things is faulty. They cure myopia but worsen her paranoia, which leaves her unable to see Grant properly – is he a feckless charmer or a psychopath? No matter how good your eyesight is, you can never look inside another person's head.

The camera mortifies life, causing us to freeze when it looks at us. Yet for Hitchcock this counted as a ghoulish advantage, as *Suspicion* suggests in its presentation of another bespectacled character. Gavin Gordan plays a forensic pathologist, whose sister, also a connoisseur of corpses, is a detective novelist. 'Ah, arsenic!' he breathes while sectioning the puny breast of a Cornish hen on his dinner plate. He wears rimless spectacles with lenses like plate-glass windows: armour for eyes that spend the working day in the study of forbidden sights, as he lays bare our insides. When Fontaine is overwrought, he takes 'a good look' at her. The phrase is his sister's, and she adds 'though he doesn't usually examine living people'. Fontaine, however, is asleep or sedated when the examination takes place, which makes it the next best thing to an autopsy.

Hitchcock's films are shadow plays, deciphering a chiaroscuro like the London fog in *The Lodger*; they are also about the play of eyes –

quizzical, barbed, camera-like in their cold fixity. The cop in *Psycho* glares through the car window at Leigh as she sleeps beside the road. What makes his face so intimidating is his dark glasses. She gabbles an explanation about her drowsiness the night before, and says that she almost had an accident, because 'I couldn't keep my eyes open'. The cop's blackened vizor may cover the secret of his invulnerability. Perhaps, like the despots who rule totalitarian states, he does not need to sleep. In the motel parlour, the glazed eyes of stuffed birds keep watch, while Anthony Perkins remembers 'the cruel eyes studying you' in the asylum.

As Leigh undresses for her shower, Perkins plugs his eye to a chink in the parlour wall: we see it peering into the orifice, which glows. In Robert Siodmak's *The Spiral Staircase*, made in 1945, the eye of a killer (George Brent) stares out from its hiding place in close-up. Siodmak shows the eye with startling frontality, but Hitchcock looks at Perkins's eye in profile – indirectly and therefore analytically. True, its fringes of hair make it clear that this eye, a peep-hole for the shuttered brain, is a sex organ; but we are also invited to see it as a scientific instrument, which miniaturizes a universe of information by relaying light into the darkness of the cranium. The shot is both a daringly intimate anatomy lesson and a diagram about the workings of photography. The lookout drilled in the wall serves Perkins as a pinhole camera. The curved glass of a camera lens concentrates light, imitating the crystalline lens behind the iris in the human eye; doing without glass, the pin-hole camera concentrates light by reducing the aperture. A much longer exposure time is necessary, but that's no problem if the watcher is a fixated voyeur.

A strange, frail reciprocity unites the cameraman and his subject in this scene: the encounter between Perkins and Leigh is one of the more tender and searching relationships in Hitchcock's films – a brief communion and commiseration of souls, sexually consummated by a killing. When Perkins moves back from the wall, the pin-prick of light shining out of the next room hovers on his face, as if cast by a laser. He too is under surveillance because Leigh has seen into him, like a photographer making an X-ray. She overhears his fight with his mother, and goads him to rebel against her or to lock her up. After

such insight, what forgiveness can there be? The close-up of his live, smouldering eye is followed by another shot, only two or three minutes later, of her dead eye – still dilated in amazement, with a waterdrop from the shower clinging to it in place of a last regretful tear. The next stage comes at the end of the film, when the camera discloses the emptied eye sockets in the wizened head of Mrs Bates.

Hitchcock continued to worry about the punishment for unwarranted looking, with which Ritter threatens Stewart in *Rear Window*. Suzanne Pleshette's eyes are pecked out in *The Birds*. Rod Taylor shields her cratered face with his hand in examining the body, and also covers his young sister's eyes to protect her from the sight of this when he leads her out of the house. The farmer visited by Jessica Tandy suffers the same mutilation: Hitchcock referred to this character, seen only as a corpse dressed in striped pyjamas, as 'the man with no eyes'. Oedipus punctured his own eyes to arraign himself for his lack of self-knowledge. Hitchcock knew himself only too well, and put out the eyes of others to prevent them from looking back at him.

Cutting and Splicing

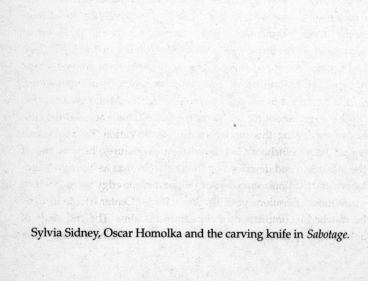

Sylvia Sidney, Oscar Homolka and the carving knife in *Sabotage*.

The modern spirit, in art and in science, had a simple, drastic premise. Reality was to be broken down, or cut up. D. H. Lawrence objected to this treatment of nature, which he called 'the Great Abstraction', and protested about the way that science had reduced existence to a shaky conjunction of atoms or molecules. 'The very statement that water is H_2O is a mental tour de force,' he said. 'Our bodies . . . know that water is *not* H_2O,' but we are 'bullied by the impudent mind'. The same logic that dissected a water-drop went to work on the complex structure of human society, formerly held together by shared beliefs. In 1898 the anthropologist Franz Boas, writing about the traditions of an Indian tribe in British Columbia, propounded a truth that summed up in advance the intellectual habits of the twentieth century. 'It would seem,' he argued, 'that mythological worlds have been built up only to be shattered again, and that new worlds were built from the fragments.' Creation depends on and derives from our endemic destructiveness.

In 1924 Léger made a film called *Le Ballet mécanique* that showed, as he said, the way 'a shadow cuts across the hand placed on the counter' or an eye is 'deformed by light'; it studied 'the life of fragments'. Once fragmentation had occurred, how could those visual scraps and shreds be made to cohere? The painters, following Picasso and Braque, employed collage, glueing together torn, tattered scraps of paper, while film-makers constructed sequences by using montage. G. K. Chesterton in his collection of stories *The Man Who Knew Too Much* – a remote source for Hitchcock's two films – accused the cubists of expressing this modern sense of dislocation 'by angles and jagged lines'. Hitchcock borrowed their procedures; he was one of the dissident band described by Chesterton in 1922 as 'the new angular artists', a connoisseur of quick cuts and of the edgy utensils which made those transitions possible. At a Lincoln Center tribute in 1974, he watched a compilation of clips from his films. The anthology of abbreviated killings concluded with Grace Kelly stabbing her

attacker in *Dial M for Murder*. 'The best way to do it,' Hitchcock commented, 'is with scissors'. In 1935 Bertolt Brecht welcomed the scissors as a diagnostic tool, dissectively slashing through the messy sentimental empathy of traditional theatre: 'with an epic work, as opposed to a conventionally dramatic one, you can take a pair of scissors and cut it into individual pieces, which remain fully capable of life'. The victim in *Dial M for Murder*, however, disproves the last part of Brecht's assertion. The Russian director Grigori Kozintsev, who thought of celluloid as sentient flesh, had no compunction about ruthlessly applying 'scissors, razor blades' to this 'warm, live substance' in the cutting room. Kozintsev found an analogy to this editorial art in the Japanese practice of ikebana, which transformed a 'gardener's scissors' into 'ancient knives'. He relished the cruel finesse of the ikebana master's procedure: 'the love of flowers leads to their annihilation, the cult is born of destruction'. Film derives from the same gory surgery, suturing wounds, in those days before editing became bloodlessly digital, with cement.

As Hitchcock explained to Bogdanovich, 'Pure cinema is complementary pieces of film put together, like notes of music to make a melody.' His reference to music took account of the same procedure in another art. The notes that make up the melody, counted out in one of Schoenberg's twelve-tone rows, are also joined by force, not natural affinity. Like Hitchcock, Stravinsky valued the incisiveness of scissors, which engineered jolting, razor-edged transitions. At the end of his ballet *Orpheus*, the mythological singer is decapitated by the Bacchantes. A solemn contrapuntal lament by the horns is several times curtailed so that a harp can describe the descent of Apollo and the apotheosis of Orpheus. Stravinsky made short work of the change from brutal death to divine rebirth: he cut off the fugue, he said, 'with a pair of scissors'. No wonder that André Bazin mistrusted montage. He considered it heretical, because it manipulated and rearranged a reality ordained – according to Bazin's Catholic mysticism – by God. The art historian Elie Faure noted in 1934 that film confirmed the researches of the new physics. It showed us, Faure claimed, a 'molecular universe'.

Before collage or montage could reconstruct the world, it had to be

selectively destroyed. This is the process that fascinated Hitchcock: a conceptual murder, like nuclear fission. He enjoyed fracturing objects and dispersing them through space. The florist carefully pieces together Carlotta's posy in *Vertigo* and presents it to Novak, who carries it with bridal solemnity and then scatters the flowers on her own prospective grave before she jumps into the bay. Later, in Stewart's nightmare, the bouquet's component parts fly apart, with petals and blossoms hurtling through the space like shrapnel. Hitchcock could make furniture dismember itself, as if he had the power to unglue the atoms that had solidified as houses or furniture inside them. Hence what he called the 'collapsible' apartment in *Rope*. The ten-minute takes in *Under Capricorn* required a dinner table to disintegrate in the middle of a meal. The table was carved into sections; when the camera encroached, individual diners allowed it to pass by toppling backwards on to a mattress, clutching their own portion of the board and the food attached to it.

If rooms and their fixtures could be treated this way, why not human bodies? In 1937 Hitchcock described his technique as a kind of butchery, saying that he saw 'an acted scene as a piece of raw material that must be broken up, taken to bits, before it can be woven into an expressive visual pattern'. The violence is all the more striking because the example Hitchcock discussed in this essay on direction was Sidney's killing of Homolka in *Sabotage*: she treats him as raw material, and breaks him up or takes him to bits with a carving knife. More invitingly, Kelly in *To Catch a Thief* offers Grant his choice of leg or breast. She is referring to the chicken in their picnic basket, though her vocal insinuation makes it clear that the offer applies to her own body. Seduction, like carving, proceeds by targeting our physical fault lines, and it pays separate, specific attention to our juiciest anatomical portions. The idea of the scissors predictably stimulated Hitchcock's taste buds. For him, murder was aesthetic, erotic, but also appetitive. He rejected a shot from *Dial M for Murder* because the blades of the scissors did not flash as they arched through the air. 'A murder without gleaming scissors,' he reasoned, 'is like asparagus without the Hollandaise sauce – tasteless.'

Stewart, the vacationing physician in the second *Man Who Knew*

Too Much, jokes about the fruits of such surgery. His family trip to North Africa has been paid for by a gallstone from which one of his Midwestern patients suffered, and Doris Day while in Paris exchanged someone else's tonsils for a purse. Stewart glances down at his suit and realizes: 'I'm wearing Johnny Matthews's appendix.' It is a surreal jest, like the Bal Onirique given for Dali in New York in 1935, when guests came dressed in their diseases – tumours, mutilations, rashes and carbuncles. Just what kind of doctor is Stewart anyway? His son calls him away from the tumblers in the Marrakesh market: 'We're going to see the medicine man – maybe you can learn something, Daddy.' Or maybe not. Cajoling Day to swallow a sleeping pill after their boy is kidnapped, Stewart reminds her: 'I make my living knowing when and how to administer medicine.' Hitchcock was a doctor with different therapeutic preferences, who dispensed shocks and stimulants, not sedatives.

The editing of bodies is most apparent in the way Hitchcock directed love scenes. We never see the cleaving of flesh, the reunion of separate selves; his lovers do not sleep together like spoons aligned in a drawer. Concentrating on segments of people, he shows the difficulty of coition. When he composes a two-shot, there is usually some embarrassed fumbling as people align themselves and quickly rearrange their extremities. In *I Confess*, Montgomery Clift, who has joined the army, leaves the marching troop to embrace Anne Baxter. Before he can do so, he has to free his hands, one of which is busy holding his rifle. Instead of setting it down, he thrusts it into her arms, and can then grab her with both hands. It is a piece of choreography that tells you everything about their vexed relationship. Hasn't he signed up, just as he later takes holy orders, to escape from her? He is defending himself sexually with that gun. Fearfully grasping it while he says goodbye to her, she is unable to reciprocate.

Notorious contains another manual emergency, resolved with beautiful ingenuity. Before the party, Bergman purloins and palms the key to the wine cellar, holding it with both fists clenched. Rains, however, prises her hands open to bestow grateful kisses. The only way she can protect the key is to throw her arms round his shoulders and hug him, passing the key from the fingers of one hand to those of the

other, then dropping it and lightly kicking it out of sight. While offering herself for an embrace, she has retained control of the key: he is not to be allowed access. In the next scene, the camera cranes down from the ceiling to Bergman's hand as she stands beside Rains in the foyer, nervously jiggling the key – an absurd risk, but where else about her person could she hide it and still have it ready to transfer to Grant when he kisses her hand?

More than uranium, *Notorious* is about the transmission of bodily secrets – earlier leaked from the murmuring lips of Grant and Bergman during a kiss with a scandalous duration of two minutes and forty seconds, here passed on by dabbling hands. Fontaine had a humorous dispute about pronunciation with Selznick while recording the spoken prologue to *Rebecca*, in which she refers to the 'secretive and silent' walls of wrecked Manderley. She wanted to say '*se*cretive', whereas Selznick thought it should be '*secre*tive'. She won, although the ambiguity is intriguing: does possession of a secret imply a secretion, like a guilty sweat? Bergman, drunk in Miami, sneers that her party needs a little 'gland treatment'. When Rains finds out about her treachery, he tells his mother (played by the basilisk-faced Madame Konstantin) that he must have been insane 'to believe in her clinging kisses'. His mother, like a Prussian Mrs Bates, barks: 'Stop wallowing in your foul memories!' You can almost hear the trickling of body fluids.

Genitalia, being concave and convex, slot easily into each other. But how can obtrusive hands, mouths, breasts and legs be made to join? Noses require careful negotiation. Bergman expertly avoids Grant's during that kiss in *Notorious*: she inclines her head to one side, and keeps her balance by grabbing the lobe of his ear. Kelly's first appearance in *Rear Window*, mistily materializing in Stewart's dream, demonstrates the technical awkwardness of splicing bodies together, and the terrors it arouses. He is asleep; she creeps towards him, her teeth bared, her mouth scarlet, like a softly slinky predator. She hovers, and her shadow covers his face and blots it out, as if she were about to consume him. His eyes, not expunged, open wide and white, and they stare in alarm. Then, recognizing her, he smiles at the shadow that has settled on him. Roles are reversed. It was Jove who

impersonated a cloud in order to ravish Io; usually it's the prince, not a princess, who kisses the passive sleeper awake. Slowed down, slightly jerky in its motion, Kelly's face in profile alights on his, and their lips graze in a squelchy moment of connection. A kiss, like any act of coupling, is a mechanical feat: your aim must be exactly right.

Only later, after a whispered dialogue, does Kelly display the body to which the face belongs. Stewart, pretending to be as puzzled and titillated as we are, asks who she is. She withdraws into a long shot and replies: 'From top to bottom, Lisa – Carol – Fremont,' gliding around the room and turning on lamps as she utters each word. She has applied the editorial scissors to her physique, and divides herself vertically into three zones with different names. Lisa is the head, Carol the breast, and Fremont the nether parts, with the lamps as spotlights directed at those separately delectable areas. The sectioning is underlined by her monochrome clothes: for this fully dressed striptease, she wears a black top with a white wrap, then below it a white, filmy skirt covered by black cobwebbed tendrils.

Elsewhere the outcome is less happy. In *Champagne*, the prodigal daughter runs towards the camera, her eyes shining with delight as she greets a visitor. Her face blurs, and her mouth presses on to the lens. Then we see what she has kissed: the tight, desiccated lips of her father, whose face – when the camera pulls back – is frozen with disgust. The wedding guests in *The Ring* include a variety of fairground folk whose bodies disqualify them from sexual partnership. Two Siamese twins are shown from behind, with the floppy bow on their dress bundling them into the same costume. But they are at war inside that shared skin, and tug apart as they disagree over which side of the church they should sit on. A morose giant sulks in a pew: how will he ever find a mate? Beside him is a dwarf, equally unfit for pairing.

Stewart in *Rear Window* is more resourceful. In Kelly's absence, he replaces her with a long wooden rake, which he has been given to soothe the itches underneath his cast. It is an ersatz sex aid, though it also functions – like woman in her role of man's conscience, his better half – as an admonishing rod. He pokes it into the crevice beneath his plaster cocoon to caress the irritant place, and beams in solitary gratification. Later he uses the same implement to punish himself,

thwacking his leg when Corey convinces him that Burr has an alibi. Corey ogles the cavorting Miss Torso, and Stewart – cradling the scratcher like a cane, a sign of stricture and chastisement – asks him: 'How's your wife?' During a conversation in which he lectures Corey on how to investigate the case, Stewart brandishes the prop like a teacher's ruler, gesturing with it as if he were banging a blackboard to explicate a theorem. Then it changes back to a wand, capable of conjuring up pleasure. Now his toe, exposed at the bottom of the cast, starts to itch. He reaches out with the wooden prongs, and beams ecstatically when he makes contact. In the courtyard, a coloratura soprano celebrates his success. She practises a trill, and sprays the air with silvery sound as she ricochets between two notes and, for one long moment, causes time to stop. The protruding, pacified toe and the snatch of music apparently have nothing in common; brought together from opposite ends of the set by Hitchcock's montage, they hint at an orgasm, narrating a scene we can imagine but not see.

Such substitutions work because bodies for Hitchcock were kits of parts, available to be transposed. After the storm in *Marnie*, there is a close-up of Hedren's seeking, whispering lips as Connery kisses her. Her mouth could be any other bodily vent, painted to signal accessibility. The remembered killing of the sailor – an abusive client of Marnie's mother, a prostitute – is narrated in a shot of bare entangled limbs. His leg, lean and hairy, prods hers, which is pinker and puffier; outside the frame, he has apparently impaled her groin. In his head, Hitchcock devised story-boards for sequences in *Marnie* that remained unfilmable. He told Bogdanovich, with excitedly emphatic italics, that what Connery's character really wanted was 'to have *had* her during a *robbery* – right in the midst of one. By a *safe*!' With Evan Hunter, he was equally explicit when describing Connery's marital rape of Hedren on their honeymoon: 'Evan, when he sticks it in her, I want the camera right on her *face*!' Luckily, he had to make do with substitutions for these fantasies. Accessories and office furniture replaced the contraband organs and orifices; those primal scenes were performed as symbolic charades. The film begins with a close-up of a yellow purse, gripped under Hedren's arm. The leather puckers like skin; running down the middle is a vertical clasp, clamped

castratingly shut. Next Hedren's former employer is seen shouting 'Robbed!' and pointing to his empty safe, whose contents are now in the portable strongbox that she carries under her arm. She has robbed him, though it was his intention to rob her, as he reveals when he sneers about her prudish habit of 'always pulling her skirt down over her knees as if they were a national treasure'. The man empties himself; the woman is fulfilled – financially if not emotionally – as the bulging purse boasts. We watch the same forbidden act at the casino in *To Catch a Thief*, when Cary Grant drops a ten-thousand-franc plaque down the décolletage of a woman at the roulette table. She gives him gambling chips in return. Intercourse is a banking transaction. The man makes a deposit; later there is a withdrawal. Because *To Catch a Thief* is a comedy, the physiological rule is fortuitously reversed and Grant does not suffer the usual sad male diminution. He inserts one thin token, and gets back a towering pile of credits.

A lacerated body can be 'woven' – to use Hitchcock's daintily artful, decorative word – into a visual pattern, as the editing of the shower scene in *Psycho* showed with such gelid skill. But is it possible to reverse the effects of such destructiveness, as Boas hoped when he said that new worlds could be made from the fragments of old ones? All his life Hitchcock retained a fondness for J. M. Barrie's *Mary Rose*, first staged in 1920; late in the 1960s, he still hoped to film it. Mary Rose is a fairy child. Like a younger and wispier version of Miss Froy in *The Lady Vanishes*, she disappears on a magic island, then reappears a generation later, not having aged during her long sojourn in the fourth dimension. Hitchcock denied that the piece was a fantasy, like Barrie's *Peter Pan*, about perpetual childhood. He saw it as an optimistic scientific parable, 'an illustration of the proposition . . . that a person can be atomically disembodied . . . and then reassembled'. The studios did not share his enthusiasm for the subject. In any case, hadn't he already illustrated this metaphysical proposition – first in *The Lady Vanishes*, then again in *Vertigo*? Deputizing for the director, a befuddled apprentice to a carnival magician tries reassembling a sectioned human being in a 1961 instalment of *Alfred Hitchcock Presents*. The boy slices in half the voluptuous Diana Dors, who

fails to grow back together when he waves his master's wand. 'The saw worked excellently,' Hitchcock reports in his epilogue, 'the wand did not.' The television network thought Robert Bloch's story distasteful, and banned transmission of the episode.

It is not surprising that Hitchcock should have associated montage with vivisection. A technique for him was a mental weapon. His psychiatrists in *Spellbound* do not confine themselves to analysing problems. They scrub up, don white smocks and face masks, get their scalpels out and go to work on their patients in an operating theatre. Editors perform surgery with scissors, not knives; Hitchcock never ceased to be amazed by the power and versatility of the humble tool. Stand a pair of scissors upright, and its blades become legs: in 1937 he thanked his editorial scissors for transporting Robert Donat and Madeleine Carroll to the Scottish highlands – where they never set foot – in *The 39 Steps*. The stars stayed in the London studio while their doubles exhaustingly scampered across the moors. The wily scissors equalized the footage.

Scissors can cut film, but are also liable to carve up human bodies. The young man in Josephine Tey's *A Shilling for Candles*, on which Hitchcock based *Young and Innocent*, complains that the film star Christine Clay organizes her emotional life with the brisk brutality of the editing suite: she has discarded him 'like bits on the cutting-room floor'. *Dial M for Murder* is Hitchcock's own edgy homage to the scissors. In the production notes to his play, Frederick Knott included some tips for amateur companies staging the piece. The scissors were a particular worry. He was concerned that they might be knocked off the desk on to the floor during the struggle, so he recommended taping them down. He also advised using 'trick scissors' with a spring to retract the blade. The actress was directed to remove them from the back of the dead man and replace them in a desk drawer left open for the purpose. The drawer, Knott advised, should be lined with felt, to muffle any clatter. The actor playing the husband was encouraged to turn the victim's body 'away from the audience so that the scissors are not visible'. Hitchcock dispensed with such caution, using 3–D to sharpen the scissors and elongate their blades. Kelly could hardly be expected to return them tidily to a drawer: the

dead man tumbles backwards, and his fall drives them deep into his body.

Despite the theatricality of *Dial M for Murder*, Hitchcock used its plot to make visible an inimitably cinematic process: the way the world is atomized and reconstructed, like scraps of film fitted into a sequence or like the press cuttings that Milland asks Kelly to paste into his scrapbook. 'It was only a question of arranging the pieces,' says Tony to Lesgate in Knott's play; 'the pieces were all there.' In the film, we watch characters arranging those pieces, which – to the untrained eye – are indistinguishable from each other. The outcome depends on latchkeys, which, as the police inspector admits, all look the same, and on raincoats, which are equally interchangeable (though his own, the inspector says, has a hole in its pocket, through which he pretends the key has dropped). Left to itself, reality generates a random mess. The editorial task is to repair the tatters, to align the straggling strands. Kelly mends her stockings, and John Williams, playing the policeman, gets out a comb in the last shot of the film and uses it to discipline his moustache.

When cinema began, its first audiences were startled by close-ups, which looked like severed heads. Hitchcock joked about this naive superstition – and about the pretensions of psychoanalysis, which sets out to shrink ballooning heads – in *Under Capricorn*. Bergman recoils from a grinning shrunken head left on her bed, and Joseph Cotten comments: 'There's a trade in that sort of thing around here – it's forbidden by law.' Ed Gein, the Wisconsin serial killer on whom Bloch based Norman Bates, conducted the trade in his own way. The cinema encouraged the separation of heads from bodies, or of faces from the minds beneath them. Gein decapitated his victims, and sometimes tenderly stripped the skin off their skulls and used their faces as masks. Editing and montaging entire human bodies, he sewed the nipples of his female victims into belts, and bottled their sex organs. Was this so very far from the purse made from a tonsilectomy in *The Man Who Knew Too Much*, or the appendix that is removed so that Stewart can wear it as a suit?

Hitchcock's experiments were bloodless, but the principle remained the same. In *Psycho* he took a macabre pleasure in sectioning

people and rearranging them in a slightly different form. Leigh's head screams in the shower, but the rest of her belongs to a body double. In the film's trailers, she even forfeited her head: the face that shrieks when the curtain opens belongs to Vera Miles in a blonde wig, effaced by strident capital letters before you can identify her. With the character of Mrs Bates, Hitchcock the vivisectionist had a field day. Anything could be done with or to her, because she did not exist. He pretended to be considering theatrical matrons like Judith Anderson and Helen Hayes for the role, and invited agents to nominate their own candidates. Like Frankenstein's monster, the Mrs Bates seen in the film consisted of limbs and organs from half a dozen donors. One double loomed behind the shower curtain, another wielded the knife. Anthony Perkins carried a third stand-in, who happened to be a midget, downstairs to the cellar. Two actresses, Virginia Gregg and Jeanette Nolan, made separate contributions to Mrs Bates's voice. (Nolan, who played Lady Macbeth in Orson Welles's film of the play, also vaguely recalled supplying screams for both Leigh in the shower and Miles in the fruit cellar: this enabled her to be frightened by herself.) And because Mrs Bates is, after all, a transvestite man, Hitchcock engaged Paul Jasmin – a friend of Perkins's, with a talent for mimicking Midwestern crones – to record some of her harangues.

The cutting-up continues, though nowadays it is called deconstruction. Hitchcock has lost his exclusive rights to *Psycho*; those of us whose dreams it has penetrated feel that it belongs to us, and – replaying it in our heads – we recut it to suit ourselves. In 1998, when Gus Van Sant directed his remake of *Psycho*, a group of musicians remixed the soundtrack and rearranged Herrmann's score for a commemorative disc. Howie B.'s contribution chops up and jerkily loops the invitation to a homely dinner of sandwiches and milk which Vince Vaughn (playing Norman) issues to Anne Heche in Van Sant's film. The stalled, helplessly repetitive voice denotes an obsession – Norman's, but also ours. Heche, repenting her theft, says to Vaughn that one act of madness in a life is enough. The musical track corrects her: it is entitled 'Once Is Not Enough', and the motto applies to our private insomniac screenings of *Psycho*. The video artist Douglas Gordon has slowed *Psycho* down, so that a two-hour film lasts a whole

day. The experience of watching it becomes penitential or purgatorial, which is the whole point of Gordon's dreary exercise.

Scissors, or the motorized saw used by the magician's apprentice, analyse the world into fragments. To reassemble the broken bits, Hitchcock needed a stronger fixative than the glue on which the collages of Picasso and Braque relied. The forcible connection was made by a penal toy that became one of Hitchcock's fetishes and a constant presence in his plots. What scissors take apart, handcuffs brace together.

Handcuffs are a device for disabling people. For Hitchcock, they therefore symbolize detention in a double sense – both legal and amorous. Donat and Carroll in *The 39 Steps* are fused at the wrist by metal manacles, and their quarrelsome courtship explores the awkward and unseemly logistics of this twinning. How does a woman remove her wet stockings if her hand is joined to a man's? Donat's fingers, coyly affecting limpness, accompany her on the journey beneath her skirt. An earlier Hitchcockian suitor goes a-wooing with a set of handcuffs. The lovelorn policeman in *The Lodger* describes the cuffs as 'a new pair of bracelets for The Avenger'; but before catching the criminal, he buckles them on to the wrists of the squirming Daisy like an engagement present. His talent for metaphoric substitution leads him to equate the throttling tokens of execution and marriage. He sketches a noose with his finger, and rolls his eyes as he pretends to swing from the gallows. 'First I'll put a noose round The Avenger's neck,' he says, 'then I'll put a ring on Daisy's finger.'

He manages to apply the cuffs to the lodger, who escapes with Daisy. Now it is she who, thanks to the steel bracelets, has him in affectionate custody. In a pub, she feeds him some restorative brandy. His arms are hidden, so the other drinkers wonder if his hands have been amputated. Their guess is almost correct: has he been emasculated – robbed of male autonomy – by her cosseting, enchaining love? Worldly-wise men in Hitchcock's films are automatically wary of women who sport the impedimenta of capture. Hodiak in *Lifeboat* looks askance at Bankhead's diamond bracelet and asks: 'Where did you get the handcuff?' She admits that it is the memento of a conquest.

Hitchcock's handcuffs, which couple bodies and yoke minds into an uncomfortable intimacy, resemble the 'communicating vessels' described in 1932 by Breton in his treatise *Les Vases communicants*. Breton's title refers to a scientific experiment, which he used as a parable for the psychology of surrealism. If two vessels are joined by a tube, whatever liquid you transmit through it will rise to the same level in both containers. The tube, Breton said, worked like 'a *conduction wire*' between the opposed states of sleep and waking, unreason and rationality; it demonstrated the adjustment of subconscious minds, enforcing what he called – in one of his Paris nocturnes – 'the absolute power of universal subjectivity, which is the royalty of night'. Handcuffs solidify the link made by that fragile glass tube. Thanks to their manacles, Hitchcock's couples are as irrevocably wedded as the Siamese twins in *The Ring* or *Saboteur*. Hitchcock told Truffaut that he had studied with interest the handcuffs and other 'evidence of sexual aberrations by restraint' during a guided tour of the Vice Museum in Paris. He wondered if Truffaut had been there. Truffaut, though he lived in Paris, had never heard of the place. Could Hitchcock have imagined it? His fantasy followed the same track as that of Louis Aragon, who declared in 1924 that 'a new vice has been born, a new madness given to man: surrealism, son of frenzy and darkness'. In any case, Hitchcock erased the anecdote about the museum visit by advising Truffaut: 'Better not print this.'

A trailer for *Spellbound* concludes with Bergman and Peck embracing, while a superimposed headline shrieks: 'Together, To Hold You Irresistibly!' They hold each other, and grip us with the same tenacity. Recognizing our eager identification with the bodies on the screen, a Hitchcock two-shot is always a 'menage à trois'. Novak in *Vertigo* looks over Stewart's shoulder as he hugs her – glancing up at the tower from the livery stable, or looking at the nun who has climbed the ladder behind them. She knows that they are not alone. Hitchcock is watching, and so are we. In the hotel bedroom, he mounted Novak and Stewart on a turntable so that the camera could study their coupling from all angles. During the protracted kiss in *Notorious*, the role of the supernumerary third party – Hitchcock's deputy, and ours – is played by the telephone. While chewing Bergman's face, Grant calls

his hotel to collect his messages. He holds the mouthpiece of the telephone between their magnetized mouths, and addresses the hotel clerk in the same breathy undertone he uses when exchanging endearments with Bergman. It is as if he were making love to the microphone. Once at least the off-screen participant is visible, though only briefly. *Rope* begins with the culmination of a three-way embrace: Dall and Granger have the body of their friend squeezed between them as an intermediary. He is, to paraphrase Baudelaire's definition of the eavesdropping reader, the 'hypocrite spectateur' who has inveigled himself into their afternoon tryst; either of them could call him 'mon semblable, mon frère', because he is their schoolfriend. They grip him as we are gripped by Peck and Bergman, and tighten the cord around his neck to kill him.

At the end of *Notorious*, Grant abducts the poisoned Bergman from Rains's house. It is one of Hitchcock's strangest, tenderest love scenes – almost a delicately tactful love-death. We watch as Grant directorially performs the task that Hitchcock saw as the challenge of *Mary Rose*: he reassembles a human being who is as good as dead, and makes amends for the remorseless editing of bodies in other films. As he approaches her sickbed, her hand reaches up and twitches. He touches it lightly, afraid of causing pain, and wraps his own hand around her outstretched thumb. His mouth lowers itself towards her as she babbles, but he cannot kiss her. Instead he rests his head on her pillow, and positions his cheek next to her face.

Now the directing begins. 'Sit up,' he tells her. The man is here the woman's better half, beckoning her aloft. Grant has played the role before, on the morning after the drunken party in Miami, when the hung-over Bergman hid among the bedclothes while he roused her with medicine and a patriotic summons. On this occasion she can't sit up, so he manoeuvres her to her feet. She anchors herself with an arm over his shoulder, and presses her mouth to his, without making contact. The camera swirls around them, which is the only way of seeing both their faces. Next he orders her to put on her robe. Again there is a precedent: in Miami he told her to wear a coat before their night drive. She responded then by saying that she'd wear him instead. He tied a scarf around her naked midriff, ensuring at least

that her navel would not catch a chill. Now Grant fetches her fur coat, and wraps it around her. It is a more solicitous, less bullying anticipation of the episode in which Stewart renovates Novak's wardrobe near the end of *Vertigo*: the Hitchcockian lover is a man who dresses women, rather than undressing them. And, as in Miami, this is a love scene in which the man struggles to get the woman out of bed, not into it. 'Say it again,' pleads Bergman, who has been drugged with sleeping pills; 'it keeps me awake.' 'I love you,' he says: it is a wake-up call, not amorously soporific.

Breton in *Les Vases communicants* disparaged wakefulness, and coaxed us to enjoy 'the sacred evil, the incurable sickness' by dreaming. He thought it absurd that sleepers should be ashamed when caught napping. He would have approved of Stewart's somnolence in *Rear Window*: he daydreams and dozes his way through the film, and possibly hallucinates its plot. He is fast asleep as the film begins, despite alarm clocks shrilling in the courtyard and a voice on a neighbour's radio that asks male listeners if – weakened perhaps by nocturnal emissions? – they feel listless in the morning. He sleeps on, with a thermometer recording a temperature of ninety degrees. This could be the city's heat, but it might also measure the inferno inside Stewart's head.

Drowsy in Miami, drugged in Rio, Bergman is twice rescued from the kingdom of shadows. Life wrestles with death, and gains a reprieve. Grant's final order to Bergman in *Notorious* comes as he readies her to descend the stairs towards freedom. 'Go on, walk, talk!' he tells her. It is the director's command to his creation, like Frankenstein's electrical animation of the monster, but on this occasion, Hitchcock's representative utters the words affectionately. Shadow acquires substance; the inert Bergman begins to move, and regains her voice. Orpheus – improbably enough, though we long to believe in his magical feat – is able to lead Eurydice out of the underworld. Hitchcock here, as in *The Wrong Man*, documents a miracle on film. The outcome is beautiful and touching because so exceptional. More usually in Hitchcock's films, we watch the same journey in reverse, and willingly go along as people venture into a nether realm whose mysteries only the cinema can reveal.

The Religion of Murder

A Visit to the Sphinx

Hitchcock in Egypt.

By the 1960s Hitchcock had become the world's favourite ogre, a cantankerous practical joker like the God of the Old Testament. His status was first recognized when the poster for *North by Northwest* carved his face on to Mount Rushmore; but he possessed powers beyond those of the politicians with whom he kept company on that cliff. On tour in the Middle East to promote *Psycho*, he acquired a more mythological authority. Visiting Egypt, he was photographed beside the Sphinx.

Their profiles are aligned, and Hitchcock upstages the monument. His head in close-up appears to be the same size as that of the androgynous beast, which hovers above his cranium like a headdress. He is also in better shape than his crumbly companion. For a start, he still possesses a nose, proudly thrust forward to snub the Sphinx, who long ago lost hers. Her eye is blind, pitted by erosion; he stares unblinkingly into the desert sun. Unlike her, he has an ear, and he refuses to be outdone by the leonine mane that protects her head: his own hair is combed back to imitate her coiffure. Her lips have been worn away. Hitchcock ensures his own precedence by making his lower lip jut out to rhyme with his cheeky nose. Her skin is pockmarked, entrenched by age. He by contrast is the picture of well-nourished health. In the heat, the collar of his white shirt, blazingly bright, has curled upwards at its tip. It resembles a wing. Does Hitchcock possess the Sphinx's aerial talents? Maybe not, but his camera did.

The photograph was more than a spoof. Hitchcock had a perfect right to position himself competitively beside the Sphinx. She represents the terrors of our condition, compounded in the puzzles she set men to solve. Those who could not produce the right answer were killed; the Sphinx herself died when Oedipus solved her riddle and freed men from fear. Freud, following Oedipus, set out to tame the Sphinx. He kept a Greek terracotta Sphinx in his study, and on his walls he had photographs of the Sphinx in her Egyptian setting and a reproduction of the Ingres painting in which Oedipus submits to

interrogation by her. As interpreted by Freud, the legend offered therapeutic hope: Oedipus is the analyst, vanquishing the monstrous irrationality of illness. Hitchcock, however, identified with the incubus, not with the clever hero who outwitted her. His own riddles, concealed in his films, are harder to solve, and the answers offer no reprieve for traumatized human beings.

He does dare us to try our luck, like Oedipus. His pugnacious attitude in the photograph is a challenge in itself. The films play hide-and-seek with us, scattering false clues. A closet door in *The Trouble with Harry* swings slowly open, terrifying the conspirators gathered in Shirley MacLaine's living room. Yet it discloses only some unoccupied coat-hangers dangling inside. The apparent mystery is never the important one: in *North by Northwest* we neither know nor care what information is being smuggled out of the country on the microfilm in the icon's belly. And who is buried in Mrs Bates's grave in the local cemetery? The sheriff in *Psycho* speculates about this, but does not answer his own question. We are teased into thought, even given hints about what kind of thinking we should do, then either misled or warned off before our mental quest is concluded. *Rear Window*, which is about the projection of cinematic fantasy, also supplies a guide to interpreting those fantasies. But the advice is contradictory, so we end without arriving at any certainty. Kelly, persuaded of the salesman's guilt, adopts the voice of the analyst or the critic, like Oedipus outfacing the Sphinx. 'Tell me everything you saw,' she says to Stewart, adding after a brief pause, 'and what you think it means.' She knows that there are layered secrets awaiting retrieval beneath the surface, as if in the sealed tombs of that Egyptian valley. But elsewhere in the film, excavation is obstructed. The meddling sculptress warns Burr as he scratches in his rose beds, 'I wouldn't dig so deep if I were you.' He tells her to shut up. He has a body to bury, and graves cannot be shallow. Hitchcock, whenever he felt in danger of being found out, said that critics dug too deep: disdaining profundity, the films – he claimed – were just entertainments. Thus, like the Sphinx, he guarded his secret for a while longer.

He laughed at the inefficiency of the old interpretative methods.

The absent-minded doctor in *The Trouble with Harry* stumbles through a country walk reading a book. Engrossed in the text, he twice stumbles over the corpse, but continues on his way once he has recovered his glasses. The first time he doesn't notice Harry at all. The second time, assuming that he's still alive, he apologizes to him. You can't read a film as you would a book. A new kind of literacy has to be developed, able to interpret gestures and second-guess faces, alert to tell-tale patterns and repetitions. Watching a film, we are reading a language of ciphers. Of course we do the same when we read a book, but we have forgotten it: after long training, we take the words to be things, rather than the insignia for absent objects. Hitchcock's films confront us with the enigma of those objects – a seagull, a banister, the twisted knot of a woman's hair-do – and goad us, in Kelly's phrase, to guess their meaning.

The talents of the amateur detective are necessary even for the most innocuous social outings. In *The Age of Innocence*, Edith Wharton describes the 'hieroglyphic world' of patrician New York, 'where the real thing was never said or done or even thought, but only repre-sented by a set of arbitrary signs'. English society, in Hitchcock's early films, operates according to the same quaint rules. Derrick de Marney, on the run in *Young and Innocent*, turns up at a children's party where people have gone into hiding as hieroglyphs. They wear funny hats (nautical, horned, or furry), blow whistles, and play arcane games. Two stone dwarves are among the guests. The symbols, as Wharton pointed out, are arbitrary. De Marney, whose character is actually named Robert Fisdall, disguises himself with a double-barrelled alias, then causes consternation when he muddles it up. He has chosen the surname Beechcroft-Manningtree. Those modules can be rearranged at will. Why not Beechtree-Manningcroft, or even Treecroft-Beech-manning? He further subverts the charade when the bossy hostess hands him plates of ice cream to distribute. She decodes them for him: 'The red's strawberry, the white's vanilla.' He does a double-take: 'Fancy that!' But this is a world in which white does not necessarily symbolize vanilla. It might, after all, be chocolate. *Young and Innocent* concludes in a hotel with a dance band whose musicians are white men made up as blacks.

Symbolism, which deals in substitutes for what Wharton calls 'the real thing', offers tempting opportunities to alter or conceal meanings and to question the very pretence of reality. Perhaps the Sphinx's riddles were absurd, insoluble. Hitchcock flirted with this revelation in adapting Buchan's *Thirty-Nine Steps*. The steps in the novel belong to a staircase running down to a harbour, the site for a rendezvous with German agents. There is no such place in Hitchcock's *39 Steps*, whose title is as frivolously symbolic as the pipe in Robert Donat's pocket, which serves him as a make-believe gun. The film's steps supposedly refer to a clique of spies, but the dialogue loses no chance to joke about the silliness of the label. When the thirty-nine steps are first mentioned, Donat asks: 'What's that, a pub?' Madeleine Carroll, overhearing the thugs at the inn mutter that they must warn the thirty-nine steps, wonders: 'How can you warn steps?' The formula for a new and prodigious military engine, which the spies hope to smuggle out of the country inside the head of Mr Memory, is equally spurious: a garbled array of alphabetical and arithmetical symbols, decreeing that 'the ratio of compression is R minus 1 over R to the power of gamma'. Can this be the Sphinx's secret?

There is a refined mental pleasure in solving puzzles, as Oedipus discovered. Hannay in Buchan's *Thirty-Nine Steps* is 'pretty good at finding out ciphers', and in *The Three Hostages* he boasts: 'I am rather a swell at codes.' Hedren in *Marnie* quietly paraphrases Hannay's self-congratulation. Mentally rehearsing a robbery, she watches as her distracted boss repeatedly forgets the combination of the office safe, which is 'only five numbers'. She has had some experience with computers, she tells him when offering her help. But Hitchcock identified himself with the Sphinx, not with Oedipus: he did the enciphering or encoding, making up the mysteries, and derived his own pleasure from baffling the brains of would-be interpreters. Hedren meets her match in Connery, who gives her a draft of his anthropological treatise to retype. He knowingly sets her a challenge, and says with a complacent grin, 'If you can't decipher any of it, speak up. I typed it myself, and I'm a very creative typist.'

Aventure Malgache, the propaganda film about the French Resistance in Madagascar that Hitchcock directed in 1944, concerns a

booby-trapped code. Even after the Resistance telegrams have been deciphered, their messages – 'Get stuffed, where's the butter?' or 'The chestnuts will be ripe on 35th April' – are still meaningless. As the police chief wearily remarks, there are no chestnuts in Madagascar. He has paraphrased the disbelieving and imperceptive comment of the man in Hitchcock's fable about the MacGuffin, who asks an acquaintance in a railway carriage what his bulky luggage contains. It is, the second man tells him, 'an apparatus for trapping lions in the Scottish highlands'. The first man says, 'There are no lions in the Scottish highlands.' The second counters this prosaic objection by replying, 'Well then, that's no MacGuffin!' His smile, as he utters this non sequitur, is presumably Sphinx-like. For Hitchcock, the anecdote summed up the irrelevance of plots. Explaining the theory to Truffaut, he used a phrase that is more absolute and more jovially nihilistic than the version – translated from English to French and then back into English for foreign editions – in the published interview. After his laughter subsided, he said, 'That shows you the emptiness, the nothingness of the MacGuffin.' Yet this admission of fraudulence is another of Hitchcock's bluffs. We should not be so easily deterred from our quest for meanings.

Hitchcock's narrative art mimicked the professional trickery of espionage. Near the end of *Foreign Correspondent*, George Sanders tells Herbert Marshall that his daughter, played by Laraine Day, has been kidnapped. Marshall says, 'Don't be so cryptic! I've no idea what you're talking about.' But his own identity is encrypted. He is soon exposed as a German agent, and in a casual aside before the clipper is shot down, he tells his daughter that though she is English, he isn't. A subtle trap has been set for us. We have heard the name of Marshall's character throughout the film, but have never seen it written down. Fisher, we gather, is actually Fischer. Hitchcock loved tripping up auditors in this way. The thirty-nine steps *are* the members of a gang, but Donat assumes that The Thirty-Nine Steps *is* a pub. The capital letters and the number of the verb make all the difference. Hitchcock enjoyed the apparent error in the publicity slogan for a much later film, which announced '*The Birds* is coming!', and relished even more keenly the mistake made by a young studio employee

who raised his voice at a meeting to ask whether the phrase shouldn't be 'The birds are coming!'

Maugham, in his 1941 preface to *Ashenden*, railed against the twin twentieth-century revolutions in literature and politics. His preface defended the antique practice of telling a story in the conventional order, refuting the mannerisms of modernists who 'do not give you a story' but only 'the material on which you can invent your own'. Maugham was aware that his protest came too late, just as his own mission to Russia in 1917 'to prevent the Bolshevik revolution' had obviously failed. The writer's stubborn conservatism is refuted, however, by the expertise of his hero. Ashenden – conscripted for the beginning of a mission or sent in at the end, never allowed to follow through 'a completed action' – initially feels like a character in the kind of fiction Maugham disliked, the victim of temporal discontinuity: 'It was as unsatisfactory as those modern novels that give you a number of unrelated episodes and expect you by piecing them together to construct in your mind a connected narrative.' But when he sits down to decipher a cable, turning its grouped numbers into words, he unwittingly composes according to the modern rules that Maugham decried. 'His method was to abstract his mind from the sense': he would not have been flummoxed by those non-indigenous chestnuts, or by that non-existent date in April.

Abstracting your mind from the sense produces bizarre and beautiful visual patterns. During a showdown on the top floor of a London restaurant, *Foreign Correspondent* pauses to contemplate a graphic puzzle. Sanders looks out of the window at the restaurant's sign, whose letters run vertically down the side of the building. We only glimpse bits of words – the middle of the verbal action (as Maugham would have complained), not the beginning or the end – and even those fragmentary syllables are distorted by the camera's angle and by a steep, receding perspective. The letters, slanting diagonally across the screen, appear to spell out CORZO. The pictorial riddle can be solved with the help of the surrealist Aragon, who reported on the ambiguous sign of a Parisian house of ill fame. Its red letters said MAISON ROUGE, but, if you looked at it from an angle, ROUGE appeared to rewrite itself as POLICE. Hitchcock's conundrum begins

from the same premise. The restaurant too is called MAISON ROUGE, as we discover from a later long shot of the façade; what Sanders sees is the letters 'ON ROU'. The 'N', looked at from above, twists sideways into 'Z'. On its own initiative, the baffled eye turns 'U' into 'C'. Before we have time to work it out, Sanders behaves surreally and jumps through the window, relying on the restaurant's canvas awning to break his fall. A detective in one of the stories collected by Chesterton in *The Man Who Knew Too Much* practises 'a sort of wild analysis' while attempting to solve a murder. He resolves 'to read the hieroglyph upside down and every way until it made sense'. And his conjectures launch him, like Sanders when he makes his unpremeditated leap, into an abyss: he has 'thoughts on the border of thought, fancies about a fourth dimension which was a hole to hide anything'. Such graphic quizzes strain to cope with a suddenly modernized reality, where you can 'see everything out of a new window in the senses'. Analysis must be wild, because the world being analysed is mad.

Wiser and slyer than Maugham, Hitchcock happily permitted those who saw his films to invent stories of their own, and took pleasure in the battle of wits with his prospective interpreters – providing of course, that he won. By the time he made *Psycho*, modernism was old-fashioned, and Maugham's strict respect for chronology could be made to seem revolutionary. To preserve the secret of the film's ending, Hitchcock ordered cinema managers not to admit customers halfway through a session, and recorded a message to be played in lobbies that explained why he wanted ticket-holders to be kept waiting. '*Psycho*,' he said in his usual funereal tone, 'is most enjoyable when viewed beginning at the beginning and proceeding to the end. I realize this is a revolutionary concept, but we have discovered that *Psycho* is unlike most motion pictures, and does not improve when run backwards.' It was a dare, issued by a Sphinx who delighted in toying with us.

Telling Truffaut about his disdain for logical plots, Hitchcock said, 'I practise absurdity quite religiously.' The remark was facetious, but philosophically exact. Our mortal predicament, according to Camus, is absurd. What other religion is available to us? Hitchcock set out to

mystify us, to estrange us from reality – for instance in that bewildering glimpse of the restaurant sign. But his perversity was principled: his riddles pay homage to the obscure and iniquitous conditions of our existence. Hannay in *The Three Hostages* decides that the superman Medina is mad, because 'madness means just this dislocation of the modes of thought that mortals have agreed upon as necessary to keep the world together'. A uniquely modern frisson runs through the definition. The world needs to be kept together, because if left to its own devices it will split apart; reason, like reality, is a calculated and desperate fiction. Hannay, held captive under Medina's hypnotic spell, tries to fend off madness. Hitchcock, however, did not resist. Symbolism, as he employed it, was another willed dislocation of the thinking process that maintains a proper order in the world. To read MAISON ROUGE as CORZO, your eyes must be incurably kinked.

In his *Structural Anthropology*, Lévi-Strauss classifies symbolism as a mode of 'pathological thought'. Hitchcock, if he could have been prevented from evasively joking, might have concurred. What Lévi-Strauss calls 'normal thought' conducts a patient search for elusive meanings 'in a universe that it strives to understand but whose dynamics it cannot fully control'. By contrast, 'pathological thought' is only too successful at investing things with meaning; it 'overflows with emotional interpretations . . . in order to supplement a deficient reality'. Hitchcock had his own succinct equivalent to Lévi-Strauss's 'pathological thought', which quivers with numinous dread: it is the mental state summed up in the title of *Suspicion*. In *Before the Fact*, the novel on which the film was based, Francis Iles saw the pathological flaw as a premature conviction of guilt, confirmed by events. A woman suspects that her husband has set about stealthily killing her; fascinated, she watches the process and does nothing to prevent it. Is the guilt his, or hers? Dali had another name for the same helplessly morbid attitude. In 1930 he entitled it the paranoid-critical method. For him it was less a world-view than a way of living: 'paranoia', he said, 'is my very person'.

The method worked, Dali explained, by marshalling 'a series of systematic interpretative associations', which made ordinary objects delirious or repellent by linking them with dreams or queasy

fantasies. Breton called the method an 'ultra-confusional activity', and said that it proved 'the omnipotence of desire', which counted as 'surrealism's only act of faith'. A watch, associated in Dali's imagination with a piece of overripe Camembert, dissipates before our eyes: the resulting image, called *The Persistence of Memory*, sums up Einstein's subjective chronology and the warping of our own psychological time, which embroils the present in an inescapable past. Dali felt particularly paranoid about telephones, and thought that the sticky endearments people breathed into them somehow adhered to the humid mouthpiece. He therefore recommended sterilizing telephones by setting them in ice-buckets. Sometimes he imagined a lobster taking the place of the telephone. Crustaceans, which have armour not skin, are saved from the soft, fleshly vulnerability that disgusted him when he looked at the telephone's apertures. Similar residues cling to Hitchcock's telephones. Grant commutes between the black bakelite mouthpiece and Bergman's mouth in *Notorious*. Hedren in *The Birds* dials a number using a pencil rather than her finger, as if afraid of contagion. No doubt she has seen *Dial M for Murder*, where Milland dials as if pressing his finger to the trigger of a gun. The telephone is the repository of his guilty secrets: he listens to Kelly gasping and gurgling as the cord tightens around her throat.

In 1973 Dali described how his personal delirium was confirmed when he first read Jacques Lacan's account of paranoid psychosis, which refuted the 'vulgar error' of psychiatry. His account of the matter even flirtatiously approaches the title of Iles's novel: Dali argued that, before Lacan, theorists assumed that paranoiac delirium developed 'after the fact', as a kind of 'reasoning madness'. 'Lacan,' he went on, 'showed the contrary to be true: the delirium itself is a systematization. It is born systematic.' It exists, in other words, before the fact – which is the claim made by Iles's title.

Although Iles's novel was published in 1932 and Dali read Lacan in 1933, the approximation between the story and the theory is coincidental. What else, however, is paranoia but coincidence made systematic? The hero of Graham Greene's novel *The Ministry of Fear* – published in 1943, and filmed in 1944 by Fritz Lang – staggers through a plot whose sinister coincidences are arranged on purpose

to persecute and madden him: 'he felt directed, controlled, moulded, by some agency with a surrealist imagination'. That agency is the eponymous Ministry – a modern bureaucratic hell, which diffuses a 'general atmosphere' of mistrust and terror, 'so that you can't depend on a soul'. The Ministry is all the more threatening because it does not exist. It may, like the sick bay in the nursing home where the hero Rowe is detained, be merely 'a fantasy of disordered minds'. Nevertheless, those disordered minds, which specialize in the kind of dislocated modern thinking defined in *The Three Hostages*, run the world. At Scotland Yard, Rowe's case is handed over to an inspector who is described as 'the surrealist round here'. The Ministry's phantasmal policy follows the logic of the paranoid-critical method.

Dali's point is confirmed, not refuted, by Hitchcock's apparent bowdlerizing of *Before the Fact*. The heroine of the novel capitulates to the wastrel who defrauds and then murders her; *Suspicion* exonerates Grant, and allays Fontaine's fears. But perhaps the luxuriant suspicion of Fontaine is a reflex of this paranoid character's self-dislike. Mousy and awkward, she cannot believe herself worthy of a glamorous man's attentions, so she volunteers to be hurt by him. The story is even crueller if he refuses to gratify her self-destructive desire. The glass of soothing milk he brings to her bedroom does not contain poison, only a submerged light. All the same, the bulb irradiating the liquid makes that glass a surrealist object, like Meret Oppenheim's tea-cup lined with fur – a thing that is lethal because of its wrenching psychological associations. In 1931 Dali anatomized the perverse or obscene objects treasured by the surrealists, and observed that the fetish 'tends to bring about our fusion with it and makes us pursue the formation of a unity with it (hunger for an article and edible articles)'. His own list of articles surrealized by his private distaste for them included 'milk, bread, chocolate, excrement, and fried eggs'. The drink Grant offers to Fontaine – who declines it – certainly belongs on such a list.

Hitchcock's culinary fads may not have been the same as Dali's, but his films treat milk with deserved suspicion. In *Foreign Correspondent*, Robert Benchley plays an alcoholic journalist who, temporarily on the wagon, asks for a glass of milk in the bar at Victoria Station.

He winces at the disgusting stuff, and says it 'doesn't taste like the way it did when I was a baby – that's got poison in it'. Milk comes from inside the body of another creature, which is reason enough to be wary. The lecherous oil man in *Psycho* makes that grisly connection when he remarks that the weather in Phoenix is 'hot as fresh milk'. He means milk fresh from the cow, not the refrigerator – steaming because it has just squirted out of its throbbing bodily container. Milk also takes the place of a mother who, in weaning us, denied us access to the home-grown source. There is a pitcher of milk (presumably chilled) on the supper tray that Perkins brings down from the house for Leigh. Could this have been the contribution Norman's nurturing mother made to the meal? Leigh nibbles at a slice of bread, but does not touch the milk.

Hitchcock had a similar mistrust of eggs, which are, after all, excreted by hens. In *Frenzy*, Alec McCowen consumes a fried breakfast at Scotland Yard. He begins by making an incision in the yolk of the egg, and dips the sausage and bacon into the oozing wound. A colleague watches intently, as if studying an autopsy. The opening narration of *Under Capricorn* summarizes Australia's early history as a penal colony by referring to the transported felons as 'raw material', gradually moulded into responsible citizens. But a cooking lesson at Ingrid Bergman's house reveals how hard it is to progress from the raw to the cooked, from natural man to the civilized citizen. Bergman orders three slatterns, competing for the job of cook, to prepare breakfast. Cotten is served charred, scorched eggs, and Wilding dabbles with a runny, glutinous yellow puddle.

Pathological thought invests innocuous food with unpalatable meanings, and punishes it for suspected crimes: Jessie Royce Landis in *To Catch a Thief* executes a fried egg by stubbing out her cigarette in its yolk. *Rebecca* exhibits a more nauseous symbolic horror when Florence Bates, playing Mrs Van Hopper, douses her cigarette in a jar of cold cream. Dali could not have imagined anything more appalling. Hot ash muddies cool milk; a phallic tip is drilled into the moist female lake, and extinguished. Mrs Van Hopper smokes with manly aggressiveness. She uses both gloved hands to grip a lighter, which looks like a small fire-breathing gun. Ordered out of Maxim's hotel

room by her former employee, she makes plain her contempt by flicking ash on to the carpet: as blatantly hostile an act as a dog's defecation indoors. A woman wielding a cigarette was almost as frightening, in Hitchcock's estimation, as a woman behind the wheel of a car. In either case the female is ignited, placed on the offensive.

But the cigarette, militaristically brandished, contains its own judgement on the short life and expiring power of the smoker. The cream in *Rebecca* is not for drinking: it pampers the skin of the bedridden Mrs Van Hopper, who tweezers her bristling eyebrows and tries to disguise her sexual superannuation. The ash might be her body's dusty deposit, and it gives the lie to the cosmetic pretences of the jar. Rebecca too turns out to have been a self-consuming smoker. Olivier – during Maxim's account of their final quarrel – remembers her 'lying on the divan, a large tray of cigarette stubs beside her. She looked ill, queer.' Hitchcock mischievously claimed that Selznick, as Manderley burned, wanted the billowing smoke to inscribe the letter 'R' across the sky. There is no evidence of any such plan; nevertheless, *Rebecca* demonstrates that we will soon enough be fumes, drifting into oblivion. Mrs Van Hopper commits unlamented suicide when she grinds that butt into the cleanser. Her male and female halves abruptly meet, and cancel each other out. The glowing point wilts; the cream is sullied.

We unify ourselves and the object, as Dali said, when – whether eating, drinking or smoking – we ingest it. Surrealism therefore paid close and alarmed attention to the place where the ingesting occurs. The mouth is the site of our self-betrayal, as we hunger for those irresistible and probably fatal foreign bodies; opening our mouths, we show how sadly we deceive ourselves. We rely on our teeth to kill the food that fuels us. Usually, however, they predecease us.

In the first *Man Who Knew Too Much*, Leslie Banks visits a dentist in Wapping. It's the equivalent to James Stewart's trip to the Camden Town taxidermist in the remake, and the establishments are more or less interchangeable. The dentist repairs or replaces one of the moribund body's faulty parts, while the taxidermist performs surgery on bodies that are already dead. Mrs Bates, it should be noted, has a fresh set of protuberant choppers. Alas, they are of no use to her: the

dead don't eat. That sums up the irony of teeth. When we smile, we show off a home-grown cemetery. The dentist in *The Man Who Knew Too Much* advertises his office with a sign that would have delighted any surrealist. A double set of dentures grins above the street, sandwiched between gruesome rubbery gums. Each tooth is like a tombstone. Below, an amputated hand points to the door, and a light flickers on and off like an agonized nerve. It is no surprise to discover that the dentist who conducts business upstairs would sooner kill than cure, just as the huckster who forcibly cleans Stevie's teeth in *Sabotage* causes his death.

Our dental miseries recur in *Rebecca*, when Maxim's sister Beatrice (played by Gladys Cooper) quizzes the waiter who is serving her lunch. 'Still having trouble with your teeth?' she asks. 'Unfortunately yes, madam,' he replies. She briskly prescribes a remedy: 'You should have them out. All of them. Wretched nuisances, teeth.' If your right hand offends you, why not chop it off, and continue carrying out such summary justice whenever you feel a twinge somewhere else? The body itself is a nuisance, and death guarantees to cure all our ailments. Still, confronted by a drastic recommendation like this, we would all much rather go on being ill. So would Beatrice herself. She throws up her hands in pretended dismay when she sees the quantity of food she has piled on her plate, then sets out to wolf it down.

A more perceptive but equally uncomfortable diagnosis follows in *The Wrong Man*. Henry Fonda's financial woes have their origins in the mouth of his wife, played by Vera Miles. All four of her wisdom teeth are impacted, and the dentist, along with a quote for killing them, treats her to 'a lecture on evolution' that she repeats for Fonda's benefit. It seems that the human jaw has become smaller over the centuries, though the same number of teeth are squeezed into the cavity, where they engage in a Darwinian struggle for survival. We all have more teeth than we know what to do with: how wise is that? The dentist's reasoning is omitted, but it is possible to guess what it might have been. Our jaws have contracted because, although we are still carnivores, we do not have to slaughter our prey when we catch it, and we have much less industrious chewing to do as we eat. It is an eminently Hitchcockian interpretation of the problem. Our teeth

were designed as murderers. Denied that pleasure, they start picking painful and expensive quarrels with each other. Is there a chewing order in the universe, like the pecking order among animal species? The outsize false teeth in the Wapping street might belong to a deity who, following Saturn's example, cannibalizes his own creation. After his mistrial, Fonda reviews his tribulations and remarks: 'It's like being put through a meat grinder.' He has been fed to a machine with implacable serrated teeth. Perhaps men are the gods' hamburgers, not their tennis balls.

If you follow such trails of paranoid association, you find a method in the mad grotesquerie of Hitchcock's images. The recurrence of a word can point to a symptomatic unease. The mother in *Marnie*, for instance, worries when Hedren removes some flagrant red gladioli from a vase and replaces them with a chaste white bouquet. The 'dripping', as she puts it, makes her anxious. Much later, Diane Baker – Hedren's scheming rival for Sean Connery – uses a fastidious phrase when asked to pour tea. She pretends to have a sprained wrist, and can't lift the pot. 'There's sure to be droppage and spillage,' she says. The tiniest domestic transactions cause oceans to overflow. All this dripping, dropping and spillage recalls Dali's dissolute watch, except that, for Hitchcock, the messy fluency is associated with women, not time. The female body is a leaky sac of fluids.

Hitchcock would not have appreciated such clarifications. Freud admired the hero whose intelligence vanquished the Sphinx. Hitchcock, keen to defend himself against demystification, was sceptical about psychoanalysis, and did his best to frustrate its inquisitions. The opening titles of *Spellbound* explain the purpose of the new science, which aims to expel 'the devils of unreason . . . from the human soul'. It is a melodramatic view of the matter: perhaps it refers to the diabolism of Francis Beeding's *House of Dr Edwardes*, in which the sanatorium is given over to devil-worship, Black Masses and rites of human sacrifice. The novel goes into more detail than the film about psychoanalytical methods, and connects its characters with the founder of the new science. Beeding's Dr Murchison has been highly spoken of by Freud. Murchison himself, explaining the techniques of the missing Dr Edwardes in the novel, says that he

tabulated psychic pecularities 'according to a system of his own, which is a derivative of the symbolist method of Freud'. When put in charge, Murchison liberalizes Edwardes's regime, relaxes discipline and humours the inmates. The irrational devils are not necessarily expelled or exorcized; they can stroll through the grounds (as in Carpenter's *Halloween*), and engage in mayhem. In *Spellbound*, this is the mode of treatment favoured by Edwardes, whose identity is usurped by Gregory Peck.

Beeding's Murchison discusses the Freudian figure called the Zensur, 'describing it as the Warder who stood perpetually on guard at the gate that separated the unconscious self from the intelligent and regulated activities of the mind'. This guardian, creakily allegorized as Warder Jones, intervenes in the plot at the end of Beeding's novel to raise the alarm. In Hollywood, the Zensur had a literal equivalent in the censor, whose rulings were outwardly respected and secretly circumvented by Hitchcock. Censorship disapprovingly edited the dream sequence Dali planned for *Spellbound*. Bergman objected when asked to wear a metallic dog collar, or to pose as a Greek statue whose alabaster skin cracked open to release colonies of ants, seething from her innards. The studio's warders slammed the gate on what Beeding calls 'a darkness that stirred with primeval memories', and sought to lock it. But did they succeed? Murchison in the novel warns against Freud's method, which 'sought to lure the Warder from his post' and to entice the primitive, amoral will out of hiding; he likens this to the perilous plight of the sorcerer's apprentice, who 'raised a horde of demons whom he was unable to control'.

The first victim of devilry in *Spellbound* is the feline minx played by Rhonda Fleming, a fury with predatory claws. The doctors at the sanatorium call her a nymphomaniac, but she has a healthy scorn for their clinical puritanism, and invents outrages to excite them. She tells Bergman – who plays a prim Scandinavian analyst – about a beau whose smooching disgusted her. Pretending to kiss him, she treats herself to a surreal snack: 'I sank my teeth into his moustache and bit it off!' Fleming is the red-headed id, while Bergman is the bookish, bespectacled, white-coated ego. Freud promised that ego would drive out id. In this case, however, the process is reversed.

Bergman's male colleagues insist that the doctor from the frigid north needs defrosting. They nickname her 'Miss Frozen Puss', and claim that she thinks with an icepack on her head. She stiffens when one of them embraces her: he says she's as rigid as a textbook. The film's murder plot turns on thawed snow, which Bergman believes might conceal the gun used in a killing; its erotic plot is about the thawing of Bergman herself.

Peck invites her for a walk in the country, to look at 'sane trees, normal grass, and clouds without complexes'. As they walk, she starchily complains that 'the greatest harm to the human race has been done by the poets', because they dispense delusions and write about love 'as if it were a symphony orchestra'. She is obviously deaf to the film's soundtrack, because a symphony orchestra has accompanied them on their outing and is playing the stealthy love theme composed by Miklós Rózsa. After analysing love as mere chemistry, Bergman falls over, losing the rational uprightness she is so proud of.

That night – urged by the same musical sorcery, now entrusted to a single, wheedling violin – she goes to Peck's bedroom. One of Hitchcock's most entranced and enviable kisses follows, and its imagery refutes the therapeutic aims of psychoanalysis. Peck strides forward into close-up. Bergman closes her eyes as a precaution, then contracts the muscles of her eyelids to shut them tighter. This switches on the cinema inside her head, and a series of white doors on oiled hinges swings open in surrender. Beeding's novel refers to that gate which must be guarded to keep out a 'blindly dynamic' darkness, and to 'the secret forces that lie beneath the threshold of consciousness'. But in Spellbound four doors give way, and disclose a crucible of ardent sunlight in the innermost room. Rather than André Breton's darkened cinematic room, this is a room irradiated.

We need to succumb to unreason, rather than repressing it. At Pennsylvania Station, Bergman urges Peck to let his subconscious memory speak for him, and he blurts out a request for a ticket to Rome. 'What Rome?' asks the bewildered clerk. Bergman covers for him by saying that he means Rome, Georgia; in fact there is another Rome nearer to hand, in upstate New York. But the Rome Peck has in mind turns out to be the Italian original, even though he claims never

to have been there. He eventually remembers that he was a fighter pilot, shot down over Rome during the war. The aerial attack on the fascist capital revives and updates a Freudian scenario. Freud himself – tragically aware of the discontents that flawed civilization – had a rankling grudge against Rome. He counted Hannibal among his personal heroes, and admired his march across the Alps to topple the proud, rational citadel.

Disbelieving in facile cures for our maladies, Freud insisted that psychoanalysis was not a branch of medicine. Hitchcock expressed even graver doubts, and scandalously flouted medical protocol. Peck – an analyst who moonlights in the operating theatre – has a babbling breakdown in *Spellbound*. While sewing up a patient who has cut his own throat, he tears the surgical mask from his face and cries out that the madmen must be set free. An even more convulsive reversal occurs in the dental episode of *The Man Who Knew Too Much*. Leslie Banks stretches out in the chair as the ether hisses, like T. S. Eliot's 'patient etherized upon a table' in 'The Love Song of J. Alfred Prufrock': he is in that state of visionary prostration that the surrealists recommended, ready to enjoy a chemical dream. Then he panics as the malevolent dentist gets ready to gas him, and asks: 'Doesn't a doctor have to do that?' To save himself, he throttles the dentist, bundles him on to the chair, and slaps the rubber nozzle of the gas mask over his face. Since he is no anaesthetist, he probably kills his reluctant patient. Peter Lorre later casually remarks that the dentist suffered from apoplexy.

Murchison in *The House of Dr Edwardes* mentions an analyst who was 'murdered by his patient in an access of dementia'. The same thing happens in *The Man Who Knew Too Much*, although Banks, far from being demented, acts in cold blood, and the crime is unregretted. Like a shaman, the doctor in Murchison's anecdote is at risk because he has 'concentrated upon himself all the dormant evil of the sufferer'. Lévi-Strauss defined psychoanalysis as 'the modern version of shamanistic technique', which places it closer to the savage practice of witchcraft than to modern medical science. When Stewart's old friend tells him in *Vertigo* that Novak is possessed by a revenant from the past, he recommends taking her to 'the nearest psychologist

or psychiatrist or neurologist or psychoanalyst'. The impatient bluster of synonyms reveals how little regard he has for such meddling therapies. What if an exorcist had been available?

The first close-up of a woman's lips during the credits of *Vertigo* recalls the fable of Cupid and Psyche. The nymph Psyche gave her name to the human mind, and her story explains its retentive closure. Cupid, during their love affair, introduced her to the world of the gods, but forbade her to tell what she had experienced there. He placed his finger on her mouth to seal it; the indentation remains as a vertical groove above the upper lip on all our faces. That mark imposes an embargo on speech, and on confiding your dreams – a ban with obvious relevance to the dualistic heroine of *Vertigo*. Having unavailingly focused on her lips, the camera next looks into her shifting, uneasy eyes, but it can only interpret the contents of her brain abstractly: from now on, Saul Bass's credits are given over to a morphological ballet. Whirls and spirals and dilating or pulsing knots transcribe her thoughts in a code we cannot crack. A blue fishy form floats into view, with a central slot that might be a sexual crevice or perhaps an open mouth; it also resembles the serpentine coil in Madeleine's hair. These shapes allude to sphincters, those clenched bodily muscles that relent to permit invasion. According to Greek grammarians, the Sphinx derived her name from the sphincter's tight-lipped closure. Yet such ambiguous clues hardly count as testimony. This Sphinx, we know, will never part with her secret.

Into the Next World

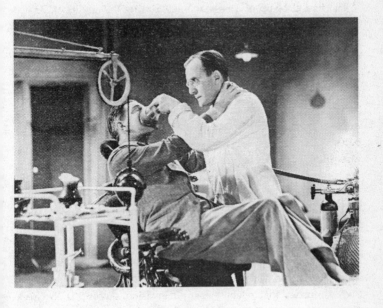

Leslie Bank's dental appointment in the first *Man Who Knew Too Much*.

Hitchcock did not keep his amusement about the MacGuffin to himself. Robert Donat in *The 39 Steps* is sceptical about the narrative of the foreign woman he shelters, and remarks, 'Sounds like a spy story.' When he needs help to make an early-morning getaway from his flat, he encounters the same incredulity: 'Trying to kid me with a lot of tales about murders and foreigners!' scoffs a milkman. Madeleine Carroll later reminds him that the action of this film for which their services have been engaged is a farrago. 'Still sticking to your penny novelette spy story?' she yawns. The international intrigue in *Foreign Correspondent* provokes a similar reaction when Joel McCrea broadcasts a summary of the plot over the radio of the ship that has rescued him from the crashed clipper. George Sanders, cueing him, gasps, 'I can't believe it, old boy!' The ship's captain shakes his head and says, 'You don't expect anyone to believe that?'

The plots could be teased because they were a pretext; the subtext lay somewhere else. Hitchcock took delight in leading us astray, and he bestowed the same teasing habit on Tippi Hedren in *The Birds*. An idle socialite, she does a different job every day. Twice a week, she works for Travellers' Aid at the San Francisco airport. 'Helping travellers?' asks Rod Taylor incredulously. 'No, misdirecting them,' she pouts. She is simply following Hitchcock's mischievous or self-protective example. *I Confess* begins with a nocturnal tour of Quebec City. The wet, bleak streets are deserted, but signs in French give orders to non-existent traffic. These signs invoke the authority of Hitchcock's profession, announcing DIRECTION and illustrating the command with arrows that point from left to right. But the director himself, who affixes his signature by marching across a plateau at the top of a steep street, ignores the rule: he walks from right to left.

His films adopt the policy of evasive subterfuge that causes the police inspector to suspect the priest in *I Confess*. Karl Malden, irritated by Montgomery Clift's secrecy, says, 'I don't want this mystification to make things awkward for you,' and adds 'Too much

mystification might lead one to suggest that both priests were one and the same.' He is both right and wrong. The father confessor, like the psychoanalyst cited by Murchison in *The House of Dr Edwardes*, takes possession of someone else's guilt and is taken over by it; he is, as Lévi-Strauss said of the shaman, a 'professional abreactor'. Clift did not kill the blackmailing lawyer, but he might have given the pretended priest in the stolen cassock a subliminal order.

Beyond or beneath the fussy mystification of plotting lie mysteries that can only be approached indirectly, or with the scrambled aid of misdirections like those Hedren issues at the airport. In his 1924 manifesto, Breton hoped that 'the mysteries which really are not will give way to the great Mystery'. Hitchcock disposed of the mysteries that were not by encouraging his actors to wink unbelievingly as they struggled to preserve national security. About 'the great Mystery' he was more reserved. But his films tentatively probe the same proscribed, subterranean areas that have traditionally fascinated the theologians of mystery, from ancient Greece to the surrealists in the early twentieth century – the tense balance between creation and destructiveness; the tug of irrationality, which mines civilization from within; the affinity between love and death, or between sex and murder.

Esoteric religion has always relied on puzzles; but the divine riddler takes a risk. What if a bright spark like Oedipus were to guess the answer? The Sphinx asked which creature has a single voice but becomes four-footed, two-footed and three-footed. Since the Sphinx herself was a lion with wings and a human head, you expect that the answer will be some equally monstrous hybrid. In fact, as Oedipus realized, she was referring to man, who crawls on all fours as an infant, then stands upright, and finally leans on a stick in old age. The Sphinx promptly killed herself: human intelligence had vanquished the power of gods and monsters. Samson in the Bible made the mistake of being too trustful, and gave away the answer. After he killed a lioness and took honey from the carcase, he summed up the episode in a riddle and cryptically informed his companions at a feast: 'Out of the eater came forth meat, and out of the strong came forth sweetness.' His wife complained because he wouldn't tell her the solution.

THE RELIGION OF MURDER

He relented, whispered it to her, and she passed it on. In revenge, he abandoned her. Hitchcock took notice of Samson's error, and made sure that, even if we know the answer, the mystery remains.

The spy stories, by Buchan and others, from which Hitchcock derived his early plots were concerned less with espionage than with divination. The vogue began with Erskine Childers' *The Riddle of the Sands*, published in 1903. The riddle in the title refers to the problem of navigating in the treacherously sandy terrain around the Frisian Islands, which enables two yachtsmen on holiday in the North Sea to foil a planned German naval attack on Britain; yet Childers hints throughout that more is at stake. To start with, he apologizes for publishing a story that should only circulate at the upper levels of government, and regrets that the imperatives of democracy have eroded secrecy. He wants to keep an enclave for the mysteries, and he does so by mystifying the tricky sport that his characters have taken up. The narrator Carruthers learns 'the subtle mysteries of the art' of steering a boat, and proudly describes the occasion on which he first negotiates the channels in the sand as 'My Initiation'. When he eavesdrops on a conference of the German naval planners, he is baffled by their jargon and exerts himself to find 'the key to the cipher' that might clarify their meaning. Davies, who maps whimsical currents and charts the sands, sees his hobby as 'a sort of religion, promising double salvation'. Or perhaps, as he is led astray during a storm by the guile of the spy Dollmann, its promise is perdition: Carruthers suspects that Dollmann 'was piloting you into the next world'. Towards the end, Carruthers finally admits that the political intrigue has religious repercussions. The race to beat Dollmann is 'a struggle of men with gods, for what were the gods but forces of nature personified?'

In classical Greece, Breton's 'great Mystery' was institutionalized in the festival of Eleusis, when neophytes were permitted to share in a forbidden knowledge. Because they did not report on the initiations they had undergone, the mystery is still insoluble. For this reason, it remains intriguing. A young woman in D. H. Lawrence's Australian novel *Kangaroo*, published in 1923, wants to 'touch the private mysteries', to trespass on 'secret intimacies', and imagines that she might achieve this by working as 'a stewardess on a boat, a chambermaid

in an hotel, a waitress in a good restaurant, a hospital nurse'. It is not such a foolish idea: chambermaids and nurses are privy creatures. Ezra Pound recalled the Eleusinian ceremonies in his 1938 *Guide to Kulchur* when he asserted that poetry was more valuable than prose, even though it may be less informative, because 'beyond its doors are the mysteries. Eleusis. Things not to be spoken of save in secret.'

Pound repeated the embargo on penetrating 'the secretum'. Nevertheless, we are free to guess about the experience that the chosen ones underwent at the festival: it seems to have been a preview of death, mercifully allowing a return to life when the ritual was concluded. The blessing was probably mixed. Janet Leigh certainly felt that way when, seeing *Psycho* for the first time, she watched herself die: 'Even though I knew what was going to come, I screamed. And even though I knew I was sitting there in that screening room quite alive and well, it was a very emotional thing to see your own demise.' Somehow her survival did not mitigate her terror and distress. She had been made to witness her own end, which most of us would prefer not to see.

The festival of Eleusis had links with the agricultural rites that commemorated Persephone's release from the underworld, where, according to the myth, she was bound to spend half the year in detention. Her reprieve permitted the earth to be fruitful again in the spring. At least two of Hitchcock's films allude to such a migration between upper and lower worlds. In *Psycho*, Norman stows his mother in the fruit cellar, like the reaped or harvested provender of the fields. She objects, and wonders if he thinks she is 'fruity'. She is indeed, when we finally see her face, somewhat overripe; and Norman himself might well be suffering from the sexual disablement that his classical predecessors saw as the price of the priestly career. Hippolytus reported that the hierophant in Eleusis prepared himself to celebrate 'great and unspeakable mysteries' by drinking hemlock, which made him impotent. Could this be Norman's problem? Attis, as Hippolytus noted, made a more drastic renunciation, and underwent castration. Here too there may be a clue to Norman's abnormality: his mother, metaphorically at least, has gelded him.

Either way, it is hardly in character for Norman to masturbate his way to a grunting climax, as Vince Vaughn does in Gus Van Sant's

remake of *Psycho* while looking through the peep-hole in his office wall. Hitchcock brooded about chastity as a requirement of the priestly vocation, and made this the secret anguish of Clift in *I Confess*. He followed the same rule of self-restraint in his own profession, and gruesomely punned about it to Truffaut. Commenting on *Psycho*, he agreed that Leigh 'should not have been wearing a brassière' during the tryst in the Phoenix hotel, because Gavin would surely have wanted to 'feel her breasts rubbing his bare chest'. Then, in an aside omitted from the published interview, he denied that he got 'any particular kick' from such matters. 'I'm a celibate, you know,' he confided to Truffaut. 'That's why they call me "the celibated director".'

In the first *Man Who Knew Too Much*, Leslie Banks and Hugh Wakefield drop in on a mystery religion when they gatecrash evensong at the Wapping tabernacle. A sign with flaring arrows of flame above the door beckons them; Banks explains that the congregation consists of sun-worshippers, who probably pray in the nude. His surmise is not so very far-fetched. Sun-worship became a popular cult during the 1920s, aspiring to cast off the carnal shame of Christianity. D. H. Lawrence's novel *The Plumed Serpent* investigated the Aztec rites of human sacrifice that fed the greedy sun with blood; Leni Riefenstahl's film of the 1936 Berlin Olympics began with some eurhythmic exercises performed by naked nymphs who dance in celebration of the sun. In Hitchcock's tabernacle, devotees drone through a hymn that recites the same pagan truisms, acclaiming the sun as the force of life. As the service proceeds it brazenly stages an act of initiation. The acolyte, however, does not bask in the sun. Instead he is mesmerized by a colder, more obsessively focused, artificial light: the beam that, in the cinema, vivifies shadows. A hatchet-visaged priestess announces the induction: 'Before proceeding to the mysteries of the Seven-fold Ray, which of course are only for the initiate, it is of course necessary for the minds and souls of all of us here to become purged and to be made clean.' She requests that anyone not 'in tune' should submit to control and agree to be placed under the guidance of the Fourth Circle.

Despite her mumbo-jumbo, she is describing the state of mental preparedness that the cinema requires of us, and her reference to

attunement acknowledges the pact between film and music, with its unique capacity – demonstrated in the cantata played at the Royal Albert Hall later in the film – for mind-control. Wakefield has to be purged hypnotically. She dangles a gem in front of him, and says, 'Keep your eyes fixed on this light.' His trance is illustrated by the camera's subjective, illusory vision. The monocle slips out of his eye, and the face of the priestess prismatically jars into facets, then blurs. The instructions she murmurs transform his consciousness into a cinema screen. 'Before receiving the first degree of the Seven-fold Ray,' she says, 'your mind must be white and blank. You are already feeling sleepy. Your mind is becoming quite blank.' He obediently nods off. A film, however, abbreviates the hypnotic preliminaries, and allows us to dream with our eyes open.

The cinema gave a home to the heterodox mysteries that, ever since the worship of Eleusis, had skulked on the fringes of official religion. In Elizabethan England, poets belonging to the 'school of night' venerated unorthodox goddesses like the dark lady of Shakespeare's sonnets; in Mozart's *Die Zauberflöte* the freemasonry of Sarastro, whose priests sing anthems to the sun, is countered by the demonic witchery of the Queen of the Night. During the nineteenth century, romantic poets and musicians probed the Eleusinian mystery of the love-death – an expiry that was ecstatic, like a sexual consummation. At the end of Wagner's *Tristan und Isolde*, the heroine dies spontaneously, with no apparent cause, and her 'Liebestod' describes the process of sublimation, as she dissolves into an elemental universe that does not differentiate life from death or keep souls imprisoned in bodies. Hitchcock has his own Tristan and Isolde, who almost share in the posthumous coital union described by the 'Liebestod'. During a storm in *Lifeboat*, Tallulah Bankhead and John Hodiak – who have until now spent their time bickering – snatch each other in a sudden, frantic embrace, convinced they are about to drown. 'We might as well go down together,' gasps Hodiak. They soon bob up again, like Proserpine or the Eleusinian inductees, but the experience transforms them. The salty Bankhead tells Hodiak when they dry themselves off: 'That was a dead giveaway, darling, wanting us to . . . die together.' The pause she inserts in the line draws attention to the pun buried in it.

Dying, for the Elizabethans, meant the expenditure of spirit in sex: the orgasm was a delightful death, followed (after a recuperative interval) by resurrection. There are similar hints in du Maurier's *Jamaica Inn*, as Mary, suffering through 'the crisis of the night', watches the pirates lure a ship on to the rocks and slaughter its crew. The sea thrashes the shingly beach, and waves bent on self-destruction concuss themselves in a 'crash of fulfilment'. She might be witnessing sex, rather than death. Exactly synchronizing a back-projected ocean, Hitchcock arranged the same crash of fulfilment when Stewart kisses Novak on a coastal road after their walk through the sequoia forest. 'Dying together,' as Bankhead remarks to Hodiak, 'is even more personal than living together.'

Isolde's 'Liebestod' is played by an orchestra at an open-air concert in Buñuel's *L'Âge d'or*, and acted out by a pair of lovers who grapple in the dirt; in Fritz Lang's *The Blue Gardenia* it is heard in a music store, and – forensically linking love with death – serves as a murder clue. The cop who finds the bludgeoned body of Raymond Burr removes a recording of the 'Liebestod' from his turntable and comments 'Artist. Got murdered to music.' Richard Conte, a hard-boiled newspaperman, asks 'What key?' At the end of the film, a reminiscence stirred by the music prompts Conte to save Anne Baxter, unjustly accused of the crime. A canned rendition of the 'Liebestod', improbably enough, plays over the loudspeaker at the Los Angeles airport, where Conte is catching a plane to witness an atom bomb test in the Pacific. He cancels his departure, and traps the real murderess: an employee in a music store, who sold Burr the fatal disc, allowed him to impregnate her, then murdered him when he would not marry her. While the *Tristan* prelude plays, she goes to the bathroom, smashes a glass, and cuts her wrists with the slivers. Not quite the voluntary, painless and bloodless extinction Wagner had in mind for Isolde.

Lang's plot paraphrases Hitchcock. The prelude to *Tristan* accompanies the stream of consciousness of Herbert Marshall in *Murder!*, helping to make his thoughts audible as he gazes into the shaving mirror and ponders the case of the accused actress. The 'Liebestod', quietly invoked by Herrmann's score throughout *Vertigo*, is finally

quoted when Stewart and Novak make febrile, despairing love in her hotel. The reference to Wagner establishes the morbidity of both Marshall and Stewart, detectives impelled by an obsession that is at first erotic, then necrotic. Marshall vows to save a woman from death, but is he attracted by her air of apathetic fatality, or aroused by the gallows in the prison courtyard next to the room in which they meet? Stewart is commissioned to prevent a woman from killing herself; he loves her pale deathliness, and causes her to die twice. The 'Liebestod', this time unheard, peeps into view again in *The Birds*. Propped on a rack, it has pride of place in the record collection of the frustrated schoolteacher played by Suzanne Pleshette. Its presence summarily tells the story of her life. She loves Rod Taylor, but must content herself with dying for him. Her life in Bodega Bay is a slow death; then comes the actual sacrifice, when she shields his young sister by offering herself to the gulls.

Rope begins, behind curtains closed against the daylight, with a love-death. Concealing the preliminaries, Hitchcock starts with the climax. Through the curtains we hear a cry that might be either anguished or ecstatic. Then we see the face of a young man, sandwiched between his two killers. His head tilts back, and as he dies his mouth opens in a smile of shocking sexual bliss. Hitchcock manages to photograph three forbidden acts at once – sex between men, sex in a group, and murder – while pretending not to. The participants are on their feet, vertical not horizontal; but why shouldn't one have sex while standing up, free from the lowly protocols of the marital couch? They are also formally attired, and the two killers even wear gloves. Yet what kind of alibi is that? To dress for sex shows a more sophisticated taste than undressing for it.

At once, belying these cautious cover-ups, the innuendi begin. John Dall, once he has steadied the excited rhythm of his breathing, switches on a lamp. Farley Granger recoils, nestling in a notional bed, and pleads, 'Let's stay this way for a minute.' Dall lights a post-coital cigarette, pulls off Granger's gloves as if helping him to unpeel a prophylactic, and opens the curtains. He suffers a twinge of regret, sorry that they needed to cower in the darkness: he wishes they had 'done it . . . in the bright sunlight'. Granger wonders 'How did you

feel?' Dall asks 'When?' Granger, still embarrassed about speaking the name either of love or death, says 'During it.' Dall's reply begins blandly, but his tone thickens, he lowers his voice, and he completes his confession in a panting whisper: 'I don't remember feeling very much of anything until his body went limp. I knew it was over. And then I felt tremendously exhilarated. How did you feel?' Granger can only gabble 'Oh, I – '. They too have done some experimental dying. Recovered, they now have the energy for another celebratory sexual bout, this time à deux. Hitchcock films the act allusively, by watching them open a bottle of champagne. Dall grips it to his abdomen, rotating it and pressing its neck with delicate, insistent fingers. Just before the crucial moment Granger, with exquisite timing, seizes it from him, continues to apply pressure, and eases the overflow of foam into two glasses.

Rebecca contains a corresponding scene – an attempted lesbian seduction, also implicitly troilist. Mrs Danvers (Judith Anderson) takes her new mistress (Joan Fontaine) on an intimate tour of Rebecca's dressing room. The two women are drawn tremulously together by the suggestive presence of a third, who is dead but has left her clothes behind to represent her. du Maurier's novel is more candid about Rebecca's pan-sexual appetites than Hitchcock's script could afford to be. In the book, Mrs Danvers robustly comments 'She ought to have been a boy,' and boasts that Rebecca said 'You maid me better than anyone, Danny.' A noun is unidiomatically employed as a verb: could she also mean 'made'? Danny and Rebecca conjoined in long late-night sessions of penance that they called 'hair drill'; Danny would apply the brush for twenty rigorous minutes at a time.

Maxim's denunciation of Rebecca is delivered almost verbatim by Olivier – though one crucial sentence is deleted. 'She was,' he says in the novel, 'not even normal.' But, as with the gloves or the uncorked champagne in *Rope*, the truth can be told or shown symbolically, which is why Hitchcock devised the scene with Rebecca's wardrobe and personally walked Anderson through it, handling the garments for her and demonstrating how she should utter her infatuated lines. 'Feel this,' she sighs, and strokes Fontaine's cheek with the bristles of a chinchilla coat. Fur is an animal skin, the emblem of a wildness that

rich, pampered women in polite society ought to keep under wraps. Anderson next fondles Rebecca's underclothes, made by 'the nuns at the convent of St Clare's'. Rebecca reversed the usual order of values. Her outermost layer was savage, regrowing the fur that human beings long ago shed; next to her skin she wore the apparel of sanctity and chastity, which allowed her to mock the nuns who toiled to beautify her.

Finally Anderson entices Fontaine towards the veiled bed, bordered by suffocating flowers. She removes Rebecca's transparent black lace nightie from its embroidered case, allows it to unfurl, and reaches inside it. 'Look,' she breathes, 'you can see my hand through it.' Her fingers tickle the interior, and make the sensitized fabric shudder. Fontaine rushes out, perhaps appalled by her own fascination. Anderson returns the unused room to its dark sleep. It is a mausoleum and a reliquary, though the trophies it contains are fetishes. The dressing table is an altar, and Anderson upbraids Fontaine for laying profane hands on that disciplinary hairbrush.

Aware of Granger's lassitude and depression as *Rope* begins, Dall tries to rouse him by opening the curtains. 'It's the darkness,' he says, 'that's got you down. Nobody ever feels safe in the dark.' Indeed not, but Dall's efforts at elucidation may be a mistake. In his manifesto Breton enticed the waking, rational mind to plumb 'the depths of that dark night', promised that the dreams that ensued would reveal 'a kind of absolute reality', and recommended narcotics to quell fretful consciousness. In *The Lady Vanishes* the sinister doctor played by Paul Lukas tells his helper, a nursing sister, to drug Margaret Lockwood's brandy. A small dose, he says, will stun the brain, a larger dose provokes madness. The suggestible Lockwood, believing she has taken the draught, passes out. But she is in no danger: the nun has refused to administer the dope, and Lockwood soon wakes up again. We travel safely through the dark night, because the sedative wears off before dawn. *Rear Window*, however, rescinds this safeguard. The briskly brutal Ritter knows that the lonely spinster is about to attempt suicide because she recognizes the woman's hoard of red rodium triecamol capsules. Ritter herself has handled enough of these, she brags, 'to put everybody in Hackensack to sleep for the

winter'. With her dream of making an entire New Jersey town hibernate, is the nurse a wishful mass murderer?

Like a hierophant at the festival of Eleusis, Breton beckoned those who wished to enjoy a preview of the afterlife. 'Surrealism,' he said, 'will usher you into death, which is a secret society.' Hitchcock had the perfect ceremonious manner for the role of usher, or undertaker. The mysteries he exhibits to us – as members of a secret society recruited from the darkness of the cinema, where we sit in rows like churchgoers – are manifold. A family vault in *Rebecca* and an unweeded cemetery in *Family Plot*. A gaping grave in *Vertigo* and an empty coffin in *Secret Agent*. A tightly shrouded body in *The Lady Vanishes*, another that has been embalmed in *Psycho*, and two more that have hardened into rigidity in *Frenzy*. In *Rear Window*, a man paralysed by first one and then two plaster legs, weighed down by this calcified shroud like the sleepers turned to ashen stone at Pompeii. The living death of imprisonment in *The Wrong Man*, set in a city where arrest can mean your consignment to a penitentiary nicknamed The Tombs. A corpse that can still apparently use its legs in *The Trouble with Harry*.

Jamaica Inn hints at the most recondite sight of all, reserved for privileged witnesses. A bawdy smuggler whose body is emblazoned with amorous tattoos looks forward to receiving 'a proper public execution, with the women watching', and vows 'I'll make 'em sit up!' Presumably he has in mind the legend about hanged men ejaculating. His ribald corpse, in a scene we do not see, neatly summarizes 'the great Mystery' by equating extinction and orgasm.

Excursions Underground

Jerry Mathers, Shirley MacLaine and the resilient corpse in
The Trouble with Harry.

Imagination is a cinematographic talent: it gives us the power to make pictures. These archival films are projected on to a screen inside our heads, because they show what we have been forbidden – by parental embargo, or our own timidity – to look at. Freud called such episodes of revelation 'primal scenes'. In his theory, the scene we most want to witness is our creation, when our parents made love and begot us. Hitchcock's films more often make visible a terminal, rather than a primal, scene. They show how life ends, and they dare to visualize what comes after that ending. In an aside, Hitchcock asked Truffaut: 'When people are cremated, do they burn the box or do they tip the body out?' Truffaut tastefully edited the query out of the interview he published.

In du Maurier's *Rebecca*, the narrator and Maxim share a memory from their separate childhoods that must be common to all unappeasably curious children. They both recall that their parents had a book that they kept hidden in a bedroom; they sneaked away to peep at it, despite being told not to do so. Hitchcock's film had no place for such musings, but eventually he allowed one of his characters to open the book that surely contains – depicted by images, not described by tame, approximate words – the primal or the ultimate scene. Vera Miles picks it up in the bedroom of a damaged child in *Psycho*.

Selznick rejected the first script for *Rebecca* because of Hitchcock's liberties with the source. Hitchcock produced a second draft that stayed closer to du Maurier, while taking tricky advantage of the producer's literal-mindedness. Much of what du Maurier had described could not be shown; *Rebecca* itself, though a best-seller, might have been that forbidden book in the bedroom. The flowers at Manderley, for instance, are obscenely fertile, flaunting their pudenda. According to the novelist, the blood-red rhododendrons look 'slaughterous' and have 'crimson faces'. Because flowers are the genitalia of plants, du Maurier's Maxim maintains a prissy or perhaps fearful floral regime,

distinguishing between flowers that grow wild in the grounds and those that are cultivated for display in the house. Bluebells stay outside, roses belong indoors. This unmanly fussing disappeared from the film, but Hitchcock all the same deployed flowers, which have no shame about their private parts, to place on show the sexual scenario underlying the action. Fontaine covers herself in them, hoping that their open invitation might make up for her timidity. The evening dress she orders from London comes with a bouquet of stitched-on roses, which turns her chest into an ornamental hedge. On the gown she wears to the ball, the spray of flowers has slumped lower, dangling beneath her waist. Told to change it, she rushes to Rebecca's bedroom to accuse Mrs Danvers of coaxing her to copy her predecessor. There she finds Anderson arranging gladioli in a vase, tenderly positioning their prongs. Du Maurier's unseen rhododendrons were vaginal; Hitchcock's gladioli, frankly exhibited, are penile, and they have much to say about the masculine Danny. Mrs Danvers is a supposedly married woman with a non-existent husband. Maybe she herself played the husband, with Rebecca – who calls herself Mrs Danvers when she visits the doctor in London – pretending to be her wife.

The mystery guarded by that prohibited book is probably sexual, though in *Rebecca* this shades into a greater and even more alluring mystery, which is the knowledge of death. Du Maurier's narrator feels squalid when she can't stop herself speculating about Rebecca's fatal accident, and condemns her imagination with a social slur: she resembles someone in a tenement, sneaking a glimpse of a dead neighbour's body. She is equally intrigued by the family vault, and wonders 'what a crypt was like, if there were coffins standing there'. The novel vouchsafes stray details about the corpse that Maxim wrongly identified as Rebecca's. Flung against rocks and tugged to and fro by currents for two months, it had lost both its arms. Would Selznick, who expected the film to duplicate the novel, have wanted this on screen? Obviously not; Hitchcock, however, chose to film Olivier's identification of the second corpse, which is actually Rebecca's, although this visit to the local morgue does not occur in the novel. He kept the body out of sight, but the dialogue encourages

us to do our own visualizing by noting that it is fleshless. 'A body rots in water, doesn't it?' asks the narrator in du Maurier's book. Decomposed, Rebecca refutes the Shakespearean image of a drowned man growing into a jewelled reef, alluded to in the title of Hitchcock's 1932 comedy *Rich and Strange*: Ariel in *The Tempest* assures Ferdinand that his father now has bones of coral, with pearls for eyes, and promises:

> Nothing of him that doth fade
> But doth suffer a sea-change
> Into something rich and strange.

Selznick's edict contained provisos, since censorship forbade strict fidelity to du Maurier's story. Maxim shoots Rebecca, whereas in the film she has to die accidentally. The doctor's X-ray of her malformed uterus is omitted, along with Jack Favell's sick, worried query about whether cancer is contagious: he's afraid it might be a sexually transmitted disease. One primal, unfilmable scene in the novel Hitchcock left until later in his career. Olivier does not gun Rebecca down; ever the gentleman, he is not even sure that he hit her. Somehow she fell over, banged her head and killed herself. It was a hygienic solution, because it left no mess to be cleaned up. But in the novel Maxim discovers that 'when you shoot a person there is so much blood'. He has to make relay trips to the beach to fetch buckets of sea water, and then gets down on his knees to scrub the floor with a dish-cloth. The murder horrifies him less, in retrospect, than the menial chores he had to perform to cover it up. All Olivier needs to do is carry the body to the boat and sink it, which he does off-camera. Hitchcock made amends in *Psycho* for this suppression of du Maurier's scene. Perkins wields the mop with none of Maxim's lordly disgust, rinses out the tub, and uses the shower curtain as Leigh's shroud.

At the end, Hitchcock's *Rebecca* had to go further than du Maurier's novel. The novel concludes with a distant view of a false dawn as Manderley burns. Selznick, having torched Atlanta for *Gone With the Wind*, could hardly resist this smaller-scale conflagration, and the scene enabled Hitchcock to compose a surreal poem in praise of decay and purgative fire. du Maurier's characters are all incorrigible,

untidy, self-consuming smokers. Mrs Van Hopper discards her butts in dishes of grapes when no cold cream is handy, and her companion's duties include the disposal of stubs. Mrs Danvers knows about Maxim's nocturnal misery, because cigarette ash, the detritus of unquiet, guilty thoughts, lies scattered on the floor around his armchair in the morning. The narrator burns the dedication page of a poetry book and watches it sift away: 'It was not ashes even, it was feathery dust.' When Rebecca is reburied, she recites the terminal mantra – 'Ashes to ashes. Dust to dust' – and imagines the crumbling corpse as 'dust. Only dust.' Yet the novel stops short of that ultimate scene, the incineration of Manderley. Hitchcock filmed it, with a last close-up of Rebecca's scorched bed, and made it a grandly operatic climax. It is his equivalent to the 'Liebestod' in the crypt that ends Buñuel's *Abismos de Pasión*, a version of *Wuthering Heights* with the added benefit of a Wagnerian soundtrack. Transfigured, Anderson dances through the flames and dodges falling rafters like Brünnhilde among the wreckage of the Gibichung hall as the funeral pyre flares in Wagner's *Götterdämmerung*. A simple case of arson becomes an immolation, cauterizing the polluted world.

Rebecca derives her power from the fact that she remains unseen, represented only by her signature. (The first American posters for the film bathetically included her, and made her look like a gauzier Veronica Lake.) In *The Trouble with Harry*, a corpse is only too obtrusively visible. Harry's presence above ground excites speculation about both primal and ultimate scenes. Shirley MacLaine's son, who discovers the cadaver in the woods, presents John Forsythe with a dead rabbit, which prompts him to ask how rabbits are born. Forsythe replies, 'Same way elephants are,' which fortunately satisfies the boy. Though he declines to spell out the logistics of mating, he is happy to represent such mysteries abstractly. One of his paintings, snapped up by an eccentric millionaire, shows 'a blob caught in a thunderstorm'. Forsythe glosses the squiggles, which are 'symbolic of the beginning of the world'. Edmund Gwenn remarks that this image of cosmic nativity reminds him of something he did at kindergarten; it's not clear whether what he did at kindergarten was produce a painting or merely make an incontinent mess.

Harry lasts better than Mrs Bates, and manages not to moulder during multiple trips back and forth between the fertile fields and the cold subterranean locker or chilly bath-tub in which he is stowed for safekeeping. He is a seasonal god, who dies annually and is reborn on cue – although, thanks to the film's New England setting, he does not have to wait until the spring. Autumn is the season, as Keats put it, of 'mellow fruitfulness', and Harry is part of its rich harvest, along with cider, berries and bottled fruit. His reluctance to stay beneath the ground means that the other characters in the film become expert morticians. They also learn to appreciate the benison of death: when Harry finally decays, he will help to fertilize the earth. His example emboldens Gwenn, the superannuated mariner who fancies an equally restive spinster (Mildred Natwick). She, a slightly dried-up Pomona, offers her autumnal bounty, inviting him to her house for blueberry muffins and elderberry wine. Forsythe smuttily warns him that he will be the first man ever to – er – cross her threshold. Gwenn remarks with a smirk that she's 'a very well-preserved woman – and preserves have to be opened some day'. There is a chuckling ghoulishness in the old man's lechery: the character played by Natwick is called Miss Graveley, so perhaps he will be entering a musty, clammy crypt. Despite Harry's resemblance to a god of fertility, his own quota of potency seems to have been merely human. He was married to MacLaine, who brains him with a milk bottle when he reappears to claim her. She cannot forgive him for deserting her on their wedding night. 'There are some things,' she explains, 'I just don't like to do alone.' When asked how she wants him disposed of, she shrugs 'You can stuff him for all I care.' Her phrase, flirting with the slangy curse 'Get stuffed', remembers her sexual discontent, but connects it with the practice of taxidermy. Love and death once more make an ideal match.

As far as the plot is concerned, James Stewart's trip to the taxidermist's establishment in *The Man Who Knew Too Much* is a time-wasting detour. He goes looking for Ambrose Chapell, the master-stuffer, when he should have gone to Ambrose Chapel, a dingy place of worship; but the excursion takes us directly into the film's catacomb of underground associations, with tunnels leading back to *The Trouble*

with Harry (made the previous year) and ahead to *Psycho*. The absurdity of the mistake conceals its actual pertinence to Stewart. The character he plays is a doctor, and taxidermy is a parody of medicine, prolonging and preserving death, not life. Between Stewart and the elderly Mr Chapell stands a stuffed pelican, its beak weighed down by the purse in which it stored food. Chapell inclines his head next to the bird's, and his eyes behind their glasses are aligned with its eye of black glass. In this laboratory, hidden away down a back alley, natural law is revised. Creatures here can migrate between species, and between life and death.

The conversation hints, by way of misunderstandings, at other mysteries. Stewart asks the old man if he is Ambrose Chapell. He replies 'I've been Ambrose Chapell for 71 years – but I think I understand your problem.' He goes to fetch his son, who perpetuates his name and his genes: nature allows him to be immortal by proxy, as an alternative to taxidermy. The younger Chapell sends his father off to have a rest. The older man bridles at the euphemism, and says, 'I've centuries of rest ahead of me, thank you.' His trade has taught him an Egyptian notion of the afterlife, which will be, he thinks, a long rest, apparently not involving decay. Stewart tells the son about the instruction he received from the spy in Marrakesh, adds that his informant is dead, and presents a 'business proposition'. Chapell is flustered: he thinks that Stewart has come to have his defunct friend stuffed!

The camera looks sideways at the activity in the workshop. Stuffing, to which MacLaine so cheekily refers in *The Trouble with Harry*, is a violent business, a post-mortem rape. A worker uses his fist to shove bales of straw into a leopard skin, forcing his way in through the cavity where the beast's head (temporarily removed) would have been. Elsewhere on the premises, lions, tigers, deer, pheasant and humble ducks attitudinize. The mouths of the big cats gape in a soundless growl, the birds are stilled in mid-flight. When a fight begins, the dead predators galvanically leap back to life and do their best to kill the grappling Stewart. Old Mr Chapell wields a mutant fish, half-organism and half-machine, that has a razor-edged saw jutting from its mouth. The serrated blade edges towards Stewart's

throat, and in escaping he thrusts his hand into the jaw of a lion. Possessing better weaponry than those sets of artificial choppers advertised by the Wapping dentist in the 1934 film, it bites him from beyond the grave.

Hamlet, weakened by poison, calls death a 'fell sergeant' who is 'strict in his arrest': a policeman, impatient to take him in charge. In Hitchcock's films, the metaphor is reversed. Arrest is a rehearsal for death, a rite of passage to the underworld. He often filmed the graduated stages of the process, a funeral ceremony for people who are still alive. The enigmatic widow played by Valli in *The Paradine Case* is given a shroud to wrap herself in. Her hair is unpinned, and a wardress with a gnarled face rakes knotty hands through it. Escorted to her cell, she is invited to enter her coffin. The door clangs shut behind her, signalling the termination of a life. Her solicitor consoles her by saying, 'You're allowed a few things at this stage.' Like the taxidermist in *The Man Who Knew Too Much*, he takes an Egyptian view of this purgatorial eternity. At least, for a while, you are accompanied by some personal mementoes.

Fonda suffers through the same descent in *The Wrong Man*. He stares aghast at his incriminated fingers after they are dipped in ink to be printed. His paltry belongings are taken from him and tallied – a crucifix, a comb, and the grand total of $6.17. He glances abjectly at the bare plank that will be his bed, and the filthy washbasin in a corner. Barred windows rule the floor into a few exiguous squares, between which he shuffles. Here is existence reduced to a grudging minimum. Before the cell door slides shut, he has to surrender his tie, a merciful means of self-destruction. This is to be a living death; actual death would be tantamount to a pardon. Released on bail, he finds that the city to which he returns is an extension of this shadowland. When he and his wife search New York for a witness who might corroborate his alibi, all they find is nonchalant forgetfulness. In a street beside the George Washington Bridge, two giggling girls come to the door. One of them, scarcely able to contain her mirth, says that Mr Lamarca is dead, while Mrs Lamarca's whereabouts are unknown: it was all three months ago, and the agreed term for mourning and commemoration is shorter than most prison sentences.

Near the docks, a neighbour tells them in Spanish that another witness has died, adding a haughty shrug.

There are many ways of dropping out of life. Though Fonda is freed, Miles – who lapses into depression under the strain of his trial – ends incarcerated, as if she has taken his place. A psychiatrist prescribes 'a controlled environment', explaining that she already inhabits the realm of shades: 'she's living in another world from ours, a frightening landscape that could be on the dark side of the moon', and her loved ones are only 'monstrous shadows of themselves'. Gruff cops hustle Fonda into the crypt; he tenderly coaxes his wife into her padded underworld, carrying her bags. She does not acknowledge his farewell, or look back as the white-coated attendants guide her upstairs. When he comes to visit, she dismisses him. A closing title reports on another miraculous intervention of grace, attempting to cheer us up with the news that after two years she left the sanatorium and went to live in Miami. We see a distant happy family strolling in the sun, their backs turned. These, however, are stand-ins filmed by the second unit, not Hitchcock's protagonists at all. We are free to imagine a more realistic outcome.

The allusion to *The Tempest* in the title of *Rich and Strange* acknowledges that this film, supposedly a comedy of manners and sexual morals, takes us on another journey beyond life. Fred and Emily – suburban Londoners, played by Henry Kendall and Joan Barry – are enriched by a relative's legacy. Choosing to spend the money on a cruise around the world, they are estranged from their normal existence, almost from existence itself. Ariel sings of a sea-change that Ferdinand's father, saved from the shipwreck, was spared. Fred and Em also escape from a capsizing steamer, but they come closer than Shakespeare's characters to experiencing that elemental transformation which dissolves men, as Prospero says, into 'air, thin air' – or into smoke from a crematorium chimney and ashy residue in the furnace.

The opening of *Rich and Strange* anticipates that of *The Wrong Man*, with a downcast man returning home from work. At least Fonda is a musician; Fred has the misfortune to be an accountant, and spends his time doing sums not playing jazz. Fonda works the night shift, so his ride home on the subway to Queens before dawn is peaceful.

Fred is shoved and jostled by the rush-hour crowd in a subway that London dolefully calls the Underground. Fonda scans newspaper ads for a car he cannot afford, but like a true American he believes in the prospect of good fortune. Fred, more painfully, is accused by the advertisement he sees in a newspaper someone else in the train is reading. 'Are you satisfied with your present circumstances?' it demands.

At home, Em suggests a night out. 'Damn the pictures,' growls Fred. 'I want some life!' As a toiling, disgruntled clerk, he is hardly alive: he belongs in those crowds of bowler-hatted, besuited corpses T. S. Eliot saw crossing London Bridge in *The Waste Land*. Having rejected the cinema, he suggests an alternative means of release – a smaller and darker room, eventually penetrated in *Torn Curtain*. 'The best place for us,' he reflects, 'is the gas oven.' The telegram from his uncle addresses Fred's grievance: 'You say you want to enjoy LIFE as a change from your existence.' This absent magus, like Prospero, awards his nephew a subsidy to travel 'everywhere' so as to experience 'all the life you want'. But is this the action of a good fairy, or a wicked one? The fulfilment of our stifled wishes may be a curse.

The sea-change can only happen if you die first, and at every stage of their journey Fred and Em are threatened with extinction. Title-cards set an obstacle course for them. 'To get to Paris you have to cross the Channel,' we are reminded. They have a rough crossing, and the lurching boat makes Fred's stomach heave as he tries to aim his camera. 'To get to the Folies-Bergère you have to cross Paris,' and the transit leaves them frazzled and disoriented. Domesticated spaces yawn into vast eternities, or booby-trapped battlefields. A third card advises that 'to get to your room you have to cross the hotel lobby', and we see Fred and Em weaving to and fro, blinded by drink. Their routine at home guaranteed security, reliability. When you set out on the road, you abandon custom and open yourself to risk.

Maugham, in one of his Ashenden stories, sends the spy for a walk around Naples, and takes the opportunity to distinguish between the tourist, the travel writer and the tramp. The first, he says, conscientiously looks for what ought to be seen, while the second is more self-indulgent and notices only what he can make literary use of. The

third is the most authentic traveller. For the tramp, Maugham comments, 'whatever happens is absolute'. Why shouldn't he welcome random happenings? He has nothing to lose. Hitchcock's middle-class characters, clinging to their identities as if nervously feeling for the wallets and passports in their pockets, have no talent for living dangerously. When his son is kidnapped in *The Man Who Knew Too Much*, Stewart identifies himself to the Moroccan policeman as a surgeon, a tourist, and an American citizen. Denying any connection with espionage, he repeats his plaintive credo: 'I'm a tourist, I'm travelling for pleasure.' In Hitchcock's world, that is asking for trouble: how do you know in advance that what happens will be pleasurable? You cannot prevent disasters; you can only react to them when they occur, as Stewart learns to do. *The Birds* begins with a summons to the hopeful, pleasure-bent tourists of the world. Above Union Square, hoardings for airlines utter siren songs: JET BOAC TO ALL 5 CONTINENTS, or AIR FRANCE JET TO PARIS DIRECT FROM CALIFORNIA – symptoms of the imbalance in nature, now that planes have stolen the sky from birds.

Travel in Hitchcock's films is an experience of deduction or deprivation, a luxurious death. On the Asian cruise in *Rich and Strange*, Fred runs off with a gold-digging princess. Em befriends Commander Gordon (cosy Percy Marchmont again) and impulsively forgets to use his title. 'Let it stay lost,' he says. At Colombo, betrayed by her husband, she tells Gordon that she feels 'at sea'. They take a moonlight walk to the far end of the deck, stepping over chains and passing an open cabin where the sailors drink and squabble. They have quit society, ventured beyond its landed limits. Twice, on these excursions to the rear of the boat, Gordon makes the same comment as they look back: 'Want to see a ship on which we were once passengers?' Like ghosts, they seem to be retrospectively surveying a former life. Later Fred and Em wander alone through a sinking, deserted ship, which a title-card calls a 'drifting derelict'.

Hitchcock found inklings of allegory in such maritime disasters. Twice he tried to make films about ships adrift, empty of passengers: first *The Mystery of the Marie Celeste*, later *The Wreck of the Mary Deare*. Romantic poets liked the idea of the drunken boat, the 'bateau ivre' as

Rimbaud called it – a vessel subject, like the poet himself, to the turbulent, inspirational whims of the elements. Hitchcock preferred the notion of a skeletal boat, a communal graveyard ferrying itself through limbo like the ship in *Between Two Worlds*, directed by Michael Curtiz in 1944. The passengers in this film think they are sailing from London to the safety of New York. In fact they are already dead, and on their way to judgement. An Atlantic voyage during those wartime years could easily become a venture into the underworld.

The clipper from London to New York is shot down at the end of *Foreign Correspondent*. Travelling in the opposite direction, the characters in *Lifeboat* watch their ship sink: it is as if the soul, pausing on its way elsewhere, had looked back to witness the extinction of the damaged body. When a child dies, the black steward Joe (Canada Lee) supplies appropriate words: 'Yea, though I walk through the valley of the shadow of death, I will fear no evil.' The dark, sullen, hungry Atlantic is that valley, and the film is about the effort – more arduous than the prayer lets on – not to feel fear. The Nazi commandant Willie (Walter Slezak), stoked with energy pills, indefatigably rows the boat, but he is no saviour. Like Charon, he is steering his cargo towards the German supply ship that will transfer them to a concentration camp. On the way, he soothes them by singing lullabies. The ocean quietly carries out its own policy of euthanasia: he encourages Gus (William Bendix) to drop over the side, and gives him a helpful push. The others gang up to kill Willie, which, as Ritt (Henry Hull) points out, destroys their motor. The pious steward says, 'We still got a motor,' and glances upwards. Ritt, an unbeliever, shakes his head, says, 'We're through,' and discards the cigar that has been his comforter. When they are saved it is by accident, not providence.

Torn Curtain narrates another descent into the underworld – or rather a horizontal passage into it, since the kingdom of the shades now lies above ground, beyond that Iron Curtain that Julie Andrews refers to with dread when Paul Newman decamps from a scientific congress in Copenhagen and flies to East Berlin. His journey, though it happens in northern Europe during the early 1960s, begins and ends in nether realms, places of supernatural torment. The film starts

in ice, on an unheated ship in a Norwegian fjord. It reaches its climax in fire, among the flames of Dante's inferno during a ballet about Francesca da Rimini. Ice and fire are the two conditions tensely combined by the Cold War, a combustible conflict that was temporarily refrigerated.

An American agent disguised as a farmer takes Newman for a ride on a tractor to brief him, then remarks: 'Well mister, this is where you get off. Pleasant dreams.' A strange phrase to use about an assignment that requires Newman to keep all his wits about him, since he must engage in an intellectual duel with a rival physicist, but accurate: *Torn Curtain* is a traumatic trip, an unpleasant dream, and the stages of its plot allude to Dante's transit through the afterlife. Newman is kept under surveillance by the suspicious thug Gromek (Wolfgang Kieling), introduced by the Stasi chief as 'your guide'. This is his leather-coated, motor-cycling version of Dante's Virgil. But whereas Dante relies on Virgil's tutelage, Newman murders his guardian. Towards the end of the film, on his way to the Dantesque ballet, he is set upon by a desperate internee who wants him to be her guide out of the inferno: Lila Kedrova plays a cranky aristocrat who needs an American sponsor to help her escape to freedom.

The credit titles seem to be set in hell, among a seething frost of blue clouds seared by a red flare like the emission from a jet. Agonized bodies drift through this icy, fiery fog. Embracing, Andrews and Newman look like the adulterous Francesca da Rimini and her lover Paolo, murdered by her husband and left to be buffeted for ever in the second circle of hell in *The Divine Comedy*. Tormented faces are blown into close-up – Kieling in his death throes, Newman being strangled, Kedrova tear-blotched, Andrews gaping in stupefaction – then borne away into windy limbo. Brian Moore's script deftly draws attention to the destination of the story. Newman collects the clue to his assignment at a Copenhagen bookstore. After he leaves, the grumpy and oddly ungrammatical owner snarls at his assistant: 'Them religious books is in a hell of a shambles, Magda.' She hastens to tidy up the shelves, and returns with a stack of English bibles. Her boss orders her to take them to the stockroom and say a prayer for Newman on them.

When Newman finds that Andrews has tagged along on the flight to East Berlin, he abuses her, choosing his words with care: 'What in hell's name are you doing here?' Eastern Europe is a hell consisting – as Sartre specified – of other people, marshalled to deny privacy to one another. The university students in Leipzig are ordered to form search parties, scurrying through corridors or up and down staircases to detain Newman; in the theatre, when he interrupts the ballet, he and Andrews are trapped in a crush of pulped bodies, victims of a society where community has congealed and solidified into a mass. Newman and Andrews start and finish the film swaddled amorphously in blankets – first snuggled in bed, then drying themselves after they are fished out of the harbour in Sweden. Despite their rescue, they are still shivering, and they huddle together for comfort, as if they were about to be ejected again into the limbo we glimpse in the credit titles.

Torn Curtain connects the skulduggery of espionage and the arcana of nuclear physics, then merges both with that ultimate mystery which Breton spoke of in an undertone. Professor Lindt in Leipzig, Newman says, has 'got the key to a puzzle in his head, and I've got to get that key'. The old man, played by Ludwig Donat, is a grizzled Sphinx, whose formulae Newman must decipher. Previous Hitchcock films concern battles for control of actual keys. One opens the wine cellar in *Notorious*, another undoes the latch in *Dial M for Murder*. Retentive housekeepers – Anderson in *Rebecca* or Margaret Leighton in *Under Capricorn* – carry the clanking insignia of their power around with them like prison warders. Perkins juggles a handful of room keys in *Psycho*. After a flicker of hesitation, he awards the first cabin to Leigh, settling her fate. In *Torn Curtain* the key is theoretical, and it unlocks a forbidden knowledge. Newman impersonates Satan, tempting Lindt by appealing to his curiosity. He wants to translate the old man's mathematical proof into missile technology; the result, like the eating of the prohibited fruit in Eden, will bring death into the world.

At this exalted level, science resembles Breton's 'secret society', because it stages a Faustian raid on the rights of creation and destruction, once the preserve of God. Physics has learned how to bring about an optional, playful apocalypse. Guy broods about this in

Highsmith's *Strangers on a Train*, as he attempts to explain the dualistic bond that connects him with his opposite and alter ego, Bruno. Is he oscillating between the positive and negative sides of a single, sundered identity? 'The splitting of the atom,' he reflects, 'was the only true destruction, the breaking of the universal law of oneness.' Hitchcock liked to boast that the FBI kept him under scrutiny for three months during his preparations for *Notorious*: it had come to the bureau's attention that he was asking highly placed scientists questions about uranium. The MacGuffin in this case could do more than bag non-existent lions. The shipboard conference in *Torn Curtain* features a lecture on neutrino collisions, and Newman grumbles that his Gamma Five project has been cancelled because American policy-makers 'do not want to see atomic warfare abolished'.

Gamma Five is the coded name for a scientific mystery. Hitchcock's symbols protect their top-secret classification by taking on new, unofficial significances. The book Newman collects in Copenhagen contains the password that will give him access to a cadre of helpers in East Germany: the letter 'π'. He scratches it in the dirt at the farmhouse, but fails to conceal it from the policeman who tracks him. Gromek says, 'Looks like a sign. What kind of sign?' He scornfully recites the mathematical meaning of 'π', which is the ratio of a circle's circumference to its diameter, then spits out another meaning: 'π' stands for 'a dirty little two-bit organization for spying and escaping'. Could the cipher have other dirty implications? Newman takes the book containing the message to a lavatory cubicle. Crouched in the stall, he decodes it, and copies 'π' on to a square of toilet paper. A close-up shows the ink from his fountain pen diffusing through the coarse weft, staining it as if excrementally.

When Newman and the ancient wiseacre fence with equations, Hitchcock turns the scribbling of their chalk on the blackboard into an abstract exchange of fantasies. The American's opening sally, which allegedly concerns velocity, is

$$O$$
$$Rs = [-w^2Rs]$$

The German corrects this with a sniff of condescension. Newman

gasps, 'Oh my God!' when he sees the revised version. He then rubs everything out, restoring the blank slate recommended by the priestess in *The Man Who Knew Too Much*. He unravels a skein of apparently Arabic letters, then stands back to cockily remark: 'That works.' Lindt prophesies that it will blow up (like the world), and executes his own victorious twiddle in Gothic script:

$$V_g = V_o - V$$

In awe, Newman studies the solution and rapidly learns it by heart, mumbling to himself. He is committing an intellectual theft, like Stewart stealing images in the Greenwich Village courtyard – mentally photographing the formulae without a camera. Despite his rapt face, we cannot see the equation, and would not comprehend it if we did. Lindt tugs down an empty blackboard to cover the surface they have been using, like Kelly reproachfully lowering the blinds in *Rear Window*. His reaction admits the witty imposture of the episode: 'You told me nothing! You know nothing!'

A plot that turns on nuclear physics reaches its climax during the performance of a ballet. It takes quite an associative leap to bridge these different worlds; *Torn Curtain* manages the feat with insouciant ease. The explosion that the physicists worry about actually occurs in the theatre when Newman, watching the dancers pirouette among paper flames, cries: 'Fire!' The ensuing confusion allows him to escape. Suddenly the supercilious ballerina (Tamara Toumanova), hitherto kept on the margins, becomes crucial. She spots Newman in the audience, and denounces him: it is her revenge for an earlier snub, when his press conference upstaged her arrival in East Berlin; and perhaps, in a subtext that the film keeps buried, she instigates this revenge on behalf of the meek, sacrificial Julie Andrews. In the ballet, danced to Tchaikovsky's symphonic poem *Francesca da Rimini*, Toumanova plays the victimized Francesca – a double for Andrews, who loyally follows her lover into political damnation. Like the mismatched acquaintances on Highsmith's train, they sit together on the plane from Copenhagen, and Toumanova bristles in black fur while Newman rails at Andrews, who is dressed in soft shades of yellow and orange.

This duality, splitting the 'oneness' of nature, as Guy reflects in Highsmith's novel, is the conceptual crime of modern physics, and it explains the tendency of the film's other female characters to split apart, revealing antagonistic sides of themselves. The farmer's wife (Carolyn Conwell) is at first nurturing, maternal. She offers 'apfel-wein', and Gromek calls her 'Cookie'. Then she transforms her kitchen into an abattoir. She hurls a pot of soup at Gromek, drives her carving knife into him, and hauls him towards the gas oven. Farming tools are no longer employed to make the earth fruitful: she breaks his legs with a spade. Once he is dead, she reverts to wifely solicitude, removes Newman's bloodied coat to burn it, and leads him to the sink to wash his hands. Even Kedrova, as the Countess who longs for a new life in the West, has a double nature. She begins by shielding the runaways and inviting them to tea. When ingratia-tion fails, she tries blackmail. Whether or not the world survives, the moral and mental damage done by nuclear science is irreversible.

Hitchcock's Cold War films speculate about an ultimate kingdom of shadows: the sunless bunker where the lucky ones may be allowed to sit out the conflagration and the mortified winter that will follow. He initially wanted Newman to resign his political mission in disgust at the end of *Torn Curtain*; but how could a star be asked to behave unpatriotically? Even so, the film concludes with a gesture of denial. A news photographer begs for a picture of Newman and Andrews; they refuse to pose for the sort of smoochy, all-forgiving two-shot that might have concluded a more conventional film, and he pulls their shared blanket over their heads. Leon Uris's novel *Topaz* frets about the outcome of the Cold War, and – after the existential gam-bling of JFK – questions whether American interests will prevail. In Uris's book, the French President Pierre La Croix chooses to ignore the report on the network of Soviet agents in his government. La Croix was based on de Gaulle, whose fanatical dislike of the United States encouraged him to overlook Russian infiltration. Devereaux (played in Hitchcock's film by Frederick Stafford) is spurned by his colleagues for exposing this treachery and forced to flee for his life, while the campaigning journalist who helps him is kidnapped and presumably killed by corrupt French officials. Hitchcock could not

imperil NATO by defaming an ally; nor would he risk alienating one of his own European markets, the nursery of his highbrow reputation. But he remained unsure about how else he could end *Topaz*, and filmed several evasive or dismissively flippant alternatives: the spy's abrupt suicide behind closed doors; a duel in a deserted football stadium, during which the spy is shot from the sidelines by a Russian hit-man; and a chance meeting at Orly Airport, with a cynical farewell from the spy who, in this version, is spirited off to Moscow.

Finally he settled on a scene that adds a footnote to an episode recalled in Uris's novel. Hitchcock's *Topaz* starts with a parade of military hardware through Red Square and fades out, much less buoyantly, with a glimpse of strollers and dog-walkers on the dusty Champs Élysées. A passer-by tosses aside a newspaper; its headline announces the Russian withdrawal from Cuba. The view of the avenue evokes Uris's flashback to the liberation of Paris in 1944, when La Croix – then a general, 'flushed with a holy sense of calling' – led a marching mob of his 'hysterical countrymen up the Champs Élysées to the Arc de Triomphe' where, in a fit of Napoleonic arrogance, he declared himself President. Uris comments that La Croix 'captured lightning in a bottle by playing one of the most emotion-filled moments in human history to his own ends'. He profited from the jubilation by establishing a tyranny. In Hitchcock's coda, no heaven comes down to earth on the Champs Élysées, and the stragglers on their way to the arch at the top of the hill expect no triumph. News of the earth's reprieve is broadcast by a scrap of wind-blown litter. Humanity, like the initiates at the festival of Eleusis, has experienced the thrill of an imminent collective extinction, and survives both to tell the tale and to forget its moral.

Holy Dread

Montgomery Cliff ministering to O. E. Hasse in *I Confess*.

To Hitchcock himself, the popularity of his films was a 'strange phenomenon'. Why, he often asked, did audiences pay him to frighten them? One of his favoured analogies was the mother who spooks her six-month-old infant by saying 'Boo!' to it. First it screams, then it giggles with relief. Surely Hitchcock misinterpreted the mother's motive: she wants to surprise the child into recognizing her, not to terrify it. He once presented Tippi Hedren's young daughter with a toy version of her mother, laid out in a tiny coffin; the girl screamed in earnest, with no appreciative chuckles to follow. His own daughter Patricia has vouched for his harmlessness by remembering a practical joke he played on her. He would creep into her bedroom, locate her lipstick, and draw a clown's face on her while she slept – surely, despite Patricia's compliance, a strange way to express affection.

Interviewed by the BBC in 1966, Hitchcock elaborated on what he called 'the game of putting the public in the place of the victim'. He recited his customary parable about the mother curing her baby's hiccups with a shock, and went on to claim that the child who undergoes this induction soon becomes addicted to fear. That same baby 'goes on a swing and swings higher and higher, then on the switchback railway, then into the haunted house'. Perhaps amusement parks are contemporary sites for the Eleusinian mysteries: places where we experience a hurtling, shrieking death, from which we are permitted to recover. Alternatively we go to the cinema, which sends us careening along the loops and twists of a virtual roller-coaster. The Universal Studios theme parks have an interactive pavilion dedicated to Hitchcock, where you can suffer Stewart's seizure as the tower rocks beneath him in *Vertigo* or 'feel the sting of the shower in *Psycho*'. Everyone, Hitchcock concluded, relishes 'a little scare'. He admitted that this might have a bad effect on sick minds, but thought it couldn't hurt those who were mentally healthy.

Two of his films test his defensive argument by observing the

behaviour of people at funfairs. Fear soon ceases to be enjoyable in *Mr and Mrs Smith*. After a trip to a nightclub, Mrs Smith (Carole Lombard) suggests going out to the fair. The man who is squiring her takes her to the grounds where the World's Fair was held in 1939. They pay twenty-five cents each to go on the parachute jump, and are strapped into a swaying bucket chair, which is jerkily hoisted aloft. They have a stomach-turningly steep view of the crowd below as they overtop the Trylon and Perisphere. Through gritted teeth, with a keen edge to her voice, Lombard insists that it's all such fun – especially when the operators of the jump pretend that the little open bench has stalled in mid-air, just to add to the excitement. This, however, is no stunt. The ordeal is the more grimly ironic because the parachute jump is sponsored by LIFE SAVER CANDY, whose logo is spelled out in neon on the pillar and the circular platform at the top. Not, you might think, a very diplomatic piece of product placement. Life Savers may imitate life jackets, but they have a hole in the middle: an emptiness into which you might plunge, with no parachute to buoy you up. While Lombard and her companion dangle far above ground, it begins to rain. Soaked, they start sneezing.

The incident spilled over into reality in a prank Hitchcock allegedly played on his long-suffering daughter while filming *Strangers on a Train*. He sent her up on the Ferris wheel in the amusement park, then had the machine stalled. He intended to leave her hanging overnight; Patricia's hysterics, according to the legend, persuaded him to relent. W. H. Auden believed that Ferris wheels and roller-coasters were engines of sublimation, allowing us to experience 'the volitional joys of a seraph'. But angels, as Hitchcock might have pointed out, do not usually scream as they swoop through the air.

In *Strangers on a Train*, Farley Granger's wife behaves like the baby in Hitchcock's anecdote. She screams as she sails through the Tunnel of Love, then lapses into flirtatious giggles as she fights off two flirtatious assailants. But her actual death is less amusing. Her reaction, as Robert Walker's hands fasten on her neck, is stifled, silent; and when the carousel spins away from its moorings at the end of the film, the danger exceeds the bounds of play. Hitchcock sent a grizzled old electrician crawling under the berserk platform to switch off the merry-

go-round. If the man had raised his head an inch or two more, he would have been killed. Hitchcock told Truffaut: 'I'll never forgive myself for letting that happen, and I'll never do it again. It was a terrible, terrible thing to do.' Truffaut spared his blushes by not publishing the aside.

Fear, whether enjoyable or not, is what Hitchcock's films are about, which is why they are such a reliable guide to the pitfalls – psychological, spiritual, even political – of the world we live in. Modern life promised to banish the atavistic menace that plagued men in less enlightened days. Why should we be afraid of the dark, now that we have electric lights? Among the Four Freedoms promulgated by President F. D. Roosevelt's New Deal was Freedom from Fear. The *Saturday Evening Post* illustrator Norman Rockwell painted this enviable state in 1943: doting parents tuck in their child, whose rag dolls are scattered on the bedroom floor. Outside this nursery, however, there is still reason to be afraid. The father in Rockwell's painting clutches a newspaper with a headline report on the London blitz. Freed from fear, Americans soon began to fear their freedom. The sociologist Erich Fromm published a book called *The Fear of Freedom* in 1941. Modern man, Fromm argued, possessed a 'manipulated personality', liable to seek 'security in submission to a leader, race or state' – or, perhaps, to a wily film director.

Ideologues less compassionate than Roosevelt resuscitated fear and made it an instrument of government. In 1918 Lenin declared that Bolshevism would not be victorious 'without applying the most cruel revolutionary terror'. Fritz Lang agreed about the necessity of fear, and in 1967 made it a matter of belief. He asked: 'What do people believe? What are people fearing?', as if these were interchangeable questions, and replied: 'That is physical pain. And physical pain comes from violence. That I think is today the only thing that people really fear.' Lang's films give us plenty to flinch from: the scalding coffee hurled in Gloria Grahame's face by Lee Marvin in *The Big Heat*, the liver sliced by Edward G. Robinson in *Scarlet Street*. Hitchcock, operating more subtly, creates mental apprehension. A glass of lukewarm milk in *Suspicion* is as dangerous as Lang's pot of boiling coffee, and there is no need to chop up offal. *Spellbound* demonstrates that you

can provoke a nervous breakdown by scratching lines on a tablecloth with your fork.

In *Stage Fright*, Marlene Dietrich's lover threatens to eliminate the young dupe, played by Richard Todd, who has helped her get rid of her husband. 'You make me afraid,' she gasps. 'You don't know what fear is,' he replies. The remark is both scornful and admiring. It assaults Dietrich's self-possession, guarded by the masked fixity of her face. Her lover's aim, like that of the speaker who exhibits the handful of dust in Eliot's *The Waste Land*, is to introduce her to the knowledge of fear. Hitchcock's men often make such seductive threats to women. In *To Catch a Thief*, Grant asks for Kelly's assistance during the party at the villa. Exquisitely teetering between dread and expectancy, she asks, 'Will it be dangerous?' After one of the kidnappings in *Family Plot*, Karen Black tells William Devane that she is tingling all over. He supplies a lewd diagnosis of this frisson: 'I told you about danger. First it makes you sick, then it makes you very, very loving.'

Fear has an intimate connection with sexual arousal, because the prospect of gratifying our desires terrifies us. What monster, bred in our dreams, are we about to confront? Cornell Woolrich, in a novel published in 1944, voted against Roosevelt's electoral promise to cast out fear. He called the book *The Black Path of Fear*, and a character in it is afflicted by panic, defined by Woolrich as 'fear without any real reason to be afraid'. Yet panic does have its reasons, which are implicit in the word itself. Panic, like all fearful reactions, contains an element of religious awe, and acknowledges the deranging presence of Pan. 'Fear,' as D. H. Lawrence claimed, 'is the first of the actuating gods.'

Graham Greene believed in the unorthodox deity that Lawrence called 'the God of fear', as he testified in his novel *The Ministry of Fear*. Although Greene's title sounds political, its meaning is actually religious. Greene worked at the Ministry of Information in Bloomsbury during the war, so it is tempting to assume that he was writing about an annexe of this establishment – or else an offshoot of the Bureau of Surreal Research that, with headquarters at 15 rue de Grenelle in Paris, was described by Breton as 'a romantic inn for unclassifiable ideas and continuing revolt'. But the capital letters in the title

have to be erased. The Ministry of Fear is actually a ministry of fear; the man who dispenses fear is a minister of religion, not a bureaucratic administrator. Greene derived the phrase from Wordsworth's autobiographical *Prelude*, where fear is a ministering agency or angel, like the 'silent ministry of frost' in a poem by Coleridge. The haunted sensation serves the young Wordsworth – who says that he 'grew up /Fostered alike by beauty and by fear' – as a tutor or a mentor. Nature sometimes seeks out the favoured child with gentle visitations, but on occasions it employs 'Severer interventions, ministry/More palpable'. When Wordsworth steals a boat, he senses as he rows away that he is being stalked by a mountain peak that has witnessed his crime. He thanks this soul in the landscape for 'sanctifying, by such discipline/Both pain and fear'. Later, after a giddy account of ice-skating, he composes a pantheistic hymn to the 'Presences of Nature', again using the two words Greene brought together in the title of his book:

> can I think
> A vulgar hope was yours when ye employed
> Such ministry, when ye through many a year . . .
> Impressed upon all forms the characters
> Of danger or desire; and thus did make
> The surface of the universal earth
> With triumph and delight, both hope and fear,
> Work like a sea?

Coleridge invokes the same sense of nervous awe in 'Kubla Khan', calling it 'holy dread'. Genet too later admitted that his legal and sexual crimes stimulated in him a 'religious fear'.

The mother who says 'Boo!' to her baby lurks in the vicinity here. We usually personify nature as a mother, but Wordsworth, emphasizing its stern inculcation of moral discipline, saw it as a father. These intimations of sexual identity in landscape were first explored in 1757 by Edmund Burke in his treatise on the sublime and the beautiful, which probed the psychological yearnings within the romantic religion of nature. Burke suggested that we like beautiful things – patches of wild flowers, birdsong – because they remind us of our

nurturing mother. But nature has more prodigious powers, displayed in jagged mountain ranges or thunderstorms or angry seas. We call these sublime, and enjoy a fierce, terrifying excitement when exposed to them. They correspond, for Burke, to memories of our father: bigger than we are, more authoritative, occasionally wrathful, not to be trifled with. Hitchcock, in his explanation of why we enjoy being afraid, roughly paraphrased the theory of the sublime, but with a telling difference. He swapped the parental categories proposed by Burke. In his anecdote, the mother not the father is the source of fear.

A succession of lop-sided Hitchcock families illustrates the point. In *Notorious*, Rains's gruff and sexually jealous mother sits up in bed and lights a cigarette as she plans the disposal of her daughter-in-law. In *North by Northwest* and *The Birds*, Grant and Taylor remain in thrall to their strict, disapproving mothers. Is Mrs Bates, baritonally castigating a son she calls 'boy', a mother at all? Perkins puts on her clothes so he can excoriate himself. In *Frenzy*, Barry Foster introduces his mother to Jon Finch. He and his chubby, henna-haired mum lean over the window sill of Foster's flat and wave down to the street below: the window, we recall, is where Mrs Bates sits in her rocking chair or paces like a sentry. Foster keeps a photograph of his mother on the mantelpiece beside the bed in which he rapes and strangles his victims. It is to be hoped that he turns it to the wall – as Gavin proposes to Leigh in *Psycho*, when she says that she will henceforth only meet him for respectable dinners, supervised by her mother's picture – before he goes into action. In all these households, the father is missing, presumed dead. That leaves the mother to administer 'both pain and fear'. You look to your parents for love. It is their duty to make you feel at home in the world. What happens if they withhold that reassurance, and choose to scare you instead? The world remains an alien, alarming place.

This, for Hitchcock's French devotees in the 1950s, constituted the wisdom of his films. They prepare us for a life that is at best tenuous, at worst intolerable. The psychological quirks they betray do not impair their austere truthfulness. Truffaut, writing about *The Birds* in 1963, returned to the scenario of the child whose mother says 'Boo!', and improved on Hitchcock's argument by contending that it does

us good to be scared. He cannily accounted for the underestimation of Hitchcock by proposing that critics – spokesmen of the upright superego – could not forgive him 'for making us afraid'. In Truffaut's review, the point developed into a personal credo. 'I believe,' he wrote, 'that fear is a "noble emotion" and that it can also be "noble" to cause fear. It is "noble" to admit that one has been afraid and has taken pleasure in it. One day, only children will possess this nobility.'

Truffaut took his cue from Eric Rohmer and Claude Chabrol, who discerned in the second *Man Who Knew Too Much* 'a kind of emotion nobler than the sentimentality proper to espionage stories'. Buchan's *Three Hostages*, the novel that beckoned Hitchcock for so long, likewise contains a chapter entitled: 'How a French Nobleman Discovered Fear'; the discovery conducts him towards 'enlightenment'. We may blink at the notion that feelings have aristocratic pedigrees, but Hitchcock's French supporters were right. His films do more than dispense spurious thrills, like the switchback railway; they put our psychological courage on trial. This is where they join forces with the Wordsworthian ministry of fear. Burke's sublimity is the best example of a noble feeling, because it is available only to those with the gallantry to expose their vulnerability. More ignobly expressed, the issue is raised again in Stephen King's novel *Bag of Bones*, where a writer resolves to confront a poltergeist that invades his home. In taking this decision, he follows the 'New Age wisdom that said the word "fear" stands for Face Everything and Recover'. Then he changes his mind, recognizing that 'fear is actually an acronym for Fuck Everything and Run'. (*Bag of Bones*, not coincidentally, is King's homage to *Rebecca*, with the dead woman impishly rearranging the furniture.) Truffaut's ethic of nobility assumes that we will stay around and face up to the assault. Hitchcock, more cautious, shows his characters on the run, like the refugees from Bodega Bay in the last shot of *The Birds*.

The thriller is not a meagre, squalid genre, crassly exploiting our qualms. At best, its concerns are philosophical, or – more precisely – existential. Breton in *Vases communicants* paid tribute to his favourite 'romans noirs'. The books he refers to are Gothic novels, dating from the late eighteenth century, but the tradition had a thriving life in his

own time, with works like *Rebecca* or *The House of Dr Edwardes*. And the Gothic novel begot a modern variant of the 'roman noir' in the criminal thrillers by Highsmith, Woolrich and others that were published in France as the 'Série noir'. Breton wanted a glass-fronted bookcase, fretted with crockets and crenellations, in which he could arrange his collection of thrillers. He wished, he said, 'to build [a] little temple to Fear' – a place where Greene's minister would be in charge of devotions. Despite his enthusiasm for the Soviet demolition of God, Breton remained an incorrigible mystic. Speaking for his fellow surrealists, he explained 'the attraction that "mystery" held for us' by saying that it represented 'a state of mind such that its atheism shouldn't disqualify it from being termed religious'.

By the same token, Hitchcock's films deserve to be termed religious. It does not matter that his places of worship – the alpine church in *Secret Agent* or Westminster Cathedral in *Foreign Correspondent*, Ambrose Chapel or San Juan Bautista – are used for committing crimes: a murder can be a sacred offering to a carnivorous deity. Nor should it matter that Hitchcock's priests are often wolves wearing dog collars, like Bernard Miles in *The Man Who Knew Too Much* and Devane in *Family Plot*. Cotten's revulsion from rich widows in *Shadow of a Doubt* is positively monastic. Wrongdoing can be a vocation, a principled inversion of conventional piety. 'Evil,' as Milton's devil put it, 'be thou my good.'

The thrillers of the 'Série noir' were admired by Sartre and Camus, who saw them as a stark moral education. The grim curriculum is laid out in a novel published in 1940 by Eric Ambler, aptly entitled *Journey into Fear*. (Selznick recommended Ambler to Hitchcock as a possible scriptwriter, and although they never worked together, Ambler married Hitchcock's indispensable aide Joan Harrison. The film of *Journey into Fear* was directed in 1942 by Norman Foster, with Orson Welles – who appeared in it – looking over his shoulder.) Like most of the stories Hitchcock told, Ambler's novel is an allegorical traversal of our dicey existence. The journey of the hero Graham takes him from Turkey back to England. On the way, estranged from his innocuous, insulated past, he discovers 'the fear of death'. Geographical co-ordinates fade out: 'he was a man alone, transported

into a strange land with death for its frontiers' – like Cary Grant on the parched prairie highway. Graham's chest clenches, his heart hammers, his stomach sags. Yet despite the discomfort, these 'queer, horrible' sensations are 'stimulating'. For the first time, he reads the instructions on lifebelts, grateful to be reminded that peril might be imminent.

He resigns himself to his end with the hardbitten fatalism of the 'noir' protagonist, aware that 'living wasn't even so very pleasant'. When he escapes certain doom, a consular official pats him on the back. Graham recoils: 'There seemed to be something strangely fatuous about congratulations on being alive.' It is as if he had merely succeeded in keeping his eyes open during a Hitchcock film. But that too – because the films exhibit our worst fears, showing us the face of Mrs Bates – counts as a small victory. When *Rear Window* was re-released in the early 1960s, the director himself appeared at the top of the poster, issuing a challenge to his customers. 'See it!' he commanded, 'if your nerves can stand it after *Psycho*.'

Hitchcock allowed himself to be branded 'the master of suspense', though the label encouraged a misunderstanding of his actual purposes. Of course he enjoyed suspensefulness, that uneasy deferment of an inevitable end that makes time tick away so slowly during the countdown to the explosion in *Sabotage*. But his real interest was in suspension, the physical proof of our anchorless uncertainty. Long before he picked out the word as a title, vertigo had been identified as a symptom of our mortal predicament, as we review our position in a world no longer founded on belief in God. Baudelaire reported its onset in 1862 in his *Intimate Journals*: 'In the moral as in the physical world, I have been conscious always of an abyss . . . Now I suffer continually from vertigo.' He cultivated this hysteria 'with delight and terror', which is exactly Hitchcock's amalgam of emotions. Breton in his 1930 manifesto called surrealism 'this tiny footbridge over the abyss', specifying – in an anticipation of the bell-tower at San Juan Bautista – that there should be no guard rails.

Stewart's vertigo is, like the moral failings Breton delighted in, a 'sacred evil'. His plight seems all the more metaphysical because Hitchcock, scorning logic, declined to supply him with a means of

physical rescue. The film's prelude leaves him swaying from the buckled gutter of a rooftop. How did he get down, since the cop who tried to help him has plunged to his death? Surely, in his woozy state, he could not have hung on until the firemen arrived? Presumably he fell, though the only damage is a bad back that requires him to wear a surgical corset. But when we next see him on solid ground, he no longer believes in the sustaining horizontality of terra firma. Barbara Bel Geddes asks why he does not apply for an office job in the police force. He rejects the suggestion: he might just as easily have an attack of vertigo if he stooped to pick up a pencil that had rolled off his desk. The abyss sensed by Baudelaire wants to engorge us all; gravity unsettles minds as well as threatening bodies. While she chats with Stewart, Bel Geddes sketches a brassière that does without straps at the back or sides. She extols its 'revolutionary uplift', based on 'the principle of the cantilevered bridge' and designed by an aeronautical engineer from the peninsula south of San Francisco. If only the devices that combat sagging flesh could uplift our stricken brains!

Modern religion is less concerned with the starry heights above us than with the emptiness gaping below. As Nietzsche put it, man is 'a rope over an abyss', stretched between animal and 'Übermensch'. Brandon in Patrick Hamilton's theatrical version of *Rope* cites Nietzsche as the sponsor of adventure and danger. His name is not mentioned in Hitchcock's film, but Stewart makes punning play with Nietzsche's metaphor. Producing the length of rope used to strangle the young victim, he says that it lends 'an additional element of – er – suspense' to the plot. Taut, tensed, that rope can be extended into a trapeze. The character played by Grant in *To Catch a Thief* is a veteran of the highwire. So, supposedly, is the transvestite circus performer in *Murder*, though he employs the rope as a noose not a life-saver, and uses it to commit suicide.

The vacuity below can be convenient, as James Mason realizes when planning Eva Marie Saint's involuntary disembarkation from his plane in *North by Northwest*. 'This matter,' he tells the slinky Martin Landau, 'is best disposed of from a great height, over water.' The camera then lifts up to a great height and looks back down on Mason

and Landau, prematurely assuming the altitude of triumph. For those who find themselves treading on empty air, the experience is less happy. In *Young and Innocent*, the floor of an abandoned mine capsizes, and the pit of rubble gobbles a car; the heroine is hauled back up to the edge of the crater, her arms flailing. Hitchcock chuckled at the mishap of Chabrol and Truffaut who, on their way to interview him at a French hotel in 1955, sank through a frozen crust into a pond. He later said that every time he heard the clink of ice cubes in a cocktail glass, he thought of their chilly, floundering dismay. Even a comforting drink, for him, could evoke the inhospitable vacuum in which we struggle to remain afloat, like the survivors who cling to the torn wing of the plane in the heaving ocean in *Foreign Correspondent*.

Howard Hawks summed up both existence and the movies when he said 'To stay alive or die: this is our greatest drama.' In Hawks's world, our fears can be overcome by strenuous action – policing the city like Bogart in *The Big Sleep*, rounding up refractory cattle like John Wayne in *Red River*. Such physical bravura is unavailable to Hitchcock's people. If they move at speed, like Grant when the crop-duster strafes him, it is because they are running away. More often, they are rendered immobile by self-doubt and perplexity. Dietrich in *Stage Fright* makes pointed use, like Stewart in *Rope*, of the word that is so associated with Hitchcock's directorial purposes. Jane Wyman, pretending to be her dilatory maid, has arrived late for work. Dietrich waves away her excuses, but allows herself a peculiarly phrased rebuke: 'You did leave me a trifle suspended, however.' She might be Carole Lombard when the parachute jump breaks down.

There is a curious sequence in *I Confess*, when Clift, sentenced to inertia by his vow of silence, takes his perturbed conscience for a walk through Quebec City. Everything he sees – the traffic cop whose raised arm stalls him at a crossing, or a headless mannequin in the window of a clothes shop – reminds him of crime and its punishment. Finally he passes a statue of Christ bowed beneath the cross, a symbol of submission. On the way, he stops outside a cinema and studies its placards. Here Hitchcock, unusually, acknowledges the existence of another film-maker: the cinema is showing *The Enforcer*,

a Bogart vehicle directed by Raoul Walsh, who, like Hawks, specialized in salving, energetic action. Clift stares at a lobby card, which has an image not of Bogart but of a minor character wearing handcuffs. Those symbols of our incapacity to help ourselves are what attracted Hitchcock's gaze. The pained glance of the priest measures the difference between a Hitchcock hero and the more extroverted figures played by Bogart in 'film noir', or by Wayne in so many classic Westerns. The man with a gun, like Walsh's enforcer, fights against fate. Hitchcock's protagonists lack both the weaponry and the will; and there are no horses to help them outpace their destiny. Tippi Hedren in *Marnie* gallops her adored stallion into a fence, and has to shoot it.

Hitchcock's characters are poised above a precipice, like Olivier on the cliff at the beginning of *Rebecca*, and their angst cannot be cured by action. Hawks's credo paraphrased the soliloquy in which Hamlet contemplates those twin infinitives, 'To be or not to be'. Hitchcock saw the hero's choice rather differently. Hawks assumed that we will go on living for as long as we can. If we die, it will not be our fault, or our choice. An accident may eliminate us, like the plane crash in Hawks's *Only Angels Have Wings*. When that happens, no one is maudlin, so the dead pilot's comrades jauntily pretend to forget him. Hitchcock's view of the matter was starker, without Hawks's stoical fortitude. Olivier stares down at the rocks and the angry breakers in *Rebecca*, and is furious when Fontaine's intrusion prevents him from jumping. Perhaps the actor was silently quoting Hamlet as he stood there: when Olivier made his own film of Shakespeare's tragedy in 1948, he placed himself on a parapet high above the foaming sea at Elsinore and, as if alluding to Hitchcock, delivered 'To be or not to be' as an internal monologue while hesitating on the brink.

Hamlet, of course, does not jump; but Hitchcock shows what it would look like if he had. In *Suspicion*, Fontaine (who might be re-enacting that first scene of *Rebecca*) imagines Grant pushing Nigel Bruce over a cliff. He tumbles on to the rocks, laughing maniacally as he goes. Omitting this self-destructive glee, Hitchcock repeated the shot when Stewart dreams of falling into a grave in *Vertigo* and again when Martin Balsam plummets backwards down the staircase in

Psycho. Fontaine's prophetic vision is revised, as always in this film about the untrustworthiness of visual impressions. She visits the place and sees skid marks at the eroded verge where Grant managed to reverse the car just in time. Still, he and Bruce learn a lesson from her nightmare. They call off their real-estate venture, because the cliff-top soil is too chalky to support houses. Fear may not always be enjoyable, and its nobility can also be questioned. But it does inculcate reverence: it warns us never to forget the world's dodgy physics, and its doubtful, possibly inimical metaphysics.

In 1952, Vladimir Nabokov – lecturing at Harvard on *Don Quixote*, and protesting against the novel's brutality – suggested a new human right, a possible fifth instalment of Roosevelt's squeamish liberal creed. 'One of the few things that may save our world,' Nabokov argued, 'is Freedom from Pain, the complete and permanent outlawing of any kind of cruelty.' In that enlightened society, the churches would have to be summarily closed, and so would any cinema which showed a film by Hitchcock.

A Hymnal

Doris Day and James Stewart at their devotions in the second
Man Who Knew Too Much.

Though he disliked sharing credit, Hitchcock once admitted that his direction accounted for only two-thirds of a film's impact. After the shooting was over, he relied on Bernard Herrmann to supply the final third when he added a musical score. Music augments the cinema's appeal to imagination by speaking about things we cannot see. Hitchcock's films are rites, and the music in them conducts us through the stages of a macabre ceremony.

We like to think that we can tame music, using its repetitions to soothe uncertainties and reconcile discords. Hence the round song chanted indoors by the schoolchildren in *The Birds*, while Hedren sits outside smoking as she waits for Taylor's sister. The rhyme with its invariable refrain passes and pacifies time, as does Hedren's nicotine habit. But both means of reassurance are deceptive. The birds, gathering unseen behind Hedren on the climbing bars in the playground, fly in unexpectedly, in fits and starts, and we are given only intermittent glimpses of them as they amass a battalion of flapping wings and scissory beaks. They defy the predictable rhythm established by the song, or by Hedren's meditative puffing, just as Herrmann's score for the film – a collage of toneless avian squawks and screeches, played on an electronic keyboard – discards the emollient manners of music in favour of jarring, lawless noise.

According to the myth of harmony, music holds the world together, since the vocalizing spheres collaborate to sound the notes that make up an octave. In the same way, music has been charged with maintaining the artifice of human rationality. Dissonances could be briefly set free, so long as they were reined in by a dominant tonality. Bel Geddes fondly upholds this superstition in *Vertigo*, putting Stewart through a course of musical therapy. A bright, reasonable piece by Johann Christian Bach plays during their first conversation in her apartment; when he is interned in the sanatorium, she relies on Mozart's 34th Symphony to revive his spirits. But he asks her to turn off the Bach, and apathetically ignores the sprightly snatch of Mozart.

Burbling in embarrassment, she marvels about a society in which music has become a patent medicine: 'they have it all taped now . . . They have music for dipsomaniacs, and music for melancholiacs, and music for hypochondriacs.' Despite her good humour and common sense, she finds herself speculating about the possibilities for Hitch-cockian mischief, and wonders 'what would happen if they got their files mixed up?' You could create bedlam by prescribing the wrong tunes. In *Spellbound* too, music subverts the healing work of psycho-analysis. The electronic wand of the theremin, like the ululation of a banshee, makes Gregory Peck's guilt complex audible. This is the music of a strung-out brain, not of the well-tempered spheres.

Farley Granger in *Rope* is meant to be in training for his debut as a concert pianist. He provides some entertainment at the party, playing the first, obsessively repetitious *Mouvement perpetuel* by Francis Pou-lenc. Its tinkling motion leads nowhere; meant to calm the nerves, it only abrades them when the scrap of melody strays out of tune. Stewart, already suspicious, snares Granger by using a musical gad-get. He sets a metronome intrusively ticking on top of the piano, then twice increases its speed as his questioning becomes more insistent. Granger is unable to think as quickly as the metronome requires, and swivels aside on the piano stool: he can't play, he says, with 'that thing' clucking its tongue at him. Hitchcock himself learned from the incident. According to Kim Novak, he used a metronome to give scenes in *Vertigo* a 'staccato feel – and it had to be exactly so'. On their final ascent of the tower stairs, alternately scrambling and halt-ing, she and Stewart took their cues from the metronome. Hitchcock – who brought an entire orchestra on to the set to provide off-screen accompaniment for Herbert Marshall's Wagnerian monologue in *Murder!* – hired a timpanist while filming *The Birds*. His job was to startle the actors with drum rolls, which announced the invisible squadrons of birds battering the house. In these cases, the director was a conductor, employing music to create emotion.

Hollywood musicals relied on song and dance to banish depres-sion. Against this ideology of optimism – displayed when Busby Ber-keley's chorines in *Gold-diggers of 1933* tap-dance on gold coins – Hitchcock valued music for its intimations of mortality. Stephen

Sondheim's professed aim in the prelude to *Sweeney Todd* was 'to scare the audience to death', and he learned how to do so by studying Herrmann's scores for Hitchcock. A solemn, lachrymose organ at the start of *Sweeney Todd* is interrupted by a shriek from a factory whistle. 'That came,' Sondheim has explained, 'from a murder game I played once with some friends at school. We were in the chapel, in pitch dark, and I was at the organ. Suddenly I opened up all the stops. The sound made the building shake, and did those guys scream!' Sondheim pays homage to Herrmann and Hitchcock with a recurring harmonic shock: 'a tritone sitting on top of a minor chord – very scary, because it can't be resolved. Whenever I hear that, I want to look behind me.' The infirm, unsettling sound derives from Herrmann's score for *Hangover Square*. In that film, based on Patrick Hamilton's novel, Laird Creager plays the composer who murders a music-hall singer and sets fire to the auditorium in which he performs his deranged Lisztian piano concerto.

Like a ghost, music seems to materialize in the air, though it remains invisible. Rebecca haunts her bedroom, conjured up by Franz Waxman's score: a wheezing, shuddering organ note, apt for a funeral parlour, augmented by stealthy strings. Mrs Paradine absently pervades the bedroom of her country house, thanks again to Waxman, who wrote a frenetic rhapsody for the scene in which Gregory Peck explores the house. A piano pounds out the feelings Peck cannot express; an electric violin suggests the wired intensity of his obsession. What secret, sensual knowledge, untranslatable into words, do these melodies encapsulate?

Hitchcock, acknowledging the subtle mental operation of music, made it crucial to several of his plots. He may have been influenced by Buchan's *Three Hostages*, in which a Salvation Army hymn tune, 'infinitely recondite' despite the doggerel words set to it, contains the solution to a puzzle. Buchan's Greenslade discounts one possible explanation, commenting 'Different key. Wrong tone,' and describes himself as 'an Aeolian harp to be played on by any wandering wind', open to other suggestions. The musical encoding of clues migrated from this novel into Hitchcock's version of *The 39 Steps*. Hitchcock replaced Buchan's plot with one of his own, whose denouement

depends on the melodic tag that introduces Mr Memory in the London music hall. Buchan's *Thirty-Nine Steps* contains no music hall, and no Mr Memory: Hitchcock was filming *The Three Hostages* by other means. Robert Donat whistles the catchy tune while he wanders through the Scottish highlands, annoyed by the retentiveness of his memory. Those few persistent bars alert him to the wizardry of the subconscious mind. Mr Memory can smuggle scientific formulae abroad inside his head, so the spies never need to write anything down. Dame May Whitty in *The Lady Vanishes* carefully notates a Balkan folk song and coaches Michael Redgrave to memorize it and carry it back to London: the tune encodes 'the vital clause of a pact between two European countries'.

Music floats undetected across borders, and can also – like the motif crossing from *The Three Hostages* to *The 39 Steps* – pass between one mind and another. With its connivance, people find that their fantasies have entered into an illicit dialogue with those of strangers. Teresa Wright in *Shadow of a Doubt* can't stop humming the *Merry Widow* waltz, even though she doesn't know what it is. 'I think,' she says, 'tunes jump from head to head.' In this case, the music is borne on the air like a contagion, because it disseminates Cotten's guilt; and it does so seductively, with the infectious lilt that makes Viennese waltzes so enticing: evil whispers sweet, irresistible nothings into our ears. At the chapel in both versions of *The Man Who Knew Too Much*, a hymn covers up a conspiracy. The intruders at the service sing the same tune as the rest of the congregation, but supply their own revised text, rewriting dialogue as recitative. 'There's trouble coming soon,' chants Leslie Banks in 1934, and Stewart in the remake croaks, 'Look who's coming down the aisle.'

Three of Hitchcock's films deal with musicians and their professional travails, and make the art they practise a matter of life and death. *Stage Fright* arranges an encounter between a trio of very different musical performers. Dietrich languidly prowls through her stage show, admitting her ennui in the refrain of her Cole Porter song, 'I'm the laziest girl in town.' Her moves are premeditated; she is drilled to manufacture emotions she does not feel. When Jane Wyman warns her of the killer's proximity, she replies in her cynical

drawl, 'The only murderer here is the orchestra leader' – though she too murders the songs she sings, lagging just behind the beat or under the note, chopping up lines into separate, guttural syllables.

By contrast with her weary, mannered pretence, two rather more spontaneous improvisers confide their thoughts to very different instruments. Alastair Sim, playing Wyman's father, cleaves to his accordion. He takes it to bed with him, cuddling it as a substitute for the wife (starchy Sibyl Thorndike) who denies herself to him. It responds to his embrace by contentedly wheezing. Sim pretends to a detachment like Dietrich's, and even manages to resist her siren songs when he attends her show. 'She'd have made me laugh,' he says, 'if I hadn't been strictly on my guard.' But his accordion belies this emotional immunity, voicing an exhilaration or anxiety that he tries to disown. When Wyman tells him that she loves Richard Todd, he squeezes out a few frisky bars of Mendelssohn; as she denounces Dietrich for bewitching Todd, he contributes a little melodramatic motto, the accompaniment for a villain who ponderously tiptoes into view. Michael Wilding, though cast as a detective, has an incongruous talent for piano-playing, and is made to perform when he comes to Thorndike's house for tea. Like Sim, he prefers unrehearsed utterance, and dashes off a pastiche of Chopin, which wins Wyman's affections away from Todd. After he leaves, she dotingly eyes the silenced piano and the vacated stool. Thorndike, listening, makes the connection betwen Wilding's job and his hobby: 'Oh, it's just like Sherlock Holmes and his fiddle. A stream of beautiful sound, and suddenly out pops the solution!' There is another, more technical reason for the affinity. A musician deciphers scores that have already enciphered emotions; he works back to front, reconstructively, as a detective does in investigating a murder.

The music that Sim and Wilding make up as they go along represents their gift for emotional empathy. Like Greenslade in *The Three Hostages*, they are a pair of Aeolian harps, agitated by stray breezes. In *The Wrong Man*, music loses this levity. Fonda, employed as a bass fiddler at the Stork Club, repeatedly identifies himself as 'Emmanuel Balestrero, 38, musician'. But music confirms his doom rather than gaining him a reprieve from it: the art, with its strict obedience to

time, here stands for inevitability, the predestinate rigour of a fate that has been scripted or scored in advance. It is as if Fonda were dubbing or looping his own existence, overruled by the shadowy lookalike predecessor who has committed the hold-ups. He learns at work that his duty is to go patiently through the motions. In the film's credits, the band wearily churns out a rhumba for as long as there are customers on the dance floor.

This man is punctilious, punctual. One of his sons practises Mozart on the piano while the other tries to distract him with a wheezing harmonica. 'You mustn't let anything throw you off the beat,' Fonda advises. When the boys fret about their overdue music lesson, their mother calms them: 'You know Daddy – he said 5.30, and he's always on time.' This is a virtue for a musician, and also for a law-abiding suburban family man. Yet Vera Miles's phrase can equally well denote a vice. Later she complains that Fonda 'always wanted to buy things on time'. She means that he encouraged her to live on credit, borrowing money for a vacation: the interest payments, spread over time, recklessly mortgaged their future. Trudging along in obedience to the beat, Fonda dreams of skipping ahead of it. Hence his notional gambling: he fills in the racing forms every night, but never places a bet. He blames this harmless addiction on his musical calling: 'It's the arithmetic I like . . . You know musicians are always fascinated by mathematics. They can't read, but they can fig-ure.' It is the sedate predictability of his movements that leads him into a trap. The police telephone to check on his arrival time, and are waiting outside the house. 'Just a routine matter,' they shrug as they hustle him away. Routines are rituals that have lost their sacred motive. The cops share Fonda's regularity, but their rhythm is more plodding and dogged. They parade him through the stores they believe he robbed, so that the shopkeepers can identify him. At the deli, a detective commands: 'Just walk in. Same routine.' When Fonda frets, he is told: 'Everything has to be done according with cer-tain procedures.'

As the squad car taking him into custody starts up, so does Herr-mann's music, with the plucking of a bass fiddle like a startled pulse and snarls of dyspeptic alarm from the brass. There is a depressing

continuity between Fonda's life before and after his arrest: music, like imprisonment, is a matter of keeping or doing time, an enforced apprenticeship to duration. Music has the same doomed, inescapable fixity in the second *Man Who Knew Too Much*. Like the ticking of a detonator, the performance of Arthur Benjamin's *Storm Cloud* cantata is the countdown to an assassination, with a gunshot timed to coincide with a clash of cymbals. The remake schools us in routine, requiring us – like the spies in *The 39 Steps* or *The Lady Vanishes* – to memorize the crucial section of Benjamin's score. We watch Herrmann's rescored variant of Benjamin during the credits, performed at the Albert Hall without a chorus; we listen three times to a gramophone record of the brassy climax as the conspirators make their plans; then we are present at the concert itself, with Herrmann conducting while the camera follows the printed score in close-up.

Music is given a new urgency and culpability in the second *Man Who Knew Too Much*. In the 1934 film, it is incidental to the plot. Edna Best plays a sportswoman. On holiday in St Moritz, she fires at clay pigeons; back in London, her marksmanship saves her daughter when she shoots the rooftop sniper. Bereft of Best's rifle, Doris Day in the remake plays a very different creature: a docile American housewife of the 1950s, who gives up her musical career to marry a Midwestern doctor, and obediently swallows the sedatives he prescribes for her. Luckily she still possesses her voice, even in retirement, for it is her only weapon. Best squirms through the Albert Hall concert with her daughter's brooch gripped in her palm. She fidgets in doubt and indecision, wracked by two different duties – to prevent an assassination, or to protect her child. Her outcry, when it comes, is more a squeak than a scream, giving vent to the intolerable contradiction within her. It does not solve the problem; she has to go on to another round, reverting to guns, during the siege in Wapping. But Day's scream, exactly pitched and projected, makes the assassin miss his target, so there is no need for a subsequent exchange of bullets.

When Bernard Miles rehearses the assassin by playing a gramophone record of the cantata, he remarks condescendingly 'Music's less in your line than marksmanship.' He is wrong: the technical requirements overlap. Both the player and the shooter must possess

nervous readiness and accuracy in attack. Miles adds 'You've only got time for one shot, and if you need another, the risk is yours.' Musical performance is also a succession of unrepeatable moments, because a note once sung or sounded cannot be recalled. (It can, however, be preserved artificially. Like Ambrose Chapell's taxidermy, the record they use to plan the killing defies nature and mortality.) The instant of opportunity to which Miles refers is – thanks to Hitchcock's excruciatingly calculated, painfully protracted montage – the convergence of two separate sounds. The cymbals clash, representing the thunderclap described in Benjamin's score. Simultaneously the gun fires. However, a third sound, Day's screeched warning, fractionally anticipates the climax and, to use Fonda's phrase from *The Wrong Man*, throws everyone off the beat. The ambassador treats the assassin's death as if it were a musical error, an ill-timed collision of cymbals. 'The marksman panicked,' he angrily reports to Miles, 'and made a fatal crash.' It is a strangely suggestive way of saying that he fell from his box.

A voice, raised in a scream, has the same ballistic power as a bullet; and there is a covert affinity between the gun and the cymbals that are meant to mask its shot. The credit titles introduce these bronze discs. After banging them together, the player – as imperturbably formal as Hitchcock in his dress and demeanour – holds them in front of him. They resemble polished wheels, recalling the close-ups of trains speeding along the track in *The Lady Vanishes* or *Number Seventeen*. The likeness is not accidental: their clash mobilizes the air, creates shock waves of aural panic. An association of ideas and images leads directly to the bus bound from Casablanca to Marrakesh in the next scene, photographed from just above the whirring wheels. Held up frontally, the cymbals fill the screen and obliterate the face of the man who plays them. Still, in this position they are harmless. In profile they may look innocuous, but that's when they are most dangerous, because they are about to strike each other. An epigraph to the credits draws attention to their power: 'A single crash of Cymbals and how it rocked the lives of an American family'. The capital letter is curious. Does it hint at a pun? It would not be the only one in the film. Ambrose Chapell is easily mistaken for Ambrose Chapel; in an

early draft of the script for the first *Man Who Knew Too Much* a sniffy landlady says that the worshippers at the Wapping tabernacle are indulging in 'queer sex', though all she means is that they belong to one of those 'queer sects'. Given the untrustworthiness of words and the slipperiness of spellings, the cymbals may well be symbols – of music, and its lethal momentum.

The text of the cantata, written by D. B. Wyndham-Lewis, comments on Hitchcock's expertise at nervous torment and his religious cultivation of fear. The storm's approach is charted psychologically. A 'whispered terror on the breeze' gives advance warning, the forest quakes,

> And on the trembling trees came nameless fear,
> And panic overtook each flying creature of the wild.

While shooting his films, Hitchcock liked to imagine people screaming as they watched them. Benjamin's chorus describes an avian pandemonium as, 'screaming,/The night-birds wheeled and shot away' from the trees. This anguish exemplifies Hitchcock's theory of suspense: the interval spent waiting for the storm is worse than the storm itself. Finally, after some rumbles and elemental ructions, come the lines that conclude that time of uneasy anticipation, signalled by the symbolic thunderclap from the brass:

> Finding release from that which drove them onward like their prey,
> Finding release the storm clouds broke and drowned the dying
> moon.
> Finding release the storm clouds broke –
> Finding release!

The release, however, is agonizingly delayed. For the remake, Benjamin added more than a minute's extra music to the cantata, and before the exclamation that cues the cymbals and the gunshot Herrmann braked the tempo by bringing in the Albert Hall's solemnly stately organ. The male and female choirs separately declaim the crucial words 'Finding release' at least fourteen times before they join in the final outburst. This longed-for release is music's promise to us: the art works by exacerbating tensions and chromatic contradictions

that, as if quelling and gratifying the friction of sexual desire, it finally allays. But the repetitions of the chorus are unavailing. They remain stalled, like the characters in Beckett's *Waiting for Godot* who say to each other over and over again, 'Let's go,' and then do not move.

Release never comes, because Day's intervention mars the climax. Her scream relieves her, but only for a moment. She saves the anonymous dignitary in the box; her son is still at risk. A second vocal feat is required of her, when she projects her voice upwards to the embassy attic and summons her son, like Orpheus whose lyricism called the dead Eurydice back from the underworld. As Day's voice echoes and fades through the remote tiers of the building, Hitchcock splices together a succession of staircases, at first gilded and plushly carpeted, then starker, barely functional. Is this the climb that leads to heaven? No wonder more prayers are not answered, since her pleading voice, so far below, cannot cross this haughty distance. The boy's rescue, like Robert Donat's use of a hymn book as armour in *The 39 Steps*, is no miracle. Day exerts herself by tunelessly yelling, to the consternation of her listeners. She wills the response, and it comes when her son whistles the tune. The scene at Ambrose Chapel reaches the same conclusion. As Stewart climbs the rope, the bell in the steeple irregularly tolls. This is not a summons to devotion; like Doris Day's scream, it sounds an alarm. And the thunder that cracks the clouds at the end of the cantata is just as unsettling. The poet George Herbert called prayer 'reversèd thunder', so perhaps thunder is prayer in reverse, prayer that ricochets back from angry heaven to strike the earth with a fiery malediction.

As we listen over and over again to the stationary chorus uttering its final phrase, we have plenty of time to think about what 'finding release' might entail. It is a notion that echoes throughout Hitchcock's work and sums up his profoundest motives. Release is what we are supposed to find at the end of a tragedy. This loftiest form of drama enacts a killing: the Greek word 'tragedy' refers to the song of a slaughtered goat. According to Aristotle, the ceremonial performance – in part sacred, in part brutally profane, like the cantata at the Albert Hall – was supposed to supply the actors and the audience with a

psychic release, which he called catharsis. Although Aristotle thought of this as a moral and spiritual benefit, the term he applied to it was medical, since catharsis means purgation. The word startlingly crops up in Bloch's *Psycho*, when Norman broods about his mother's presumed sense of guilt and thinks, 'Perhaps catharsis would help her.' The American bathroom ought to make catharsis a simple matter of personal hygiene. Norman, still preoccupied by tragedy, likens himself to Lady Macbeth when he washes his hands, and Bloch's Mary hopes that her shower will get 'the dirt cleaned out of her insides'. But how can you irrigate the body internally? Her image anticipates a blood-letting. It also explains the interest in taxidermy that Norman shares with Ambrose Chapell: there are ways of removing and replacing the corruption within.

The screenwriter Joseph Stefano agreed with Bloch in thinking of the story as a tragedy – though his chosen prototype was *Oedipus Rex*, not *Macbeth*. Norman's experience dramatized the Oedipal travails of Stefano himself, who began each day with a visit to his psychoanalyst and then drove to Hitchcock's office to work on the script. In 1999 he remembered 'I said to Hitch once that I could have killed my mother. I was capable of it at one time. For some reason, I didn't. So for me, it was a deep psychological drama, kind of a tragedy.' This, he explained, 'came from personal experience. There are things a boy child cannot beat – a mother who is sexual, who flirts with him, but then puts up a stop sign. I imagined that this is what happened with Norman too, when he was growing up.' Psychoanalysis affords belated relief to the adult; Stefano implies that the most reliable catharsis might be matricide.

Hitchcock, a connoisseur of other people's traumas, quizzed him about those sessions on the analyst's couch, though he had no faith in the curative outcome. Despite Stefano's view of *Psycho* as a tragedy, Hitchcock emphasized its humour. A tragedy ends in purgation, restoring reason and social order; a comedy has no such responsibility. The dissonance need never succumb to the tonal norm. We may seek release, but we are not permitted to find it.

The Sacredness of Cows

Hitchcock sharing Marlene Dietrich's frilly bower on the set of
Stage Fright.

When actors quizzed him about the motivations of their characters or critics lectured him on his own motives, Hitchcock took refuge in a dismissive formula. 'It's only a movie,' he liked to say. But just what *is* a movie? Films, among other things, are spiritual experiences for people who no longer believe in God. Angelic presences shimmer on celluloid: Hollywood, during Hitchcock's decades there, was the headquarters of a man-made religion. MGM liked to boast that its roll-call of performers comprised 'more stars than there are in heaven'.

In *Rope*, the cocktail-party conversation diverges into a discussion of the star system – its astrological credulity, its invitation to sexual reverie, and its desecration of idols who forfeit grace. Joan Chandler and Constance Collier slight an anonymous 'new girl' they have seen in a recent film, although the young woman pronounces her costumes 'absolute heaven' and the dowager calls them 'simply divine'. Then they name names. Chandler is a fan of the 'attractively sinister' James Mason, and Collier, who prepares horoscopes, promotes him to the zodiac by identifying his bullishly stubborn manner with Taurus. Chandler goes on to praise Cary Grant. Remembering his screwball acrobatics, Collier adds 'Capricorn the goat – he leaps! divine!' Hitchcock next allows them to puff one of his own recent efforts. They burble about a film in which Grant appears with Ingrid Bergman, but air-headedly forget its one-word title.

Collier promptly assigns Bergman to the firmament: 'She's the Virgo type.' It is one of Hitchcock's cattiest jokes. He well knew – because Bergman had confided in him about her adulterous liaison with Capa – how unvirginal she was. After the scandal of her affair with Roberto Rossellini, he regularly updated the jest. In 1966 he treated an interviewer to a global tour of female types, and mentioned Bergman as an example of 'the apple-cheeked blonde peasant girl', apparently bovine and homely, though 'extra-curricular events showed differently'. His prudery missed the point. Hollywood's

sacred monsters were not bound by Christian marital vows, and behaved as amorally as their classical forebears on Olympus. Herrmann's score for *Vertigo* enrols another Hitchcock heroine in the pagan pantheon by wordlessly identifying Novak as the goddess of love. When Stewart first sees her in Ernie's restaurant, and again as he spies on her in the flower shop, bright strings quote the theme that introduces Venus in Gustav Holst's suite *The Planets*: a shimmering lullaby, which surrounds the actress's figure in a lambent sonic haze.

Hitchcock understood our ardent attachment to the silver, sky-high faces on the screen, because he shared it. In *Spellbound*, the old psychiatrist laughs at Bergman when she tries to protect Peck from the police, calling her 'a schoolgirl in love with an actor'. *Rebecca*, *Vertigo* and *Marnie* describe a doomed infatuation with an illusory object of desire. The ailment, which might be called nympholepsy, is endemic to cinema. Like all forms of religious credulity, it leads to despair and disillusionment. How can we believe in a deity concocted by our own fantasy?

Casting his films, Hitchcock participated in the industrial manufacture of gods and (more often) goddesses. Like Prometheus or Frankenstein, he could mould and animate inert flesh. His male characters often assume the same directorial power over their female protégées. Gladys Cooper in *Rebecca* tells Fontaine that Olivier is very particular about women's clothes. Fontaine therefore orders a low-cut black dress that she has seen in the magazine *Beauty*. She sways uncertainly into the room, trying to look sophisticated. 'What on earth have you done to yourself?' her husband grunts. He also dislikes the way she has pinned back her hair, though he says – with the intention of appeasing her – that it doesn't matter how she looks. In *Suspicion*, Grant is less complacent. On the wind-torn hill, Fontaine's hat and coat fly off as he grapples with her. 'Did you think I was trying to kill you?' he asks. He claims that he was reaching round to fix her hair: 'It has such wonderful possibilities. For the moment, I became a passionate hairdresser.' He rearranges her maidenly plait into a topknot, then loosens it in fetching disarray.

'In the documentary,' Hitchcock told Truffaut, 'God has created the basic materials for you. But in the fiction area, you must create life.'

The gift of life, however, can be revoked. At the auction in *North by Northwest*, Eva Marie Saint is first seen from behind. Her hair, metallically blonde, is an impervious helmet, but the nape of her neck is exposed, and Mason's hand strokes and fondles her flesh. Grant taunts them by asking how much Mason paid for this precious figurine. When she rears up in a fury, he sneers, 'Who are you kidding? You have no feelings to hurt.' She is a thing of beauty – chilly, pallid, preserved from the anticlimax of being alive. Grant disgusts Mason because he is too obstreperously, noisily lively. 'The only performance that will satisfy you,' Grant replies, 'is when I play dead.' 'Your very next role,' purrs Mason. 'You'll be quite convincing.' And so he is, when he play-acts death after being shot with blanks in the cafeteria at Mount Rushmore.

In *Vertigo*, Stewart organizes a make-over for Novak, watching as the blowsy shop-girl is transformed into a facsimile of his dead idol. He fusses over her clothes and shoes, then sends her off to be beautified at Max Factor. Hitchcock films the metamorphosis by sectioning Novak, showing her separate parts – eyes, mouth, hair, nails – as they undergo treatment. Before this baptism at the salon, Novak has russet hair and wears a green dress: her colours are those of the fertile earth. She re-emerges as a monochrome ghost, with white hair and black eyebrows, dressed in a grey suit. Her fatal error is to remain alive, to be physically needy. As she produces the necklace that betrays her secret, she says, 'Suddenly I'm hungry,' and relishes the prospect of a steak. Divinities, like spirits, should not have such healthy appetites. Quitting her immaculate pedestal, she flirtatiously tells Stewart to 'muss me a little' before they go off to dinner. Now that he knows she is not a goddess, he intends to do more than ruffle her hair.

Stewart's remaking of Novak, despite its deathly consequences, served as a precedent for Hitchcock's finicky and possessive grooming of his next heroine, Tippi Hedren. He spotted her in a television commercial for a diet drink, and supplied her with a revised identity and a wardrobe to match. As a professional model, she announced her availability for transformation: she was ready to lend her image to whatever product was being sold. Hitchcock hired Martin Balsam

to converse with her in a screen test. Balsam sat on a couch, while Hedren posed and preened in front of the camera in a succession of gowns and mantles, like the mannequins parading in grey suits for Stewart and Novak in *Vertigo*. Hitchcock ordered her to stalk across the room to the sofa, and forewarned Balsam of her approach: 'Marty, I'm sending over to you a high priestess – but of what, you'll have to discover.'

That was the quizzical issue for Hitchcock himself. He was a priest, but precisely what religion did he practise? His slavish devotion to white goddesses like Hedren resembled the malady named after Leopold von Sacher-Masoch. The whip-wielding heroine Wanda in Sacher-Masoch's novel *Venus in Furs* tells her grovelling acolyte Severin: 'You look at love, and especially women, as something hostile . . . Their power over you gives you a sensation of pleasurable torture, even of pungent cruelty. This is a genuinely modern point of view.' Severin's point of view was modern in 1870 when Sacher-Masoch published his novel, and it remains modern more than a century later, because it separates sex from the old-fashioned drudgery of procreation, treating it both as a substitute for religious faith and an introduction to the unequal distribution of power in society.

The terms of the arrangement between Hitchcock and Hedren, and the tensions it generated, are placed on view in some comic banter at the start of *The Birds*. The name of Hedren's spoiled socialite is Melanie Daniels. Mitch – the character played by Taylor, who might be a surrogate for Hitch – catches the bird she has released in the pet shop and comments, as he locks it up, 'Back in your gilded cage, Melanie Daniels.' The door snaps shut on his assertion of ownership. But already there is a stand-off between opposed impulses. Hedren is more than the director's obsequious pet. The character she plays shares his fondness for practical jokes. Hitchcock once hired a respectable old lady to come to a dinner party, then pointedly ignored her and told the other guests he had no idea who she was; he sabotaged the marriage of a man and woman who hosted a breakfast radio programme by bombarding the wife with anonymous gifts and suggestive love notes while they were on air. Taylor berates Hedren for a little prank that smashed a plate-glass window. He might have

been referring to a surreal jest perpetrated by Dali, who in 1939 tore apart a window display at the Bonwit Teller department store in New York, shattering the glass and making a bath-tub skid on to the sidewalk. The judge, Taylor says, should have sent Hedren to jail. She asks if he is a policeman. 'I merely believe in the law,' he replies. 'Is that,' she wonders, thinking of the bird, 'why you want to see everyone behind bars?' Their dialogue summarizes the conflict within Hitchcock between frisky desire and law-abiding propriety. He may have worshipped the goddess he was creating, but he did not necessarily approve of her.

Nor was she allowed to forget her dependence on her maker. Marnie's office jobs are lessons in Hedren's lack of uniqueness. The star is a work of art expressly created for the age of mechanical reproduction, fitting the needs of a medium that depends on duplication – Hitchcock screen-tested Hedren by making her perform scenes from his earlier films – and on easy disposal. At her first place of employment, Marnie operates the copying machine. Calling her in to type his manuscript, Connery says he wants 'the original and one copy'. Hedren herself was not permitted to be an original, only a wan copy. Her personal predicament was that of Fontaine in *Rebecca*: the second Mrs de Winter catastrophically copies her ball gown from a portrait that has already been copied by her predecessor.

The director and his custom-made muse fell out while filming *Marnie*, allegedly – though Hedren has never confirmed this – after he attempted to molest her. The circumstances are obscure, but perhaps they resembled those of a story told by Dali in 1930. The anecdote concerned a young man on a train who removed the magazine he was reading to show a woman opposite him 'his penis, erect, complete and magnificent'. The woman, according to Dali, was plunged into 'delicious confusion', but did not protest; the other passengers had the man thrown off the train. Dali condemned their puritanism, which he called 'abominable behaviour against one of the purest and most disinterested acts a man is capable of performing in our age of corruption and moral degradation'. Hitchcock may have believed, during that murky epiphany in Hedren's trailer, that he was making just such a pure, disinterested offer.

Episodes like the one described by Dali often figured in Hitchcock's sexual ruminations, with the woman wishfully cast as the aggressor. The partner he imagined was always a demure English lady who, once she was comfortably settled beside him in the back seat of a taxi, forgot her manners and began to grope him. He was mentally arranging for one goddess to metamorphose into another: chaste Diana changes into her sister Venus. He regaled Truffaut, off the record, with a related scenario, supposedly a new kind of love scene. Though the couple would remain seated on opposite sides of the room, Hitchcock imagined the man opening his trousers, while the woman raised her skirt and lifted her knees as if in readiness for a gynaecological examination. Exhibiting themselves to each other, they would then sedately converse about the weather.

Whatever the scene, Hedren refused to play it. Hitchcock retaliated by snubbing her on the set, and denigrated her performance after the film's release. The masochistic slave of beauty could instantly assume the role of the sadist. Hitchcock gloated over the humiliation to which he submitted Madeleine Carroll in *Secret Agent* by showing her greasily smeared with cold cream. Film is the enraptured worship of faces; but it can also deform those expensive, unblemished countenances. At Mount Rushmore, as Hitchcock complained, 'the authorities wouldn't let me work on the faces at all. I had to work *between* them.' This meant that Cary Grant could not squeeze inside Abe Lincoln's nostril. But Hitchcock had already made disrespectful play with the face of Lincoln. Henry Fonda, cast in *The Wrong Man*, brought with him the stiff rectitude of his performance in John Ford's *Young Mr Lincoln*. Hitchcock took that iconic face and made it express a misery and rage that were alien to Lincoln, one of America's secular saints and martyrs.

He did much the same with Grant, whose irresistibly seductive image Hitchcock twisted awry. Howard Hawks's comedies used Grant as a flustered, elastic-limbed light comedian. Hitchcock, however, saw him as a Shakespearean revenger or, even better, as a murderer. Though these schemes were vetoed, in *Suspicion* he did make Grant an irresponsible, improvident bounder. The self-possessed Grant is literally turned upside down at the beginning of *Notorious*.

After Bergman's party, he puts her to bed. Next morning she glances up and finds him standing at the door. Prone and still hungover, she sees him lounging diagonally, the door frame tilted at a sick angle. When he walks across the room and around the bed to inspect her, his body – viewed from the same low angle – revolves through a semi-circle and comes to rest as if dangling with his feet clamped to the ceiling. He is suspended, left in suspense, as he stares down at her. The actor's identity has also been rotated: for most of the film, Grant the dapper flirt plays a merciless cynic. After his own persona has been inverted, he begins a campaign to break down the persona of Bergman. Her character in this scene mimics that of a hard-boiled, dipsomaniac moll from a 'film noir'. Grant, appealing to her residual patriotism, sets out to make her vulnerable. She claims that the government wants to set her up 'in a shooting gallery'. That, at least, was the director's desire: to aim the camera at her imperturbable face until it gave way.

The cinema can certainly change the way things look. On the drunken drive in Florida, black, bedraggled clouds flutter across the windscreen of the car. They are wisps of Bergman's hair, seen from her point of view, which cloud her vision of the road ahead. Later, succumbing to poison, she retreats into a subjective miasma. The silhouettes of Claude Rains and his mother blur and switch from black to glaring white, while the walls of their circular foyer swim and buckle. Showing off these facile distortions, *Notorious* asks whether intrinsic, interior changes are possible. At the café in Rio de Janeiro, Bergman – who has been sober for eight days, and has sworn off men – refuses a drink. 'You don't think a woman can change?' she asks Grant. He concedes that 'a change is fun – for a while'. He sarcastically paraphrases the grumpy remark made by Olivier in *Rebecca* as Fontaine grapples with her inappropriately slinky evening dress: 'That's very nice – for a change.' Grant's scepticism goads Bergman to resume drinking. During their long embrace on the balcony, she begs him to tell her that he believes 'I'm nice and I love you and I'll never change back'. Grant does belatedly come to believe in her reformation. Hitchcock, however, changed Bergman back, and put her through the agonizing transformation from alcoholic slattern to

redeemed spouse all over again in *Under Capricorn*. The plaintive protest she voices in *Notorious* – an unavailing appeal to the director – sounds once more before Novak consents to be remodelled in *Vertigo*. 'If I let you change me, will that do it?' she asks Stewart. 'Will you love me?'

Hitchcock apparently allowed Grant to get his own back in *North by Northwest*. By 1959 the star was a product not a person. Hustled away from the auction in Chicago, he tells the cops not to manhandle him: 'I'm valuable property.' Yet his remark rebounds: Grant, fifty-five at the time – though still required to run, jump, strip to the waist and make love, his blue hair never showing the strain – asks to be treated like one of the antiques whose value he so impishly questions when he disrupts the sale. At the Chicago airport, he meets another Hitchcock veteran, Leo G. Carroll, who also complains of feeling superannuated. Puffed out as he runs for a plane, Carroll, then sixty-seven, says 'I'm getting too old for this kind of work.' It pleased Hitchcock to remind his actors of approaching obsolescence. Their creator reserved the right to destroy them or declare them redundant.

Hollywood, when Hitchcock arrived there in 1939, was a laboratory for confecting gods and goddesses. Like Jupiter on the lookout for mortal mistresses, the studios and their talent scouts picked ordinary young men and women – cocktail waitresses, soda jerks, tennis pros, deckhands on yachts – and raised them to the skies, where they remained for as long as they kept their looks. Selznick perfected the procedure when searching for an actress to play Scarlett in *Gone with the Wind*, and repeated it, in collaboration with Hitchcock, when selecting a second wife for Maxim in *Rebecca*. The procedure became crucial to Hitchcock, who even interviewed dozens of candidates before casting Barbara Leigh-Hunt in *Frenzy*. He believed himself to be the inventor of the women he chose, which is why he described Grace Kelly as 'mousy' in *High Noon*, made before he transfigured her. Kelly, gently refusing his offer of *Marnie* in 1962, glanced at his mixed motives with a knowing smile. In her letter she conceded that there were 'many other "cattle"' who could play the role as well, but she hoped she would remain 'one of your "sacred cows"'.

A goddess who proved refractory was immediately tugged back to earth, like Marlene Dietrich in *Stage Fright*. Here, as with Grant or Fonda, Hitchcock was dealing with a star designed according to someone else's specifications. Dietrich began as the exclusive creation of Josef von Sternberg, who controlled the public's interpretation of her. He delayed the release of their first film, *The Blue Angel*, until after audiences had seen the second, *Morocco*: he did not want Dietrich's initial image to be that of the Berlin tart Lola. Sternberg lushly spiritualized her. One of their films identifies her as a *Blonde Venus*; Ernst Lubitsch, equally devout, cast her in *Angel*. In Richard Boleslawski's *The Garden of Allah* she played a needy soul seeking enlightenment in the desert. Then, like Hitchcock changing his mind about Hedren, Sternberg demonized this sacred monster: their collaboration ended with *The Devil Is a Woman*. When his successors inherited this fabricated creature, all they could do was question Dietrich's cast-iron mystique. She played a version of Lola for Fritz Lang in *Rancho Notorious*, where she is finally gunned down in a Western shoot-out. Billy Wilder also resuscitated Lola in *A Foreign Affair*, casting Dietrich as an unregenerate Nazi cabaret singer in ruined Berlin. At least Orson Welles in *Touch of Evil* devised an affectionate self-parody for her. Lola here, still accompanied by a tinkling pianola, plies her trade in a Mexican bordello.

In *Witness for the Prosecution*, Wilder gave Dietrich a double role. As Tyrone Power's wife, she is tautly glamorous and unyielding; but the intrigue also requires her to disguise herself as a cockney slattern, with false teeth and a cosmetic scar. A similar dualism enabled Hitchcock to dramatize his own contradictory view of woman, an object of both worship and fear. Novak plays a double role in *Vertigo*, and Bergman almost does in *Notorious* and *Under Capricorn*, since she is a different creature before and after her redemption. Dietrich has only one identity in *Stage Fright*, though Jane Wyman is split down the middle. As the heroine Eve, Wyman is loyal, brave, and charmingly guileless. Yet she also happens to be a drama student, and sets out to trap Dietrich by disguising herself as a slovenly, fag-puffing maid called Doris. Perhaps she even has a second alter ego in Patricia Hitchcock, who as well as playing her colleague at drama school was

pressed into service as Wyman's stunt double and drove a getaway car for her at high speed in the film's opening. Wyman was too valuable a property to be jeopardized; Hitchcock evidently considered his daughter expendable. Later in the film, Wyman tells Michael Wilding that she cannot understand what goes on in the mind of a woman. She makes this odd comment while they are sitting in the back of a taxi, which is where Hitchcock located so many of his private sexual reveries. Wyman, being a woman, surely cannot be bewildered by her own sex. It was Hitchcock, increasingly frustrated, who could only wonder about the women he both venerated and dreaded. His plots subjected them to trials and ordeals that were calculated to make them betray their secrets.

Stage Fright displays the process of creation and destruction that moulds and then shatters the divinity. Dietrich here needs no director to design her. She herself is in charge of her brittle persona, though she relies on menial helpers. Being fitted for widow's weeds, she commands the milliner to lower the neckline and 'work in a little colour'. The veil is a hindrance. She has to lift it to smoke, clutching a cigarette in her painted talons. She soon struggles out of the mournful garments, and complains that they make her feel miserable, which is, of course, their purpose. 'I shouldn't feel sad,' she says, 'it's *so* depressing.' Emotions are a by-product of costume, and she soon recovers.

Preparing to leave the theatre at the end of the film, she drapes a dead, dyed, gutted fox over her shoulder. This woman adorns herself with corpses. Dietrich has all the vixenish ferocity forfeited by Mrs Paradine when Selznick's scriptwriters bowdlerized the novel by Hichens; she is what Rebecca might have been if we were allowed a glimpse of her. Singing Cole Porter's song about the laziest girl in town, she lolls on a divan against a sky of frilly clouds – an arrogant, idle Olympian, afloat above the earth. When she gives evidence to the police, she makes a brazen claim to sanctity: 'It's the sacred truth, I swear it is.' Wyman, however, denounces her as 'an evil spirit'. Once her guilt has been exposed, she demands that the detective find her a chair, enthrones herself, lights a cigarette, then acidly recounts a story about a pet dog that hated her. It bit her, and she had it shot. Hitchcock films her in close-up from a high angle as she speaks: the

pinched, hard mask of her face, with its plucked and pencilled eye-brows and razory teeth, is wreathed in smoke. The vamp, after all, is a vampire.

The film is about the defamation of Dietrich. Our first view of her, when Richard Todd opens the door of his house, establishes Hitch-cock's priorities. The camera pans up her body, starting with her legs. Then she tears open her coat to reveal a puddle of blood on the front of her dress – that of the husband Todd says she has killed, or her own? The attack is blunted a little by Hitchcock's admission that the damned spot might have been placed there by the male imagination, expert at transferring guilt. During the theatrical garden party, Alast-air Sim dottily hallucinates and dreams up a blotch that is suddenly superimposed on to a white dress. This gives him an idea for tricking Dietrich. There is no doubt, this time, about where the blood comes from. He cuts his own finger, and muddies the skirt of a doll; he then hands it to a pre-pubescent boy scout, who presents it to Dietrich while she sings 'La vie en rose'.

The episode is one of Hitchcock's eeriest pieces of sorcery. The 'evil spirit' can only be confounded by black magic. Dolls, being symbolic substitutes, are often used in witch doctoring. The shrill and toothy Joyce Grenfell runs a stall at the garden party, where, cracking open a rifle with dangerous incompetence, she offers customers the chance to 'Shoot some lovely ducks!' The prize for a direct hit is a doll. Sim wins one, which he then pollutes or wishfully slaughters by smearing its frock with blood. Grenfell is in the business of totemism, though her charitable alibi is raising funds for orphans; at the end of the scene she transfers her pitch for the 'lovely ducks' to her 'lovely dolls'. She demonstrates the manoeuvrability of their rubber limbs, and makes one of them salute while sitting. She might be advertising the uses of Dietrich, with her clockwork manner and her increasing need for handlers or manipulators on stage, like the chorus of men in top hats who serve as walkers in her first musical number. The star is an erotic plaything. In your fantasy, she willingly responds to your every command. You are also free to damage or dirty her whenever your mood alters. Sternberg presented Dietrich as a blonde Venus, just as Sacher-Masoch's heroine is a Venus in furs who must wear

ermine to keep warm in the refrigerated north. The weather in Sacher-Masoch's novel is a form of religious persecution, warning that the pagan love goddess is unwelcome in what Severin calls 'this icy Christian world'. In *Stage Fright*, Dietrich plays a Venus who is even colder than the climate, a sensual-seeming automaton manufactured to please the market.

Hitchcock temporarily recovered his faith in *Marnie*. When Hedren rinses the black dye out of her hair at the beginning of the film and for the first time shows off a face surrounded by a golden nimbus, we watch the birth of Venus – though rather than rising from the sea, she has her nativity in a hotel washbasin. At last, in *Frenzy*, Venus is murdered. The character played by Leigh-Hunt runs a dating agency. When she castigates Jon Finch, her divorced husband, for his bad temper, he rages 'Me, violent! Would I raise a hand to the goddess of love?' In fact Leigh-Hunt is rather a prim Venus – unvoluptuously Nordic not Mediterranean, and a frugal eater (as Barry Foster comments when he interrupts her lunch). She has a more prurient counterpart in the puffy-faced receptionist at the Bayswater hotel where Finch takes Anna Massey for an afternoon of sex. The woman who checks them in is called Glad; Hitchcock gave the role to Elsie Randolph, who forty years before had played the gamey spinster on the cruise in *Rich and Strange*. She looks the couple up and down with what used to be called the glad eye, asks if they require a matrimonial-sized bed, and allocates them the Cupid Room, which she says they'll find very cosy. Finch cools her fervent imagination by signing the register 'Mr and Mrs Oscar Wilde'. Nevertheless the porter wonders if he requires anything – meaning a condom – from the pharmacy. Finch may not want to commit the crime of deicide, though it is soon carried out by his friend Foster, who rapes and murders Leigh-Hunt in the office where she brings emotional comfort and sexual satisfaction to a needy clientele. During the attack, this would-be Venus converts to Christianity. She mumbles a prayer, then beseeches help from Jesus as Foster twines his tie around her neck. She is wearing a crucifix, clearly visible – in a wrenching post-mortem shot – between her bruised throat and her bared breasts. But though it hung in the danger zone, the Christian token afforded her no protection.

After the murder of Massey, Foster's next victim, Vivien Merchant and Alec McCowen speculate about the circumstances. He is the detective assigned to the case; she plays his wife, a would-be gourmet cook who serves up corpses for dinner – another of Hitchcock's maenads, like Grenfell waving the gun and babbling about lovely ducks. Merchant wonders what the dead Massey was gripping in her clenched hand: 'A locket? a brooch? a cross?' She snaps a breadstick as she imagines the murderer breaking the corpse's rigid fingers. The ferocity with which she chews the brittle bread marks her as a potential devourer of men. Then she changes her mind: 'Not a cross, I think.' McCowen corrects her: 'I don't see why not. Religious and sexual mania are closely linked.'

The link between sanctity and profanation holds good for Hitchcock, and it also explains the ambiguity of the cinema, at once astral and carnal. Directing the more gruesome sequences in *Frenzy*, Hitchcock alternated between performing supernatural stunts and indulging his cruelty. For a scene that was eventually cut, a woman retrieved from the Thames was laid out on a mortuary slab for inspection. Hitchcock sat down beside the naked model and, as she shammed death, leaned forward to ask: 'How's your mother?' The cadaver jumped back to life, first shocked, then overcome by gratified laughter. Hitchcock, it turned out, had known her mother during his early days in England. The mood was different when he supervised Leigh-Hunt's strangulation. Two assistants deputized for Foster, tugging at the cloth looped around her neck. Hitchcock edged his own chair close to that in which Leigh-Hunt was slumped, and she heard him muttering instructions. 'Tighter,' he whispered, as if talking to himself, 'tighter.' Which scene did he enjoy most? In one he miraculously raised the dead for a session of nostalgic chat, in the other he choreographed a killing without getting his own hands dirty. Such are the director's divine or devilish rights.

A Haunted Head

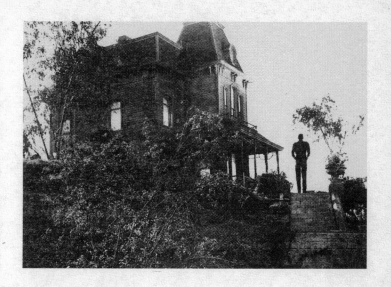

Anthony Perkins on his way home in *Psycho*.

Hitchcock brought fear home to us. His films assault the very idea of the house, and deprive us of its moral support. The dangers begin on a slippery, tilted rooftop and go on multiplying until we reach the cellar, which may be intended for wine or fruit but is actually a crypt. In between, each room has its resident incubus. Bedrooms and kitchens are places of carnage, while bathrooms contain the residue of our guilt. The different levels of the house are negotiated by way of the stairs, where Hitchcock set many of his creepiest scenes. The staircase, scaled so often by his camera, loses its confident uprightness. Our toiling upward quest is frustrated by dizziness, or a door that creaks ajar on the first landing. In *Shadow of a Doubt* Joseph Cotten, tearing from the newspaper a column with an article about a murder he has committed, constructs a typical Hitchcock house. His small act of vandalism creates a door. Nimbly ripping the rest of the page and folding it over, he soon erects a tiny mansion. Made of newsprint, it is walled with stories, and a gaping hole in its side admits intruders.

The Birds exposes the vulnerability of our shelters. Gulls dive-bomb a front door, and sparrows pour down the chimney. Only a skylight in the garage, reinforced with chicken wire, resists the crows. After Taylor boards the windows in preparation for a siege, Jessica Tandy asks what will happen when they run out of wood. 'We'll break up the furniture,' he says. But how can a house that consumes itself protect its inhabitants? As birds drill through these barriers, Hedren retreats to a sofa in a corner. She raises her legs as if hoping that the sofa might absorb her; when it fails to do so, she literally climbs the wall behind her. She embodies the spatial paranoia that provokes us to build houses in the first place, and to hide inside them. Near the diner in the middle of Bodega Bay, Hitchcock strands Hedren in the most meagre of aedicules, a house reduced to its flimsy essentials: a phone box. The cubicle is lashed by an uncontrolled hose when gulls attack the firemen, so her view is smudged, ripply, unreliable. Then the walls are splintered by beaks. A man gnawed by birds

presses against the glass, his face in shreds. She does not open the door: her box provides for single occupancy only, like a toilet stall or a coffin.

Though Hitchcock trots out of the pet shop in *The Birds* with two of his own schnauzers, the dogs in his films cannot be relied on to defend property and uphold the law. Nova Pilbeam's wire-haired terrier in *Young and Innocent* bares its teeth at the bumbling police and keeps them from entering the abandoned mill where Derrick de Marney is hiding. Herbert Marshall's mastiff in *Foreign Correspondent* makes a show of ferocity, but is placated with treats. Joel McCrea's instincts are more aggressively canine than the dog's. When Marshall advises him not to reveal the identity of an accomplice, McCrea is indignant: 'A famous diplomat kidnapped right before my eyes, and I muzzle myself?' He insists on preserving his freedom to bite.

What Hitchcock liked about dogs was their irresponsibility. We may expect them to police society, but they are as happily unsocialized as the id. A dachshund in the 1934 *Man Who Knew Too Much* scampers across a ski run and causes a contestant to skid and crash. Another specimen of the same breed in *Secret Agent* breaks its leash, erupts into the gaming room of the casino, and is expelled. Jasper, the cocker spaniel in *Rebecca*, mopes outside the bedroom of his dead mistress and snubs Joan Fontaine, though he scampers off to greet the sleazy intruder George Sanders. On a tour of the estate, the dog leads Fontaine astray, scurrying towards the beach house where Rebecca conducted her illicit affairs. When she drags him back to the approved path, Olivier takes out his anger on the dilatory, digressive spaniel: 'Hurry up, Jasper, for heaven's sake.' Dogs are convenient whipping boys.

Other dogs, put to more dubious uses, wait in the wings. In Hichens's *Paradine Case*, the lawyer's wife Gay has a dachshund called Sausage. It's a shame that Hitchcock's film excluded him, because his crimes and their punishment permit the Keanes to indulge in some brisk connubial therapy that is denied to Gregory Peck and Ann Todd. The dog mauls a pair of sofa cushions, and Gay slaps him for his naughtiness. Then, repenting, she caresses him, and he shows 'symptoms of ecstasy'. Hichens leaves us to imagine what

an ecstatic sausage looks like. Later the unregenerate dog chews some more soft furnishings, and Gay says to her butler, 'Give me the whip.' She adds that she only intends to 'thrash the floor', compelling the sausage to detumesce. This canine imagery migrates from the Keane household to that of the Horfields, played by Laughton and Ethel Barrymore. Their relationship is that of sadistic judge and masochistic culprit, and can be summarized with reference to the kennel. Hichens comments that Lady Horfield, menaced by her husband, 'looked like a frightened bitch who was expecting a beating'. Doubtless she received it.

Cary Grant, the burglar nicknamed 'Le Chat' in *To Catch a Thief*, naturally keeps a cat, the insolent emblem of his trade. In David Dodge's novel, however, Robie has a dog, a female setter. She pricks up her ears when the police arrive at his villa, but Robie has already been warned by the insects in his garden: 'the crickets were better watchmen'. Another dog turns out to be crucial in Dodge's plot. This one is a decorative pet, made of diamonds with emerald eyes; Mrs Stevens buys it, leaves it uninsured, and loses it to the thief. In retaliation, her daughter Francie makes Robie her dog, and when they go to Monaco he feels 'the leash tight on his neck'. Hitchcock knew better than to ask Grant to play Grace Kelly's poodle, and Dodge's invisible, metaphorical leash disappears from the film – as does the moment when Robie, after burgling a third-storey hotel room, makes his escape 'with a string of rose pearls around his neck'. Nevertheless, Grant's first costume in the film includes a polka-dot cravat, tied in a stranglehold like the choke-chain of a restive pet.

That leash and McCrea's muzzle, along with the handcuffs from *The 39 Steps* and Tallulah Bankhead's bracelet, are stowed in Hitchcock's personal jewel box. Like the Vice Museum with its armoury of sexual restraints, his films archivally file obsessions in the separate compartments of our haunted heads. Mrs Belloc-Lowndes, in the novel on which Hitchcock based *The Lodger*, sent her characters to visit two institutions that resemble the Vice Museum. The policeman takes Daisy and her family to the Black Museum at Scotland Yard. Daisy, like Truffaut, professes ignorance of the place, and says, 'I thought there was only the British Museum.' Hitchcock before long

went to the British Museum as well, sending a blackmailer to flee through its galleries of uncompassionate gods. Meanwhile, the Black Museum is acclaimed by Mrs Belloc-Lowndes's cockneys as 'a regular Chamber of 'Orrors' – a tool shop of soiled knives, a pharmacy of implacable poisons. The novel ends in another Chamber of Horrors, among Madame Tussaud's gallery of waxen murderers. Hitchcock omitted both episodes. There was no need for them: all of us, watching his film, are already inside what Léger called 'la chambre sombre'.

Robert Bloch's *Psycho* treats the Bates house as a combination of the Black Museum and the Chamber of Horrors. Lila is aghast at its green-striped wallpaper, 'like something out of the last century'. The bathroom fittings – an upright tub on legs, exposed pipes, a toilet with a metal pull-chain – belong in a museum, and she calls the rocking chairs and closets of dark oak 'antique horrors'. The previous sets in Hitchcock's film – the hotel room in Phoenix, the realty office, the hardware store and the motel cabin – are shoddily utilitarian. But the interior of the Bates home, finally explored by Vera Miles, is elaborately muffled by its Victorian decor. Every item of furniture is overlaid with quilts, shawls, comforters, tent-like drapes and antimacassars. The paraphernalia of genteel concealment hints, like padded bustles or bosoms, at what cannot be seen. Limp dresses hang in Mrs Bates's wardrobe; a crystal pitcher and glass stand beside a square block of soap on her washbasin, providing for physical transactions that she no longer performs. Miles feels the pillow for some memory of a body's heat. Any house, certain to outlive its owner, is a mausoleum in waiting. Du Maurier's heroine avoids Jamaica Inn 'as one turns instinctively from a house of the dead'. Hitchcock's characters, less determined to survive, react differently. A house of the dead is what they all long to explore. Inside, there may be only underwear that will never be worn again or hairbrushes given no exercise, a gramophone record at rest on the turntable or a book with no title on its leather binding. It does not matter that the rooms are depopulated. Emptiness invests these places with an extra potency. A sinister genie presides over the dressing table, or entangles the sheets on the bed.

The fetishes Hitchcock admired at the Vice Museum were objects

imbued by association with a sexual magnetism. A fetish originally was a conjuror's charm; fetishes serve as a means of sexual sorcery, displacing the body as an object of desire, just as Hitchcock's houses are substitutes for the live beings who have – generally under suspicious circumstances – vacated them. The motive of the fetishist is religious, despite its perversity. Pilgrims who travelled in quest of grace formerly returned with relics: a scrap of saint's bone, and (if they were lucky) a splinter of the true cross. Travellers today bring back souvenirs, sanctified by association. Bloch's novel reports that the Bates Motel was closed down to prevent 'morbid curiosity-lovers' from stealing the towels; this trade in curios continues at the Universal Studios theme parks, where you can buy towels mono-grammed with the fatal name. In an epilogue to *Rebecca*, cut before publication, du Maurier anticipated the same future for Manderley. She imagines the burned house rebuilt as a country club, equipped with the latest and fastest attractions: the opening weekend begins with 'a famous film star . . . diving into the swimming pool in evening dress. The dress no doubt to be auctioned afterwards.' The narrator, in exile abroad with Maxim, expects that 'the guests will sleep soundly in their beds', and hopes that 'our ghosts will never trouble them'.

Hitchcock wished otherwise. Already, in his early silent film *The Farmer's Wife*, a domestic interior is comprehensively fetishized. The farmer's wife dies, and before doing so she orders the housekeeper Minta to air the master's pants. The next scene narrates Minta's ventilation of Sam's long johns, which prepares him for sexual rejuvenescence. He woos a series of potential bedmates, who are discussed as if they were items of domestic linen. His third choice is a plump, ageing nymphet, whom he fancies because he likes 'pillowy women'; Minta warns him that if she is a pillow at thirty, she'll be a feather bed at forty. We clutch pillows as replacements for an absent body, and after the death of her mistress, Minta arranges a single pillow in the middle of the double bed the couple shared. While her employer is courting, Minta stifles her own love for him but longingly studies his vacant chair. She caresses its wooden back, then nervously settles into it, crushing his crumpled jacket to establish her ownership. To sit

there and face the corresponding chair on the other side of the fireplace is tantamount to marriage.

A house is the receptacle for a private life, and therefore a sanctum of mysteries. *The Paradine Case*, for instance, is a tale of two bedrooms. Ann Todd occupies a chaste shrine in the London house she shares with Peck; he sleeps in an adjoining room. Her bed is canopied, its veils and drapes cocooning her, but its surface is flat, and it lacks pillows. The fireplace has been blocked off, replaced by central heating, and a low camera angle emphasizes the moulded ceiling – a lid, a container, a repressive limit. The bedroom in Cumberland that once belonged to Alida Valli is a less inhibited place, a jungle of hirsute surfaces, with a shag rug on the floor and a fur coat draped across a chair. The housekeeper who shows Peck around apologizes for the untidiness, which contrasts with the prim regime maintained by Todd; she says she has been packing up Valli's things, though it looks as if the occupant herself were still there, negligently undressing. A footstool sits by the bed, and a bolster is ready to support her head. Peck studies the filmy nightclothes on the bed, and the brace of fox tails on a gaping trunk. Every object in the room is a sexual solicitation.

The alluring woman herself, confined to prison a few hundred miles away, is present thanks to two surreal acts of substitution. A portrait of her has been painted on the carved headboard of her bed. Her face is sly, feline; a scarf billows behind her head, making her a winged Victory or an aerodynamic Valkyrie. And, on the soundtrack, the frenzied rhapsody of a piano – composed by Franz Waxman, although the music for a sonata called *Appassionata* by Francesco Ceruomo is propped on the instrument – serves as her wordless voice. Peck completes his research by venturing into the bathroom. Inconceivable in an English country house, it might have been designed for use by Cecil B. de Mille's Cleopatra. A black tub is sunk in the bristling carpet, like a woodland pool. Romping naiads are etched on the glass walls, commemorating the birth of another marine Venus. A massive mirror is framed with shelves for the bottled unguents and aromas with which the seductress pampers her flesh. This suite of rooms encourages Hitchcock to imagine orgies.

Houses, like clothes, remember our bodies; rooms indelibly witness what happens in them. Edgar Allan Poe thought that the detective should train himself to be a physiognomist of the domestic interior, and in *Rope*, following the procedure recommended by Poe, James Stewart incriminates the furniture. As he surmises what might have happened to the dead boy, the camera travels through the apartment to narrate the end of an invisible figure's life. A ghostly nobody arrives in the hall, hands over a non-existent hat that is placed in the cupboard, moves towards the drinks table, and glances at the piano (which Farley Granger was probably playing). Then the camera studies the chair the spectre sat in, and stares down at the floor on to which the body fell.

The tidy, housebound dramaturgy of *Dial M for Murder* is shockingly disrupted when Hitchcock interpolates an aerial shot of the police conducting a forensic examination. Lamps are toppled, the rug rolled back to expose bloodstains. The dead man's shoes have been deposited on the desk. In disarray, the room resembles a movie sound-stage between takes; a camera is set up to photograph the corpse. As if during a break on set, Ray Milland brings in a tray of tea, and uses this to create some extra disorder. He puts it down on the table, pushing aside a blotting pad. The action uncovers Kelly's second stocking, which he has hidden there. In the film's third act, Milland's disquiet communicates itself to the fixtures and fittings. Now living in the flat alone, he camps there precariously, with wastepaper baskets overflowing and bottles and cups scattered all around. He has dragged an unmade bed into the living room, and props an electric radiator in the middle of the floor rather than cosily lighting the fire.

If you make a mess, it's because you suffer from guilty jitters. But a clean-up implies that you have something to cover up. After her party in *I Confess*, Anne Baxter nervily refuses the maid's assistance and empties the silver, scallop-shaped ashtrays herself, tipping them into a pan with an adjustable lid. She is as briskly efficient as Perkins swabbing the motel bathroom, and like him she hopes that neatness might serve as a proof of innocence. The rectory in *I Confess* is being repainted, and the senior priest remarks that the police suspect 'we

hide crime with paint'. He denies it, and adds: 'we have made sure that the walls underneath are spotless'. In that case – you might ask – why paint them?

A house is a place of conviviality, a shared space in which meals taken together manifest our fellow-feeling. Hitchcock disturbs this ancient function of the human shelter. Miss Lonelyhearts in *Rear Window* serves an intimate supper for two, complete with amorous toasts. She is, however, alone; her guest and prospective lover is imaginary. The dinner table is meant to sustain community, and its rituals are a secular communion. When the housekeeper in *Rope* worries that the candles won't look right on the trunk, John Dall corrects her: 'I think they suggest a ceremonial altar, which you can heap with foods for our sacrificial feast.' Why not consume a meal on top of a grave, since when we eat we are ingesting cadavers? In *Young and Innocent*, one of Nova Pilbeam's brothers holds a rat he has shot above the lunch table. Another brother, instinctively associating nourishment with decay, exhibits the hole that the dentist has excavated in his mouth and boasts: 'I may have to have a plate.'

Nurture is not the purpose of Hitchcock's kitchens. In *Marnie*, Hedren's frosty mother prepares a pecan pie for a neighbour's child. Her culinary tools and the ingredients she uses testify to a long history of emotional refusal. Hedren – mistrustful of men because her mother promiscuously squandered affection on sailors – fingers a nutcracker as if meditating revenge. Her mother pours the treacle with a sinister grin: sentiment is syrup, commercially bottled and bad for your teeth. Even bomb-making in *Sabotage* is a culinary affair. The Professor, played by William Dewhurst, keeps the incendiary ingredients of his trade in his Islington larder, and warns against mixing the contents of the tomato-sauce bottle with another substance from the jar that purports to be strawberry jam. Since kitchens are equipped for execution or torture, it seems natural to commit murders there. In *Lamb to the Slaughter*, an episode from his television series that Hitchcock personally directed, Barbara Bel Geddes kills her philandering husband by concussing him with a frozen leg of lamb. The man was a cop; when his colleagues arrive to investigate, the new widow cooks the defrosted meat, and the police consume the evidence.

Frenzy examines the analogy between gormandizing and killing. At the beginning of the film, as a corpse is fished from the Thames, a spectator on the embankment fondly recalls Jack the Ripper. He happens to be standing next to the impassive, bowler-hatted Hitchcock, and might be speaking for him, like the dummy suborned by a ventriloquist. The Ripper, the onlooker points out, 'sent a bird's kidney to Scotland Yard once, wrapped in a bit of violet writing paper. Or was it a bit of her liver?' Whatever the organ, a woman is defined as offal. Barry Foster neither carves up his victims nor cannibalizes them, but he does combine rape and murder with a quick lunch. Before strangling Barbara Leigh-Hunt, he steals a bite from her half-eaten apple. Once she is dead, he casually chomps the rest of it, and then – not wanting to make a mess – pockets the core. Foster buys and sells fruit at the Covent Garden market. Despite his crimes, he is less culpable than most carnivores. 'Not a lot of meat on it,' grumbles Alec McCowen when his wife serves him a pig's trotter, complete with nails. The porcine foot fights back as he tries to spear it, while he muses about the dead body bagged with a consignment of potatoes: 'Did you ever hear of a corpse that cut itself out of a sack?' He should not be surprised by such antics, because his dinner consists of creatures that enjoy a half-baked life after death. The little legs of a roast quail twitch when Vivien Merchant removes the lid from the serving dish. Whiskered, tentacular monsters float in the muddy broth of her fish soup. Lumps of rubbery matter quiver as McCowen surreptitiously returns them to the pond in the tureen.

Houses recognize that we have segmented lives. Walls guarantee each person's privacy, and staircases segregate our activities, hierarchically ranking our activities. We receive visitors downstairs, and go upstairs to bed. If there is a bathroom on the ground floor, its uses are strictly delimited: guests, according to the polite formula, wash their hands there. Hitchcock bypassed these prohibitions, and constructed other routes through the house. McCrea, needing to escape from the Amsterdam hotel in *Foreign Correspondent*, climbs out of his bathroom, edges along a parapet, and re-enters the building through the window of Laraine Day's bedroom. She has guests in her sitting room next door; they discover McCrea, which compromises her.

Another unfrequented back passage links the kitchen and the bathroom, which ought to be kept apart for sanitary reasons. Hitchcock manoeuvred them into proximity because they are the two ends of the alimentary canal: we eat, we evacuate.

The bathroom is the most revealing place in the Hitchcock house, precisely because it is the most sequestered. It is also – if you share his misgivings about the body – the guiltiest. Commenting on the documentary accuracy of the silent prelude to *Blackmail*, Hitchcock mistakenly recalled that the police officers took the man they arrested 'to the lavatory to wash his hands'. It was an interesting slip: after muckily finger-printing the criminal, the detectives go to the washroom on their own before leaving work – but it as if some of his moral grime adhered to their hands. In *Spellbound*, Gregory Peck wakes up at night in Rochester, gropes his way to the bathroom and switches on the light. The tiles glare, and light bounces back from the unbesmirched towels. He rubs his chin and considers a shave. He opens the razor: the blade gleams icily. He mixes foam in the shaving mug, and whips up a frothy blizzard. The theremin keens electronically as he looks at the sink, then at a white chair, stained by stark linear shadows. The bath-tub is a polished, pristine slab, like the operating table in the surgery earlier in the film. These stainless, pitiless white surfaces accuse him, knowing that he is bound to sully them. He reels to the door. A brief visit to the bathroom has induced a nervous breakdown.

For Hitchcock, any task performed in there qualified as suspicious. In *Marnie*, waiting to rob a safe, Hedren hides in a toilet stall until the office empties. The compartment resembles one of the curtained booths in churches, where secrets are ventilated in a whisper. Like a skulking priest, she listens to the intimate chatter of her colleagues. Raymond Burr in *Rear Window* scrubs down the walls of his bathroom, where he sectioned his wife. Thelma Ritter, watching, muses that there must have been a good deal of splattering. At the beginning of *Sabotage*, Homolka scrubs his fingernails before returning to the cinema. The water draining from the basin is milky, grainy – full of the sand that clogged the Battersea turbines. In *North by Northwest*, Grant inspects the toilet articles belonging to the notional CIA agent,

supposedly resident at the Plaza. He picks up a comb, grunts in disgust, and diagnoses dandruff. The housekeeping in the hotel room is anally immaculate. A maid changes the linen on a bed that has not been slept in, and the valet takes suits that have not been worn to be dry-cleaned. Still, Grant's phantasmal double leaves one proof of his bodily presence: those tell-tale flakes trapped by the comb.

On the train, he dodges into the toilet of Eva Marie Saint's compartment while the porter opens the bed, and passes the time in contemplation of her miniature shaving kit: a brush with a tiny pubic clump of bristles (making visible the very thing it helps to deny) and a razor so small it could probably only remove one hair at a time. Later he uses it to shave himself in the lavatory at the Chicago station, while a burly fellow beside him scowls at his dainty scratching and scraping. Eva Marie Saint asks what took him so long. 'Big face, small razor,' Grant replies. The remark glances at the distresses of stardom and its magnification of faces. Luckily, Grant escaped the pillory because his famous face was covered in lather. As well, his comment acknowledges the battle between civilization and wildness, still being fought whenever we look in the mirror and study our subcutaneous shame. In *I Confess*, the older priest uses a startling metaphor when he rebukes the young colleague who doesn't know how to mend his bicycle tyre. 'One has a face,' he says; 'one should shave it.' Another commandment has been added to the decalogue. Hitchcock contributed yet more: one has a neck, so one wears a tie around it – as he sternly told William Friedkin, who arrived to direct an episode of *The Alfred Hitchcock Hour* sporting an open collar. The refrain is taken up in *I Confess* when Anne Baxter's husband mocks the clichés of the parliamentary opposition in a debate by jeering 'Curb your dog, keep your city clean.'

In the first *Man Who Knew Too Much*, Peter Lorre stages a tantrum in a hotel bathroom, and tears the toilet paper from its holder sheet by sheet, swearing in bastardized Spanish among a surf of tissue. A family conference is squeezed into an office toilet in *Mr and Mrs Smith*, with deliberations interrupted by the chugging of pipes as a skyscraper processes its load of waste. Hitchcock calculated the optimum length of a film – which he thought should never exceed two hours –

by citing the audience's periodic need to urinate. The bladder's endurance, he said in a 1966 interview, is the 'fundamental problem' of cinematic narrative, and it dictates a crescendo of excitements towards the end, planned to keep the public from being 'physically distracted'. These scruples spill over into the films themselves. We cannot prevent ourselves from wondering what arrangements for relief are made by Robert Donat and Madeleine Carroll, handcuffed together overnight in *The 39 Steps*. And how do the survivors in *Lifeboat* finesse such matters during their long, exposed ordeal?

It amused Hitchcock to lock people in lavatories. In *Number Seventeen*, Ben (played by the comedian Leon M. Lion) is bundled into this place of penance and solitary confinement. 'First I'm a murderer,' he complains, 'then I'm a liar, now I'm a bathroom fixture.' Later, unconscious, he is deposited in the bath-tub, like the corpse in *The Trouble with Harry*; when he comes to, he clobbers the detective with a scrubbing brush. Dame May Whitty is stowed in the lavatory of the roomette in *The Lady Vanishes*, and remains there until the train crosses the border. She perches on the washbasin, her bottom sagging into the sink. All of us vanish when we go to the bathroom to attend to invisible, unmentionable functions. One of the cricketing Englishmen warns his friend (who's ensconced in a lavatory in the train corridor) about the hunt for a missing person; Naunton Wayne, emerging, says indignantly, 'Well, she hasn't been in here!' When Dame May finally reappears, he assumes that she was detained in the toilet: 'Bolt must have jammed.' For Hedren in *Marnie* the bathroom is the clenched enclave of virginity. On her wedding night, she spends forty-seven minutes cloistered there, while Sean Connery impatiently studies his watch. 'You're very sexy with your face clean,' he snarls when, looking scrubbed and pale, she comes out. After submitting to him, she transfers her ablutions to the swimming pool, where she tries to drown herself.

Perhaps the only Hitchcock character who uses a bathroom for its ordained purpose is the heroine of *The Lodger*. She soaks in the tub while the dubious lodger mutters to her through the door; wrapping a towel around herself, she lets him in. Warm vapours condense into mist in the bathroom. Hitchcock subtitled the film *A Story of the Lon-*

don Fog, evoking the gloom in which the serial killer operates. The steam from the bath is hot fog: the interior of the house has been invaded by the atmosphere that mystifies the city outside.

Throughout his career, Hitchcock nudged the cinema towards explicitness about the body's diurnal crimes. There were setbacks. The censor, having reviewed the script of *The Wrong Man*, obliged him to 'eliminate the toilet fixture in the cell'. He also had to remove the mild, euphemistic curse word 'Jeez': to take Christ's name in vain and to place a toilet on view were comparable offences. By *Family Plot*, he had outlived such interference. After returning their first hostage and collecting the ransom, Karen Black and William Devane clean out the windowless cell in which they hold their captives. She strips the bed and, glancing at a chemical toilet, tells him to 'empty that out'. Its lid is lowered, though a roll of paper squats atop the tank. He objects that the task is beneath his dignity as a jeweller. Gems and germs seem not to mix – though don't diamonds begin as sooty, squalid carbon? The necklace in *Number Seventeen*, studded with precious stones, is reminded of its origins by being dumped in a toilet cistern for safekeeping. Black tells Devane that his nasty chore is 'the wages of sin'. All he says in reply is 'Bitch.'

In Hitchcock's cellulated house, to cross a doorstep counts as one of those trespasses for which we pray to be forgiven. Judith Anderson, opening up the wing of Manderley that was Rebecca's lair, challenges Fontaine's timidity: 'You've always wanted to see this room, haven't you? Why did you never ask me to show it to you?' Balsam may not knock on the front door in *Psycho*, but before stepping into the house he politely removes his hat – a sad scruple, which in retrospect turns him into a victim, voluntarily approaching the altar at the top of the stairs as if mounting an Aztec pyramid. With his hat off, he has cleared the way for Mrs Bates's knife to gash his forehead. Fences too represent limits, and tease us to transgress them. In *Under Capricorn* Joseph Cotten, a groom in Ireland before his transportation to Australia, remembers that Ingrid Bergman when out riding would 'go at a fence like it had the kingdom of heaven on the other side of it'. Cotten has to shoot his favourite mare after Michael Wilding runs the horse into a closed fence.

The title-cards that introduce *Spellbound* proclaim that the purpose of psychoanalysis is to open 'the locked door of [the patient's] mind'. Peck, delirious in the operating theatre, cries out, 'The doors! Unlock them!' He is demanding the liberation of the madmen incarcerated at the sanatorium, and a surreal play of images grants his wish. As Bergman walks upstairs to the library, a sliver of light beneath Peck's door announces that he is awake. The leakage glows as if molten, seething like lava banked behind that wooden barricade. On her way downstairs she enters the room. Though they are both in their night-clothes, an open door discreetly divides them. They occupy separate parts of the suite, Peck in the bedroom and Bergman in his outer office. As they kiss, imaginary doors swing wide: permission has been granted. A guardian has been posted at the symbolic door, though he does his job as ineffectually as any of Hitchcock's watch-dogs. In *Spellbound* this role is played by the ticket-checker at Grand Central Station. Twice he is bemused by the comings and goings of Peck and Bergman as they catch trains, and the film ends with a shot of him scratching his head over their newlywed canoodling. His cap identifies his function in the psychic allegory. It labels him GATEMAN, and – like the usher who tears tickets at the cinema – he patrols the border between sleep and waking. To be on a train is to be propelled along, not of your own volition. Renouncing control, you let the dream carry you away. He waves Peck and Bergman through; at Grand Central in *North by Northwest*, Grant evades one of this functionary's colleagues when he sprints on to the platform without a ticket, calling out that he is seeing someone off.

Doors, gates and fences may tempt us to breach them, but for Hitchcock the most obliging barriers are windows, which give the eye free passage without requiring the body to risk itself by venturing over the threshold. A film director organizes the world to fit a frame, and Hitchcock's oblong windows – like the panoramic wall of the penthouse in *Rope*, or the triptych of panes in *Rear Window* – often allude to the shape of the cinema screen. The narrator in Cornell Woolrich's story spies on his neighbours from a bay window in his rear bedroom; Hitchcock in *Rear Window* flattened out the recess, and – at a time when the cinema was increasing the horizontal ratio of its

name, he said that she was the kind of girl you could lean on. Like a banister, it's her duty to play a supporting role. But, despite Patricia Hitchcock's plump solidity, Chubby is less trustworthy than the balustrade in *Under Capricorn*: she blithely betrays Wyman when she tells the detective about her absence from drama classes.

The identification between his daughter and a staircase catches Hitchcock's deceptive guile, his wicked playfulness, his surreal gift for merging reality with dreams. Replacing a human body with a wooden prop, he could destroy it without spilling blood. In *Number Seventeen*, a detective and a girl are tied together, as if in a 'tableau vivant' at the Vice Museum, and trussed to a rickety banister in the dark, deserted house. 'It's like the pictures, isn't it?' she giggles with ironic knowingness. 'Too much for my liking,' he replies. Then the banister crumbles, and they lunge into the stairwell. 'Ooh, I fainted,' says the girl, relishing the sensations that Hitchcock identified with the cinema's delectable nightmares.

She has fallen into a film, and is reluctant to be hauled back to reality. At the end of Brian de Palma's *Body Double*, Craig Wasson offers to pull Melanie Griffith out of the pit in which she is about to be buried alive. 'Here, take my hand,' he says, paraphrasing Grant as he reaches out to Eva Marie Saint on Mount Rushmore. De Palma's film is an anthology of such citations. Its plot couples *Rear Window* and *Vertigo*, combining voyeurism with reincarnation. Wasson carries round with him a childhood trauma that he inherits from *Spellbound*, and there is even a shower scene as a tribute to *Psycho* – though one of the bathers is a vampire in black leather bondage gear. Griffith herself, Tippi Hedren's daughter, is a living quotation. Playing a porn star with a tattooed buttock who is hired to masturbate with a clothes brush, she enacts Hitchcock's coarser fantasies about women. Surprisingly, she spurns Wasson's aid. She accuses him of being a necrophiliac (which she translates as 'corpse-fucker') and snaps 'I'm not dead yet!' She might equally well have called him a cinephile: film fans, as the director Nicolas Roeg has said, are 'trapped in the little dark room' and 'want to make love to dead people'. Wasson looks wearily down into the murky cavity where Griffith sprawls, and says 'Are you gonna stay in there for the rest of your life?'

I could ask myself the same question about my preoccupation with Hitchcock, and the answer I would have to give to Wasson's question is: Yes. By now my obsession is incurable, and I no longer expect or wish to be relieved. At home in London, I think of Hitchcock's houses every time I go into or out of my own. The front door, like that of the building where Barry Foster lodges in *Frenzy*, opens directly off an inner-city street. Ahead of me, when I come in, I have three flights of stairs as my solitary domain. I could add an extra flight if I included a slanting metal ladder that can be tugged down from the ceiling whenever I need access to the eaves. But I prefer to omit the attic from my mental calculations: look at the trouble Hedren got into when she couldn't resist those final steps in *The Birds*. Going upstairs, I often feel like one of Mrs Bates's uninvited visitors, even though it is the indentation of my own body that I see on the bed. Going down, my movements also often inadvertently quote from a Hitchcock film. Like the camera in *Frenzy* making its exit after the murder, I sometimes glance over my shoulder at the house before disappearing underground at the station on the corner. The façade is unforthcoming, the curtains drawn. No silhouetted old lady guards the window, no photographer pokes his lens out of the shadows. Surely, unlike Foster's flat (which stands less than a mile away in Covent Garden), that anonymous slice of brick harbours no secrets?

In fact, if you investigate, it is a pile of psychological contraband – belonging, I hurriedly add, to Hitchcock, not to me. The secrets begin as soon as you open the front door, and they congest the walls in the entrance hall. Stacked on two flights of stairs, they have begun to overflow into the kitchen and also (I know that Hitchcock would have approved) into one of the lavatories. The evidence I refer to is my Hitchcock posters, which have spread out to take up all the available space. Now, moving between floors, I trudge through a tunnel of dreams. At the last count, there were exactly a hundred of them. A good point, I know, at which to give up collecting, to free myself from the craze. Rather than that, I am wondering about the prospect of a larger, lonelier house, preferably on a hill.

At the auction in *North by Northwest*, where the offerings include Louis Seize fauteuils and Aubusson settees, Grant jeers when he sees

image, thanks to the anamorphic CinemaScope lens – provided James Stewart with his own domestic equivalent of the three adjoining screens used by Abel Gance in *Napoléon*. Translucent blinds only partly shield these windows, and they roll up during the credits without anyone needing to tug their cords, like Miss Torso disrobing in triplicate. As Stewart enviously ogles the honeymooners, Ritter calls him a 'window shopper'. The window is a showcase, where commodities – protected from our greedy appetites by the sheath of glass, unlike Miss Torso whose guests paw her – are placed on display.

Hitchcock's characters can look through their windows with impunity, so long as no one returns their gaze. Stewart panics when he realizes that Burr knows he is being watched, and orders Ritter to retreat into the shadows. She does so reluctantly, taking the occasion to rebut the feminist attack on Hitchcock's so-called scopophilia: 'I'm not shy,' she says, 'I've been looked at before.' Nevertheless, according to the director's house rules, her homespun moralism gets it wrong. She says that people should stand outside their own homes and look in for a change. But what would they see? Privacy denuded, secrets despoiled. Breton, who made sexual candour an item in the surrealist creed, bragged that he lived in a glass house. Hitchcock preferred a more shuttered, occluded dwelling.

For him, the most exposed and perilous part of any house was that indistinct area that connects and yet separates the reclusive residents: the staircase. Two early films, both made in 1929, establish its hubristic enticements and its treacherous insecurity. The painter who seduces Anny Ondra in *Blackmail* points out his studio as they stand in the stairwell: 'I'm right up there, at the top.' He sends her on ahead, and she ascends as haltingly as if she were mounting the scaffold, while he loiters below. When he catches up, the camera levitates to follow them, showing the cross-sectioned house with its cutaway beams. On its crane, the camera is excused from the effort of climbing; it wafts upwards, with the breezy ease of the libertine. In Hitchcock's next film, *Juno and the Paycock*, the stairs are a chute leading directly to perdition. Opening out the theatrical enclosure of Sean O'Casey's play, he gave the staircase in the Irish tenement an almost

choral function. It tallies and equalizes comic mishaps and tragic falls. Joxer and the roistering Captain Jack hurtle down it towards the pub, and a procession of keening mourners use it on their way to a funeral. The killers of Johnny Boyle (John Laurie) drag him down the stairs as he screams his rosary; finally the removal men cart away the furniture, which the Boyles have not paid for.

A staircase may be inert, but for Hitchcock it was the motor of drama. It facilitated quests, encouraged competitions for pre-eminence, and yet finally demonstrated that all our vertical striving leads us to the same place, dizzily poised above a gulf. The balance of power between the two Charlies in *Shadow of a Doubt* is played out on two sets of stairs, inside the house and outside it. When Cotten is told about the other suspect's death in the east, he celebrates his escape by opening the front door and bounding up the stairs, while the camera vaults after him. Then, just before the landing, he turns to look back. Teresa Wright is still on the porch, preceded by a looming shadow that prints itself on the hall floor. She knows about his guilt, which drags him down from his triumphant summit. He therefore tries to kill her, sawing through a step on the rickety back stairs. She survives the fall, and calls the FBI man (MacDonald Carey) for help from a wall phone beside the staircase. She makes three efforts to reach him, and each time the camera retreats to a higher vantage point on the stairs. The aerial view signals that her uncle has retrieved the advantage; but she will not admit defeat. She races upstairs, finds the victim's ring in his room, places it on her finger, and stands on the landing to announce: 'I'll be right down.' As she elegantly glides to the ground floor, the finger with the ring on it slides down the banister and flashes an ultimatum at him. He immediately decides to leave town the next day.

'Go up the stairs!' Stewart tells Novak in *Vertigo* on their second visit to San Juan Bautista. She advances sheepishly; he has to drag her most of the way. The climb is a moral and psychological trial for him, and when they reach the trapdoor he congratulates himself on an evolutionary victory: 'I made it!' He does not have long to relish this sense of achievement. All the same, he is entitled to gloat. Stairs require stamina, a head for heights, and a certain courage, since who

knows what lies in wait on the next landing? The elevator spares you effort but leaves you unable to claim credit; Hitchcock, for this reason, seems not to have approved of lifts. In *North by Northwest*, it is only too easy for Jessie Royce Landis to rescue Grant from his kidnappers by making a joke of the plot as they all float down together in the elevator at the Plaza Hotel. Hitchcock staged his own real-life variant of this scene in an elevator at the nearby St Regis Hotel in 1964. Fuelled by several daiquiris, he travelled down from his suite with Peter Bogdanovich, and regaled him on the way with an impromptu story about a man with blood streaming from his mouth and ears. Every time the elevator stopped to let in more passengers, Hitchcock added some extra gore. He loudly described asking the victim what had happened to him, and as they reached the lobby, timing the conclusion exactly, he said, 'Do you *know* what he *told* me?' People tried to find reasons to linger within earshot, but Hitchcock suddenly switched off, and said no more. Bogdanovich begged to be told what the man had said. 'Oh, nothing,' shrugged Hitchcock. 'That's just my *elevator* story.' Staircases lead gradually upwards to doom, like the steps that beckon Hedren to the attic in *The Birds*; elevators take the express route down, then release you in an abrupt anticlimax.

Although to go downstairs is a return to safety, this particular rite has its own alarms. Ondra, leaving the painter's studio after she kills him, tiptoes on the treads and takes care not to let her umbrella bang on the ground. The most painfully protracted descent of a staircase comes, however, at the end of *Notorious*. Going upstairs in Claude Rains's house is hydraulically simple. Bergman is carried to bed after her collapse, and Grant races up unimpeded when he comes to rescue her. Getting back to the ground floor is more arduous – not the first time, when the crane, dispensing with stairs, swoops from above the chandelier into the foyer; but in the last scene of the film, as Grant walks the drugged and debilitated Bergman out of the house, the camera bounces down step by step, registering the impact of every stage in the gradient with a shock like that of feet rebounding. The staircase happens to be wrapped around the wall, unlike the sets of ladders placed at angles and separated by landings in *Vertigo* or

Psycho. A curved staircase does not take the shortest route, which makes the descent more indirect and tantalizing.

Hitchcock was pernickety about the deportment of people on stairs. Influenza kept him away from the set of *Psycho* on the day when Balsam was due to mount the staircase, so he authorized a deputy to supervise the filming. When he saw the footage, he rejected it. The close-ups of Balsam's feet and of his hand as it clenched on the railing made him look stealthy, as if he had come to burgle the house. Hitchcock remembered this miscalculation, and later made use of the details he excised from *Psycho*. At the end of *Frenzy*, Finch creeps up the stairs to Foster's flat, carrying a crowbar. Finch has been convicted of murders that Foster committed. Now, having escaped from a prison hospital, he is intent on revenge. The innocent hero is about to prove himself guilty after all. We hear Finch's feet in their hospital slippers pad on the carpet; what the camera chooses to look at is the way his hand not only grips the wooden banister but fondles it, opening further to caress it as he turns the corner. His fingers are splayed, and they slither across the rail. The banister might be a wooden leg, like the limbs of the rigid body in the potato sack. In part, he uses it for reassurance, following the example of the tipsy, staggering Bergman in *Under Capricorn*. Wilding helps her out of the dining room; she discharges him when they reach the stairs. 'Now I have the balustrade,' she says, steadying herself. 'Good old balustrade.' But Finch also transposes from one hand to the other the almost erotic pleasure he will derive from the crime. His right hand grips the crowbar, while the left expresses the delight he will take in using it – a moral transference too, because he is now no better than Foster. He does go through with the murder, fortuitously killing a corpse: he brains a woman in the bed, who has previously been strangled by Foster.

The banister in *Frenzy* is what analysts of metaphor call a vehicle or carrier, an object metamorphosed into the likeness of something it does not resemble. Finch's fingers confide to it the feelings that his other hand, clenching the crowbar in a tightened fist, must repress. In *Stage Fright*, Hitchcock cast his daughter as Chubby Bannister, Jane Wyman's friend and fellow student. Joking about the character's

Whatever the crime, the posters agree in deciding who committed it, or fancied doing so. Inside my window, a frowning Stewart and a square-jawed Teutonic facsimile of Grace Kelly look out of their window. The culprit they scrutinize in *Das Fenster zum Hof* is not Burr but Hitchcock, who unconvincingly holds up his hands to signal innocence. Elsewhere, in a Japanese poster for *The Lady Vanishes*, he discovers himself in the film's title. The lettering is in Japanese script except for the title, which appears in English. A tiny Hitchcock stands to one side and looks at the capitals: they are all in black, apart from the first 'a' in *Lady* and the 'h' in *Vanishes*, which flare in red. His initials press through the monotone surface like a blush or a bloodstain. He waddles into a British poster for *Strangers on a Train* and holds an extra capital letter just above the title, threatening to turn the strangers into stranglers. In a lobby card for *The Wrong Man*, he makes a walk-on appearance that you can't see in the film itself. He stands beside Henry Fonda at the counter of the diner outside the subway station, pretending – it is one of the professional snoop's oldest alibis – to leaf through a newspaper. In *Le Crime était presque parfait*, he gloats from an upper corner, his lips pensively sealed by two fingers, as Kelly writhes beneath the body of her attacker. Her hand stretches out beside the telephone, reaching for those editorial scissors. Perhaps Hitchcock is admiring the beauty of her bare, extended arm, which resembles a swan's neck. The roles are reversed in *Mistanken*, as *Suspicion* was renamed in Denmark. Here an ownerless hand – female, to judge by its polished nails – offers the director a glass of milk. This time it evidently does contain poison, since a skull floats beneath the level of the liquid. Hitchcock, like Hamlet, looks amused to discover himself cornered and accused by his own plot.

I find myself exchanging grins of complicity with his many faces. From the bottom to the top, it is a long climb; he keeps me company. So do my younger selves, dating back to the truant who slunk in to see *Psycho*. The staircase operates like the medieval wheel of fortune, or like the rotation of a projector at the cinema. When you get to the top floor, you must come back down. Reaching the end of the reel, you start to watch those irresistible images all over again. It is a lifelong process.

I have never regretted the sneaky lengths I went to in order to see *Psycho*, or the pocket money that paid for my disturbed sleep. The older I get, the shrewder that early investment seems to have been. For good or ill, the stories Hitchcock told act out the lives we only dare to lead in our imaginations, which is where most of our misdemeanours occur. He encouraged insurgent fantasy, but warned us against expecting our wishes to be fulfilled in the daylight world outside the cinema. Glancing up at the winged bombardiers in the air above us and down at the chasms beneath our feet, his films display the conditions and the limits of our existence. We have much to learn from him about the discomforts of being alive, the travails involved in dying, and the reckonings that perhaps are to come. Buddha too was a rotund joker, who smiled as he contemplated the void.

Index

Acknowledgments

My thanks to Walter Donohue, an editor with a keen and clear sense of structure, and to Kate Ward, who oversaw the book's production. As always, I am grateful to my agent Pat Kavanagh. I feel proud to be represented in New York by Gloria Loomis, an inveterate movie-goer whose faith in this project never faltered. Richard Kelly resourcefully rounded up the illustrations.

In 1999 I wrote and narrated a centenary tribute to Hitchcock for BBC Radio 3, and must thank Richard Bannerman and Nicola Barranger for their expertise as producers. Reminiscences by Patricia Hitchcock, Peter Bogdanovich, Joseph Stefano and Barbara Leigh-Hunt are quoted from interviews conducted for this programme in New York, Los Angeles and London. Tim Kirby generously enabled me to hear the original, unbowdlerised tapes of Truffaut's sessions with Hitchcock.

Jackie Webber photocopied the manuscript, and when returning it acted out Mrs Bates's invasion of the shower, complete with stabbing gestures and high-pitched shrieks: what better proof could there be that we are all performing in Hitchcock's bad dreams? Early in 2000, I used the middle section of the book as the basis for a series of classes in Oxford. Though the students who attended were mostly seeing the films for the first time, their insights opened my eyes even wider than usual, and confirmed that Hitchcock has spellbound one more generation.

Photo credits:

Pages 1 and 329, from *Psycho,* © MCA / Universal Pictures, courtesy of BFI Stills, Posters and Designs

Pages 21, from *Family Plot,* © MCA / Universal Pictures, courtesy of BFI Stills, Posters and Designs

Page 41, frame-still *The Birds,* © MCA / Universal Pictures, courtesy of BFI Publishing

Page 65, from *Blackmail*, © British International Pictures / Gainsborough Pictures, courtesy of BFI Still, Posters and Designs

Page 81, poster art from *Jamaica Inn*, © Paramount Pictures, courtesy of BFI Stills, Posters and Designs

Page 95, from *Vertigo,* © MCA / Universal Pictures, courtesy of BFI Stills, Posters and Designs

Page 119, from *Rope*, © MCA / Universal Pictures, courtesy of Peter Conrad

Page 139, storyboard by Oscar Werndorf for *The 39 Steps,* © Gaumont-British Picture Corporation, courtesy of BFI Stills, Posters and Designs

Page 153, from *The Lodger*, © Gainsborough Pictures, courtesy of BFI Stills, Posters and Designs

Page 165, from *Secret Agent*, © Gaumont-British Picture Corporation, courtesy of Peter Conrad

Page 183, *Rebecca*, © United Artists, courtesy of BFI Stills, Posters and Designs

Page 193, *Young and Innocent*, © Gaumont-British Picture Corporation, courtesy of BFI Stills, Posters and Designs

Page 209, from *Sabotage*, © Gaumont-British Picture Corporation, courtesy of BFI Stills, Posters and Designs

Page 229, portrait of Alfred Hitchcock, courtesy of Cahiers du Cinéma

Page 249, from *The Man Who Knew Too Much* (1934), © Gaumont-British Picture Corporation, courtesy of BFI Stills, Posters and Designs

Page 263, from *The Trouble with Harry*, © Paramount Pictures, courtesy of BFI Stills, Posters and Designs

Page 283, from *I Confess*, © Warner Bros, courtesy of BFI Stills, Posters and Designs

Page 299, from *The Man Who Knew Too Much* (1956), © MCA / Universal Pictures, courtesy of BFI Still, Posters and Designs

Page 313, from *Stage Fright*, © Warner Bros, courtesy of BFI Stills, Posters and Designs